"It's the Pictures That Got Small"

FILM AND CULTURE *John Belton, Editor*

FILM AND CULTURE
A series of Columbia University Press
Edited by John Belton

For the list of titles in this series, see page 423.

Edited by

ANTHONY SLIDE

"It's the Pictures That Got Small"

CHARLES BRACKETT *on* **BILLY WILDER**
and **HOLLYWOOD'S GOLDEN AGE**

COLUMBIA UNIVERSITY PRESS *New York*

Columbia University Press
Publishers Since 1893
New York Chichester, West Sussex
cup.columbia.edu

Copyright © 2015 Diaries of Charles Brackett © Clifford James Moore III,
Victoria Brackett, James Larmore
Editor's introduction comments, footnotes, and endnotes © 2015 Anthony Slide
Foreword © 2015 Clifford James Moore III
Compilation © 2015 Clifford James Moore III and Anthony Slide

Library of Congress Cataloging-in-Publication Data

Brackett, Charles, 1892–1969.
[Diaries. Selections]
"It's the pictures that got small" : Charles Brackett on Billy Wilder and
Hollywood's golden age / edited by Anthony Slide.
pages cm — (Film and culture)
Includes bibliographical references and index.
ISBN 978-0-231-16708-6 (cloth : alk. paper)— ISBN 978-0-231-53822-0 (ebook)
1. Brackett, Charles, 1892–1969—Diaries. 2. Brackett, Charles, 1892–1969—Friends
and associates. 3. Motion picture producers and directors—United States—
Diaries. 4. Screenwriters—United States—Diaries. 5. Wilder, Billy, 1906–2002—Friends
and associates. 6. Motion pictures—Production and direction—United States—History—
20th century. I. Slide, Anthony, editor. II. Title.

PN1998.3.B713A3 2014
791.4302'32092—dc23
[B]
2014015801

Columbia University Press books are printed on permanent and durable acid-free paper.
This book is printed on paper with recycled content.
Printed in the United States of America
c 10 9 8 7 6 5 4 3 2 1
JACKET DESIGN: Catherine Casalino

References to websites (URLs) were accurate at the time of writing. Neither the author
nor Columbia University Press is responsible for URLs that may have expired
or changed since the manuscript was prepared.

CONTENTS

CONTENTS

ACKNOWLEDGMENTS

Obviously, my first and most important thanks must go to Clifford James Moore III, "Jim," who trusted me with the major task of editing these extraordinary diaries kept by his grandfather. My thanks also to him and his wife Carolyn for transcribing portions of the handwritten diaries which had either never been deciphered and typed by Brackett's secretary, the incredible Helen Hernandez, or the transcriptions of which had disappeared through the years.

At the Margaret Herrick Library of the Academy of Motion Picture Arts and Sciences, where the papers of Charles Brackett are housed, my primary thanks to Howard Prouty, who went far beyond his responsibilities as an archivist, not only in providing full and unimpaired access to the diaries but also in countless other ways. Also, at the Academy, I would like to thank Jenny Romero, special collections coordinator. At the Writers Guild of America, library director Karen Pedersen and archivist Joanne Lammers were helpful.

It was Santa Barbara–based antiquarian bookseller James Pepper who first impressed upon me the importance of these diaries, and without his enthusiastic support I would not have taken on the editing of them. Additional support and help was provided by Don Bachardy, James Curtis, Lindsay Doran, Robert Gitt, Patricia King Hanson, Larry Mirisch, Sue Slutzky, and Jeff Spielberg.

At Columbia University Press, director Jennifer Crewe, and John Belton, editor of the Film and Culture series, promoted and sustained the project from its beginnings, when I first approached them as to the possibility of publication of the diaries. Also at Columbia University Press I would like to thank Kathryn Schell and senior manuscript editor Roy Thomas.

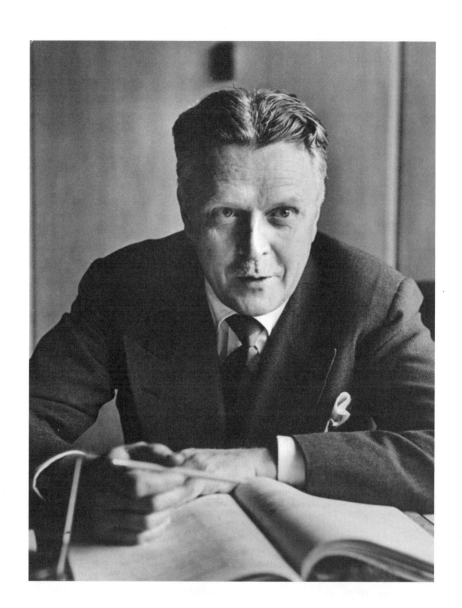

FOREWORD

There are few editorial tasks as daunting as the one Anthony Slide undertook at my urging in preparing the manuscript for this book. I am both apologetic and grateful for the three-year journey Tony endured in order to arrive at the terminal station of publication. The original journals materials with which Tony did a wonderful job cover not only a wide chronology—1932 to 1949 for this volume alone—but they also encompass a dynamic period of time for the diaries' author, my grandfather, Charles W. Brackett. The entries making up this book reflect the fourteen years in which Charlie and Billy Wilder collaborated on some of Hollywood's most formative, if not outright iconic, pictures.

Only Tony Slide, thoroughly armed with his unchallenged expertise in the motion picture industry's history and its personalities, could have been prepared for the arduous task of culling through decades of diary entries. Many of the journals had been transcribed by my grandfather's guardian secretary, Helen Hernandez, but many others were available to Tony and me in Charlie's nearly illegible scrawl in fading ink, penned on faintly-lined pages, some of which are now more than seventy years old. Not all years were complete annual records, but most years contained at least two hundred of Charlie's daily recollections, many of which are mind-numbingly detailed in quaint phrasing. Yet, in the inimitable Slide manner, the appropriately-chosen, faithfully-preserved diary entries that comprise this book belie any hint of editorial struggle. Tony's scrupulously researched notes add all-important context to illuminate the people, places, and events of a bygone era. To quote an oft-favored phrase of Charlie's, "*Mirabile dictu.*"

I will leave to Tony the details of the diary entries themselves, through his introduction, exhaustive notes, and cast of characters, all illuminating the motion picture industry's history. That is what Tony Slide does best; his work

reflects the deep knowledge and broad understanding of an expert. Having been born in 1949, my own knowledge of my grandfather's business during the years 1932 to 1949 is little better than that of an avid—though admittedly self-interested—film aficionado. But I do know the Charles Brackett behind the diaries—forever Gramps or Charlie to me. He and I met in Washington, D.C., when I was just a few weeks old, and despite the distances between us as I traveled around the country and overseas as the son of an Air Force officer, we were inseparable—bound heart-to-heart, as Charlie was with each of his three grandchildren. The Charles Brackett whose hand illuminated the diaries was not a screenwriter or a producer to me; he was a loving and generous man who was passionate about his star-crossed family. My fascination with the diaries has little to do with the details of Charlie's studio life—parsing those entries is best left to movie industry scholars like Tony Slide. As Brackett's grandson and biographer, my interest lies in better understanding the man behind the diaries, and in that quest I found much in the diaries to inform my sense of who Charlie Brackett was and, more importantly, who he wished to be.

In my youth, Gramps was my biggest cheerleader; in his weekly letters to my mother—his youngest daughter—he never failed to inquire about me, to encourage me, and to send me an allowance generously and specifically designated for "fun." Charlie urged me on in my preteens to write and take pictures, knowing more certainly than anyone else in the family that those skills would eventually be the foundation of my life's work. He lived long enough to see my first story clips and photo credits from a local newspaper in 1967. Though he had difficulty communicating by then, I'm told he smiled when he held them. He was also a diehard believer in my academic potential, pouring out an almost endless stream of letters to the admissions officers of his alma maters, Williams and Harvard, while I was still in junior high school, urging them to hold places for me in the classes of the 1970s. One of my few regrets is that I did not meet his expectations on that front; what an honor it would have been to wear those caps and gowns as a Brackett legacy graduate. But, fate has many ways of conferring legacy status on us, and the Charles Brackett diaries are evidence of that in my life.

Charlie was the most generous man I've ever known—generous with his good will, his easy smile, his sweet laugh, and his constant worry about everyone else's happiness. He kept in his upstairs study desk a gold and blue tin of Allenbury's Pastilles . . . small, slick, black currant lozenges that he knew were my favorite treat. On hearing that I was coming to visit, he stocked up on several tins, and as the front door to the Bellagio Road house opened, he

stepped out of the way and waved me to the stairs leading to the stash. I never saw Charlie flare up at anyone; he could be firm, with a commanding voice that, when pitched low, was more than sufficient to halt any unwise activity.

He was generous to a fault with his money—funding both his daughters' bank accounts well into their marriages. Never able to say no to either one, Charlie supplied wished-for fur coats and new cars and down payments for mortgages. As for his grandchildren, the three of us wanted for nothing in his presence. Birthday parties were extravaganzas—costume events with props supplied by the studio, and trips to the largest toy store in Westwood to pick out whatever we wanted. When Disneyland opened in 1955, Charlie took us all for opening day, and I still have Charlie's lifetime pass, signed by Walt Disney, with which the gates to the Magic Kingdom would swing wide open (alas, it was *his* lifetime pass and did not transfer to me, much to my own children's dismay).

One thing Charlie Brackett was not was a good driver. No one in the family expected to return un-bumped or un-bruised from any outing on which Gramps set out behind the wheel. Stick shifts, column shifts, and clutches served only to bother him as he randomly ground down yet another transmission. His impatience with female drivers who paused at stop lights to apply makeup infuriated him to the point that he once rammed the back of one dawdling woman's car, knocking her into the intersection after the light turned green. The diaries do unmask this non-mechanical Brackett; I frankly lost count of the number of auto accidents and road-departing mishaps Charlie documents with insouciance and alacrity.

My earliest recollections of my grandfather are framed by his daily journal regimen. Few events escaped his attention, and while some only merited a line or two, most received at least a paragraph, capturing the who, when, what, where, and why in his flowing scrawl. He wrote in bed, or while stretched out on a comfortable red leather fainting sofa, often dressed down in a crisply-starched white shirt, his impeccably-creased gray trousers, and a silk smoking jacket. A pair of leather slippers or slip-on shoes completed his "casual" ensemble.

That leisurely pose masked the effects of personal and professional turmoil that eventually killed him. Charlie's first wife, Elizabeth Barrows Fletcher, an Indianan whose family lineage included a direct Mayflower link, was a plain-featured, intelligent, soft-spoken woman who loved to write, and who was an accomplished poetess, well known in Indiana. She recognized and understood Charlie's need to publish, to find a voice not in his father's Saratoga

Springs law office, but in the pages of magazines and books. There is no question she was a champion for Charlie's cause. Of the hundreds of letters between them, affection is everywhere, and each professes love for the other at the end of every letter. She was also his muse, helping him to turn a phrase in a script, advising him as he plotted out his stories.

The Bracketts' two daughters, Alexandra (Xan or Xanu to the family), born in 1920, and Elizabeth (Betty or Bean), born in 1922, lacked for nothing in their childhood. The family lived in Providence, Rhode Island, in a massive three-story brick mansion designed by Charlie's maternal grandfather, George Corliss, and complete with an elevator and thermostatically-controlled indoor heating and air-conditioning. The family also employed a number of house servants and a chauffeur who was on hand to drive the girls about in the Bracketts' Cord. There were trips to Antibes, France, where the family would spend summers on the Riviera hosted by Gerald and Sara Murphy (the models for F. Scott Fitzgerald's *Tender Is the Night*), and populated by the artists, writers, and musicians of the day, including Picasso, Hemingway, Dos Passos, and the Fitzgeralds. Brackett's fourth novel, *American Colony*, published in 1929, a rather gaudy tale with homosexual and extramarital edges, is loosely based on those summer days. Photographs of all the Brackett family gamboling on La Garoupe beach in the late 1920s reveal nothing of the tensions that would soon come with Charlie's first forays to Hollywood. They are also the last family photographs in which Elizabeth appears.

After my grandfather's death in 1969, his diaries—more than thirty years' worth—were boxed up and sent to the younger daughter, my mother, in Virginia, where she put most of them in storage for several years. My wife and I also kept a short shelf's length of the diaries, and read through them, learning to interpret the Brackett scrawl. From the mid-seventies through the late 'eighties, my mother and I discussed the possibilities of "doing something" with the journals. She received a few requests from freelance writers who hoped the diaries might prove fascinating, or salacious, enough to pitch to their agents. She also sent query letters to publishers to stir up editorial interest in the diaries—but to no avail. Underlying most, if not all, of the rejections, was an oft-expressed opinion: Charles Brackett's diaries simply weren't interesting enough; they needed a marketable book. "They want dirt on Wilder, they want dirt on Dotty [Parker], they want dirt on everybody who was anybody except Charlie Brackett," my mother would vent after the receipt of every rejection—some polite, some bluntly dismissive.

Billy Wilder outlived my grandfather by thirty-three years, and when my mother and I were discussing working the diaries into a book in the 1980s, she worried that the diary entries about Billy were too raw to publish in the glow of a living legend. She knew also that the process of shedding light on her father's life by opening the diaries to public scrutiny would illuminate old family scars, including alcoholism, depression, and violent deaths. She wanted to be selective in separating the family mud from the Hollywood muck, and that was too great an obstacle for her. That fear-driven reluctance to move forward with any diary project dogged her for the rest of her life. And yet she and I always believed there was something important to be extracted from the diaries, a thread of a story or the telling of an industry history sufficiently different from the usual Hollywood tell-all fare to make for a Brackett-worthy book.

The onset of my mother's Parkinson's disease and generally failing health in the 1990s diverted my attention from the diaries, and they languished on the shelves of her study beyond her death in 1997 until just after my father's passing in 2003. When my parents' estate was settled, I boxed up the diaries, brought them to my house, and there they might have stayed, aging without purpose, and vulnerable to deterioration, but for a transforming event three years later. With the assistance of the Academy of Motion Picture Arts and Sciences, my youngest daughter surprised me with an extraordinary birthday gift in 2006: a compilation DVD of videos of my grandfather during several televised Academy Award ceremonies. For the first time in nearly forty years, I was able to see and hear my grandfather and, for the first time ever, to watch him receive Oscars for his work with Billy Wilder.

During a conversation I had the following day to thank the Academy staff responsible for helping compile the DVD, I was asked if I would give consideration to having the diaries properly stored and curated at the Academy's Margaret Herrick Library in Beverly Hills. Within a few months, the library's chief acquisitions archivist arrived at our house and, with the utmost care and respect for the diaries, boxed and shipped the entire collection to Beverly Hills. I had the pleasure of visiting the Margaret Herrick Library about a year after the diaries were received, and it was rewarding to find them finally ensconced on properly humidified and temperature-controlled shelves, not only well cared for but also properly appreciated. During my visit, I was encouraged by several individuals who knew my grandfather to consider writing the definitive Charles Brackett biography. I promised that I would

undertake that project, which is, as of this writing, well under way, thanks to much of the groundwork Charlie Brackett laid for me in his diaries.

Knowing that the Brackett diaries could be accessed by researchers—something to which I'd agreed in the process of donating the journals to the Margaret Herrick Library—opened up the possibility of my finding an academic or motion picture industry experienced writer or editor with whom to collaborate on some form of diary-based book. Once again, the concatenation of circumstances worked in my favor when I reached out to Tony Slide and was rewarded with his agreement to help me find the story that had been locked up inside the diaries for so long.

Over the course of a year or so, Tony and I read through all the diaries—the full transcripts, and the untranscribed journals of which I'd become a fairly decent translator (several years of which I eventually transcribed as Tony and I moved into the manuscript development phase of this book). Some of Charlie's writing defied easy translation. What he begins in the early evening often morphs by midnight into a manic scrawl or wandering passages—streams of consciousness—that I'm sure made sense to him at the time, but, whether due to too much partying or simply a lack of sleep (or both), make little sense sixty-five-plus years later.

Profile writers and Hollywood historians—the legitimate few, and a multitude of the mongrels of the species—have, without benefit of the diaries, created a gray-hued collage of Charlie carelessly pinned and pasted on an indistinct canvas, forever framed by the Billy Wilder legend. By some accounts, Charlie was gay, an amateur novelist, a foppish bumbler, and/or a New England patrician. In other tellings, he was an Algonquin Round Table sophisticate, breezy, knowing, and exquisitely fashioned; his novels were bright and sardonic; and in the words of one movie and theater biographer, Charlie was ". . . a piece of American literature." Contrary accounts aside, his family life was awash in alcoholism, depression, and despair. He could not control the boozy, violent, ultimately fatal marriage of his elder daughter. He was helpless to arrest the sad, inexorable decay of his wife Elizabeth's mental and physical health.

There is no clear indicator of how deeply affected he was by his wife's illness. Nowhere in the diaries is the word *alcoholism* used to describe her condition, nor does he attempt to detail her depression. At most, he will mention that she has gone back East, where a Western Massachusetts clinic took her in for care. From the perspective of a twenty-first-century spouse, it is hard for me to imagine dropping my critically ill wife off at a hospital and then going

to work—much less to Paris—with barely a nod to her condition. But Charlie was a husband of his time and New England social upbringing; it is unfair for me to compare his and Elizabeth's confrontations with illness to how married couples might deal with similar issues today. There are traces of his concern, but the diaries are generally silent when it comes to the real depths of his thoughts on Elizabeth's health. The veil of privacy, typical of time and circumstance, descends over the diaries at the moments most important to the telling of the Bracketts' backstory. Fortunately, Charlie and Elizabeth's letters have helped me lift that veil a bit, and his biography will reveal the Brackett unknown to most, if not all, of his Hollywood chroniclers.

Charlie wandered the hills near his house late at night, questioning his own worth, doubting everything, muttering autosuggestive Couéisms, cursing his decision to leave intellectually-inspiring New York for socially vapid Hollywood. Every year, as his November 26 birthday approached, he took stock of his life, often with the kind of observation he penned in 1932: "November 25: . . . As I write, I am just about passing into my 40th year, and I am as discouraged about my career as one can be who is cursed with a foolishly sanguine disposition. I have an interesting, scattered life, and I have gotten nowhere and I am getting nowhere. I wish I knew the answer." The few friends he ever had or wanted to have—many of whom were in various stages of their own declines—rarely reached out to help him in his hours of need, but he nonetheless rescued them from drunk tanks, failing marriages, and fading dreams, often at great financial and emotional cost to himself.

Someone as emotionally vulnerable as Charlie was becomes particularly vulnerable to the scandal buzzards. Such scurrilous carrion eaters hover over fading or forgotten heroes who, if they had no champions in life, are left alone in death to be picked apart without mercy. There have been, for example, numerous attempts by rumormongers to drag Charles Brackett's body out of a gay closet as if somehow such a revelation would be sensational. It's not; it's simply bad journalism. These carelessly written stories appeal to so many publications whose editors have no desire to check facts, back up stories, doubt their writers, or question unverified submissions. Tony Slide takes on this issue in his introduction, and I think he does well with what he has—a thin gruel of rumors and unsubstantiated innuendo signifying, in the end, nothing.

I knew my grandfather for almost twenty years and I have read every scrap of his correspondences and diaries covering more than seventy years; my mother, his youngest daughter, was close to him for forty-seven years. There

was no hint, no whisper, no behind-the-scenes confession or dark family se-
cret about Charlie's sexuality. Was he gentle? Yes. Could be appear effemi-
nate? Only in that he had a great appreciation for beauty and form not just
in art, but in people—men and women. Were the words he wrote and spoke
to friends dear and soft? Yes, he was a master of the soothing turn of phrase,
and he directed that skill toward family and friends alike. Charlie Brackett
had a kind heart that sank with the fall of every sparrow in his life, and he did
not hold back his affection to those in need of succor. Personally, it wouldn't
bother me a whit if Charlie was gay; one cannot read the diaries and dismiss
that possibility. The point is, gay or not, he was a gifted writer, a devoted and
self-sacrificing friend, and a loving husband, father, and grandfather.

Now, most important to this book, do the diaries shed new light on Char-
lie's relationship with Billy Wilder? More than one school of thought exists to
address this question, and all their answers are in conflict, but not nearly as
much as are the diaries themselves.

At the heart of this book, on page after page of the diaries, Tony Slide
has done a masterful job of revealing the story of the odd-couple partner-
ship between Charlie Brackett and Billy Wilder. Two more different men you
would be hard-pressed to find; two more talented ones, almost impossible to
replicate; two more mercurial ones, in one place in time, have not been seen
since. The diaries make it indisputably clear that the Brackett-Wilder part-
nership was a solidly professional arrangement based on each writer's unique
literary and theatrical skillsets and bonded in the heat of a very dynamic and
unforgiving business. Neither man served at the will of the other—Brackett
was not Wilder's secretary, Wilder was not the sole source of their success.

I never heard my grandfather take Billy's name in vain, and in conversa-
tions with him about the movies on which he and Billy worked, he never ven-
tured into criticisms about the partnership. Whatever anger he might have
had, he buried deeply; whatever disappointment he felt, he took in stride;
and whatever success Billy achieved after *Sunset Blvd.*, Charlie acknowledged
it graciously. And yet the diaries suggest Brackett was far from sanguine about
the relationship. In fact, some pages almost burst into flames when Charlie
lays the tinder of his frayed emotions down in writing and then strikes a
match of genuine anger in describing one or more of Billy's mean-spirited
maneuvers.

From day to day—sometimes from hour to hour, as Charlie dutifully
jots—Brackett and Wilder loved each other, hated each other, defended each
other, sold each other out, delighted in the partnership, and longed for the

pairing to die. Billy had little use for Charlie's conservative politics, Charlie denounced Billy's communism; Charlie's writing was lyrical and intellectual, Billy's was raw and exciting. Charlie had great affection, and, I think, a lot of sympathy for Judith Wilder. Billy respected Elizabeth Brackett and Charlie's second wife, Lillian (Muff, Elizabeth's sister), but he was not often a Brackett party guest, preferring livelier Hollywood venues.

Their collaborative process, frequently noted in painfully exacting detail by Brackett, was far from organized and not always congenial. As Charlie appended to the diaries, "This was before I learned the routine with this temperamental partner. The thing to do was to suggest an idea, have it torn apart and despised. In a few days it would be apt to turn up, slightly changed, as Wilder's idea. Once I got adjusted to that way of working, our lives were simpler."

For the better part of their fourteen years together, they shouted, they pouted, they showed up late, or not at all, they worked at each other's homes, and in bars or restaurants, and on planes, trains, and boats. Charlie's prissiness comes through, as does Billy's churlishness and angst over every little slight or critique from studio leaders. Tempers flare—as on the day when Charlie, finally fed up with Billy for playing a small flute in the office, snatches the instrument and breaks it in front of Wilder.

Both men were hypochondriacs. Based on the diaries alone, it would be hard to know which one suffered the most, but my bet is that my grandfather's imagined health worries trumped Billy's most of the time. Charlie was forever getting his B-12 shots, experimenting with strange electric stimulation machines, spooning cod liver oil at the onset of a cold, having his Eustachian tubes "blown out," coming down with the flu or experiencing high fevers. He analyzed and usually documented every little rise and fall of his blood pressure, thyroid, and metabolism. But Billy was no slouch when it came to imagined illnesses; he was quick to rush to the cardiologist's office at the news of someone else's heart problems.

After years of reading and digesting the contents of the Brackett diaries and by referring to my own extensive collection of family correspondence, and with sufficient time to scrub my own affectionate prejudices, what Tony Slide has collected here reinforces my own feeling that my grandfather was simply a lonely man prone to deep introspection and self-loathing. He was at home with the English language, but he was adrift in Hollywood, out of place among the profane and driven owners and professionals of the movie business who tapped into Charlie's legal skills, political aptitude, and emotional

pliability, to play him for what it was worth to them. With the violent death
of his firstborn, the subsequent death of his son-in-law, and with the massive
criminal, legal, and financial issues that followed the family deep into the
1960s, Charlie's resolve to find a way out of trouble failed him. The heartbreak
that killed him had been a constant companion that finally turned on him.

F. Scott Fitzgerald, who knew Charles and Elizabeth Brackett and had
joined them on occasion in Antibes in the 1920s, and who later worked in
Hollywood with Charlie, wrote in one of his notebooks, "Show me a hero,
and I will write you a tragedy." Charlie Brackett was a hero to me and the rest
of the family. He was a hero of convenience to many of his friends and col-
leagues and quite a few strangers; and he was a hero to Billy Wilder, of that
I am certain. And yet, when the hero went home at night and put his pen to
that day's diary, the tragedy he wrote was his own.

 Jim Moore

"It's the Pictures That Got Small"

INTRODUCTION

"It's the pictures that got small." That line, spoken by Gloria Swanson as Norma Desmond, is one of the most famous in movie history—if not the most famous. It has become a part of American popular culture, American folklore, revered, loved, and often quoted with glee by film enthusiasts. Yet, while it is so iconic, it is often misidentified as being from Billy Wilder's *Sunset Blvd.* It is not. It is from Charles Brackett's and Billy Wilder's *Sunset Blvd.* The authorship of the line was a collaborative effort and, even though Wilder may have directed the film, as Brackett's diaries prove it was he who was first to acknowledge the importance of the speech. It was Brackett who went over that and other lines with Swanson, and it was Brackett who insisted on retakes of that specific line, delivered by Swanson to William Holden.

Some might argue that no one in the film industry could have had better luck than to be professionally partnered with Billy Wilder, as was Charles Brackett. Yet for the latter it approximated a curse with an inevitable conclusion. Brackett would die, Wilder would continue on and increase in fame and popularity; Brackett would write and produce *Niagara* with Marilyn Monroe, but Wilder would showcase the star in *The Seven Year Itch* and *Some Like It Hot.* The last are films which continue to be screened to enthusiastic audiences, while *Niagara* is basically forgotten. Brackett's name would sink into semi-oblivion—a screenwriter with a famous colleague—while Wilder was around to emphasize his importance in the relationship and to receive the fame and glory for an early career and also for almost two decades more of films after his erstwhile partner's career had ended. Some foolish Wilder advocates have even gone as far as to suggest that Brackett functioned as little more than a secretary. And yet surely the name Brackett and Wilder suggests in and of itself who is the senior partner here? To contemporaries,

the names were inseparable, and one producer of the period suggested that as their collaboration was indivisible, the title credit should read, "Story by Brackettandwilder."

Even this volume of Brackett's diaries must bear the name of Billy Wilder, without whom immediate interest might be limited. Hopefully, publication will prove that estimation grossly unfair. The publication for the first time of entries from these diaries should do much to reestablish Charles Brackett's reputation and also determine him to be a screenwriter (not to mention pro-ducer) of worthy consideration alongside Billy Wilder and others.

If nothing else it is revealing that the "I" which Wilder used in later years in discussing the films on which Bracket and he had worked together is equally prevalent during the years the two men were together—much to the obvious and well-recorded irritation of Brackett.

There is little point in documenting Billy Wilder's life and career in that it has already been the subject of close scrutiny.[1] Charles Brackett has yet to be the subject of any biography. Born in the affluent community of Saratoga Springs,[2] New York, on November 26, 1892, the son of a prominent lawyer, banker, and New York state senator, Edgar Truman Brackett, and his wife, Emma Corliss, he was educated at Williams College (class of 1915) and Har-vard Law School (class of 1920). In typical self-deprecatory style, Brackett once commented, "it was the theory of my parents that a child should veg-etate, and I did."[3] In later years, Brackett was to claim that his only form of exercise was moving the pegs up and down a cribbage board. He was ba-sically growing up alone in that his one brother, Edgar, had died of blood poisoning in his early 'teens. Brackett himself synopsized his World War I work in a diary entry dated October 9, 1947. He wrote short stories (most notably for *The Saturday Evening Post*),[4] along with four novels of the 1920s, *The Counsel of the Ungodly* (D. Appleton, 1920), *Week-End* (Rob-ert M. McBride, 1925), *That Last Infirmity* (John Day, 1926), and *American Colony* (Horace Liveright, 1929), which are quite frankly difficult to read and appreciate today, together with a later one, *Entirely Surrounded* (Al-fred A. Knopf, 1934), which is primarily of interest for its at times wicked parody of some of Brackett's friends: Alexander Woollcott (here called Thad-deus Hulbert), Dorothy Parker (Daisy Lester) and Neysa McMein (Leith O'Fallon). In 1925, Brackett was hired by Harold Ross as drama critic of *The New Yorker*, a position he held until 1929, when he resigned voluntarily to devote himself entirely to writing fiction. As Billy Wilder's first biogra-pher Maurice Zolotow has it, "He was a piece of American literature."[5] Billy

Wilder, himself, has commented, "Brackett really knew English. He wasn't just an American, but he was educated and articulate. He was patient, and he never laughed when I make a mistake in English, which was most of the time. He understood what I meant, and he showed me the right way."[6]

However, Brackett is not such a prominent exponent of American literature in the first half of the twentieth century as to be regarded on the same level as F. Scott Fitzgerald, Ernest Hemingway, or even Charles Jackson (with whom Brackett argued almost constantly during the adaptation to the screen of the latter's novel, *Lost Weekend*). He is a humorist—a literate New Yorker with a sense of humor—as opposed to Wilder, whose humor is very much European in style and delivery.

It may well be that ultimately Charles Brackett will never be recognized as a great man of American literature, but he will be acknowledged as America's foremost, if not only, Hollywood diarist. In his day, Charles Brackett was prominent as a screenwriter, but perhaps in later years he will be recalled, equally importantly, for his diaries and the mirror of truth they hold up to Hollywood filmmaking and to Hollywood society. His work in recording the day-to-day working life of a Hollywood studio is comparable to that of Samuel Pepys in the seventeenth century documenting a crucial period—the Restoration—in British history. Like Brackett, Pepys had wide-ranging interests, with his diaries mingling the personal with the impersonal. As with Pepys, the diaries of Charles Brackett can be trivial, but they can also be witty and crucial to an understanding of life in past times and during such troubled periods as World War II and the McCarthy era's Hollywood blacklist. In his day, Samuel Pepys was prominent as a politician, but he is remembered only as a diarist. The same cannot be said, and should not be said, of Brackett; his diaries must always remain secondary to his prominence as a screenwriter.

There is, of course, another diarist who comes to mind—and that is James Boswell, alive a century later than Samuel Pepys. In his diaries and journals, Boswell kept a record of the activities, conversations, and opinions of Samuel Johnson, which he later used as a basis for his 1791 biography. The similarity here can be lost to few. Just as Boswell documented lexicographer and literary critic Samuel Johnson, so did Charles Brackett record the daily behavior of Billy Wilder. If Wilder had been alive to read the diaries of his collaborator, I wonder if he might have repeated the comment of Sherlock Holmes in regard to Dr. Watson, "I am lost without my Boswell."[7]

In the late 1920s, three of Brackett's short stories were adapted for the screen. From *The Saturday Evening Post*, "Interlocutory" became *Tomorrow's*

Love, released by Paramount in January 1925, and "Pearls before Cecily" became *Risky Business*, released by Producers Distributing Corp. in October 1926. In December 1929, Paramount released *Pointed Heels*, based on the story of the same name that had been published initially in the December 1928 and January 1929 issues of *College Humor*. Brackett provided the original story for Paramount's September 1931 release of *Secrets of a Secretary*, directed by George Abbott and starring Claudette Colbert, both of whom were to figure later in his diaries.

Brackett's first major and direct contact with Hollywood came in 1932 with a contract at RKO. Brackett views the community rather as might an Alice in Wonderland according to the entries in his diaries, although the same diary entries do not reflect his later claim that he "was assigned to twelve different stories in my first year."[8] The reality is that Brackett was a failure who returned to life back East and the comfortable embrace of its literary and theatrical set, only to be called back to Hollywood in 1934 with a Paramount contract, which was renewed through the years, and which led in 1936 to his teaming with Billy Wilder.

Never was a better portrait painted of the two men together than by *Liberty* magazine in 1945:

> The distinguished Viennese-looking gentleman is Charles Brackett of Saratoga Springs, New York. The tough New Yorkerish cherub is Mr. Billy Wilder from Vienna, Austria.
>
> Mr. Brackett's poison is Mr. Wilder's meat. Brackett, a man of sartorial elegance, prefers double-breasted suits in conservative designs and colors. Wilder goes around wearing a pull-over, without necktie, his shirt sleeves rolled up. Brackett is reserved, serene, gentle. Wilder is electric, impassioned, and (outwardly) tough. Brackett loathes physical exercise and buys shoes without laces because he considers tying his laces hard labor. Wilder goes in for tennis, swimming, and other tiring outdoor sports. Brackett looks like the vice-president of a small-town bank, which he is. Wilder looks like one of the cynical police reporters from *The Front Page*, which he was. Brackett takes his sunshine in doses of vitamin B-12 plus cod-liver oil: Wilder never gets enough of Hollywood's brilliant sun. Brackett is a stout arch-Republican. Wilder a left-wing Democrat.[9]

The political description of both men is arguably a convenient one, rather than a totally accurate assessment. Wilder was a Democrat certainly and left-

wing when it suited, particularly in his dealings with Brackett, who at one point in 1947 regards him as, if not a Communist, at least a "fellow traveler." Brackett was unashamedly Republican, but not as rigidly so as his friend, gossip columnist Hedda Hopper. He had no problems in dealing with and maintaining a friendship with those fellow writers with a strong liberal slant—the majority of them it would sometimes seem—and would doggedly argue with one and all at meetings of the Screen Writers Guild. He could appreciate the point of view of an extremist such as John Howard Lawson or a dogged liberal such as Philip Dunne (whom he found dull). There is an innate kindness to Charles Brackett, even when dealing with those whose politics are far left to his own. He was as one writer put it, "politically unimpeachable."[10] And as Brackett himself unabashedly declared on January 10, 1938, he would never be "unfaithful to Democracy, who is really my lady."

Unlike Wilder, Brackett would hang out with the socially elite of the entertainment and literary worlds. It is not so much that the two did not socialize together—they certainly spent enough time together at the studio and, equally, working at each other's home—but rather they moved in completely different social circles. Perhaps there is some validity to Wilder's claim that "we had nothing in common except writing,"[11] but the pair spent too much time together, discussing each other's lives and, in the case of Wilder, his love affairs, for it to be labeled as a strictly professional partnership. Certainly, Wilder did not belong among Brackett's friends and Brackett did not belong among Wilder's, although there were obviously exceptions, most notably Walter Reisch and Ernst Lubitsch who were equally close to both men. There are frequent entries in the diaries which might seem to brand Brackett as anti-Semitic, and, yet, at the same time, no more so than the majority of Americans of the period. He can be critical of the Jews with whom he comes into frequent contact—this is, after all, Hollywood—but he often lavishes praise on his Jewish compatriots. Interestingly, on January 19, 1949, he records going to see *Words and Music*, a pseudo-biography of Richard Rodgers and Lorenz Hart: "It's a mediocre picture but I find it surprising that, being made by a Jewish producer, the two young Jewish men of genius, Larry Hart and Dick Rodgers are portrayed by Mickey Rooney and Tom Drake. Certainly if Irishmen had been doing it about Irishmen of genius, they'd have had Irishmen or torn the screen down."

Middle European Jews in particular irritated Brackett, especially during World War II when their sympathies appear to lie, as far as he reports, in a Russian victory and the defeat of England.

Brackett's beloved friend Alice Duer Miller wrote a verse-novel in 1940, titled *The White Cliffs of Dover*, which was immensely popular at the time. The sentiment mirrors very much that of Brackett, with the closing lines,

> . . . I am American bred
> I have seen much to hate here—much to forgive,
> But in a world in which England is finished and dead,
> I do not wish to live.

Brackett's diary entry for May 25, 1941, resonates with the same sentiment as the words of Alice Duer Miller:

> . . . I went to a British War Relief party at C. Aubrey Smith's place on top of Coldwater Canyon. It was a large party filled with professional and non-professional character parts, and it was a grave troubled party— none of the British arrogance so irritating in times past, which would be so welcome now. I had a feeling that it was an odd and touching way to see an Empire shake, if not crumble, at a garden party in Hollywood.

It has been claimed, quite rightly, that the Brackett-Wilder partnership was the most successful in Hollywood. Certainly, it was, and is, the best known, eclipsing that, for example, of the husband-and-wife team, Frances Goodrich and Albert Hackett or, earlier, Anita Loos and John Emerson. The comparison of Brackett and Wilder to husband-and-wife writing teams is not a wild one, for, in many ways, the two men functioned as husband and wife—agreeing and disagreeing in their relationship as much as would any married couple. They were, in the words of *Life* magazine, "The Happiest Couple in Hollywood,"[12] with a professional friendship comparable to that of Beaumont and Fletcher. "These collaborators exercise an astonishing degree of self-government on the Paramount lot," wrote Phil Koury in the *New York Times*. "Writers not generally given to soft talk about fellow artists are quick to admit that the Brackett-Wilder setup is as rare as radium."[13] The Brackett and Wilder success is due somewhat to the couple's combined egos and combined versatility. They were creative writers, but they were also—as *Life* magazine described them—"executive writers," with their respective contributions including directing and producing the films which they had scripted.

The year 1949 marked the end of the Brackett-Wilder partnership. The diaries confirm Wilder's comment that "something had worn out and the

spark was missing. Besides, it was becoming like a bad marriage,"[14] but also indicate that the breakup had been years rather than months in the making. In later years, Wilder would try to avoid discussion of his relationship with Brackett, although after the split, he insisted, "we stayed friends."[15] Writer-director Garson Kanin quotes at length Brackett as he lies dying, having him claim that he "never understood" the breakup, that their mutual wives liked each other, that he and Wilder never had a serious quarrel; "I suppose it was foolish of me to think it was going to go on forever. After all, it wasn't a marriage. 'Till death do us part.'"[16] No, it was not a marriage and, despite these later words to Kanin, which read more like Kanin than Brackett, the former had every intention of ending the partnership, and at times positively delighted in the thought of it. It is the diaries—always—that should be taken as gospel, for such they are.

Charles Brackett might have continued on at Paramount, working with a new partner and friend, Walter Reisch. However, in October 1950, Brackett, on behalf of the Academy of Motion Picture Arts and Sciences, went on a two-day visit to New York to address the Motion Picture Advertisers Association. Paramount Production Head Sam Briskin objected, claiming the trip delayed studio production. "I am not in the habit of giving anyone an accounting of my comings or goings," responded Brackett angrily. It was the last in a number of disagreements that he had had with the studio over the previous few months, and resulted in Brackett's resigning. Paramount put out a statement claiming the split was amicable, but gossip columnist Louella Parsons reported otherwise.[17] It must have been galling for Brackett to leave a studio that had been "home" for more than a decade; in 1945, he had reported grimly but with pride, "I am actually filthy of hair and scraggy of finger nail and unbarbered, to try and get something done for Paramount."[18]

A month after quitting Paramount, on November 6, 1950, Brackett signed a seven-year contract as a writer-producer with 20th Century-Fox. It was a good contract, freeing Brackett from the financial worries which seem to have raged against him through the years at Paramount. His new seven-year salary, specifying him as a producer and writer, was set at $2,500 a week, with an annual expense account of $10,000 and additional salaries for a full-time secretary and assistant.[19] Brackett's agent, Charles K. Feldman, wrote of Brackett, referencing the typical 20th Century-Fox production, to Darryl F. Zanuck, "I think he is one of the outstanding talents in the industry, and I am sure you think so also. I think he is probably more qualified than any other writer-producer in this business to turn out the family comedies, like *Father of the*

Bride, Cheaper by the Dozen, etc., the serious dramas, and, of course, the Clifton Webb yarns. I was happy today when you expressed your thoughts sharing my enthusiasm. I only hope I will be able to deliver this person to you."[20]

Feldman did deliver Brackett, who began his new career at 20th Century-Fox with *The Mating Season*, which he produced and co-wrote. It was a good opener at the new studio, bringing together, as it did, so many who had worked earlier with Brackett; assisting on the script were Walter Reisch and Richard L. Breen, directing was Mitchell Leisen, and in the cast were leading man John Lund and character actress Cora Witherspoon. With Brackett primarily involved as producer, other successful films, both comedies and dramas, followed, including *Niagara* (1953), *Titanic* (1953), *The Virgin Queen* (1955), *The King and I* (1956), *Ten North Frederick* (1958), *Journey to the Center of the Earth* (1959), and his last, *State Fair* (1962).

On September 18, 1962, 20th Century-Fox head of production, Darryl F. Zanuck, fired Brackett, along with most of the top executives. Brackett filed a breach-of-contract suit which was settled out of court.

While still in his sixties, Charles Brackett suffered a debilitating stroke, which forced an end to his career. He had been deaf for a number of years, an ailment from which he had suffered since as early as the 1940s.[21] Brackett died, in the loving care of his second wife who just happens to have been the sister of his first, in Bel-Air on March 9, 1969. He is buried in Saratoga Springs, New York.

"Dear Charlie's suffering is at an end,"[22] wrote Cornelia Otis Skinner, a frequent figure, along with Emily Kimborough, with whom she wrote *Our Hearts Were Young and Gay*, in the diaries from the 1940s. "I wish I could have been there . . . to pay Charlie my last devoted and deeply affectionate respects," wrote Brackett's favorite leading lady, Olivia De Havilland. She recalled, "my last times with Charlie who had given so much to my own life."[23]

Brackett records in the first entry in the diaries, dated June 7, 1932, that he was "impelled" to keep a diary after reading the Civil War diaries of his great uncle, William Corliss (1854–1915). Corliss is best-remembered, if at all, for his invention of a large, unbreakable safe, a somewhat minor invention compared to that of his older brother, George, responsible for the Corliss steam engine. The current disposition of those diaries, or even their existence, is unknown at this time. This was not Brackett's first attempt at keeping a diary; on December 11, 1915, he began what is presumed to be his first diary, which begins with the words, "This morning as I lay in bed . . ." None of the later entries are dated, but the volume ends with a report that he went with his

mother to see matinee idol and Sarah Bernhardt's leading man, Lou Tellegen, in *The Ware Case*. "He is delightfully subtle," Bracket reports.

That first diary utilized a lined exercise book, and Brackett adopted a similar-type volume for his later diaries. Each was lined, approximately 149 pages, including the inside back cover, which Brackett would often use, with a sturdy front and rear, and sold by the A.L.S. Co. of New York. They were not printed diaries as such, and Brackett would write in the dates, occasionally getting confused and having two entries with the same corresponding days. The days of the week relative to each entry were seldom referenced. Later diary entries are generally shorter than earlier ones, and I doubt there is any other entry as lengthy as that for February 4, 1933, as Brackett details a dinner with Monty Woolley and his highly dysfunctional family.

As already noted, there is a naïveté to the early entries in the diary as Brackett writes of his first visit to Hollywood. From a close reading of the fan magazines, he knows where he should eat and be seen. He is thrilled and excited by it all, obviously anxious to please as a writer and basking in the reflected glory of his friendship with George Cukor. The enthusiasm quickly disappears in the years ahead as Brackett contemplates his life in Hollywood as a screenwriter, what his life might have been had he never come to Hollywood, and even that he might have been happier staying in Saratoga Springs or Providence and working as a designer.

But Brackett is not in Saratoga Springs, he is in Hollywood, and he makes himself very much a part of community life. He is an active member of the Academy of Motion Picture Arts and Sciences, and the diary entries record his dealing with its iconic head Margaret Herrick and also the political infighting on the board. What is perhaps most amazing is to discover from the diaries that the giving of Honorary Awards were generally not decided until the day prior to the actual ceremony. Much space in the diaries is devoted to meetings of the Screen Writers Guild, but I have deliberately excised much of this, simply because it is generally difficult to comprehend what is going on, and even with foreknowledge, the meetings are long, filled with political fights between the left and right factions, and, most importantly, dull and boring. Brackett will often bemoan the fact that the meetings have gone on beyond midnight and accomplished nothing. A reader might well have the same complaint. Little known and recorded of Brackett's activities is his membership on the board of the Motion Picture Relief Fund (now the Motion Picture and Television Fund). Surprisingly, little space in the diaries is devoted to his work here. Sometimes, it would appear that his charitable activities are more personal, as

with his providing funds for her return to New York to character actress Cora Witherspoon, fighting a losing battle with drug addiction.[24]

The almost "throw-away" manner in which Cora Witherspoon's drug addiction is presented exemplifies the way in which much information in the diaries is to be found. There is nothing leading up to a revelation and nothing offered by way of explanation. Brackett knows of whom and what he writes and does not consider it necessary to explain matters to himself. What the diaries offer most often are valuable clues to an individual's personality or way-of-life. They tell us more than many a biographer has been able to uncover. The reference to Cora Witherspoon might be classified as gossip, but as presented here it is not. It is, however, apparent that Brackett enjoys gossip, with its first appearance on July 6, 1932, as he discusses in great detail the shooting death of Libby Holman's husband, tobacco heir Zachary Smith Reynolds.

A diary entry dated April 15, 1941, notes, "Start a new volume of this diary with a sad realization that instead of making entries which catch some unique facet of the day they record—I made every record of the routine events."

Yes, many days in Brackett's life are typical—although the sometimes sad reality of daily life can be of interest. The diary records his arriving at the studio around 10:00 a.m. and an often lengthy discussion with Wilder as to a film they both saw (usually separately) the previous night. Their office on the ground floor of the Paramount Writers' Building consists of three rooms, one for secretary Helen Hernandez, one for Wilder, described as the Game Room, where a game of cribbage was always available, and, finally, the largest office, called the bedroom, in part because it is where Brackett enjoys his daily afternoon nap. Reclining on the couch, with his shoes off and a pad of yellow paper on his knees, Brackett writes down the script in pencil while Wilder paces. "Every scene, every bit of dialogue, every camera angle is decided in this room. Frequently wild violent shouts come out of the room and the secretary closes the window so the neighbors won't listen. Their fights never last very long. Wilder is pacing the floor, swinging a cane, while Brackett sits in a soft chair, displaying the lethargy of a graduate of a Yogi school."[25]

Lunch is at the commissary or at Lucey's. Brackett's regular luncheon companion—always at Perino's on Wilshire Boulevard—is fan magazine writer and editor Ruth Waterbury. The conversation between the two has little if anything to do with fan magazines but more to do with the latest gossip, on which Brackett thrives. If Brackett lunches in the commissary it is at the writ-

ers' table, where he participates in the Word Game, an amusement apparently limited to Paramount's writers.

After lunch, Brackett generally takes a nap; "the secret of my success always being asleep," he records in the diary.[26] Brackett and Wilder do actually accomplish some work, writing in mid to late afternoon. Studio chores are brought to a close with a game of cribbage, the only exercise which Brackett is willing to tolerate, although Wilder was apparently somewhat less enthusiastic.

A newspaper portrait of Brackett from late 1959 provides a pretty accurate description of the man, supported by the diary entries (excepting peanut butter soup which is not mentioned): "He is warm, energetic, affable and regards all sports with a jaundiced eye. He is equally unfond of sunshine, vitamins and fresh air. He's a wizard at cribbage and likes to play bridge, attend movies and has a penchant for peanut butter soup for which he has a crazy (but great) recipe."[27]

The working day does not end with departure from the studio, but will often start at that point once dinner has been eaten. Brackett and Wilder will assemble, usually in the latter's home, and, if necessary, work until after midnight or until Wilder has an assignation with his latest female companion. Family life is limited to the upbringing of Brackett's daughters prior to their marriage, and, later in the 1940s, to the care of his grandson, "Tig," the son he never had. When not working in the evening, he may take a walk down Hollywood Boulevard or through Westwood in search of an intriguing film. The title is seldom selected in advance, and Brackett is happy to stand in line, presumably buying his ticket just like any other moviegoer. He may attend a party—more often than not at the homes of others rather than his own. Brackett is not a heavy drinker, and only very occasionally does the diary record his getting "tight."

Obviously, much of Charles Brackett's personal life is included in the diaries, and yet much is deliberately glossed over as the writer seeks to suggest a sense of normality within his family. His wife Elizabeth may have been an alcoholic and may have been housed at times in a mental institution, the Austen Riggs Center in Stockbridge, Massachusetts, but that is not mentioned— references to Elizabeth's returning East would appear to be euphemisms for a return to Austen Riggs. "A river of alcoholism," as one family member has it, runs through the Brackett clan, affecting both daughters and resulting in the unfortunate marriage of the oldest to the alcoholic James Larmore, Jr. While the description of the building may be inaccurate, there is much truth

in Maurice Zolotow's statement that "The Victorian façade of Elizabeth and Charles Brackett's mansion concealed a Victorian tragedy."

Charles Brackett was not a happy man, and this is at times brutally obvious from his diary writings. And to a large extent, in my opinion, this is what makes the diaries most accessible and most appealing. We are not reading about a Hollywood celebrity, a famous screenwriter and producer, but, rather, a man of extraordinary capabilities who is trapped in a world in which he does not really belong. Through all those years in Hollywood, he is a man without a country—a man whose home is back East, who regrets always the sale of his Saratoga Springs house during a low ebb in his financial status,[28] and who would be mingling with New York's literary society and have been a full-fledged member of the Algonquin Round Table rather than someone who was always lurking on the outer edge, acknowledged but never truly welcome.

I wonder sometimes if the more famous figures from the Round Table, Lillian Hellman and Dorothy Parker, really appreciated Brackett in his own right, but perhaps subconsciously saw in him someone to help cope, as with Parker, with her own, lengthy bouts with alcoholism, or, as with Hellman, someone who understood how to deal with an alcoholic partner, Dashiell Hammett. According to the latter's biographer, William F. Nolan, after Hammett had completed the screenplay for *After the Thin Man* in the summer of 1938, Brackett paid off his substantial outstanding debts (including six months' rent at the Beverly Wilshire Hotel, liquor bills, and limousine service), and then put him on a plane to New York, where Hellman was awaiting him.[29] Nothing of this appears in the diaries. It would seem that no drunkard would be rejected by Brackett, particularly if he was as famous as Robert Benchley or F. Scott Fitzgerald.

It may well be that *Lost Weekend* is the most personal movie with which Brackett was associated. "This one they *had* to write," claims Maurice Zolotow. "It is evident to me that Brackett was writing himself in the characters of Don Birnam's brother and Jane Wyman, and that Wilder was writing Wilder in the opposing constellation of sardonic characters—Howard da Silva's bartender, Doris Dowling's hooker, Frank Faylen's homosexual Bellevue Hospital nurse." It is an appealing, if somewhat simplistic, notion. Again, the diary entries provide a healthy dose of reality. Both Brackett and Wilder found humor in the story they were attempting to script, suggesting bribes to which they were open from the alcohol industry, and, certainly after it was completed, Brackett records a number of comical moments in which

the two were involved, most amusingly a preview at which a drunken projectionist put on the reels in the wrong order.

While surrounded with full-fledged alcoholics and those bordering on the edge of the disease, Brackett does not appear too affected, generally limiting himself at parties to one cocktail or one glass of champagne. He will at times record going to a party and getting tight, and an entry dated June 29, 1945, is crossed out as unreadable, with the comment, "A mixture of Morpheus and Bacchus seems to have made this entry illegible."

In discussing an elderly Jewish lady—he describes her as a grandmother—whose behavior reminds him of a sexual predator who must be repulsed, Brackett notes, "those who do not immediately respond to a sexual advance in Hollywood are either impotent or homosexual."[30] Certainly, there is no suggestion that Brackett was the former, but a number of rumors have circulated in modern times that he was a homosexual male, or more accurately in view of his marriage and children, a bisexual one. What do the diaries and Brackett's published work contain in response to such rumors? In truth, the evidence is as confused as perhaps Brackett himself was in regard to his sexuality.

A lengthy discussion of a subject's possible homosexuality might seem inappropriate, but anyone writing on Charles Brackett is forced to face the issue thanks to undocumented observations of and assumptions by others. In his definitive biography of Billy Wilder, Ed Sikov writes that "the Hollywood rumor mill of the 1940s had it that [James] Larmore had been Brackett's lover as well as his son-in-law." In his definitive study of homosexuality in Hollywood, *Behind the Screen: How Gays and Lesbians Shaped Hollywood, 1910–1969*, William J. Mann goes even further. British writer Gavin Lambert is quoted, "I got to know Charlie fairly well. There was a certain subtext between us. We didn't have to discuss it. He knew I was gay. I knew he was." While Mann admits that "Lambert didn't know for certain . . . the exact relationship between Charles and the young man . . . who had fathered his own grandson," he claims that Lambert believed the stories of a lover relationship between the two to be true. Mann has this assertion backed up by Christopher Isherwood, his lover Don Bachardy—"It was an accepted fact among everyone"—and even playwright/screenwriter John Van Druten, who is described as "a confidant of both Brackett and Larmore."[31]

One Billy Wilder biographer has it that because Larmore was Brackett's son-in-law, and by extension, his lover, Brackett tried and eventually succeeded in having Larmore hired by Paramount. Supposedly, this so outraged

Wilder that he pretty much broke off all social engagement with his collaborator. Wilder would no longer visit with Brackett and his wife on Sundays for fear of meeting Larmore. In fact, the diaries provide little if any evidence of regular Sunday meetings between Brackett and Wilder, and such social intercourse seems unlikely in that Brackett's wife was not kindly disposed towards Wilder. The reality, as the diaries show, is that Wilder had Larmore and his wife move into a garage apartment on his property—hardly a display of outrage.

From a scholarly standpoint, there are immediate problems with much that Sikov and Mann have written. Both are honorable historians quite rightly challenging mainstream histories that have largely ignored gays and lesbians. But where is the documented evidence? All sources are secondhand, sometimes thirdhand, and always anecdotal. Further, how can one believe Mann's statements, when among them is the comment that Larmore was "a strikingly handsome youth with deep-set eyes and full lips." In reality, photographs of Larmore show him looking somewhat degenerate and anything but handsome—it is a face which offers far beyond the mere hint of alcoholism.

The pseudo-psychiatric nonsense delivered by Gavin Lambert has it that Wilder and Brackett split up because the latter's closet homosexuality affected his work, in particular *Sunset Blvd.*, with which he "wanted nothing to do." Lambert concludes, "I suppose there must have been some terrible guilt for Charlie, and that can be very bad creatively. I think just as he was uptight about being gay, so was he uptight creatively. He didn't want to overstep any line, push any envelope. It might have made people think, 'Oh, there's more to Charlie Brackett than I thought.'"[32]

With Brackett's homosexuality firmly established, William J. Mann is able to quote screenwriter Arthur Laurents that "I don't think one can be fully creative and not at peace with one's sexuality"[33]—a statement easily refuted in that Brackett is as fully creative as his collaborator. Perhaps most insultingly, Mann ends his discussion of Brackett, the closet homosexual, with the comment, "Brackett himself died a lonely and confused man, haggling over his memoirs."[34] Just as Brackett had a tremendous amount to do with *Sunset Blvd.*—read the diaries—again, here is a statement that can be refuted and which ignores the love and affection that Brackett and his second wife shared.

What is surprising about Isherwood's diaries are that despite their being written by a gay man, who is open about his sexuality, the diaries contain not one hint or suggestion that either Brackett or Larmore are gay. In fact,

one entry, dated September 3, 1956, reported that the Bracketts are coming over and that Isherwood's lover, Don Bachardy, has cut from European home movies that the couple had taken, "footage which seemed to linger unduly on the weird fishy-shaped cocks on the statues in the fountain in Venice." This is hardly the action of an individual, whom many might consider obnoxious (and who apparently was when drunk), faced with entertaining a supposedly closeted Hollywood producer. The only curious reference to Brackett occurs on March 29, 1956, when Isherwood reports that his friend Speed Lamkin "is also much preoccupied by the scandalous history of the Charles Brackett family. I think he must be planning to write about it." Lamkin, who is little remembered today except as "the poor man's Truman Capote," never did write his play on the Brackett family, and the disposition of any notes he may have made is unknown.

Most of the discussion regarding Brackett's possible homosexuality appears to be a matter of guilt by association. As the diaries record, the gay John Van Druten, whose 1950 play *Bell, Book and Candle* has a gay subtext and who the following year adapted Christopher Isherwood's *Berlin Stories* as *I Am a Camera*, is a close friend, whom Brackett often promotes as a screenwriter. There are also letters between gay writer James Leo Herlihy and Brackett relating to the latter's production of the screen adaptation of Herlihy's *Blue Denim*, which are signed with "love," and there is one in which Herlihy writes, "my affection for you is not reasonable. I think you're the berries." It is all suggestive, but, at the same time, it can be dismissed as nothing more than Hollywood hyperbole.

Brackett's earliest published references to homosexuality are in his novels *American Colony* and *Entirely Surrounded*. The former features three attractive young men, whose bodies are described in some detail, and one less attractive young man named Sydney Gibbs, who wears raspberry-colored Chanel underwear, and is early in the novel identified as a "fag," although later he is assured that homosexuality is "a good fashionable vice."[35] *American Colony* is dedicated to the homosexual Alexander Woollcott, and he is also featured in *Entirely Surrounded* as the character Thaddeus Hulbert. Hulbert is one of a group in the book who is told the story of a young man, Smith Wetherby, Jr., identified as "homosexual" and "an incurable fairy."[36]

It is surprising that few of those with a gay agenda bring up Charles Jackson, the author of *Lost Weekend*, with whom Brackett had a decidedly stormy relationship, and whose 1946 novel, *Fall of Valor*, has a gay theme and who apparently took a gay lover at the end of his life.[37]

As already noted, one gay man with whom Brackett, his second wife, and the Larmores do socialize in the 1950s and 1960s is Christopher Isherwood. His diaries provide a sad record of a man apparently in creative decline. Despite the time spent together, Isherwood does not really like Brackett: "Sunday lunch we went to the Bracketts'—why, God knows."[38] "A lifeless party . . . a collection of (perhaps) the most boring people I've ever known,"[39] including the Bracketts and the Larmores. "A really funereal party at the Bracketts"[40] Isherwood describes one supper at the Brackett house "as like *Mourning Becomes Electra*, with oldest daughter Xan dressed in black," which "turned . . . into a very old and creaky drawing-room comedy."[41] As he drives past the Brackett home on November 17, 1966, he stops to think of Brackett and his wife: "to describe their probable life: 'The shuffle of slippers and cards.'"[42] Isherwood probably meant the description unkindly, but it is also moving, a sad reflection on the last years of a great man.

What is important about the Isherwood diaries is not what the subject himself records, but what the editor of those diaries, Kate Bucknell, chooses to add to her brief biography of James Larmore. In the glossaries for both published volumes of the diaries, she notes under the entry for James and Alexandra (Xan) Larmore, but not the entry for Charles Brackett, that "according to rumor," Brackett and Larmore were lovers. As far as I can ascertain, this is the source for all later statements to this effect, and it might seem, therefore, important to know the editor's original source for such a rumor. Unfortunately, she does not have one, and responded to my question with the quite extraordinary statement, "Gossip circulates and cannot be verified, so there is no point in seeking any source for this."[43]

When I spoke with Don Bachardy, a friendly and open individual, his first question to me was how did I know that Brackett and Larmore did not have a relationship. I don't know. But, then, when faced by the same question, Bachardy freely admits that he does not know that they did. "How can gossip like that be verified," he asks, "gossip down a windy hallway . . . it seemed to me perfectly possible."[44]

As Bachardy recalls, "Christopher knew Charlie from an earlier time— perhaps he found him boring later—he always liked to escort men to parties, and Charlie and his wife were never censorial about Christopher's being so upfront about his being queer." If Isherwood found Brackett and his wife dull, Bachardy certainly did not. He sketched both of them, as well as other members of the family. He considered Brackett to be "a very intelligent man," which he certainly was. And he appreciated that Brackett and his wife al-

ways invited him to their home for dinner parties, unconcerned that he was a young, openly gay male. "I went to their house because I was fond of them," Bachardy asserts.[45]

Turning from the diaries of Christopher Isherwood to those of Charles Brackett, there are certainly gay references therein. On August 10, 1932, he writes amusingly of Alexander Woollcott's attraction to Charles Lederer. On September 14 of the same year, he refers to Ramon Novarro as a "queenly creature," and there are also references in the diaries to other known homosexual men and women, including Mercedes de Acosta (identified as having an affair with Garbo), Noel Coward, and Ivor Novello. When Brackett first arrives in Los Angeles, his two closest friends are David Lewis, whom he had known in New York and who introduces him to his lover, director James Whale, and director George Cukor. It is Cukor who introduces Brackett to what might be termed the gay set, when on September 17, 1932, he drives him down to Laguna Beach to meet gay actor Andy Lawler, and en route back to Los Angeles the couple stop at the Manhattan Beach home of William Haines. At Andy Lawler's home, Brackett meets Olympic swimming star Johnny Weissmuller, who is just starting his screen career as "Tarzan." Brackett is obviously impressed by Weissmuller's physique, but it might be argued that many men might be similarly awed.

Of that day's excursion, Brackett writes, "I may note of both these groups and their connecting link, George Cukor, that the language is something novel to me, and the attitude towards life something that makes me feel like [the eighteenth-century preacher] Jonathan Edwards. Nevertheless, they are all highly amusing people." The comment is suggestive of a sophisticated heterosexual male introduced to the world of sophisticated gay men, with a secret gay language, which is amusing and perhaps, although unsaid, slightly shocking.

If Brackett felt comfortable around George Cukor and his gay friends, he did not feel similarly relaxed in the company of effeminate gay men. In one diary entry (not included in this edited edition), he writes of having one of Edith Head's effeminate sketch artists sit next to him at a public screening and his embarrassment at the young man's comments.[46] On May 27, 1936, he records going to hear wife Elizabeth's cousin Bruz Fletcher sing at the Bali nightclub in West Hollywood, notes that the location is a "pansy" one and that Fletcher is "a wisp of a creature too touching to think about." Obviously, Fletcher would never be invited to the Brackett home despite the family connection. Actually, Fletcher, who was to kill himself at the age of thirty-four in 1941, might have felt quite at home with the Bracketts, born as he was,

according to his biographer, "to one of the wealthiest and most dysfunctional families in Indiana."[47]

An argument might be made that while Brackett's diaries provide no direct documentation on any open homosexual activity by him, neither do they offer similar coverage concerning heterosexual behavior. One might posit the obvious, and that being there is no reason for a married man to discuss his home life. One might further note there is one curious diary entry which does hint at a group sexual encounter—a heterosexual one. On July 7, 1933, Brackett records that wealthy mining engineer Jack Baragwanath, the husband of Neysa McMein—participants in an open marriage—hosted a "model" party to which were invited Brackett and other male friends, together with "eight of the prettiest models possible." The term "model" might certainly be used as a euphemism for high-class prostitute and while outside activity at the party is discussed, the entry remains silent as to what took place inside Baragwanath's home.

The attitude of Billy Wilder towards Charles Brackett is also worthy of consideration in regard to the latter's sexuality. At no time following the breakup of the relationship and after Brackett's death does Wilder make any reference to his former collaborator's being gay. He does not even hint at such an insinuation, and Wilder, while certainly not homophobic, is one Hollywood type who had little problem in calling a "queer" a "queer."

Ultimately, the issue is not whether Charles Brackett is gay, straight, or bisexual. It is more a matter of whether his sexuality had any relevance to his career as a writer and producer and whether it is in any way influential in his plots and his writing. It is not. Indeed, an argument might well be made that some of Brackett's hiring practices have nothing to do with the sexuality of those involved. Rather it is his somewhat innate snobbery, which certainly, in all probability, led in the 1940s to his constantly employing Dodie Smith, an English lady singularly lacking in ability as a screenwriter.

Most of all, the diaries serve as windows onto a Hollywood world which few observers have considered then or since. Charles Brackett's world is far removed from that of the fan magazines, despite his weekly luncheons at Perino's with one of the best of the writers from that genre, Ruth Waterbury. He is present at and discusses Hollywood parties attended by the wealthy, the aristocratic, and the well-connected. They are not the parties at which representatives of the fan magazines would have been welcomed.

Brackett, on January 18, 1945, writes that he has kept the diary "for future hypothetical reference." Yet it is obvious by the 1950s and the end of his years

at Paramount and with Billy Wilder that Brackett saw the diaries as a unique record of his time in Hollywood and sought to share them with a wider audience. The first step was to transcribe the handwritten diaries, which are virtually impossible to decipher thanks to Brackett's handwriting (which seems to get worse with the passing of the years). Secretary Helen Hernandez came to the rescue, as possibly the only one in Hollywood who could understand Brackett's penmanship.[48]

It is not clear if Brackett intended initially to use the diaries as source material for a biography or to publish them, in edited form. Brackett did take the opportunity provided by Helen Hernandez's transcriptions to add some later comments, and, it should be admitted, that he may perhaps have made some small emendations to the text. However, they are extremely minor and unobtrusive, and Brackett has certainly made no effort to "clean up" the text in regard to comments he makes that are perhaps somewhat damning of him in retrospect. The only major addition to the diaries can be found in the entry for August 18, 1936, wherein Brackett adds commentary as to how Billy Wilder appeared to him then. "I was enormously impressed with this world-weary man," he writes from the perspective of the 1950s, while the diary entries for the next nineteen years would seem to signify otherwise. As the years progress, it seems as if Brackett positively revels in Wilder's failings—as, for example, in the December 2, 1943, entry. At the same time, it should be noted that Brackett's opinion of Wilder is not the only change to be found in the diary entries. His initial affection for both David Lewis and Richard Haydn changes drastically, with the former transforming from best friend in Hollywood to just dull associate very quickly.

In 1961, Brackett submitted sample pages from the diary to his friend Bennett Cerf at Random House. Cerf responded,

> There are so many nuggets of pure gold in these pages at hand that, obviously, a wise selection from the completed diary will build up a wonderful book.
>
> You don't need me to tell you that long entries that are purely personal will have to be eliminated.[49]

Brackett did not pursue the possibility of publication through Random House. The reason may well have been that he realized the diaries contained too many personal observations of friends and colleagues who were still alive and with whom he might still be working. In the 1970s, his youngest

daughter, Elizabeth, tried unsuccessfully to interest Doubleday in publishing the diaries.[50]

In editing the diaries, I am pleased to note that Bennett Cerf and I both approached them from very much the same perspective. Hopefully, my chosen and partial entries are as wise as his might have been, and my deletion of the personal is on a par with his position. Most importantly, no effort has been made either to correct grammatical errors or to seek uniformity. The diaries, complete and as edited, do not obey the dictates of the *Chicago Manual of Style*. These are Charles Brackett's unadulterated words, a few of them quite obtuse and convoluted. If nothing else, the diaries are indicative of their author's love of the English language.

A comment is necessary in regard to the footnotes. I have assumed that the reader is familiar with the film industry and with most of the individuals associated therewith. I have, therefore, rejected footnoting of obvious "names," but I have tried wherever possible to identify an obscure figure, an obscure term, and even something that was instantly familiar in the 1930s or 1940s but is basically unknown today. Those names—not always of individuals—which appear frequently in the diaries are the subject of longer entries at the end of this volume under the heading of "Leading Names and Subjects in the Diaries." I might add that the limited footnoting should in no way be considered laziness on my part; as far as I am concerned it is more important to include as much of Charles Brackett's personal comment as space permits even if it results in a limitation of my own commentary.

The diaries allow the reader to be present at the studio, on the set, in the office, on a daily basis. They also provide an insight into the Brackett family's personal life—the superstition of Brackett and wife Elizabeth saying "rabbits" to each other on the first of each month;[51] the jumping into the New Year with gold clasped in the hand; and the decidedly curious spanking of oldest daughter Xan on her birthday, with each stroke corresponding to one of her years. There is much in the diaries that space considerations have required be cut, as indicated by ellipses—the details of getting around Los Angeles, the popular restaurants (although quite a few are referenced here), the raiding of the ice box in the evening, the gradual demise of the Algonquin Round Table, the trips for ice cream to Will Wright's,[52] late night sodas at C.C. Brown (a block away from Grauman's Chinese Theatre), parties that could continue into the small hours of the morning—but there is also very much more that is here: an era of great but sadly forgotten writers such as Alexander Woollcott and, more importantly, Alice Duer Miller; scenes written on the spur

of the moment at the request of an anxious producer and long forgotten as to their source; last-minute casting changes and the limitless search for the "right" leading lady or man; endless conferences with producers and directors; and, above all, the feeling of family that a contract with a studio such as Paramount evoked.

While of necessity much of Brackett's private life has been deleted—not because it is controversial but like the private lives of most us, it is dull—there are still positive glimpses of a man trying very hard to be a good husband, father, and grandfather, rejoicing in the good times with wife Elizabeth and his two daughters, and, sadly, realizing that all is not well within his family. Ultimately, it would seem that Brackett was not a particularly happy man— no matter his surface demeanor—and that unhappiness stemmed as much from his relationship with members of his family as with his relationship with Billy Wilder. The busy life that he led from the moment he got up in the morning—8:00 a.m. or earlier—until the time he retired to his bed (often the following morning) is, in all probability, his effort to escape from the overwhelming unhappiness of his life. He always wants to help others, particularly his daughters—showering them with presents; Xan had a personal bank account (where she was frequently overdrawn) as did sister Bean (which Charlie filled into the early 1960s)—as if moral or material support can help justify his lonely existence. Charles Brackett is an anomaly—a man surrounded by acquaintances, always lunching or dining with someone, but with few real friends. He needs someone to meet with or talk with almost constantly. If he is dining alone at the commissary, at Lucey's, or at a popular Los Angeles restaurant, when he first enters the facility he looks around for someone to join or for someone to join him. By so often paying for the meals of others—as the diaries record that he does—he pays for friendship rather than its coming to him free and unencumbered.

What are missing from the diaries are any frequent references to dinner parties or soirées held by Brackett and his wife at their home. And yet, Lincoln Barnett in his 1944 article in *Life* magazine records,

Sunday-noon dinners at the Bracketts' are Hollywood's equivalent of Mme. de Stael's salons in 18th Century Paris. To them troop the most entertainingly articulate writers, actors, actresses, and assorted geniuses in the craft. Brackett, who is an appreciative listener as well as an excellent raconteur, presides over them with solicitude and grace. In this function he is ably assisted by his wife, a kindly but witty lady whose occasional

corrosive remarks have from time to time been attributed to Dorothy Parker.[53]

If indeed such social events took place, they did so without interesting Brackett for recognition in his diary,[54] and those who trooped to them did so outside of the pages of the diaries.

The diaries were generally, if not always, written late in the evening. At times, they begin with mundane matters—"go to the studio"—and then become more convoluted, something little more than streams of consciousness, as if Brackett is getting more and more tired as he writes an entry.

What I have tried to accomplish with the diary, as edited, is to maintain a record of where Charles Brackett was at any time. Obviously, he is mainly based in Los Angeles, but the edited diaries do record trips back East, to New York, to Providence, and to his beloved Saratoga Springs. In later years, virtually nothing from the time that he was on the East Coast is included in that there is extremely little of interest, and the literary and theatrical friends that he once knew there are no longer around or have moved to Hollywood.

Hopefully, publication of these edited diaries will bring alive a man who was affable and warmhearted in his dealings with everyone from colleagues and studio executives to figures who endorsed his own centrist-right politics and those far to the left, whom Brackett tolerated with more than a sense of bemusement. There can have been no one in Hollywood, regardless of political persuasion, who did not perceive Brackett as being at all times honest and just. The diaries introduce new generations to a gentleman whose silver hair and patrician pose seem more suited to the banking world and to boardrooms rather than the writers' departments at Paramount, RKO, Universal, and Metro-Goldwyn-Mayer.

The Diaries

1932

June 7: The University Club, New York City. Impelled to write a diary by my pleasure in reading the diaries kept by my Great Uncle William Corliss through the Civil War Years. I begin today, though it has not been a particularly significant day.

The best I can offer in substitution for the war is the Depression, an event that seems less violent since the formation of a great bond pool last week, headed by Mr. Thomas Lamont.[1] In fact, I have not heard anyone say that a revolution was imminent since I got off the train this morning at 7:30. There is even less conviction in the statements that America is going off the gold standard.[2]

It was a clear, cool day. I lunched with John Mosher at the Algonquin [Hotel], read the manuscript of a serial to Otto [K.] Liveright, my agent, in the afternoon, and decided that if worked upon it might make a saleable story.

Had a game of squash with the professional at the Club. Dined with Alex[ander] Woollcott at the Marguery.[3] After dinner we went to see *Reunion in Vienna*[4] which we had both seen and enjoyed before. Lynn Fontanne and Alfred Lunt have not let down their superb performances. I was again irritated at the shoddy framework [Robert] Sherwood has given the

1. Thomas W. Lamont (1870–1948), banker associated with J. P. Morgan & Co.
2. On January 30, 1934, Congress passed the Gold Reserve Act, nationalizing all gold, and effectively removing the United States from using gold as a standard economic unit, and, thus, taking it off the gold standard.
3. At 47th Street and Park Avenue; Brackett and Woollcott would have paid approximately $2.75 each for dinner there in 1932.
4. *Reunion in Vienna* by Robert Sherwood (1896–1955), produced by the Theatre Guild, opened in New York on November 16, 1931, and starred the legendary husband and wife theatrical team of Lynn Fontanne (1887–1983) and Alfred Lunt (1892–1977).

play, which becomes so excellent whenever the two chief characters have anything to do. Afterward I went around to see Lynn and Alfred in Lynn's dressing room. She was looking particularly lovely in the false eyelashes she wears on the stage. They told of Ethel Barrymore's referring to Helen Hayes as "that monster."

Still later I stopped in at Tony's,[5] my favorite speakeasy. . . . I was amused that Tony, the proprietor, mentioned among the cheerful signs of returned prosperity, the fact that John D. Rockefeller Junior[6] has made a statement that he regards Prohibition as an unfortunate and discredited experiment.

June 14: . . . After luncheon I had an interview with [producer] Jed Harris about my play [*Present Laughter*]. It was an experience. It began by his slapping my face (metaphorically), and ended in a perfect Balcony Scene. I hope he is to be my Svengali but had been warned of his utter unreliability. At least he criticized the play from a high impersonal plane. I should like to work with him, suffering or no suffering.

[On June 22, Brackett leaves by train for Saratoga Springs, New York.]

June 26, Sunday, Saratoga: [Brackett travels by car to Stockbridge to spend the day with his wife, Elizabeth, "who is recuperating there from a sad and trying winter."][7]

En route I meditated on the advantages of having so good-tempered and non-domineering a wife.

June 29—Saratoga Springs: Went to dinner at the [Monty] Woolleys'. After dinner the radio was turned on and the guests listened to the Democratic Convention, everyone registering great enthusiasm for the Democratic stand

5. Owned by Tony Gardella and located at 42 E. 53rd Street.
6. John D. Rockefeller, Jr. (1874–1960), philanthropist and only son of oil baron John D. Rockefeller.
7. Institutionalized at the psychiatric facility, the Austen Riggs Center.

against the 18th Amendment, and Monty Woolley fuming and raging as if personally insulted at any expression of dry sentiment.

[On July 5, Brackett takes the train to New York, where he stays at the University Club.]

July 6—University Club: Dwight Wiman[8] told me by the telephone of the suicide of Smith Reynolds, the 20-year-old bridegroom of Libby Holman,[9] the 28-year-old blues singer. We had known them both. At the wedding of Smith's sister Nancy to Henry Walker Bagley, Dwight and I were groomsmen. . . .

The Reynolds children seemed to me perfect examples of what too much money and too little discipline can produce. The brothers hopped into the bedrooms of the guests to drop eggs on their heads or frighten them with shotguns. One brother had killed a man in a motor accident in England, and having served in an English jail, was being chaperoned by an appointee of the English Court. The night of the wedding they celebrated by throwing heavy benches from a balcony to the floor of the hall.

I first knew Libby as a nice, big girl who wore spectacles and had a couple of college degrees, but who, due to a trick voice, produced by an operation for tonsils, wanted to sing torch songs. She had made a couple of phonograph records but had no real success. When people of a certain set wanted a fourth at bridge they would telephone her and she would come and play, always jolly and amusing. Then Dwight featured her in the *First Little Show* [1929] and she became a glamorous femme fatale to the people of New York and I suppose eventually to herself, although she continued to keep much of her humor. I remember her entering a party one evening after she had played in *Three's a Crowd* [1930] and saying, "Well, you should have heard me to-night. Did I put over my big song. It was like the Perfect Tribute. Not a soul applauded."

8. Dwight Deere Wiman (1895–1951), producer of *The Little Show* and other Broadway successes; he and Brackett had been friends since World War I.
9. Libby Holman (1904–1971), notorious American torch singer and actress, who in 1931 married Zachary Smith Reynolds, heir to the R. J. Reynolds tobacco fortune; he was seven years her junior.

Smith Reynolds, when he came to New York, evidently felt a Theda Bara lure in her and they were married. I am sorry to report that [lyricist] Howard Dietz tells me that early in the acquaintance Libby said, "If the Cannon girl got a million out of this, why shouldn't I get five million?" Some of the tabloids hint vaguely that she may have shot the boy, but that is utterly ridiculous. . . .

Had a consultation with Jed Harris about my play which I left, entirely discouraged. He isn't going to be able to give me the architectural help I had hoped for. . . . [John] McLain gave the interesting information about Smith Reynolds, when last in town, was making inquiries about methods to increase his virility—a first-heard fact which seems to offer a clue.

July 7—University Club: . . . the talk was all of the Reynolds business. My idea of the case is that after some disagreement, the boy said, "All right, I'll shoot myself," and that Libby, having been bored with that threat many times said, "You're always saying that—go on and do it." I think she honestly believed that was the wise way to stop such nonsense. He was exactly the sort of boy who hadn't brains enough to take a dare and, probably a little tight, pulled the trigger. It seems to me that this accounts for Libby's collapse, as well as his death.

July 9—George & Beatrice Kaufman's, Manhasset, Long Island: Spending the weekend at a charming Normandy farmhouse George and Beatrice[10] have taken here. . . .

The creative group of Long Island has been rocked by a row between Edna Ferber[11] and Beatrice Kaufman. It seems Miss Ferber walked about the Kaufman house the other evening, looking at groups engaged in playing bridge, backgammon, etc., murmuring, "I suppose you call these brilliant people . . . I'm sure I don't know why I came . . . Never saw anything so dreary in my life . . ." [ellipses in original]. Finally Beatrice said, "Then why not go

10. George S. Kaufman (1889–1961), legendary playwright, theatrical producer, and director; despite many highly publicized affairs with, among others, Mary Astor, he remained married to Beatrice Bakrow from 1917 until her death in 1945.
11. Edna Ferber (1885–1968), playwright and novelist, whose works include *Show Boat*, *Cimarron*, and *Giant*; like George S. Kaufman, she was a member of the Algonquin Round Table and Brackett wrote of her as "our little flower girl."

home?" Thereupon Miss Ferber flew to a telephone and commanded that her chauffeur return for her. He didn't come for about an hour, and it must have been an awful hour. Since then Miss Ferber told a group of Beatrice's friends that Beatrice Kaufman was as dangerous to the community as a maniac loose with a carving knife in his hands, and had referred to her as "a python." All of which does not change my liking for Edna, who has always been grand to me and whose robust temperament delights me.

July 10 Sunday: The morning papers provided us with a text for the day printing the information that the doorknob of Libby's room at Reynolds had blood stains on it (which someone had attempted to clean away) and that a towel with marks which appeared to be blood had been found in the bathtub. Her testimony of being in a state of coma in which she only remembers a pistol shot, and Smith's saying "Libby" is not encouraging to her defenders, but I still am convinced of her innocence.... I said, rather unkindly, when I learned that there were evidences of someone's having washed, "Well, that in itself should clear Libby"—for Libby was never a soap-and-water girl....

[The following day, Beatrice Kaufman drove Brackett back to New York.]

August 3: A telephone call from Otto [K. Liveright] this morning informed me that Leland Hayward[12] had called him from Los Angeles to ask if I would go to the Coast for four weeks at $750 a week. I said that I would, and I will hear tomorrow whether Hayward clinches the arrangement. I'd enjoy the trip but feel that excursions into the cinema are departures from my regular career and probably a mistake.

[On August 8, via train and taxi, Brackett visits Neshobe Island, Vermont, "which is owned by a sort of club which revolves around Alex Woolcott and Neysa."]

12. Leland Hayward (1902–1971), major theatrical and motion picture agent; in the mid-1940s, he sold his agency and became a Broadway producer (*South Pacific*, *The Sound of Music*, etc.).

August 10: ... I am amused to watch the relationship between [Alexander] Woollcott and [Charles] Lederer.[13] Lederer is the nephew of Marion Davies, a good-looking, partly Jewish boy who had a precocious college career and graduated to great amorous triumphs among the beauties of Hollywood. He has all the qualities that entrance Woollcott—Semitism, sexual promiscuity, pertness. He likes and is amused by Woollcott and Woollcott exerts himself to the utmost to entertain and enthrall him. I know that actual sex is out of the picture, but Socrates must have felt the identical stimulation.

August 15: ... Went to *Passport to Hell*, a movie with Elissa Landi and Alexander Kirkland. Kirkland used to play in the stock company with Walker Ellis. He always called himself "Billy" Kirkland and I believe I was the person to advise him to use his magnificent name. It gives me a proprietary interest in him and I am proud to say that he did extremely well.

September 7: ... Otto Liveright telephoned to me this morning that a new Hollywood offer is on the table, advising me to accept, which I agreed to do though I have not now much inclination for the West Coast. I go to New York tonight [from Providence, Rhode Island] to discuss my play with Jed [Harris], a project which interests me much more.

[On September 10, Brackett takes the train to Providence, Rhode Island. "Telephoned Otto temperamentally that I didn't want to go to California and could I get out of it—to realize in the midst of his protestations that I was more or less bluffing, so packed my big suitcase, expressed it and bought my ticket to New York."]

[On September 12, Charles Brackett left New York for Los Angeles; his plane started from Newark at 10:00 a.m., stopped en route in Cleveland, Chicago, and Salt Lake City, and arrived in Los Angeles the following morning.]

13. Charles Lederer (1906–1976), a prolific screenwriter, the son of Marion Davies' sister, Reine. With the separation of his parents in 1912, Charles and his sister were raised by Marion Davies (1887–1961), a brilliant screen comedienne and the mistress of William Randolph Hearst.

September 13: California was a long sage-green valley. We landed at Los Angeles at 11:40. I was met by Harry Ham,[14] who represents Leland Hayward's firm out here, Joyce-Selznick.[15] Harry Ham brought me to the Chateau Elysee[16] where a room had been reserved for me. . . .

Harry asked me where I wanted to have luncheon and, knowing my fan magazines, I said "The Brown Derby."[17] We were unable to get in and lunched at Al Levy's Tavern instead. I then went to the studio [RKO] and met Adela Rogers St. Johns[18] who is the author of the story on which I am to work. "Author" is a vague term in this instance, as the story is an article she wrote about Jack Dempsey and Estelle Taylor[19] having been forced apart by the fight racket. "The champion's wife was always wrong," Miss St. Johns explained in her rather perfervid vein. Miss St. Johns (she is several times married and has three children) is a snub-faced, alert woman. . . . She, George Cukor (who is to be the director) and I then went to Miss [Constance] Bennett's[20] dressing room for a conference. Miss Bennett is a business-like beauty (well, hardly a beauty, for one can always see the bulbous-nosed, square face of her father Richard Bennett hanging over her delicate features like a doom) and I was delighted to find her intelligent. Cukor is amusing, also intelligent, in his way. Joel McCrea,[21] a long, good-looking youth, was in the dressing room (it's a suite really) and on the telephone, asking Miss Bennett if it were true that she is to become a mother, and if the father was Neil

14. Harry Breden Ham (1891–1943), former actor and producer who joined the Joyce-Selznick Agency in 1931.
15. Frank Joyce (1892–1935), brother of actress Alice Joyce, co-founder in 1928 of Joyce-Selznick Agency, with Myron Selznick (1898–1944), brother of David O. Selznick, and noted for management of top Hollywood actors and actresses.
16. Luxury residential apartment hotel at 5930 Franklin Avenue in Hollywood; now owned by the Church of Scientology.
17. The most famous of the chain, and the second to open, located at 1628 North Vine Street, Hollywood.
18. Adela Rogers St. Johns (1894–1988), journalist, fan magazine writer, novelist, and screenplay writer, who published her autobiography, *The Honeycomb*, in 1969.
19. Screen actress Estelle Taylor (1894–1958) and boxer Jack Dempsey (1895–1983) were married from 1925–1931.
20. Constance Bennett (1904–1965), leading lady of American silent and sound films, sister of actresses Joan and Barbara and daughter of matinee idol Richard Bennett (1873–1944). She, Cukor, and St. Johns did collaborate, without Brackett, on *What Price Hollywood* (1932).
21. Joel McCrea (1905–1990), major screen star of sound era.

Hamilton.[22] Miss Bennett had a snort for that. We had what is known as a story conference and was more of a discussion of Joan Crawford, then I looked up David Lewis, an RKO executive I used to know in New York. . . . I had dinner here with David Lewis, who has a larger apartment, and went early to bed.

September 14: . . . At the studio I met Cukor and Miss Bennett and told them my version of the story. They seemed to like it. Miss St. Johns appeared and on being told my version had what approached being a ground fit. That wasn't her story at all! Comedy wasn't wanted for Miss Bennett. She'd seen it as a tragic melodrama. Miss Bennett said she wanted not to have to snivel around. An excellent young woman. . . .

I walked home, wrote to [wife] Elizabeth and dined again with David Lewis which was a mistake, as one meal in company with that morbid young man is enough for a long time. To such extremities does loneliness reduce one. Afterwards he took me to Ramon Novarro's[23] house on a hill near here. It was built by Frank Lloyd Wright and as improved by Novarro is as viciously ugly a human habitation as I have ever seen—gilded Venetian blinds are the note. Novarro is a rather touching queenly creature who of course adores his house and obliged with a few songs, which he sang excellently, occasionally translating the French for us. There was a company of young men who reminded me of Margalo Gillmore's[24] response to the Englishman, who said, "Well, at least I discovered Ralph Forbes."[25] "Where were you looking?" Margalo asked, "Under rocks?"

September 15: A morning spent talking with A.R.St.J. [Adela Rogers St. Johns], looking up Bob Benchley, having my shoes shined, in an effort to kill the time that should have been a conference with Mr. [David O.] Sel-

22. Neil Hamilton (1899–1984), leading man in silent and early sound films, best remembered today for recurring role in *Batman* television series of the 1960s as Police Commissioner Gordon.
23. Ramon Novarro (1899–1968), Mexican-born film star of the 1920s and early 1930s, murdered by two hustlers he had invited to his home; the Frank Lloyd Wright–designed house was at 5609 Valley Oak Drive.
24. Margalo Gillmore (1897–1986), British-born actress.
25. Ralph Forbes (1896–1951), somewhat nondescript British-born leading man of stage and screen, married at one time to Ruth Chatterton.

znick and Cukor but which they could not give to such a conference. I had an engagement with Ilka Chase[26] for luncheon at the Ambassador but as the conference was postponed indefinitely at 12:30 we had to have luncheon in the studio commissary, where Bob Benchley joined us.

Later, hearing a great deal of the picture *Rockabye* which Constance Bennett has just finished, I asked to be allowed to see the preview with Bob, George Cukor and Mr. Selznick. Bob and George had specified that they be allowed to laugh as much as they pleased. It was a mawkish, artificial story but not as outstandingly bad as I had been led to believe. The roars of laughter of Bob, George and Mr. Selznick's reluctant admission that they were justified strike me as promising well for RKO pictures. It was decided to scrap a little more than half the picture. To scrap it all would have been desirable, largely because of the appalling performance given by Phillips Holmes.[27]

September 16: . . . finally had the conference with Mr. Selznick, Adela Rogers St. Johns, Cukor and a man named ? [*sic*] who has written swell movies. My ideas for lightening the picture towards a comedy fell absolutely flat and I had to agree that the story blocked out by Miss St. John and P. [*sic*] will make a far more interesting picture, though not such a good vehicle for Miss Bennett. I am out as far as work on the picture is concerned, until they have done more work on the script. The conference brought on a violent attack of the Hollywood blues. It was particularly funny, as [screenwriter] Gene Markey had advised against selling myself to Hollywood at luncheon, said how stultifying it was after a length of time, how dangerous to smother one's talent in cream. I had admitted that I feared for my conduct under temptation. It seems probably that that form of temptation will not be put upon me.

September 17: I read the scenarios given me as possibilities for a Constance Bennett picture and returned them to [producer] Kenneth MacGowan with an obscene phrase. He agreed that they were pretty bad. There was a copy of *Little Women* on his desk. I said that production of it seemed to me the

26. Ilka Chase (1900–1978), New York socialite and accomplished actress of stage and screen.
27. Phillips Holmes (1907–1942), insipid leading man on screen from 1928 until his death while training with the Canadian Royal Air Force.

most promising project of the studio, and he asked me to read it and make a treatment. It is certainly a long cry from *American Colony*, my last novel and the only one by which I am known to Hollywood.

. . . George Cukor motored me down to the Del Rey Beach, to swim at the cottage of an actor named Andy Lawler.[28] Johnny Weissmuller was there with a brother and a friend. Weissmuller is certainly the most magnificent physical specimen I ever saw, and to see him twist like some sort of flying fish through the breakers was a stunning sight. As Harpo [Marx] is like some woodland creature, he is like a creature of the sea.

On the way into town Cukor stopped at William Haines' house, a pretty, very interior-decorated little place. Haines and the man in business with him were there and fed us tea. I may note of both these groups and their connecting link, George Cukor, that the language is something novel to me, and the attitude towards life something that makes me feel like [the eighteenth-century preacher] Jonathan Edwards. Nevertheless, they are all highly amusing people.

September 18: . . . went over to the Sam Goldwyns' to see a picture. The Walter Wangers, Gary Cooper and the Countess di Frasso,[29] [actress] Gwili Andre and several other people were there. Mr. Goldwyn excelled, if anything, the comedy reports I had heard of him. I liked Mrs. Goldwyn, and confirmed my impression that the Countess di Frasso is the most unattractive, vulgar carnivore in North America. The picture, which was *Bill of Divorcement*, directed by George Cukor, gave me a new respect for George's ability.

September 19: George called me early this morning to say that he might need my help in rewriting parts of *Rockabye*. I hurried over, and he handed me three scenes from the hasty draft Jane Murfin had made. Before I set to work on them, however, he found in his mail a notice of a sale at some big

28. Anderson (Andy) Lawler (1902–1959), gay actor romantically linked to Gary Cooper in the late 1920s.
29. Countess Dorothy di Frasso, famous for being famous and for her love affairs with Gary Cooper, Bugsy Siegel, and others; parodied in *The Women*.

shop downtown and, collecting Jane Murfin, Ilka and myself, he took us all downtown. We wandered through the shop, raging at the enormous prices and roaring at the hideousness of much of the merchandise. ZaSu Pitts was there and I was introduced to her, with the disappointment almost inevitable to meeting comediennes. . . .

September 20: Worked at various scenes for *Rockabye* all morning. Lunched with George, [screenwriter] Bart Cormack and David Lewis at the commissary. Turned out another scene and went to a *Rockabye* conference in David Selznick's office. We went over the script scene by scene, appraising the vitality of every one, throwing away many, rushing in reliable story ideas at shots that were dull. It was a very illuminating business.

September 21: At the studio all day, working at *Rockabye* sporadically and waiting for George Cukor to be ready for conferences most of the time. Jane Murfin and I ended about 6:30 with a spurt of hurried writing. . . .

September 22: . . . On getting to the studio I found a telegram addressed to Charles Antibes Brackett inviting me to dinner at Malibu Beach this evening and signed Alexander Theatre Guild Kirkland. I telephoned an acceptance and at 7 o'clock a car came and carried me down a very tortuous road to the beach house of Alexander—a small place decorated smartly in red, white and blue . . . the Jesse Laskys appeared for dinner. We had champagne cocktails and Alexander, rather tight, told Mr. Lasky about my play *The Cocktail Crowd* so effectively that Mr. Lasky almost bought it on the spot. Alexander insisted on driving me home himself, stopping in at a garage to show me his enormous racing car. He is making sixty thousand a year and spending most of it. "It's such fun to be rich," he said, which I found an engaging and comprehensible speech.

September 23: An agitation at the studio to entirely re-do *Rockabye* with Joel McCrea in the Phillips Holmes role proved to be impractical because of expense. There was a long conference in David Selznick's office in which it

was decided to eliminate a scene which I felt was the only thing to give the story any distinction.

September 24: A day at the studio, which was meant to have been a very busy one but which proved to be a series of delays while George Cukor did other things. . . . More delays all afternoon. Finally a meeting at which it was revealed that the estimates for remaking *Rockabye* were wrong. David Selznick, a rather pathetic, harassed figure. Complete indecision as to whether to remake it with Joel McCrea, go on as we had planned with Holmes, or just patch up the horrible original with a few scenes.

September 27: Wrote a fairly good trial scene as an opening for *Rockabye*, took it to the studio. George Cukor didn't think it quite dramatic enough and at about 4 o'clock he, Jane Murfin, Kubec Glassman and I went into conferences with David Selznick on the story of the picture which is to go into production day after tomorrow. It was decided to make radical changes. Kubec Glassman to make most of them. All we had was a respectable hokum story and it seems to me that that is being thrown away. What will take its place I cannot guess. I hadn't before realized the unarchitectual and unstable quality of George's mind, and it seemed to me that David was yielding to his flightiness rather than holding it down. My connection with the picture was over anyway but I am immensely curious to see what they will make out of it.

Came home and read at *Little Women* (I am getting the flu) and dined with [humorist and writer] Corey Ford, who exults in expressing his hatred of Hollywood. Later I went to *What Price Hollywood?*, the picture in which George Cukor directed Constance Bennett, and revised my opinion of the quality of his mind. It is a swell picture. Evidently he feeds himself with many ideas, then uses the best in a kind of brilliant improvisation.

September 28: Felt wretchedly—stuffed-up head, aching joints. I finished *Little Women*, wrote a brief synopsis, took it to Kenneth MacGowan, but was stopped by George Cukor, who outlined some scenes he wanted written. Had

luncheon at the commissary with Ilka, who has the flu also and then stopped in at Constance Bennett's bungalow, where she and George were having luncheon and had coffee with them. . . .

September 29: At an interview with [producer] Kenneth MacGowan, he again commanded that I make a draft of *Little Women*, bearing in mind that it might be modernized, a modifying clause I refused to hear. . . . I worked on the opening scenes of *Little Women*, which I think should begin with the identical opening lines of the book.

. . . Mercedes de Acosta[30] came in to dinner in one of her little uniforms. I don't know what it represented—a black cloak, a tight black hat, something white about the throat, and black trousers peeping daintily beneath the cloak. Someone in New York once called her Miss Dracula, and the costume was perfect for that title. She came here on a Metro-Goldwyn contract. I met her at RKO the other day when she was looking for a job. Her stay out here has apparently been one long series of amorous triumphs, however. Her first words were that she was late because Marlene Dietrich had arrived at her house with so many presents which she must stop to admire—a Marie Laurencin[31] painting, a great vase of flowers, a watch, etc. As the eyes of Mercedes were very bright, I wondered if she had been kicking the gong around or something of the sort. Her enchanting sister, Mrs. Phil Lydig,[32] was supposed to be slightly druggy. I have an idea, however, that with Mercedes it was merely good, unhealthy exaggeration. Her conquest of Garbo when she first arrived here rang through the groves of Lesbos in the East, and she had to mention it, flaunt it. According to her, the expiration of her Metro contract was a kind of Liebestod for Garbo. She is very definitely worried about money, now.

My idea of the best pun ever made in America had Mercedes as its subject. She was in the throes of a grand passion for [actress] Eva Le Gallienne, who was then playing in [Ferenc] Molnar's play *The Swan*. Someone saw them

30. Mercedes d'Acosta, sometimes Mercedes de Acosta (1893–1968), wealthy Spanish-born socialite whose only claim to fame are her love affairs with famous women, including Greta Garbo (1905–1990) and Marlene Dietrich (1901–1992).
31. Marie Laurencin (1883–1956), French painter, stage designer, and illustrator.
32. Rita Lydig (1880–1929), whose second husband was the wealthy Philip M. Lydig, twenty years her senior; noted for her extravagant lifestyle.

leaving the theatre and asked, "Who is that?" "A social Leda," replied some anonymous but inspired wit, "and her Swan."

October 2: I worked on *Little Women* all morning, had luncheon with Corey Ford, insisting that he eat with me, and going out to buy sandwiches, as luncheons are not served in the hotel on Sunday. Wrote more in the afternoon. David Lewis took me to cocktails with Ruth Chatterton and George Brent. She is a shorter person than I had thought, innately affected—one of those people to whom naturalness, as it is ordinarily interpreted, would be completely impossible—but charming. . . .[33] George Brent, unlike his suave self on the screen, is a quite tough-faced Irishman. . . .

October 4: . . . Worked until noon, then lunched at the studio where the tepid conversation of Kenneth MacGowan and the averted eyes of Pandro Berman told me that something was amiss. Learned during my interview with Noel Gurney that RKO was not anxious to retain my services unless my work on *Little Women* proved to have been exceptional. Also by indirection that Myron Selznick, after his talk with me yesterday, had done nothing.

Ran over the draft of *Little Women*, hurriedly making obvious corrections and took it down to be typed. . . .

I've thought it amazing that I was so little affected by the RKO news and far too logical, but I now find myself deeply depressed by it and by my lack of ability to "sell" myself, when I know myself to be a more valuable piece of merchandise than many that are sold here at large figures.

October 6: . . . I was working on *Little Women* when a telephone call summoned me to the studio to do a horror scene for *Secrets of the French Police*. It was a welcome chance, I must admit. Eddie Sutherland is the director and he had to chaperone every word of dialogue, because the villain is played by [Gregory] Ratoff, who speaks with a tremendous accent.

33. In an August 1944 letter to Alan Campbell, Brackett was to describe Chatterton as "sadder than a ghost."

The striking picture of the day, and one which illustrates the condition of Hollywood language at the moment, was of Jobyna Howland, the great, brazen looking old trouper who plays the mother in *Rockabye*. She stood talking to gentle little Jane Murfin. Jobyna's dog was nearby and Jane asked if it was male or female. "A bitch, of course," Jobyna roared. "They're so much more wonderful than male dogs." "In what way?" asked Jane, who used to own Strongheart. "Oh, a male dog is always licking his balls, or takin a drop of p-p [*sic*] off his dingus." . . .

𝒪𝒸𝓉𝑜𝒷𝑒𝓇 8: Worked on *Little Women* until 12:00 when I had a call from the secretary of one Willis Goldbeck, my supervisor, asking if I had gone back to work on *Little Women* after the day I put in on *Secrets of the Paris Police*. I replied that I had, and felt unspeakably affronted at being treated like a schoolboy trying to pass without doing any work. . . .

Went to the studio for luncheon, sitting next to Willis Goldbeck and not mentioning my wrongs. . . . Went to the Ambassador Hotel for a haircut and took a bus back to Hollywood, wondering if I were not the only author who ever rode anywhere in Hollywood on a bus. Noel Gurney, the man at Joyce-Selznick who is handling me, telephoned that David Selznick has given him permission to offer my services elsewhere and that he will begin to do so on Monday.

𝒪𝒸𝓉𝑜𝒷𝑒𝓇 11: . . . After a consultation with Kenneth MacGowan about *Rockabye*, in which he seemed embarrassed, I returned home and found from my agent that my contract with RKO expired not Thursday but today. I intend to rewrite my draft of *Little Women* while waiting to see if another contract develops, because I have nothing better to do with my time and because it strikes me that it would agreeable to perform one small gesture in Hollywood on behalf of good work instead of shoddy work. Perhaps money means more to RKO than it does to me but I have an idea that they just think I can't do any good work anyway. At least don't care for my kind of work.

𝒪𝒸𝓉𝑜𝒷𝑒𝓇 12: Worked on *Little Women*, went to the studio and was impressed by George Cukor to find a quotation from *Romeo and Juliet* for the heroine of

Rockabye to say to the hero, and to write a scene incorporating it. . . . Came to my room and did some more work on *Little Women*, the bogus enthusiasm of yesterday having slipped from me. . . .

October 13: Worked more casually on *Little Women*. Went to the studio for luncheon. Was hailed by Connie, George and Joel and asked to luncheon in Connie's bungalow. "A stinking luncheon," she pronounced it in advance. . . . The luncheon consisted of scrambled eggs and sausage. The sausage, Connie claimed, were high and she wouldn't eat them. There was cabbage she thought too strong and celery she loathed. A rather small chocolate cake, contributed by Jobyna Howland, was all she liked. She and George were both exhausted but it was a droll, charming party.

October 14: . . . I took the faintly rewritten script of *Little Women* to the studio and left it to be typed. No one of interest was in the commissary so I sat at the table with Sam Jaffe,[34] as loathsome a yellow kike as I ever saw. He was wearing a black suit with white polka-dots all over it and talking about his cinematic discoveries. . . .

. . . Went to the house David Lewis and James Whale[35] have taken, for dinner. I went for dinner, but they have not taken it for that function. Ah, my immortal grammar! It is very Spanish, with a red ruled living room whose long windows look out on magnificent views on three sides. To see David ordering about his butler gave me great amusement and pleasure. David Manners[36] was there, a young man I thought even more dislikeable than when I first met him, and Dorothy Arzner,[37] the only woman director came in later. A fine, sad, abstract-minded spinster. She drove me home, stopping en route to show me her house, a Greek house immensely appropriate to the Vestal of the Cinema.

34. Sam Jaffe (1901–2000), primarily a Hollywood agent, but generally considered to have been responsible for saving Paramount from financial ruin in the late 1920s.
35. First reference to both David Lewis and James Whale.
36. David Manners (1901–1998), somewhat dull Canadian-born leading man, best known for roles in horror films such as *Dracula* (1931) and *The Mummy* (1932).
37. Dorothy Arzner (1897–1979), American film director; also editor and screenwriter, generally identified as a lesbian.

October 15: Spent the morning at the office of Joyce-Selznick, arranging for transportation and watching their promises of contracts glimmer and go out. Went to the studio and said goodbye to David Selznick, who said that he felt when a writer "of known attainments" was brought out and the studio was unable to get anything from him that he felt it was the studio's fault—a kindly-meant speech but not the most tactful in the world.

Had luncheon in the commissary, said goodbye to a million people. Saying goodbye to defeated New Yorkers is done rather well in Hollywood. Returned to my room and worked on my story of the decadent little group and had a grand time. David Lewis dropped in with a farewell present of two neckties. He has been a great comfort to me in my bondage.

[At 9:55 p.m, Brackett takes the plane from Burbank, making stops in Cheyenne, Iowa City, Chicago, Cleveland, and arrives in New York, by train from Toledo, on October 17.]

October 18: . . . Called on Otto [K. Liveright], and together we went to the office of Leland Hayward, a very Renaissance apartment with stone staircases winding between filing cabinets. Leland sat at a long carved table, surrounded by telephones, and between telephone conversations assured us that it was merely a matter of hours before I had a MGM contract. He had been talking it over with Irving Thalberg and it was all set. On the way out Otto warned me to add the customary shakeful of salt to that statement. I had already done so.

[At 3:00 p.m., Brackett leaves New York for Providence, and 45 Prospect Street, and a reunion with his wife and daughters. On October 27, he travels to Saratoga Springs, and on November 14, he travels by train to New York.]

October 27: I have thought sadly today of two of my stupidities: the fact that I am unable to realize the smallness of my own accomplishment, and the fact that I have very little sense of the passage of time. It has been months since I have had anything published, yet I always think of myself as a flourishing author and a well-known one.

November 8: Elizabeth and I went to the polls and voted two straight Republican tickets. . . . Returned to our radio, we learned for the Democratic landslide, which seems to have swept Roosevelt to the Presidency. Elizabeth said, "Well, if that's what the silly old country wants, let it have it," which I thought was generous of her, and retired muttering savagely, "Babies, Just Babies"—the name of a magazine edited by Mrs. Roosevelt. My only consolation in the election is an unreasoning conviction that Hoover was a bird of ill omen. Those frightful statements that "no President ever entered office under such favorable auspices," which were to be heard everywhere four years ago, claimed their revenge of him.

November 16: . . . I took a copy [of Brackett's as yet unproduced play, *Present Laughter*] to George Cukor, to satisfy George's personal curiosity, and found George in a story conference with Jane Murfin, Harry Wagstaff Gribble and Elsa Maxwell, who is to the play the Duchess in *Our Betters*, Connie's next picture. I had met Elsa Maxwell years ago at a miraculous party Allie McIntosh gave at Antibes, and I have heard the most affectionate and enthusiastic things about her from Cole Porter and Monty [Woolley]. She is a squat, monstrously plain woman with boundless gusto, a whisper of financial peculations in her past. As the rest of us sat chatting, she would be called to the phone and to our ears would be wafted such words as "Yes, Mrs. Vincent Astor for dinner at 8:00—no, Mr. Astor isn't asked." Again, "Will you tell Mrs. Vanderbilt that I will be there at five? Mr. Joe Burden wants to come."

Her success has been entirely social, as the entrepreneuse of great parties, and an entertainer at the piano who mingles with the guests intimately. My impression this time was of a hollow, shoddy woman, anxious to show off her social connections, not funny in the least. . . .

November 18: . . . I went back to Tony's. . . . David Selznick, a little cozy, said I was the only author he had ever known to leave Hollywood like a gentleman—which pleased me inordinately. . . .

[On November 19, Brackett leaves by train for Providence and his family. He returns to New York on November 22.]

November 22: . . . At the Coffee House . . . I had some conversation with Charles Hanson Towne,[38] who won me by quoting a line from *American Colony*. I am of course an old whore in my ability to like people—there are almost none that I really dislike, and a kind word weakens my latent softness to the mawkish point. . . .

I went to see *Autumn Crocus*, with Francis Lederer and Patricia Collinge. It seemed to me that Lederer gave the best performance I had ever seen a man give in my life. After the play I went back to see Patricia, who is unhappy in her role because she was again called "sweet" by the reviewers. Lederer was being interviewed. I inquired of Patricia about his accent and then heard from his speech, as it was wafted from his dressing room, that it was too thick for him to play anything but a Teuton. . . .

November 23 [back that day in Providence]: . . . Elizabeth advises me to put *Present Laughter* away for the time at least but I still feel some need for laying its ghost.[39]

November 25: . . . As I write, I am just about passing into my 40th year, and I am as discouraged about my career as one can be who is cursed with a foolishly sanguine disposition. I have an interesting, scattered life, and I have gotten nowhere and I am getting nowhere. I wish I knew the answer.

December 1: . . . my idea that a retreat to 605 N. Broadway [Saratoga Springs] was indicated for the Brackett family. Then we should try to live on a thousand dollars a month—not a pitiful statement in the year 1932, but as we are used to spending nearer three thousand a month, we will find it hard.

[On December 19, Brackett takes the night boat for New York.]

38. Charles Hanson Towne (1877–1949), American poet and writer.
39. On December 6, Brackett begins working on a novelization of the play.

December 20: After a very fair night's sleep I went to John's [Mosher] apartment, had breakfast with him and a long talk. Stopped at Otto's for a preliminary conversation [regarding serialization of *Present Laughter*], went to Edmund Devol's, where I met Laurette Taylor, who lived up to her reputation as an utterly enchanting person when sober.

[That same evening, Brackett returns by boat to Providence. He and the family visit New York, by train, on December 26. There are visits to the theater and to movies, and a return to Providence, by night boat, on December 29.]

1933

January 3: . . . I went to see *Secrets of the French Police*.[1] That, in Hollywood, I should have thought the tedious thing tolerable is a commentary on Hollywood. The scene I "wrote" seemed to me a little more flat than the rest.

January 10: . . . [Helen] Mackie and I to see *Frisco Jenny*,[2] the picture Ruth Chatterton told me about when I was in Hollywood and the only one of the productions in the making at that time which seems to me worth its celluloid, with the exception of *The Penguin Pool Mystery*.[3]

[On February 3, Brackett, his wife Elizabeth, and John Reed[4] travel by car to Saratoga Springs, staying with Eleanor.][5]

February 4: . . . At 4:30 we went to Monty Woolley's for a cocktail party. . . . Dorothy Woolley, Monty's sister-in-law had made cheese things and sandwiches and was saying, as we knew she would, "Oh, they're no good. That oven is too high. They're terrible." They were delicious, and with them Monty served strong cocktails in water glasses. Everyone was a little high before the

1. Released December 1932 and directed by Edward Sutherland; the screenplay is credited to Samuel Ornitz and Robert Tasker.
2. Released January 1933, directed by William A. Wellman and starring Ruth Chatterton.
3. Released December 1932, and starring a favorite of Brackett's, Edna May Oliver.
4. A classmate from Williams College who was a college professor and a close personal friend.
5. Unidentified.

afternoon was over, though Monty was fuming at me, "I suppose you think it's better to have had only one cocktail, to have maintained that famous balance of yours!" . . . We four returned to Eleanor's, soaked in hot baths, and were ready to receive our guests when they arrived at 8:00. . . .

Large cocktails were served, and we moved out to the dining room. . . . The dinner was calm until about the salad course, when suddenly Dorothy began to sob about the tragedy of her life. John Reed, knowing she was tight and on her way to high hysterics, caught her arm and said, "Now take three deep breaths." . . . Everyone ignored the incident until stertorous breathing drew all eyes to Jamie Woolley [Dorothy's husband], who was glaring at John Reed with maniacal fury in his eyes. "You stop that!" he cried.

"Oh, come now, Jamie," I said, "there's nothing to get excited about." And I looked toward Monty, expecting him to calm down Jamie, who is dimly neurotic at best. Instead, idiot fury glared from Monty's pale blue eyes also. "Yes, stop that. I saw it!" "Saw what?" faltered our little professor, looking chartreuse green. Monty didn't specify, but turned to sarcasm. "Brown, you said?" he screamed, "representing the University of Brown?"

"Monty," Elizabeth protested, "you're Eleanor's guest, and John is a friend of ours."

"I can't help that," he replied, "I admit it's impolite, but I am impolite—I am sauvage!"

"I should call it uncouth," Elizabeth said.

"Why, Monty," Eleanor exclaimed, "there's nothing he could have done at the table which would have justified all this!" . . . Meanwhile, Dorothy had begun to wail, "I'm being treated like a harlot! They (the Woolley brothers) are treating me like a harlot."

Eleanor pushed back her chair. "Aren't we having a dessert?" I asked mildly. "I'd forgotten it," Eleanor replied, sinking back. We ate the dessert in what would have been dynamic silence had good old Emily Smith not flung herself into a story about an atheist. . . . Finally dinner was finished and Eleanor and I herded the two Woolleys and Dorothy into the drawing room. . . . "You don't know what I've been through. I've stood it this long but no longer," Dorothy wailed. "I hate the name of Woolley. . . ."

Monty had tried brushing into John Reed to provoke a fist fight, and in the drawing room he turned on me savagely, "You put up with this sort of thing!"

he cried scaldingly, "You put up with it!" I had already lost my temper with him. . . . We almost mixed it up physically.

"I'll go to New York. I have fifty dollars, and I'll go to New York and start on my own." Dorothy had changed the burden of her song. "I'll take Bawbee (her beloved dog) and enter a brothel. Jamie will wake up and find Bawbee gone."

By then Jamie was beginning to show repentance of the mess he'd started but nothing could stop Dorothy. Implications of Jamie's impotence, accusations that he lay in bed till ten in the morning while she cooked the breakfast . . . "I'll kill Monty. I'll kill him!" . . . [ellipses in original]. Finally we bundled them into Emily's car and drove them home but before we left there was a final episode. John Reed, whose conduct had been flawless throughout the evening, came to say goodbye to Dorothy. "I have a right to my life," she was wailing. "I have a right to a good time."

"You certainly have," he agreed, "but you mustn't cry all the time."

"I don't cry all the time!" and drawing back, she slapped him sharply across the face. . . . When we'd gotten her into her coat, she remembered it. "I like him so much," she cried. "I like him and I slapped him." With that she darted into the drawing room, flung her arms about him and kissed him. . . .

In the car Dorothy sat with Emily, I with Jamie, and with every turn of the wheels Jamie's terror at the scene which lay before them grew more evident. When we got to their apartment he said hastily, "I guess I'd better take Bawbee for a walk," and slipped out, leaving Dorothy sitting in a straight chair, looking like a thwarted fury. For all I know Jamie is still giving Bawbee that walk.

All the ladies in Saratoga have long thought that Dorothy is in love with Monty and that he, though despising her, wants an affair with her. They were shrill in their cries of, "Well, I guess this proves it. Now do you admit that we were right?" I doubt that they were right, but perhaps. To me it seems that in their depression blues, the Woolleys each had the need for a scene as irresistibly as epileptics might have had fits. At least Eleanor provided John Reed with a good sample of melodramatic Saratoga.

February 5: . . . I found in myself a Victorian regret or rather shame that members of the supposedly upper class should have so behaved themselves before the servants.

[Elizabeth and John Reed return to Providence, and Brackett takes the train to New York.]

February 5 (continued): . . . I had telephoned Woollcott and he'd asked me to stay with him, so I taxied directly to his place, finding Alfred Lunt and Lynn Fontanne there having tea, Lynn prettier than I have ever seen her, in a chartreuse dress and some miraculously gray fur coat. Both of them shone with the glow of a new triumph, and we had a grand time. . . .

[On February 6, Brackett returns to Providence via the night boat.]

February 19: Ilka Chase and Donny McDonald arrived from Boston on the 1:00 o'clock train. After Sunday dinner with the family they went to a rehearsal, while we went to a reading by T. S. Eliot. He proved to be a languid young man with a constipated voice, very utter, without being effeminate. I believe I should have written young-looking rather than young, since he graduated from Harvard in 1910. His poems strike occasional sparks of beauty, but their importance eludes me.

February 20: Elizabeth and I went to *Forsaking All Others*, the Tallulah [Bankhead] play, and having been assured by Ilka [Chase] and Donny that it was the worst in the world, were agreeably surprised to find it merely very bad. I am sorry it is bad, for Frank Cavett,[6] one of the authors, as well as for our friends in the cast. After the play most of the cast came here to a supper party, augmented by about forty Providence gentry. I had rather shaken in my boots at the possibilities of what Tallulah might do, but though a little tight she behaved very well. Fred Keating, the leading man (ex-vaudeville) did magnificent card tricks for the guests. Roger, another member of the cast, played the piano, and when May Nicholson asked her to, Tallulah turned a handspring, as she did in the play. It was quite a festive evening. Andy Lawler of Hollywood was in the cast, as was [character actress] Cora Witherspoon, whom I have

6. Frank Cavett (1905–1973), playwright and screenwriter who won Academy Awards for *Going My Way* (1944) and *The Greatest Show on Earth* (1952).

seen snub all the better lady stars (on the stage). Tallulah signed the autograph books [for Brackett's daughters and their friends] merely "Tallulah," that having been her method during her brief, incredible vogue in England.

[On March 2, Brackett travels to Saratoga Springs, where, the following day, he listens with Monty Woolley to the inaugural speech of President Franklin D. Roosevelt.]

March 10: . . . I am hardly in the mood for creative work . . . I flatter myself that I would have been more effective as a creative artist had I been born poor. . . . Would I really? No.

March 13: . . . I had luncheon with Monty Woolley cooking it. Corned beef hash, with poached egg, toast & tea. Less than 35 cents, Monty boasted.

[Brackett leaves for New York on March 16, returning on March 17 to Providence, from where he makes a number of trips to Saratoga Springs and New York. On June 1, he is in Saratoga Springs.]

June 1: . . . Clifton Webb[7] . . . began to talk to me about the frightful time his mother had when he was born. One could see how his mother (a prize bitch by repute) had driven the fact into his mind as a child, used it as a rivet for his pathological devotion.

[June 6, Brackett leaves by plane from Albany for New York, returning on June 9 by train; he returns to New York by train on June 12, returning by train to Saratoga Springs on June 17; then returns to New York from Albany

7. To Noel Coward Brackett wrote in March 1961, "His [Webb's] tears, with which I was sympathetic, are mixed with another liquid, which I remember from a phrase of my father's: 'He's meaner than cat pee on the cellar stairs.' Tears and cat pee—it's a woeful combination!"

by plane on June 20. The New York visits are all in connection with potential production and casting of Brackett's play *Present Laughter*, a process which is to continue for several months.]

June 20: . . . I took a nap at the Club, moved my things to Otto [K.] Liveright's apartment. Otto is going away for a couple of weeks and has loaned it to me during his absence. We were having dinner together when Jerome Kern[8] called up to ask Otto to come and hear some scenes and part of the score of the musical show he is making from Alice [Duer] Miller's[9] novel *Gowns by Roberta*.[10] Otto asked if I might go along and we took the train for Bronxville, where Kern met us. I had never seen him before. He is a stocky, white-haired Teutonic looking individual radiating immense energy. It seemed to me that he treated Otto snappishly, but poor Otto was born for that kind of treatment, and Kern was in that not-too-charming position of a man who has summoned an audience to admire and will tolerate nothing but admiration. To me Kern was extremely agreeable and I was much impressed by his comprehensive oversight of the production: scenery, story, casting. I made the suggestion that Mrs. Pat Campbell play Roberta. It seemed to meet with his approval. Whether it would meet with hers, God knows, but I understand she needs the money. Kern had meant to have Rudy Vallee play a crooner who has been inserted into Alice's story but has decided that Vallee is not the man. On questioning Vallee about his comedy ability, Vallee said, "They say I have no sense of humor, but I think I have. For instance, I do an imitation of [Maurice] Chevalier. At a meeting of some club I was asked to entertain, and right in the middle of my imitation it occurred to me that I was wearing a tweed sack suit and that only my head was Chevalier, the rest of me wasn't Chevalier at all." As equipment for rousing comedy this seemed to Mr. Kern rather meager. The anecdote seems to me to point a boiled-potato quality which I have always suspected in Vallee better than anything else could.

Kern's score for *Roberta* is lovely, slightly reminiscent of his old Princess musical comedies. I liked one song which the crooner sings to the little Russian

8. Jerome Kern (1885–1945), major American composer of popular music, whose shows include *Show Boat* (1927).
9. First reference to Alice Duer Miller.
10. *Roberta* opened at New York's New Amsterdam Theatre on November 18, 1933, and ran for 295 performances; it introduced "Smoke Gets in Your Eyes" and was filmed in 1935.

heroine, to teach her about American music, but Kern smacked me down. "This," he said, playing the first number, "has everything—melody, refinement, gaiety. It's not great, but it's got every requirement for enormous box office success." There seemed little point in arguing.

Mrs. Kern was present, a somewhat submerged blonde. We sat in a quite lovely pine room with one distinctly off-note. On the little coffee table before the couch stood a prop Georgian coffee pot, sugar bowl and cream pitcher.... After the music Kern showed us the books which he has begun to collect after selling his Shakespeariana.... He has some amazing, pluperfect, uncut first editions.

[Brackett returns to Saratoga Springs by train on June 23, and continues working on the play. On June 30, he reports that "A lapse of two weeks occurs in the writing of this diary." That day he leaves again for New York.]

July 7: Jack Baragwanath was having his model party, eight of the prettiest models possible, squired by George Abbott, Jack himself, Will Stewart, Lu Ordway, Raoul Fleischer, Charlie Payson and me. Neysa [McMein, Jack's wife] was there to greet them and stay through cocktail time, then slipped away. George and I sat at the table with two unrelated Miss Fords. One passed out before dinner was over. The other, Doris Ford, one of the prettiest girls I have ever seen (a Jersey cream brunette) was also one of the dumbest human beings. George and I were like stupefied hosts at a child's party, trying to keep conversation going. Jack Baragwaneth was very amusing, making speeches about "I bring you to my home, I give you the finest foods, the rarest *Croton* 1933, and how do you repay me?" ... After dinner we played "Still pond, no more moving" on the lawn, lit with Japanese lanterns and moonlight, then separated into groups. Will Stewart and I drew a girl named Worth who fancied her voice. She walked to the edge of the lawn and sang to the moon and us until Will Stewart, the craven, sneaked back to the house.

I find that I omitted Jeff Machamer as one of the guests—a gay, delightful person, on the alcoholic side....

About 2:00 Neysa returned from her party. All the men were bored with the sappy girls, who were packed off in various cars and Neysa played ping pong with Jeff and with Stewart, danced a little with everyone. The whole evening was typical of the grace with which she moves through life.

July 17: The cast assembled to read *Present Laughter*, minus a John Chancellor (Hunter Gardner is rehearsing something else) and an Albert Payne Dick. The rest were STAN: Roger Pryor; DOROTHY: Rose Hobart (nabbed at the last moment, thank God), MRS. HEWLETT: Cora Witherspoon, LEDA: Ilka Chase; MARGERY: Nancy Ryan, MR. HEWLETT: [blank] (He thinks himself too young and the role too small); SOPHIE: Mary Taylor; BILL: Tom Hamilton; BOB: Gilbert Squarey.

Tony [Antoinette Perry] thought Mary Taylor amateurish and dreadful. The reading was around Tony's dining table. And the last act, tho tentative, was read aloud and was long and bad. Rose Hobart lacks emotion.

[Rehearsals continue on a daily basis through July 28 at least.]

[On September 11, Charles Brackett notes the lapse of a month in the diary, which "indicates activity of one sort and another." He was chiefly involved in the summer of 1933 in casting and production of his play *Present Laughter*, which was not staged in New York, but was directed by Antoinette "Tony" Perry at the Westport Country Playhouse, starring Rose Hobart, Roger Pryor, and Cora Witherspoon, and opening July 31. Brackett subsequently rewrote the play, but failed to get it produced in New York. He tried desperately to persuade Dorothy Gish to play the lead, but was not successful.]

[On October 2, Brackett records "Another hiatus, indicating this time days of apathy and discouragement."]

November 27 [Brackett arrived in New York from Saratoga Springs on November 22, "and had so good a time" that he records it all under this date. The events do, of course, take place over a period of time.]:

Arrived in New York I went straight to Otto [K.] Liveright's office. . . . I expressed my sympathy to Otto for the loss of his brother Horace (generally known as Horrors . . . [ellipses in original] not only because he produced *Dracula*). Otto was very Jewish and bravely sad, or sadly brave. He told me about Alice's and Jerome Kern's musical comedy *Roberta* which arrived in

New York after many difficulties, the book having been as wretched as we feared it might be from the samples of [Otto] Harbach's dialogue, which Kern read us last summer, and vulgar in addition. Kern had been impertinent to Alice, according to Otto. Otto had suffered torture, and somehow it seemed all linked with the death of Horace.

. . . I went on to *The Green Bay Tree*,[11] the play Jed Harris has produced. It has a great deal of dishonesty in its heart, essential perhaps to its homosexual theme, but it has also the portentous tone which I resent in plays on "forbidden subjects." Jack Baragwanath was there. We laughed together between acts. . . .

Rising about 9 the next morning I went to Macy's and made some household purchases, went to the Algonquin for luncheon with Otto [K. Liveright] and saw Alex[ander] Woollcott sitting with Edna Ferber and her nieces. I joined Alex when Otto had to leave. He said, "People seem to think I'm indifferent, feeling as calm as I do about the play (which was opening that evening) but I have merely adjusted myself to any possible outcome." Who can have accused him of too indifferent an attitude I cannot imagine. Edna and I agreed that we had rarely seen a person with so ferocious a case of the dithers.

Alice [Duer] Miller, Neysa and Jack Baragwanath dined with me at 21, Neysa looking lovely but not very well, Alice in a red velvet dress for which [husband] Harry had paid because she lost so much money at cribbage the other day. Typically, I had insisted on their coming to dinner too early, so that we would be at the theatre in time—and we were almost the first there. Alex had said that he didn't want a typical first-night audience, but glancing over the people who poured in, I remarked that he'd certainly found one which looked remarkably like a first-night audience—all the old faces, and some brilliant additions. In the row ahead of us were the Berlins, Cole Porter and Alice Roosevelt Longworth. Gary Cooper was featured in the row ahead of that. [John] Mosher was there with [Edmund] Devol.

The play[12] seemed to me absorbing but I was incapable of an aloof critical attitude. Margalo Gillmore, who played the heroine very well, came in with

11. Written by Mordaunt Shairp, and starring Laurence Olivier and Jill Esmond, *The Green Bay Tree* opened at the Cort Theatre on October 20, 1933.
12. *The Dark Tower*, by Alexander Woollcott and George S. Kaufman, opened at the Morosco Theatre on November 25, 1933, and ran for fifty-seven performances.

the worst make-up I ever saw on the stage—whitewash and blisters. After the play Alice and I went on to the Surf Club with a Mrs. Harris from Chicago and Colonel Roddy. We had old-fashioneds and lobster salad and could hear faintly the excellent singing of the entertainer.

Leaving Alice at home, I proceeded to Tony's, to find Monty Woolley sitting at a table with Leonard Hanna of Cleveland.[13] . . . Dotty Parker was in Tony's with Alan Campbell, to whom she has referred as "That faun's ass." . . . I sat 'till closing time, amused by the effrontery with which Leonard Hanna gathered up a young musician named Buddy Lewis.

[The Diary ends the year with an entry headed] Hiatus:

Work on my novel about the island[14] and it seems to me that in it I am writing well for the first time in three years. Money worries, but real failure to face the fact that we live a little beyond out income every month. . . . Elizabeth continues miserable.

13. Leonard C. Hanna, Jr. (1889–1957), Cleveland philanthropist; never married and here identified as gay.
14. Set on Neshobe Island, Vermont, lampooning the Algonquin Round Table, with each story paralleling a family history. Brackett began the novel in the winter of 1932. In March 1934, he comes up with possible titles of *Other Manners* and *Never a Dull Moment*. It is eventually published by Alfred Knopf in the autumn of 1934 as *Entirely Surrounded*.

1934

Sometime in January [Saratoga Springs, New York]: John Van Druten[1] comes up for a weekend, amusing me with a report from Hollywood about George Cukor who, in directing the breakfast scene in *Little Women*,[2] is supposed to have said, "Will you four whores try to pretend that there's some cocaine in that dish and act as though you really wanted it?"

February 3 [en route by train to Miami]: George [Abbot] and I dined together and I tried the dangerous, because it seems impertinent, experiment of telling him what I thought about his career. He controlled his temper superbly but shut me off immediately. He has decided that comedy is what the public wants in the theatre. It is a commodity which he is ill-equipped to supply. A grand creature, on the melancholy side. . . .

[On February 4, Brackett leaves by plane for Barbados, where he is met by Alice Duer Miller and Irving and Ellin Berlin, and takes up residence at the Berlin's home.]

February 17: . . . I have said far too little of Irving with whom I am very impressed. A kindly, lonely, remote little genius. He has the figure of a boy of

1. John Van Druten (1901–1957), witty British playwright, who was to have success in later years with *Old Acquaintance* (1941), *The Voice of the Turtle* (1943), and *I Am a Camera* (1951).
2. Released November 1933.

fourteen and an elderly face which I should call German-Jewish. The face of a kindly watchmaker in a child's story book. I can see nothing Russian about him. There is in him a gay, jaunty streak which it seems to me is completely expressed in one phrase in his song, "Not for all the rice in China." The phrase for which the words are "That are made by the Swiss." Without that he might be the typical maker of sentimental ballads. He has a horror of expressing any affection for Ellin in public, which is like my own hatred of demonstrativeness towards Elizabeth.

Ellin is arrogant, intelligent, ambitious, a fascinating person, charming to look at in her blonde pallor. We had great fun pretending to be a little in love with each other.

[On February 17, Brackett returns by plane to Miami, and travels by train to Saratoga Springs, New York, arriving on February 19. He finds wife Elizabeth "splendid. My absence seemed to have done her good and she seemed better than she has in several months." On March 5, he travels to New York by train, returning to Saratoga Springs on March 7.]

March 27: . . . A wire from Otto [K. Liveright] asked if I would accept a Hollywood job now. I replied that I would, but expect no further developments. [At this time, Brackett was working on what was to be an unpublished story about his experiences in Hollywood, titled "The Golden One."]

April 12 [Brackett has traveled that morning by train to New York]: . . . In the afternoon I had a message, took my things to Alex's apartment [Alexander Woollcott, with whom he was staying], stopped in at Alice's [Duer Miller] and was invited for dinner with Henry and the young Millers. I went alone to *No More Ladies*,[3] which seemed to me very thin. After the theatre I proceeded to Beatrice Kaufman's party for [publishers] Harold Guinzberg and Bennett Cerf, an enormous gay affair. [Humorist] Frank Sullivan was there, Ellin Berlin, Neysa [McMein], Muriel King,[4] Joan Payson,[5] [*New Yorker* editor, Harold] Ross, the Millers, Oscar Levant, George Gershwin, [composer]

3. A play by A. E. Thomas, filmed the following year as a vehicle for Joan Crawford.
4. Muriel King (1901–1972), fashion designer who worked in Hollywood in late 1930s.
5. Joan Payson (1903–1975), businesswoman and philanthropist.

Kay Warburg, and countless others. Late in the evening Oscar Levant was playing the piano and little Lois Moran,[6] in a pink taffeta dress, was sitting beside him. Suddenly, seized with a fit of exhibitionism she probably mistook for an urge towards self-expression, la Moran began doing an aesthetic dance, pausing for an instant, to pull off her shoes, her stockings, continuing barefoot. Beatrice Kaufman, next to whom I sat, shook with laughter which she, for some reason, seemed to think well concealed. Only the failure of the music stopped the performance.

April 17: In an agony of indecision I consulted Alex[ander Woollcott] as to the advisability of showing the ms. [of *Entirely Surrounded*] to Dotty [Dorothy Parker]. ("I refuse to advise. She's an unpredictable person.") Otto [K. Liveright] ("I guess you'll feel better if you do.") [John] Mosher ("I don't see why you want to write about these people you admire so much, Charles. I never would—That's the one thing that's the matter with your writing.") (A literary conference.) At last it was one o'clock and a proper hour to call the poetess. I asked her to luncheon. She told me to come there to luncheon. I went, bearing flowers. She and Alan Campbell the *amant* of the moment, were charming and after my luncheon (given I'm sure because she wanted to put me in the hideous position of eating her salt) I read the entire novel to Dotty. Never have I experienced greater misery. She laughed at parts, at the bits about Daisy Lester she did not laugh. Before I read the book I had said to her, "Dotty, this isn't an important book. It isn't worth publishing if it's going to hurt anyone," and in the high hysteria of the moment I meant it. As I read, the Daisy bits seemed to me churlish and unworthy of Dotty's scale. At the end of the reading she said it was a grand book and that I was a son-of-a-bitch but that she had hoped it would be published and published soon. She behaved like a great woman and I, alas, as soon as I could get to a bathroom was violently ill from sheer emotion. I'd like to dedicate the book to Dotty but feel that it would only increase the tastelessness. Perhaps not.[7]

April 21: Disheartening letter from Otto [K. Liveright] enclosing an even more disheartening one from Alfred Knopf which stated that he was not

6. Lois Moran (1909–1990), screen star of the 1920s and early 1930s, whose lover, F. Scott Fitzgerald, described as "the most beautiful girl in Hollywood."
7. The novel bears the dedication "FOR DOROTHY Some caricatures: with love."

unduly enthusiastic about *Never a Dull Moment* and wanted a word from Woollcott, which he could use as a blurb before publishing it. I replied that I didn't care to be paddy-backed to publication on Woollcott's broad shoulders and that I thought it had to try and squeeze an official boost out of Woollcott instead of trusting to his spontaneous enthusiasm. I think this was a kike trick on the part of Knopf, to ensure himself a profitable book. He'll have to take the chance or go without me on his list and apparently to do the latter will not break his heart. [On April 27, Brackett heard from Woollcott that he was providing the requested blurb, while describing the proposed title *Never a Dull Moment* as "cheap and dreadful" and suggesting a change. It was published as *Entirely Surrounded*. The Woollcott quote, inside the front jacket flap, reads: "I have read with mixed emotions this delicately murderous account of life on a Devil's Island in New England and fear it may be only because I have rhinoceros blood in my veins that I was able to find it so richly and continuously entertaining. In its behalf, my hat, already off in a gesture of homage to the skill of the author, is hereby formally thrown in the air."]

[On May 5, Brackett "motored" with Otto K. Liveright to Newark Airport, and arrived in Los Angeles the following day.]

May 7: To the [Paramount] studio about 10 o'clock, where I saw [producer] Merritt Hulburd, and met [screenwriter] Keene Thompson and Mr. [Frank] Partos, an Hungarian, who are working on the treatment of *Her Master's Voice*,[8] for which I am supposed to do dialogue. Due to an unfortunate cast they have turned it into a foolish story about improbable people and I dread beginning the task.

David Lewis and I dined at Vendome.[9] David is very prosperous, quite a bit heavier, and was rather careful to emphasize various unsuccessful aspects of my last year and a half. It was not a very pleasant evening, though I enjoyed the spectacle of his success.

May 10: Luncheon with Beatrice and Don Stewart—amused to find Don very acid about [John] Mosher, whom I regard as a far superior though in-

8. Unidentified film.
9. Popular restaurant on Sunset Boulevard in West Hollywood.

finitely less famous wit. . . . Story conference with Mr. [B. P.] Schulberg, of whose conquering charm everyone has spoken. He is a red-faced, pop-eyed Jew who says a play can't be very good because the cinema rights were sold for $11,000 . . . [ellipses in original]

May 20: . . . In the evening I went to *The House of Rothschild* at Sid Grauman's Chinese Theatre and was particularly impressed by the unearthly softness of the carpets. Excellent picture, incidentally.

May 25: A dreary day of waiting at the studio, though members of the Story Dept. assured me that the script was liked. . . . I was leaving at 5 o'clock when I was told to go to Arthur Hornblow's office. He wished me to read the script for *Pursuit of Happiness*,[10] with a view to doing some work on it. I thought it rather ironic. I was reading when David Lewis asked me to dinner at the house he shares with Jimmy Whale. I was enormously amused by Jimmy's anecdotes of Mrs. Pat Campbell who is working in his current picture [*One More River*] "I look like a burst paper bag." [To leading lady Diana Wynyard:] "Oh, my dear, you aren't going to play opposite that lovely young boy? He'll look like your son." "Mr. Whale, you mustn't let her take his hand when she leads him away, it looks as though she were taking him to the bathroom." This of young [Frank] Lawton, the leading man. And her comments to [Irving] Thalberg about Norma Shearer in *Riptide*. "You must tell her not to paw her man—ladies don't." "Yes, she looked very pretty, and such little eyes."

May 26: A conversation with Arthur Hornblow about *Pursuit of Happiness* which resulted in his request that I do a couple of scenes for him over Sunday. I find Hornblow as little simpatico as [playwright and producer] Lawrence Langner, though he is more intelligent. He is even more pompous.

May 28: Read my work on *Pursuit* to Arthur Hornblow, who wanted it funnier and less dramatic. . . .

10. Released September 1934, based on the 1933 play by Lawrence Langner and Armina Marshall, and directed by Alexander Hall; Brackett's actual contribution to the film as released is unknown.

June 5: . . . I dined with Dave Lewis. James Whale had some additional Mrs. Pat anecdotes but not quite so good. A great chandelier was being lowered over the set and she screamed to the men, "Don't drop it! Don't! I couldn't end like that, under glass!"

[On July 7, Brackett moved into a rental home at 241 Copa de Oro Road. On July 9, he gave his first dinner party there for Ruth Chatterton,[11] Mady Christians, Marc Connelly, and others. The next day, he entertained James Whale and David Lewis, and afterwards they played the new popular game in Hollywood, ping-pong.]

August 2:....Elizabeth [who had arrived on July 14] and I dined with David Lewis and Jimmy Whale, the other guests being R. C. Sherriff and his mother, who were entrancing, and Charles Laughton and his wife. Laughton is the most repellant human being with whom I have ever had to share a table and the most incredible self-caricatured ham.

Whale said, "I'd like to have seen your Macbeth. You should be the greatest Macbeth in the world." "Oh, I will be," Laughton replied in his voice like putrid custard, "but I wasn't at the Old Vic. I was tired—tired." Elsa Lanchester, his wife, wasn't much either.

August 3: . . . There is a little mix-up as to who should work with me. I want Frank Partos. Whether I get him or not has become the subject of dreadful studio intrigue.

August 19: . . . Rosalie Stewart[12] informed me this evening that Paramount has offered me six months at $750 and six months at $800 and that she refused. . . .

11. Ruth Chatterton (1892–1961), somewhat melodramatic leading lady of stage and screen—in Hollywood from 1928—who was also an early aviatrix.
12. Rosalie Stewart (1890–1971), major Hollywood literary agent, who came to Hollywood in 1932 to head story department at RKO; according to her obituary in *Variety*, she is responsible for Paramount's teaming Brackett and Wilder.

August 21 – September 8: Two frenzied weeks of work on *Red Woman*[13] resulted in a first script Frank Partos and I liked, but it didn't really please [B. P.] Schulberg . . . or the director. Three days of gigantic conferences instructed us how to write it and we had three days for the task. The result was a horror which nobody liked and we were thrown off the story in favor of Grover Jones and Vincent Lawrence. Lawrence arrived to take up out burden, dead drunk, charming, and full of ideas which sounded good at first but which on analysis of our story I thought afterwards wouldn't fit it. I was chagrinned and humiliated by the dismissing conference which took place on Labor Day, and Frank Partos came home to dinner and put on an act of such superb, comforting jauntiness that Elizabeth and I were almost in tears. . . .

Dotty and Alan Campbell arrived here three days ago, Dotty looking very pretty and almost as young as Alan and seeming gay.

In this interval we as a family were turned down for the Bel Air Bay Club because we were connected with the movies. . . . The Fred Astaires were excluded at the same time, to Fred's bitter shame, I understand. . . .

September 11: A day of sterile conferences on *Win or Lose*.[14] At the end of it Frank Partos, who has always hated the story, was taken off, to his great delight, and Louise Long,[15] an old silent-picture girl, was put on in his place. I think I like her. . . .

September 12: A conference with Louise Long this morning, mostly her life story and very interesting details of her knowledge of circuses. She is a little like Adela Rogers St. Johns but not so exaggerated. One might say she is

13. Released as *Behold My Wife!*, December 1934, directed by Mitchell Leisen and starring Sylvia Sidney; Brackett and Partos did not receive screen credit.
14. Released March 1935 as *Love in Bloom*, directed by Elliott Nugent and starring George Burns and Gracie Allen; neither Brackett nor Long received screen credit.
15. Louise Long (1886–1966). Active from the mid-1920s through the mid-1940s, with major credits at Paramount in the 1920s, including continuity for *Interference* (1929), the studio's first talkie, and often collaborating on scripts and novels with Ethel Doherty. Long tried to persuade Brackett to hire her as his assistant in 1945, and the two remained constant friends through into the 1960s.

the truth about Adela. . . . Frank Partos and I got our checks, went to the bank and lunched downtown, and I signed my year's contract and handed it to the Legal Dept. . . .

September 17: First day of my new contract and I began by getting the contract itself from the Legal Dept. I have been incredulous of it until it was in my own hands, and still am a little. Also went Hollywood to the extent of signing a contract for a Packard limousine.

October 23: Times too busy with writing to bother with a journal. This evening I have been to a preview of *Enter Madame!*,[16] a very disappointing experience. It seemed to me that the script had been chopped to bits and that the direction of my dear Elliott Nugent was slow. Elissa Landi gave a radiant performance. . . .

[There are no further diary entries for the remainder of 1934.]

16. Brackett had been working on *Enter Madame!* since June; it was released November 1934.

1935

January 31 [the first entry of the year]: A long pause, caused by many things, eventfulness not among them. *Win or Lose* went on for a few weeks. Louise Long was a dear creature to work with, but uncritical, admiring. Then there was a sudden announcement that we weren't going in the story direction expected. The project was pulled out from under us with one quick jerk. Louise had a horror of having an uncompleted script on her record. By working literally one whole night, we turned in a complete draft. We might as well not have done so.

Next I was teamed with Frank Partos on *Terror by Night*,[1] an interesting enough, small horror picture. We turned in a competent job and had fun doing so. The Front Office was not impressed, though the picture is to be shot.

I was then summoned by the great C. B. DeMille. He was about to start *The Crusades*. "Mr. Brackett," he said formally, "I need a scene in this script written with the brilliance of Noel Coward or of Oscar Wilde. Here is the situation."

After I turned in the required five pages, I was summoned to The Presence again. "Mr. Brackett, you have given me exactly what I needed. My deepest thanks."

The scene, I regret to say, didn't rate more than a snort of disdain.

I was next given a patchwork job on *People Will Talk*,[2] for Charles Ruggles and Mary Boland. This got no praise from anyone.

1. No Paramount film of that title was released.
2. Released May 1935 and directed by Alfred Santell; Charles Brackett receives no screen credit.

I found myself in an agony of thinking that I was neither funny nor competent. I'd take long walks at night, trying to Coué[3] my self-confidence back. "No one writes better dialogue than you. No one has a better sense of construction." I hope no one heard me as I murmured these endeavors to the soft air of Bel Air. Finally I reached the comforting conclusion that nothing but the absolutely commonplace pleases Paramount. Oh well, maybe now and then something with a kind of high school foolishness about it . . . [ellipses in original]

Elizabeth has been consistently ill all winter, frequently in the hospital and, according to Sam Hirshfeld, her doctor and now a close friend, at times dangerously ill. . . .

[There are no further diary entries until July 2.]

July 2: I feel the need of this diary again. During the months that have passed, I have been through all sorts of experiences that I wish were caught in it.

My poor Elizabeth is East with a bad nervous breakdown. I myself have felt that I'm on the point of having one several times when work went badly. . . .

I have sold the house in which I was born [in Saratoga Springs, New York]. . . . In selling the property I've also cut myself off from a refuge against the conflicts of maturity. . . .

One of the things I most regret about the hiatus between this and the last section of my diary is the day-by-day account of Marc's [Connelly] misery. There were rumors afloat in the gossip columns, in the air, that Madeline had fallen in love with Marc's best friend, Bob Sherwood.[4] Marc hated the thought so much he refused to think about it. He denied every such implication explicitly. He took a house on Stone Canyon Road, explaining that it

3. A form of autosuggestion based on a system introduced by Émile Coué (1857–1926).
4. Robert E. Sherwood (1896–1955), four times Pulitzer Prize–winning playwright and screenwriter; member of the Algonquin Round Table; from 1935 until his death, he was married to the former Madeline Connelly (silent screen actress Madeline Hurlock, 1899–1989).

mustn't be too small, as Madeleine was joining him later. It was the current joke that Marc didn't know which he missed most, losing his wife or his best friend. Marc's attitude was, "What was that nonsensical and malicious rumor about Madeline?"[5]

Then one Sunday in the headlines we learned that not only had the divorce gone through, but that Madeleine had married Bob . . . [ellipses in original]

Marc came to luncheon with the girls and me at the Copa de Oro house that day. And never, never in the course of our long friendship have I seen him as charming, as whimsical, as funny. Dammit, why didn't I make some record of his conversation at that time? . . .

[The balance of the diary from 1935 is recorded as "lost, strayed or stolen—probably unwritten."]

5. Marc Connelly and the former Madeline Hurlock were married from 1930 to 1935.

1936

January 1 [Providence, Rhode Island]: Gerald Murphy[1] once told Monty Woolley about an Irish custom for beginning the New Year: One jumps into it, holding gold. Undeterred by the fact that the Murphys have had some years of unparalleled misfortune, we follow the custom we got from them.

As midnight approached, each of us clutched gold and perched ourselves on a piece of furniture in the refurbished library and waited. . . . It was 1936 and time for me to take my train to Hollywood and another bout with The Cinema. . . .

I've been having an 8-week layoff which I meant to devote to writing a play the Lunts asked me to write for them, a play about a pair of glamorous adventurers in early Saratoga. The six weeks have evaporated with nothing to show for them. . . .

[Early on that morning, Brackett takes the train to New York, where he stays at the University Club.]

January 2: Edna Ferber, Dottie [Parker] and Alan [Campbell] had luncheon with me at 21. Telephoning from there I learned that the plane wasn't taking off for Los Angeles today, and switched my reservation to the 20th

1. Gerald Murphy (1888–1964), wealthy American whose family owned the Mark Cross Company and who was a close friend to Cole Porter and Monty Woolley; he and his wife, Sara, lived on the French Riviera where they entertained such American acquaintances as F. Scott and Zelda Fitzgerald, Dorothy Parker, Ernest Hemingway, and others.

Century and the Chief.[2] Edna Ferber was being unhappy. Her new apartment (once occupied by Ivan Kreuger)[3] is proving a bad luck place. I myself believe in the luck that attaches to certain places and certain objects, to a point that would qualify me for a lunatic asylum. She couldn't have found a more sympathetic ear. . . Dottie looked dubious. Alan said sensibly, "If you believe it's unlucky, the harm is done."

. . . At luncheon there was a good deal of discussion of Clifford Odets. He dined at Edna's with Dottie and Alan the other night, having warned Edna that he could not come if it were necessary that he wear dinner clothes. We all felt that this was absurd, as a proletarian gesture, since the proletariat invariably dresses to the nines within the limits of its financial power. Dos Passos has the same absurd pose.

I boarded the 20th Century with Woollcott's Reader for company. (I omitted to say that Woollcott had sent that college picture of me as a leading lady [which he also sent to Alice Duer Miller] to Neysa for Christmas. His object, during this season of good will, seems to have been to undermine me with women.)

What I should be doing, instead of writing on this diary, is to work on the Lunt-Fontanne play.

[The train and Brackett arrived in Pasadena, California, on January 5, at 2:30 p.m.]

January 6: Called at the office of the head of the Story Dept. to learn that there is no assignment for me, won't be for a couple of days. But am I under salary, my incredulous nerves cry. I don't ask the question.

Dropped in at the Vendome, to finish a luncheon Essie Borden was having with Constance Collier. Constance thought I was looking better for my trip.

2. Two of the best-known trains of the day; the 20th Century ran between Grand Central Terminal, New York, and LaSalle Street Station, Chicago, and the Chief between Dearborn Station, Chicago, and Los Angeles.
3. Ivan Kreuger (1880–1932), known as "The Match King," whose financial empire was built upon a Ponzi scheme.

"What happens to us out here, Charlie? In the East we used to be people going about with people. Not out here. We've become people in aspic." ...

January 7: A hideous day. All my leave of absence has been haunted by a dread of the reviews of *Rose of the Rancho*.[4] Today *The Hollywood Reporter* carried a sullenly disagreeable one. It ignored entirely the fact that Gladys Swarthout, the star, is a warmly lovely girl with an exquisite voice. I am one of the eight writers listed on the horror—the last. . . . All the composure and perspective I acquired in the East collapsed like foam. Though basically in agreement with the reviews, I resent them hotly. May God give me strength never to accept a really silly project again.

January 8: Lunched with Ruth Chatterton. She looked miraculously smart in Persian lamb and a suit with a lot of braid on it. It was at the Vendome. She talked about her airplane, her consuming passion at the moment. Recently flying to San Francisco she got about a hundred and fifty miles beyond it, due to false directions. "I'm accustomed to more competent direction than that," she said.

Dined at Cole Porter's. They and Sturge[5] have taken the [Richard] Barthelmess house on Sunset—a large Elizabethan structure in a grove of eucalyptus trees.

When the Barthelmesses bought it was a gloom of dark paneling and stuffy in the extreme. They painted everything dead white and, with comfortable overstuffed furniture, good-looking flowery linens and quantities of *blancs de Chine*, the effect is charming.

I arrived at 8 o'clock, too early, and Sturge showed me about, particularly proud of a sort of herbaceous border of potted plants which he and Mrs. Porter have arranged on two kitchen tables painted dark green, and very

4. *Rose of the Rancho* was in production at Paramount from late June through October 1935. The film is directed by Marion Gering, stars John Boles and Gladys Swarthout, and is the first on which Brackett receives screen credit, along with Frank Partos, Arthur Sheekman, Nat Perrin, Harlan Thompson, and Brian Hooker. Brackett makes no reference to *Rose of the Rancho* in the surviving 1935 diaries.
5. Howard Sturges (1884–1955), wealthy bachelor known as "Sturge," and Cole Porter's closest friend. On his death, Brackett wrote to Alan Campbell, "just like a man who knew how to leave a party—with grace, never to loiter and chat at the door.

smart.... The dinner was for the James Hiltons; Frances Marion (with whom they are staying), Ethel Borden and I were the only other guests. Mrs. Porter, laid up with a cold, didn't come down.... Hilton ... is a small man whom one would cast as an absconding bank clerk. His face is incredibly crooked (physically crooked, not morally)—his nose is set on the bias, his eyes not quite balanced, his teeth (the usual bad English teeth) are set without regularity. He has a pleasant, squealing laugh and glows with the success that has come to him, largely through Woollcott's worship of *Goodbye, Mr. Chips*. . . . Mrs. Hilton, next to whom I sat at table, told me that he wrote four bad novels of the kind he thought would sell, then, to please himself, *And Now Goodbye*. It got little notice. He followed it with *Lost Horizon*, also not much noticed, then came *Goodbye, Mr. Chips*, which sent a spotlight of appreciation over the two earlier novels.... When I praised Mrs. Hilton's gift for appraising her husband's work, she simply and convincingly said, "Yes, I think I am a good critic.". . .

January 11: The death of John Gilbert[6] wasn't on the front page of *The Hollywood Reporter*. One could imagine his wild-eyed ghost dashing about in insubstantial fury. Last Autumn I went to a party which included him and Marlene Dietrich, his last love. I sat between Marlene and Essie [Borden], who talked to each other constantly during the play. Gilbert, his nerves on edge with drink, pretended to be angry at their ill manners towards the play and their neighbors. As a matter of fact, it was his reputation as a great lover which made him so angry. That he had to sit neglected was a bitter affront. He and Dietrich had a bitter scene. Otherwise he was a charming, sad-eyed, beaten human being. Already rumors have risen that his death was a suicide. I suppose reporters on the local papers are looking at each other and saying, "Have we missed a bet? Can't we make it a murder?"

January 15: Luncheon at the Trocadero with Ruth Waterbury, the editor of *Photoplay*. . . . Years ago, at a party in New York, I had told her how good I considered her as a motion picture writer. She remembered it and got the idea that maybe I'd write for her magazine.... The luncheon was to have been a business talk, but we postponed business and had a swell time.

6. John Gilbert 1897–1936), major Hollywood star of the 1920s whose career went into decline with the advent of sound; his love affair with Greta Garbo is legendary.

In the afternoon I was told to report to [producer] Lloyd Sheldon and write a brief scene for *13 Hours by Air*.[7]

George [Cukor] had Moss Hart, Susan Fleming and Charlie Lederer for dinner and bridge. I went on to a Screen Writers Guild meeting, feeling as I always do at those meetings, as though I were getting together with the other kids behind the barn to get up a secret club.

January 16: Rose early and wrote a couple of scenes for *13 Hours by Air*, one which I liked; one which I didn't. Took them to the studio and had them typed, then, after luncheon, read the scenes to Lloyd Sheldon, who liked parts of both and wanted them combined. Combined them. . . .

January 17: . . . Committee meeting at Marian Spitzer's to sponsor a lecture on Nazism, a Menace to World Peace by the Earl of Listowel. Wells Root and I had fun getting out a card about the Earl of Listowel and his accomplishments, which are absolutely nothing.

January 20: Went to the studio with the changed scenes I had done for *The Duchess*, to find [Frank] Partos so bored with the whole project that he fought every change, just because it was a change. . . .

. . . A Screen Writers Guild meeting tonight, attended by a committee from the Screen Actors Guild, which is urging us to throw in our lot with them. Problems arose. Strangely enough they concentrated largely on awards to be given should such a combination be achieved . . . Should an annual award for Best Performance, Best Screenplay, etc. be given at all? If given, shouldn't they be presented at the Actors Guild Ball?

The various actors present were playing close to the parts they play on the screen. Bob Montgomery, then President, was playing the brilliant boy shoved suddenly into a position of power and carrying it off splendidly; Ralph Morgan was playing the Christly idealist, speaking with a quietly tremulous voice of "Things very close to my heart"; an English character actor was pleading against awards by saying, "You know, don't you, that it will always be the fat

7. Brackett's earliest recorded connection to Mitchell Leisen, who directed the film, released in March 1938; Brackett has no screen credit.

parts that get the awards?" (He plays bits.) [James] Cagney was merely chuckling and looking in the know.

January 21: . . . Tried to work with Frank Partos, but he is too nervous about an upcoming option to be useful, so I worked at home in bed, accomplishing very little.

Monty Woolley arrived in town and called me from the [Cole] Porters where I went and saw him. He motored across the country and is glowing from the trip. Sturge has found a small house for him here. Cole says there was a time when he could sleep in the same room with Monty (who has an abominable snore), then a time that he could sleep on the same floor. Now he can't sleep in the same house!

January 22: Got the tickets for the Listowel lecture, which I am supposed to vend. . . . The second person I attempted was Oscar Hammerstein II, who thought that Semites shouldn't agitate against Nazism too openly.

January 27: . . . Tonight I went alone to a theatre in Glendale for a preview of *Woman Trip*,[8] on which I get original story credit. I believe I'm honest in saying the picture lost point after point which the scenario made. An amusing relationship was left perfectly flat, possibly due to the fact that poor, big-faced Gertrude Michael[9] played a heroine who should have had charm and chic. . . . My Paramount blues are heavy on my head tonight.

January 28: . . . At the studio glum Frank Partos announced that we were . . . assigned to a Harold Hurley picture, a little gem called [*The*] *Sky Parade*.[10] Harold Hurley is "The Keeper of the B's" at Paramount, a small, violent man, given to shouting obscene curses in a rather high voice. He talked to us for about five minutes, mentioning scenes which were to be rewritten into a picture we hadn't yet seen. The rough cut was then run for us in a projection

8. Released February 1936.
9. Gertrude Michael (1911–1964), American actress of stage and screen, perhaps best remembered today for singing "Sweet Marijuana" in *Murder at the Vanities* (1934).
10. Released April 1936; Brackett does not receive screen credit.

room. How human ingenuity can sew it together in the two days allotted to us, I don't know, but it will be rather fun to try.

January 30: Did two scenes for *Sky Parade* and was in the barber shop when a summons came to report to Harold Hurley immediately. It was to ask for an extra scene so banal that the stomach balked at the thought of it. However, being professionals, we rolled up our sleeves. An hour late, trying passionately to compose a right speech, Frank Partos looked at me and uttered these words, "If my government fails to get control of this automatic pilot . . . it may mean the end" [ellipses in original].

My lips twitched. "Don't laugh," Frank pleaded. "Don't laugh." Then we both laughed till tears rolled down our cheeks. Finally we turned out a not-too-pungent scene. . . .

[On January 31, Brackett and Frank Partos are assigned to write the script for a new adaptation of Booth Tarkington's 1915 novel, *The Turmoil*, which had been filmed in 1924, for producer Albert Lewis. The diaries contain considerable discussion on the script, but, ultimately, on April 7, Paramount decided not to proceed with the project.]

February 3: . . . That evening I went to an Anti-Nazi meeting at Dottie Parker's. . . . After it Moss Hart came back to the house with me and talked for about an hour, not about Anti-Nazism. He'd just read *Entirely Surrounded*. "I didn't realize what good material Woollcott is," he said. [Bracket adds a note later: It was several years before Moss and George Kaufman proved to me what dramatic material Woollcott was.][11]

February 10: Dined with Syd and Laura Perelman, before [the Earl of] Listowel's lecture. . . . The lecture was a resounding failure. The audience had wanted rousing statements about Germany. They'd wanted to hear about children being tortured, about a violinist's hands beaten to pulp by Stormtroopers. Mild statements in Listowel's cultured voice gave that audience,

11. With the 1939 play, *The Man Who Came to Dinner*.

largely Jewish, the impression that things in Germany were far better than they thought. "Even more shocking," said the Earl, "is the fact that female attendance in the coeducational colleges has been very considerably lowered."

February 12: Small meeting of the SWG which gave forth gossip to the effect that Paramount was in such financial straits that production might have to be stopped, and that Louis B. Mayer is out at Metro.

February 15: At the studio, Frank in a frenzy of creation. . . . My usual Saturday luncheon with Monty, who was very entertaining on the subject of Elsa Maxwell out here. Elsa, who can be the surprising life of the party when the party consists of the rich and sheltered. Out here the presence of the professional glamor people makes her dim and assertive. . . .

February 17: . . . Dined with Mercedes de Acosta. The guests were Ruth Chatterton, Auriol Lee,[12] Marlene Dietrich, Clifton Webb, Rowly Leigh [screenwriter Rowland Leigh?] and [costume designer] Adrian. The superb Dietrich looked emaciated, nerve-wracked and lovely. She lays it all to the death of John Gilbert, says she has been taking morphine for two weeks. When she wasn't the center of conversation, she slipped from the house to breathe the night air and recover from a smothering attack. Dottie Parker had remarked of Marlene that she was acting "like a wounded nun," so I was not unprepared. . . . She had with her an outline of the story, *I Loved a Story*, which has been submitted to her in an effort to continue that picture of which $900,000 has already been spent. Clifton read part of it aloud. This treatment and the whole history of the picture makes one shudder for Paramount's stockholders. Not one really good scene for the heroine was indicated in the treatment. . . . I feel better about *The Turmoil*. . . .

February 24: Dined with Mercedes de Acosta, a party for Janet Flanner[13] who writes for *The New Yorker* under the name of Genet. I've met her but

12. Auriol Lee (1880–1941), British-born actress who became Broadway actress, producer, and director.
13. Janet Flanner (1892–1978), American writer and journalist who wrote in Paris for *The New Yorker* as "Genet" from 1925 onwards.

once, but as she and [Brackett's wife] Elizabeth grew up in Indianapolis together, I feel as though she were an intimate friend. Peter Sterne, Dottie [Dorothy Parker] and Alan [Campbell], John O'Hara and Adrian were the other guests. A great deal of talk about animals after dinner, among others the animal stars of *Sequoia*.[14] Somebody wondered what they were doing now. "Calling up their agents in a fury," Dottie suggested.

March 4: Dined at the Brown Derby with the Harlan Thompsons and proceeded to a pay party at Dottie and Alan's, the proceeds to go to the Scottsboro Case fund. There was an admixture of blacks at the gathering, Bill Robinson, the tap dancer, the most prominent of them. Stayed till about 11:00, then walked home, enjoying the walk more than the mass of people at the party—not the Negroes, but the bleeding-heart Whites. They wear me down.

March 7: . . . Dottie and Alan have acquired a Picasso. It is one of a collection Stanley Rose, the bookseller, showed. I saw it at his place, thinking it and other Picassos singularly ugly. I never really noticed it on the Campbells' mantelpiece till they gestured to it proudly. It led Thornton [Wilder], who has been seeing Picasso, to quote something he said about the wife he is divorcing or has divorced, "When I beat her even her screams were artificial." Thornton also quoted Gertrude Stein—her explanation of a line which is apparently nonsense, "A rose is a rose is a rose." She claims that poetry was in its beginnings the worship of the noun. In those days a poet could mention a noun and achieve clear beauty. That innocent day is past. Miss Stein claims that when she wrote "A rose is a rose is a rose," for the first time in three hundred years a rose really smelled like a rose on the printed page.

March 30: Wrote at the studio all day. Dined with Eddie Knopf, Irving Berlin and [George] Oppenheimer at the Brown Derby. Discussed one subject: James Kevin McGuinness and the Screen Writers Guild. Went on to a Guild meeting. Subject for four hours: J. K. McGuinness, John Lee Mahin, and the treachery of a telegram they and two associates had written to the Guild.

14. Film from 1934, directed by Chester Franklin, and starring Jean Parker as a young girl who raises orphaned deer and mountain lion.

[Brackett adds a postscript to the transcript of the diaries: "Thirty years later, I have no memory of what the telegram was—but a fight was underway. It was between the Guild and a group of writers who called themselves The Screen Playwrights. The latter were mostly Metro writers who had been developed under the protective wing of Irving Thalberg. The Writers Guild took the respectable union position of wanting to bargain with the studios on equal terms; the Screen Playwrights were, in a vocabulary entirely strange to me, a company union. It was offered all kinds of concessions, but they were concessions, not replies to demands."]

March 31: Worked all day, not very brilliantly. Went to a hurried Guild meeting at 5 o'clock which lasted for 2 hours, and arrived at a conclusion about the action to be taken on the famous telegram. It was the conclusion I had advocated from the first: not to do anything. . . .

April 7: . . . Learned from Georgie Opp[enheimer] that I am to be borrowed by Metro to do *Piccadilly Jim*—pleased but scared.

April 10: Had the rumor of my going to Metro confirmed by Manny Wolfe. I go Tuesday. This leaves Frank and me so crowded with work which must be done that we could do scarcely anything.

A Screen Writers Guild dinner preparatory to the Big Amalgamation. Many speeches, a foolish one by Marc Connelly about screen writers getting what they write on the screen, not changed without the writer's permission in fact. Realistic contributions by others.

April 13: . . . I went to the studio and worked until noon, when Essie [Borden] brought her great friend, Mrs. Vincent Astor, to have luncheon in the commissary and see the studio. She is a charming, rather grave person, and confessed that when last in a studio she was watching a scene and saw a piece of burning paper thrown on the face of a recumbent actor. She rushed in and snatched it away before it could burn him and then realized that she had ruined a difficult take. . . .

April 14: Went to Metro at 10:00, feeling like a boy about to enter a new school. I was waiting to be admitted by the doorman when Jack Morgan entered and took me under his wing. I reported to Eddie Knopf's office, was given a cell and conducted to the office of Bob [Robert Z.] Leonard, the director. He is a big, red-blonde man who seems to expect me to know more about the scenarios which have been written than I do. One is by Sam Hoffenstein, one by Eddie Knopf. Returned to my office to brief them both.

Lunched at the writers' table, between Georgie Opp[enheimer] and Herman Mank[iewicz]. It's the custom for each person there to throw dice to see who shall pay for all the luncheons. As a new boy I wasn't allowed to do so. . . . Went back to my dank office, which overlooks a cement alley. There is no couch, so I napped in the one easy chair, feeling rather homesick for Paramount. When I woke I resumed work on my "briefing."

April 15: Interminable conference with Bob Leonard, my enthusiasm for the story ebbing with every second—at it all morning. . . . About 2 hours of conference in the afternoon, of which I made a dreary outline. . . . Eddie Knopf asked me in a worried tone whether I thought *Piccadilly Jim* was my dish as a story. I answered truthfully, "You know, one always hates a story the first few days." . . .

April 16: Began a session with Bob Leonard at about 11 o'clock, he having been kept up by post premiere [of his last film, *The Great Ziegfeld*] activities until 5 A.M. Talked with him until 1 o'clock, and from 2 until 5 o'clock. He was exhausted, dozing off a couple of times, but constructive. I wasn't bad myself.

April 17: Had luncheon at the table and lost the throw of the dice, so I'm now an accepted Metro writer.

April 18: Consultation with Leonard from 10 to 1. Luncheon at the writers' table. With Leonard until about 3, then had to type my version of the story and read it to Leonard, who wants it put into shape to read to [Eddie] Mannix by 2 o'clock tomorrow. These are people who intend to get this picture

made. Incidentally, I begin to like Bob Leonard enormously.... Worked until 2 in the morning.

April 19: ... went to the studio and proofread and corrected our treatment. Was told that Mr. Leonard would see Mannix and start in with me right after luncheon.

Lunched in the commissary with Clark Gable, Howard Emmett Rogers and Tod Browning (the last named a real stinker, it seemed to me). Waited until about 4:00 when Leonard telephoned me to strike out alone....

April 21: Read the scene I did yesterday to Bob Leonard. He was pleased with it and we conferred about the next few episodes. I went to Research to get a Shakespearian quotation we need. Was amused at a conversation between the head of Research and some writer about names. It seems it's so dangerous to give a name to a gangster (the liability of a suit is so great) that they use the names of employees in the Research Department over and over....

April 22: Went to see *The Great Ziegfeld*, a long, pretentious overloaded picture. Glossy but dull. I am glad *Piccadilly Jim* has no sad intervals. I thought the pathos of *Ziegfeld* pretty bathetic.

April 25: ... Dined with Jimmy Whale and David Lewis. Mady Christians,[15] Junior Laemmle,[16] Francine Larrimore[17] and Billie Burke[18] were the other guests. Billie Burke was entrancing about *The Great Ziegfeld*,[19] in which

15. Mady Christians (1892–1951), Austrian-born actress of stage and screen; she played leading role in *I Remember Mama* on Broadway in 1944.
16. Carl Laemmle, Jr. (1908–1979), known as Junior Laemmle, son of founder of Universal Pictures, often ridiculed but responsible for production of studio's greatest successes from late 1920s through 1936.
17. Francine Larrimore (1898–1975), French-born actress of stage and screen.
18. Billie Burke (1884–1970), actress of stage and screen, best remembered for her role as Glinda, the Good Witch, in *The Wizard of Oz* (1939); married to Florence Ziegfeld from 1914 to his death in 1932, at which time she accepted responsibility for his substantial debts.
19. Opened in Los Angeles March 1936, with William Powell in title role.

she was depicted very noble [*sic*] by Myrna Loy. "If that old buzzard had been as sensible as that," she said of Ziegfeld, "I might not be as broke as I am today." After dinner we went to the premiere of *Show Boat*,[20] directed by Jimmy Whale, and as good a musical picture as I ever saw.

April 27: . . . Went to an Authors Guild Council Meeting which old Rupert Hughes electrified by suddenly inveigling against the Guild's order not to make contracts after 1938. It's probable the old fool will be in his quiet grave by that time. . . .

April 28: I am going too fast on my *Piccadilly Jim* stuff, trying to do so, at least, turning in inferior stuff. Saw Bob Leonard for only a moment. I'd suggested Cora Witherspoon for a role in the picture. He was running *The Scoundrel* and needed me to identify her. (P.S. She got the job.)

April 29: The Guild mess reached new heights with [James] McGuinness et al completely reversing their pledged attitude. At my last SWG board meeting learned that the New York half of the League Council had turned down our proposition amending the constitution. The board was in a state of deep funk, when McGuinness, [Walter] Wanger, Pat McNutt, Howard Emmett Rogers and Bob Riskin marched in on us with demands which represent about a hundred and twenty high paid and panic-stricken writers. Their demands weren't unreasonable, and were accepted. It was agreed that McGuinness, Riskin and McNutt should be on the new board. Wish I trusted the first and last of the three more than I do. . . . The meeting adjourned at 2 in the morning. I staggered home and reported to George [Oppenheimer] that the aristocrats of the Screen had won. . . . The experience of being on the board was foreign to my nature, but it has been interesting. I trust I'll have sense enough never to get involved in anything like it again.

May 2: Met David (Cassandra) Lewis on the lot. He spoke darkly about the seriousness of the producers' intention to break up the Guild and to discipline writers involved in the fight. . . . Had a conference with Bob Leonard.

20. Released May 1936; James Whale's last major success.

There was a meeting at the Thalberg Bungalow to which I was not asked. Thalberg broke down when he talked of the writers' ingratitude. There was a general membership meeting of the whole Guild at 8 o'clock. I got a last-minute summons to appear at 7:51. The board was deciding on a phrase which should specify that the no-contract-signing clause should be in until the Guild had an opportunity to have an understanding with the producers on the basic agreement. When McGuinness was consulted, he said, with a glum face, "Give me time to think about this—I've been wrong about every-thing so far." What he meant, I'm sure, was: give me time to consult the pro-ducers as to what they want in this matter. . . . He had insisted on having 20 policemen at the meeting. I believe four sufficed Standard Oil under similar circumstances. It's clear to me that McGuinness and his group went into the coalition to be in a position to obstruct. They've been defeated by the hon-esty and good faith of the board. . . . Defeated, this group made specifications about the vote of confidence. . . .

May 4: Took my stuff to Bob Leonard, who suggested some revisions, not seeming wildly pleased with my stuff anyway. . . .

Worked on the script all afternoon, handing in my revised version to Bob Leonard at about 5:00. This time he did seem pleased.

Dropped in at the Partoses and found him agitated by the rumor that fifty writers had resigned from the Guild. Called the office and found that three had resigned. This did not include Dore Schary, a man in whom we placed complete resilience. He had resigned to Partos in person.

Came home to find George [Oppenheimer] much agitated. He had had a message from Thalberg via Herman Mankiewicz requesting him to resign from the Guild. He was in despair, saying that he didn't approve of the amal-gamation anyway, as though that had anything to do with whether he should let down his fellow writers. . . . I pointed out that aspect. I'm afraid he's going to let them down anyway. . . . I'm disappointed in him, though I sympathize with his financial problem—family to support, etc.

May 5: . . . A membership meeting of the Guild which whittled down the rumor of fifty resignations to thirty. An emergency Guild board meeting at Samson Raphaelson's at which we were read a lousy letter of resignation from

the Guild by McGuinness, McNutt and Kalmar. This caused no consternation. I had to leave while the group was in a frenzy of composing replies. . . . George seems not to have resigned as yet.

May 6: Read Jim Cain's *The Postman Always Rings Twice*, getting so interested that it was dawn before I got to sleep. [John] Van Druten wakened me with a telephone call asking me to dinner. . . . Went to the studio wearily, with the scene I'd written before starting Jim's book. Read it to [Robert Z.] Leonard, saying, "Nothing that I read shall be held against me." He liked the scene, laughed at it in fact. I was immediately fresh and awake and put in a busy morning.

After picking up my cheque at Paramount and lunching with Frank, returned to MGM for another conference with Bob and wrote on the scene we discussed until 1 o'clock. . . .

May 7: . . . Took some stuff to Bob Leonard and conferred with him until 5:30. Was to dine with Dottie and Alan but got word to meet them at Wells Root's, where they were to be for a short time. There I found a disorganized, panic-stricken meeting of the Guild board in session. Listened to an account by Allen Rivkin of having been put on the carpet by Zanuck, and was moved by it. The boys' none-too-steady nerves had been shaken by threats of a blacklist for the past week.

At 1 o'clock I rose and addressed the meeting myself, saying "I haven't any business to speak, but here's my advice. Rescind Article XXI tonight, relieving the pressure on our membership. Do nothing else. Keep the California Corporation. Wait for the reaction against the terror. It will set in in about three weeks. Then start the Authors' League business." Having nothing else to say, I left.

May 8: Brief conference with Bob in the morning and another conference with Maurine Watkins[21] about the Guild. She said her views were so extreme she'd hesitate to mention them if she were a member of the Guild. I assured

21. Maurine Watkins (1896–1969), playwright and screenwriter whose most famous and enduring work is *Chicago*.

her of our liberality. She told me that among the matters she'd hesitate to mention were the fact that she was a rabid Nazi and Jew-hater. I thereupon agreed that it was better for her not to join the Guild.

May 10: A luncheon party at the Freddie Marches'. . . . The Marches approve of my SWG attitude. In fact, my invitation seemed to be a reward for it. They love lost causes. I found myself acting as though I were wearing a threadbare gray coat with an empty sleeve.

May 12: . . . Dined at the Freddie Marches'. Sat with Constance Collier and Sam Hoffenstein,[22] enchanted as always by Sam's capricious wit. Gloria Swanson was there and I was astounded by her cleverness at the game of scrabble she joined.

May 17: . . . went to the Brown Derby for dinner. I joined Jimmy Whale and David Lewis, and my mention of the Guild started David roaring and screaming so loudly that both Jimmy and I were embarrassed for him. I'd forgotten that he would regard any favorable reference to the Guild as an insult to Irving Thalberg, his idol.

May 21: Typed at the studio and had a long conference with B.L. [Robert Z. Leonard] Lunched at the writers' table (losing the dice throw) and had to buy luncheon for Herman Mankiewicz and other Guild haters, Mankiewicz proclaiming, "And if they form another club and I'll get five dollars more a week if I join it, I'll join it."

Went downtown to a meeting of an Anti-Nazi committee, headed by Herbert Biberman. I objected to various connections of their's as communist, etc. Went to a meeting at Dottie and Alan's to report the meeting downtown. Found their committee an utterly disorganized group without plans, without direction, impelled by an admirable veteran author to do something against a great current wrong. Left the meeting early, utterly out of sorts with misty-eyed bleeding hearts.

22. Samuel Hoffenstein (1890–1947), Russian-born screenwriter.

May 22: . . . Finished reading the completed script [*Piccadilly Jim*]. It seems to me incredibly dull, utterly without body or sparkle.

May 26: Worked over the last half of the script at home, writing thru the lunch hour, and stopping at a drive-in place for a sandwich on my way to the studio. Had a pleasant conference with Bob L. Dictated all the changes we'd agreed on to a boy from the Script Dept. The boy told me it was the best script in the department, which pleased me immeasurably, though I have always found praise from typists ominous. . . .

May 27: After a movie tonight I stopped at Bali to have a look at Bruz Fletcher,[23] a cousin of Elizabeth's, the son of the rich, rich cousin (Stoughton Fletcher) who ruled Indianapolis. . . . This poor little guy named Bruz Fletcher survives by singing songs at the tawdriest of pansy night clubs. He's a wisp of a creature, too touching to think about.

May 28: Back at Paramount I read a script prepared for Ben Schulberg, Dick Wallace to direct it. I found it very poor. . . . Went to a conference with Schulberg and Dick W. about the script and found it frightening that such a project should be started with two uncertain and incompetent men at the helm.

Dined at Marian Spitzer's, Bob Montgomery was there. He told me he liked *Piccadilly Jim* and that I was to be called back to Metro to do two days' cutting on it. Very pleased, in view of the Paramount situation. . . .

May 29: . . . Had a conference with Bob Leonard and Bob Montgomery which lasted all afternoon. I was amazed at how good Montgomery's suggestions were. . . .

May 31: Came to the Malibu cottage [rental located at 70 Malibu Road] yesterday, writing all afternoon on my rewrite of *Piccadilly Jim*. Wrote all

23. Bruz Fletcher (1906–1941), gay entertainer featured at the Club Bali from 1934 to 1940; his signature tune, "Drunk with Love," became something of a gay anthem.

morning, sitting on the sea side of the cottage. I don't find the sea a comfortable neighbor, however. It cries too incessantly of eternity. . . .

June 3: Highly successful conference with the two Bobs [Leonard and Montgomery], who laughed at my scenes. Will audiences? I wonder tremulously.

June 8: A wonderfully pleasant last day at MGM. Conference with the two Bobs, luncheon with John Van Druten and Cora Witherspoon in the commissary—Cora in a haze of excitement at being here, and of gratitude toward me. (Always an agreeable emotion to invoke.)

. . . A profound regret at leaving the little heaven of *Piccadilly Jim* and a deep thankfulness that the script was cut down to 125 pages.

June 10: . . . Went to the studio and started work on *Wedding Present*,[24] driven crazy by the leisurely Paramount methods—by Frank's long telephone calls and early exhaustion, by a long Hungarian visit he had with someone. In fact, I'm homesick for the professionalism of Metro.

Had luncheon at Perino's with Frank. We couldn't go to Lucey's because it's been unearthed that Lucey's doesn't pay its waiters, expecting them to live on their tips. With our new social awareness, none of us can go there in decency, and it's a real privation.

June 18: Conference with [B. P.] Schulberg, who arrived from New York yesterday. He took our sheaf of papers, glanced at the size of it and said, "Not very much," to which I replied, "But all gold." He liked the stuff, and we play along with it.

June 28: . . . in a conference in B. P. Schulberg's office and were discussing a new construction for the end of the story when Mr. Schulberg beckoned Frank [Partos] over and said, "Don't be alarmed—I think I'm going to faint." He proceeded to do so, leaning on his desk and murmuring that he'd

24. Released September 1937 with no screenplay credit.

like some Alkanox. We stretched him on the floor, applied cold compresses, rushed about for cushions. He made several jokes. I remember only one. "If anyone calls," he murmured, "tell them I'm out."

In the evening I went to a meeting at Sam Raphaelson's, one of several such meetings, purpose to dissolve the Screen Writers Guild, a California corporation. I signed a slip calling for the dissolution. So did Don Stewart, Dottie Parker, Ernest Pascal, Ralph Block. There was much talk of blacklists.

July 2: A changed Partos, a Partos with a contract, far more interested in the story, more efficient. . . .

July 3: Arrived at the office to find our stuff all copied, and disappointing. I took it over to Dick Wallace and waited while Dick and his two aides read it—with more enthusiasm than it deserved. Meanwhile, Frank went to Schulberg's office with Schulberg's copies. He was gone an unconscionable time. When he returned he shook my hand and congratulated me on being off the picture. Schulberg, it seemed, had wanted to take us off for some time, only when encouraged by Frank did he do so. Despite my sustained loathing of the assignment, I find myself offended at being canned.

July 6: Waited for an interview with Manny Wolfe until 12:00 o'clock, when he ordered us to report to a producer named Lloyd Sheldon. Sheldon is a school-masterish New Englander in his sixties, who has made a great deal of money from pictures. Sparked by his discovery of a girl he thinks will appeal to the American public, he is embarked on a project called *Jungle Queen*.[25] He gave us scripts of it to read.

In the afternoon he asked us to go on location, where they are shooting *Jungle Queen*. There I shook hands with the chimpanzee who has a big role, and met the girl, Dorothy Lamour.

Back at the studio, was called into Wolfe's office and had dangled before us the possibility of working on the next Lubitsch picture, a two-weeks' trial

25. Released in November 1936 as *The Jungle Princess*.

thing which I would have refused had Frank not been so anxious for the chance. I don't really know Lubitsch and he makes me uncomfortable.

July 7: Conference with Lubitsch, in which he told the story of *Angel*[26] brilliantly. Frank and I were not very effectual. ["Years later," Brackett adds this note: "Lubitsch could have made a hell of a picture with *Angel*, had he not run head-on into censorship, which had curious reservations about the basic story situation: a wife who drops in on a brothel to make a little money on a single job, falls in love with the customer, and meets him at her husband's house."]

In the afternoon we were reclaimed by Sheldon. . . .

July 10: A couple of days are missing from these notes because I forgot to buy a diary . . . [ellipses in original] Frank and I were transported by Sheldon to Santa Barbara, where he has built a ranch house, white with yellow shutters and filled with rather distressing French furniture. There we met his wife, a handsome woman, years younger than he. She's typical of certain Hollywood wives: exultant in her husband's possessions and prosperity, glandular, nervous, self-assertive. In the evening we played bridge to the crackle of marital animosities.

On July 10 [same day as previous entry] we are back at the studio, working on the script hard and consistently.

July 11: Found Frank working feverishly at the studio. He had been there since 9:00. We worked all day with the absorption of prisoners digging an escape tunnel. Turned our stuff over to Sheldon about 4:00.

August 4: There's a new preoccupation in town which has taken the place of *Gone with the Wind*: the Mary Astor case. Mary has decided to fight for her child, and her husband has produced her diary, with lurid details of various affairs. . . .

26. Released October 1937.

August 7: On my way home stopped at Georgie O's [Oppenheimer] and found him very smug at having been mentioned in Mary Astor's diary. Moss [Hart] says that volume should be entitled *Stars Fell on Mary Astor*.

August 9: Cora Witherspoon and her companion came to luncheon, Cora being charming and entertaining until she got her food, whereupon she burst into tears and confessed that her option hadn't been picked up by MGM, despite all sorts of praise and promises from everyone. "I'm just crying because I'm so mad," she said, sobbing heartbrokenly.

August 10: Had luncheon with Moss Hart, who told about the state of George Kaufman was in because of being dragged into the Astor case. George is staying with Moss and is having a real breakdown, tears even, which from George must have been appalling. Moss has rented Frances Marion's large, beautiful house and is enjoying it thoroughly. I asked why he didn't buy it. He hasn't the money, he says. He has earned half-a-million dollars in the last few years and because of his extravagances has left about thirty thousand of it. . . .

August 17: Went to the studio prepared to give a grouchy refusal to a proposal to shift me from *Tightwad*[27] to another story. Learned that the other story is *Bluebeard's Eighth Wife*, for Claudette Colbert, Ernst Lubitsch directing. I am to be teamed with Billy Wilder, a young Austrian I've seen about for a year or two and like very much. I accepted the job joyfully.

Frank, not as disappointed as I feared he would be, gets Harlan Ware[28] as a teammate.

Had a few moments conversation with Ernst, who heard about *Piccadilly Jim*, knows Billy's work from Germany, and thinks we might jell as collaborators. . . . After luncheon I read *Bluebeard's Wife* and found it delightful. . . .

27. Brackett had been working with singular lack of enthusiasm on this unidentified film since July 13.
28. Harlan Ware (1902–1967), whose credits at Paramount include *College Holiday* (1936) and *Artists & Models* (1937).

August 18: Worked with Billy Wilder, who paces constantly, has over-extravagant ideas, but is stimulating. He has the blasé quality I have missed sadly in dear Frank Partos. He has humor—a kind of humor that sparks with mine.

[At this point, Charles Brackett adds the following note to the typed transcription of his diary.]

(It's time to examine him as he was then: 32 years old, a slim young fellow with a merry face, particularly the upper half of it, the lower half of his face had other implications. But from his brisk nose up it was the face of a naughty cupid. Born some place in Poland ["half-an-hour from Vienna," he used to say, "by telegraph."] he has been brought up in Vienna and schooled there, the Lycée—which means he had just about the education of a bright American college graduate. He'd gone to Berlin, worked at various things, among others he'd been a dancer for hire at fashionable restaurants. And he'd written an article about his experiences in that capacity. He'd then become a successful screenwriter: *Emil und die Detective* [1931] was a delightful and successful picture he wrote.

Because he was Jewish and had an acute instinct for things that were going to happen, he had slipped out of Germany as Hitler began to rise.

In Paris he had written and directed a picture in which Danielle Darrieux played the lead.[29] One great advantage was his: he had cut the teeth of his mind on motion pictures. He knew the great ones as he knew the classic books. He'd been brought to Hollywood by a German producer and set to work on *Music in the Air*.[30] *Music in the Air* was a real abortion. After it appeared, other writing assignments were not easy to come by.

There was a time when, due to the protective affection of a woman who ran a conservative apartment house on Sunset Boulevard, he was allowed to sleep in the ladies' room, provided he was out by the time the tenants began to appear.

Discouraged and just about to go back to New York, he called his agent to announce his departure. His agent had been trying to get hold of him for days: he'd sold three stories.

29. *Mauvaise Graine/Bad Seed* (1934).
30. Released by Fox December 1934; Billy Wilder has co-screenplay credit on this Joe May–directed musical, starring Gloria Swanson.

This all sounds improbable, but it was the kind of improbability that was built into Billy Wilder. Before we were joined in collaboration, I'd known him as a jaunty young foreigner who worked on the fourth floor at Paramount, where I worked. He had been a collaborator of Don Hartman's.[31] Only one anecdote about him at that period sticks in my mind:

I'd gone to meet somebody with whom I was to have dinner in the Hollywood Brown Derby. While I waited, Billy came in and I asked him to join me for a drink. As we sat together, the swing door was opened on the wintry evening to admit a luminous figure. "Look who's coming in!" I breathed.

Billy gave a cursory glance over his shoulder. "Marlene!" he snorted. "That excites you?" I admitted that it did. "She's old hat for us," he said. "Let me tell you if the waiter were to wheel over a big covered dish with her in it stark naked, I'd say, 'Not interested,' and have him wheel her away."

I was enormously impressed with this world-weary man. It wasn't for years that I came to know that Marlene had been an idol of his, worshipped since he first saw her.)

To get back to my diary . . . [ellipses in original]

Moss Hart had asked me to dine with him and spent the night at his house so that he could read me the play he and Kaufman have been working on. It was a long session. Moss was disappointed because I didn't laugh. I explained that I never laughed at things I heard read aloud—but Moss detected something less than wild admiration beneath my protests. He was right. I loathed the play. It was *You Can't Take It With You*—too funny for me, too contrived. . . .

August 21: Went to Lubitsch at 10 o'clock. As Billy told the eight scenes we had tortured out, I hated them and saw that Lubitsch did too. Then, with lovely patience and enthusiasm, Lubitsch set to work with us and we constructed a new sequence—a simple, strong one.

In the afternoon Billy and I set to work on the first scene, acting out every line, to make sure that it would play. It seemed to go beautifully.

31. Don Hartman (1900–1958) worked with Billy Wilder on *Champagne Waltz* (1937); prolific screenwriter and also producer and director.

September 1: Went to Ernst Lubitsch's at 10 o'clock, eager to hear his comments on our work [which had been delivered to the director the previous day]. He said to me, "I liked it. I like it much better than the average first draft, but I don't think the second sequence is quite right.

Billy arrived a little later, Ernst greeting him without comment on our efforts. There was a look of such anguish in Billy's eyes that I said, "It's all right"—to Billy's intense relief. . . . Ernst then proceeded to lay out almost an entire new and improved second sequence. It wasn't right, however, and we didn't hesitate to tell him so.

Billy and he were both wearing maroon sweat shirts and gray trousers. Both of them are peripatetic thinkers. Ernst's library is an enormous room with an alcove-like angle. The two figures, identical in color, but one square and short, the other tall and slim, paced all over the room. One would have disappeared around the partition while the other was in a near corner. It was a very dreamlike effect. Finally we hammered out a position which I think will work.

September 7: Labor Day, but I met Billy at the studio at 10 o'clock and we put in a hard day's work. He is a hard, conscientious worker, without a very sensitive ear for dialogue, but a beautiful constructionist. He has the passion for the official joke of a second-rate dialogist. He's extremely stubborn, which makes for trying work sessions, but they're stimulating.

September 9: The work on the script went unconscionably slowly because I can't do first-write dialogue working at it two together, and Billy can't stand a line he hasn't worked on. A great bore.

September 11: Worked with Billy, almost driven mad by his niggling passion for changing words without changing the meaning. . . .

September 12: A hysteria of perfecting a speech made by the hero over the telephone kept us busy all day. It's a speech about business, and Lubitsch has decreed that it must be hilarious. . . .

September 13: We were at Ernst Lubitsch's and discussing the second sequence, which Ernst had read without enthusiasm. Vivian [Mrs. Ernst] Lubitsch came in abruptly about 11 o'clock, to say that Irving was dead—Irving Thalberg. It was shocking news, even for one who had known him so slightly as I. After about an hour of exploring our emotions, we resumed our conference . . . We lunched on the patio . . . We tried, unsuccessfully, to sketch a beginning for the third sequence . . . [ellipses in original] We are to go to New York with Ernst a week from today, to work on the script there. . . .

September 19: Lubitsch said to me when we first saw him today, "I made you nervous Monday." As soon as we were alone, Billy shouted indignantly, "For Christ's sake, what is this? He apologizes to you! You and he will be making a baby together before the picture is through!" . . . We tried to write the scene Ernst had ordered but adjourned about noon to pack, etc. . . .

September 21: Got on the train at 9:30 and had breakfast there. Billy joined me. Ernst and Vivian Lubitsch got on at Pasadena. In the afternoon Ernst, Billy and I polished away at the famous scene. . . .

September 23: As we left Chicago I started to write out a sequence around an idea I had, which Billy didn't like. Ernst poked his head into the compartment, said, "Ah—writing," and started to withdraw. I feloniously told him my idea and got his approval. (Treachery to a collaborator?)

I must record Ernst's enchanting leif motif regarding Vivian, the phrase "Always belittling me," spoken in the thickest, merriest voice imaginable.

September 24: So excited by the prospect of getting back to New York that I didn't sleep, and got off the plane exhausted.[32] Dropped in on [John] Mosher, though annoyed about his review of *Piccadilly Jim*, which was sour as a pickle. . . . Lunched at the Algonquin, finding Margalo [Gillmore] there, and seeing Otto Liveright, who looked very old, his hair almost white. . . .

32. It seems that perhaps Brackett is confused and that it is the train from Chicago and not a plane from which he disembarks.

Dined with Mosher, getting more and more annoyed at his lack of interest in *Piccadilly Jim*. I told him that he didn't really live his life, he knitted it, like an afghan.

[From September 26 through October 21, the diary notes work on the script with Wilder and occasional conferences with Lubitsch, punctuated by quick trips to Providence to reunite with Elizabeth.]

October 23: Working with Billy when the telephone rang and gave forth the information (Ernst speaking) that we leave for California on Tuesday—depressing news. . . . Had a farewell luncheon with Margalo, worked all afternoon, or until my daughter Bean arrived from Providence. . . .

October 26: Conference with Lubitsch, who was not exuberant about our stuff. "I don't think that's it, boys." With him from 10:00 till about 5:00, polishing the scenes. As always, he was right.

October 27: About 4 o'clock the Lubitsches, Wilder and I met at the Ambassador and set out for Newark where we climbed on a magnificent Douglas sleeper plane. George O'Brien and his lovely wife Marguerite Churchill were also aboard. It was all very intimate and a superbly comfortable trip—food superior to train food, space entirely comfortable, no hint of air sickness, the atmosphere what it must have been on the stage coaches of a hundred years ago.

October 29: Worked in the studio save for luncheon time, which I spent with Alice [Duer] Miller at the Vendome. Alice reports herself as not having done a lick of work in the last two weeks, due to not having had any conference with Hunt Stromberg, her producer. This has wrung an apology to her from Hunt Stromberg.

Went to an enormous Democratic dinner given by Ellin Berlin at the Trocadero. I thought it neatly symbolized that I, almost the only Republican

present, had to go in a borrowed dinner coat (my own being en route from New York). It was a glittering affair: Joan Crawford, Franchot Tone, Joan Bennett, Simone Simon, the Gershwins, Harold Arlen, George Jessel. I was pleased to have Sara Hayden, an excellent actress of severe young women greet me as a long-lost friend. She is a daughter of Charlotte Walker, who was living near Williamstown when I was in college. After dinner we all moved on to a public hall where there was a crowd lined outside to watch the entrance of the stars such as I have never seen and another gaping, half-witted, starveling crowd inside—enough to break one's heart. George Jessel was Master of Ceremonies. Harold Arlen played, George Gershwin played, the glamor boys and girls made bows, and Ellin, looking terrified, said a few words.

November 3: At about 9:30 this morning I voted for [Alf] Landon, without enthusiasm or hope. . . . Worked all day with Billy, or rather read books of etiquette, hoping an idea would come. One did, out of Emily Post, a fair one. . . . At 5:00 Billy and I went to Lubitsch's. He had smoothed out his own ideas and, scarcely listening to us, gave us directions on what to write. . . .

November 5: Worked at the series of dissolves prescribed by Ernst, with nausea in our hearts. At 5:00 we went to Ernst's house and read what we'd done, disclaiming all enthusiasm for it. Ernst saw the error of his prescription and changed it.

November 7: Worked at the studio. Billy a little constipated as to ideas. As I know ideas I suggest will be rejected with violence, I rarely put forth any. [Comment added later:] (This was before I learned the routine with this temperamental partner. The thing to do was to suggest an idea, have it torn apart and despised. In a few days it would be apt to turn up, slightly changed, as Wilder's idea. Once I got adjusted to that way of working, our lives were simpler.)

November 10: Worked hard and quarrelsomely with Billy all day, he very disagreeable about my past credits. I'm afraid I mentioned *Music in the Air* with some relish. If I do more on the script than he expects, he becomes very difficult. . . .

November 13: [Brackett notes this is a Friday] We began the day by taking 13 pages of script to Lubitsch (beginning with Scene D-13). When he began to read them he was not in a very good humor—at least, so it seemed to me. He was enthusiastic about them. We had a successful conference—so successful that from sheer pleasure we couldn't do much for the rest of the day. . . .

November 14: Billy determinedly boyish all morning, refusing absolutely to work. . . .

Went to dinner at Essie [Borden] and Mady's [Christians], taking John Van Druten out. We approached the party with dread, as it was to be for Max Reinhardt, whom we both think over-estimated. . . .

November 18: Worked at the studio with Billy and saw *Champagne Waltz*[33] in the projection room. This is the picture on which Billy worked with high hopes. Seeing it shattered him. It's plain poor.

November 23: At the studio was amused by the account of Mr. Wilder (the compleat amorist) of one of his methods of seduction. "You go out about the second time with a girl. You are quiet. You listen. Just at the last moment, when you've taken her to the door, you kiss her—surprisingly—then you hurry away. You stop at the nearest drug store and telephone her. 'I'm never going to see you again—it's too disturbing—it's going to get me. I'm not going to get involved in anything like this.' Instantly she tells you to come right back. By the time you arrive she's begun to undress. You see her *endishabille*. You're in bed almost immediately."

Today Mr. Wilder was not so successful on our story. We accomplished almost nothing. . . .

November 24: A day at the office, filled with pleasant insanity of a writer's life in Hollywood. In a moment of enthusiasm for an idea of Billy's, I executed a brief dance. I'm 44 day after tomorrow. The dance consisted of leaping in the air

33. Released January 1937; Billy Wilder has co-story credit on this Edward A. Sutherland–directed musical starring Gladys Swarthout.

and kicking both legs wide almost simultaneously. I said it was a dance Rumpelstiltskin danced. Billy (to whom love has just returned, leaving him mellow) insisted on my repeating it at intervals. Our work progressed slowly, but well.

Dined alone at the Brown Derby, stopping on my way out to greet Fannie Hurst, who was with Rosalie Stewart. Miss Hurst is an appalling looking human being—a great, ill, bloodless-looking Jewish lady, filled with false humility. . . .

November 25: Billy asked me to dine with him and Judith, the love of his life (his life in Paris, that is), recently come back to her native California. It was not a successful meeting. . . . At Billy's suggestion we brought the lady to my apartment for cocktails. . . . The girl, whom Billy had described as his ideal of a lady, was a smart, handsome young woman in that state of live [*sic*] which Billy induces in women. When we got to the Brown Derby they kissed constantly. . . . I slipped away from the love-birds unnoticed.

December 2: Worked at the studio but Billy had to go to the dentist and was made shaky by the pain-killer. I could wish my collaborators weren't so infirm. . . .

December 4: A day of hard but fruitless work at the studio. Billy and I are both stumped by one hard scene. . . . (Missed the preview of Billy's *Champagne Waltz*.)

December 5: Billy arrived depressed by both the preview and the notices on *Champagne Waltz*. It didn't help that the reviews echoed his opinion exactly. He had hoped for better things. . . .

December 6: Dined at Rosalie Stewart's. At my request she had asked Edna May Oliver[34] and George Kelly,[35] the playwright. I was impressed with Miss Oliver's charming, urbane clothes—a daintiness about her which is never ap-

34. Edna May Oliver (1883–1942), American comedic actress of both stage and screen.
35. George Kelly (1887–1974), playwright best remembered for *The Show-Off* (1924) and *Craig's Wife* (1925); uncle of Grace Kelly.

parent on the screen. Kelly (whose plays I admire extravagantly) was a disappointment. He has a priestly Irish face, priestly in an inferior way. It's the face of the priest of a small parish who infuses his duties with deep snobbishness . . . a priest who fancies himself for taking vows, fancies the elegance of his priestly life, a too-soft voice, caressing the syllables it utters, self-devotion, hypochondria, withdrawal from life [ellipses in original]. How can these unite in one of the glorious comedy talents of our day?

December 11: A day marked by listening to the radio speech of the former King of England [Edward VIII, the Duke of Windsor]. It was a pitiful, juvenile speech behind it (perhaps my own interpretation) the scared astonishment of a child who has never had a licking and has just been licked. . . .

December 14: Got an outline of Seq. F [of the script] on paper—pretty good, mostly mine. Interview with Lubitsch about 5:00. He was very agreeable but liked nothing about the outline. . . .

December 15: Billy and I started to work on F again when a call from Lubitsch said he was completely at our disposal for the day. We went to his house and discussed F all day, having luncheon there. . . . Ended with a tentative outline for Sequence F which neither Billy nor I like. . . . Dined at Norman Krasna's: Alice [Duer] Miller, the Lubitsches, the Pan Bermans. In discussing the *seul sujet* these days, Ernst said, "In a hundred years there will be two plays about Edward the Eighth playing across the street from each other. One will be called *The Great Lover*, the other will be called *The Fool*.

December 16: Worked on Seq. F and were frozen with horror at our results. Went to Ernst's at 5:00 and he told us the same sequence with improvements that had occurred to him. It sounded grand. Also, he said I could go East for Christmas as far as he was concerned. Ernst, in telling the sequence, had used an onion gag, saying "When I first thought of the onion gag . . . I thought it wouldn't do" [ellipses in original].

At the end of the conference, Billy said, "This is your sequence—you thought of it all."

I jokingly said, "I'm afraid I thought of the onion" (which I had).

A horrid pall of silence fell on Ernst. Billy rebuked me bitterly.

December 17: At the studio all day, working on the sequence according to the Gospel of Saint Ernst. . . .

December 19: Took the plane at 4:30 and found Bea Kaufman taking it as well. She and I played cribbage, except for dinner, until bedtime. I made no reference to the Mary Astor business, but as the plane began to darken, the subject became irresistible to Bea. She told how at the time she felt that her life was shipwrecked. Now it's all over and in the past. This is a philosophy much easier to reach for a person who works as hard at a job as Bea does at hers. She spoke of the absolute hell of having 35 reporters pop at her as she landed in America after the scandal had broken. I piled praise on her for the way she had conducted herself. (It amuses me to be in the berth above the victim of the Mary Astor diary, making this entry in my own.)

[Charles Brackett arrives on December 20, takes a plane to Boston and then a train to Providence, Rhode Island, for a reunion with his wife and daughters. "There was a week's vacation, most of it devoted to my family."]

December 28: Jimmy [Britt][36] met me at the airport and took me to the studio, where I set to work with Billy, sparing scarcely a word of greeting for my beloved Frank Partos, who was back, looking fat and healthy (for him) with a present for me. Worked all afternoon.

Billy and his bride took me to a dinner, given by Judith's uncle, an ex-lieutenant governor of California. Her mother was present too—a handsome, distinguished looking old girl who couldn't have been produced by any state but California. She was born on the family ranch up north, which has been in the family for about a hundred years. . . . She's worldly, a great talker, and

36. Jimmy Britt was Brackett's long-time chauffeur and also his somewhat elderly houseboy.

given to good phrases. "In California one lives *en negligée*." She likes Billy very much—so does the ex-lieutenant governor, who of all things wrote the song "Texacana Rose." Of him I have no impression except deafness. It's an interesting family that Billy has acquired. Billy and I visited with them through two courses, then hurried back to the studio and polished Sequence F.

December 30: Lubistch conference early this morning, He is no more satisfied with fractuous F Seq. than we are.

This afternoon Frank [Partos] came into the office and talked illuminatingly about Russia, where his brother is at the head of Infant Mortality Forces. For the first time I had a glimpse of the Soviet as a passionate and beautiful experiment. . . .

"In Austria and Hungary," Frank summarized his impression, "everyone speaks of what great times they had before 1914. In Russia, of what great times they are going to have."

1937

[The diary for 1937 is one of the longest, and, arguably, the most difficult to edit in that so much therein relates to the Screen Writers Guild. And most of what Brackett records is impossible for anyone who was not present to understand. Indeed, on September 29, Brackett records a luncheon meeting at Lucey's with Walt Disney: "our task to set Disney straight . . . and it was difficult as he was entirely without background."]

January 1: A clear beautiful day. . . . After dinner I went to see *Rembrandt* which was as dull and enobling as I had heard it was—returned here and to bed, making one New Year's Resolution to save a little money . . . [ellipses in original] and gain some peace of mind thereby.

January 2: Worked at the studio all day with Billy—the studio was closed which always makes for concentration. . . . When we stopped working I went to see *Three Smart Girls*, a charming picture.

January 8: Conference at Lubitsch's this morning to which I contributed an idea that really clicked. . . . Luncheon at Lubitsch's, Billy brought me home.

[Brackett was primarily working at Lubitsch's home on the script for *Bluebeard's Eighth Wife* from January through March.]

January 14: . . . Billy and I carried the G sequence to Ernst and received a dressing down such as I never had in my life nor will have again. The length of time we've been on the script thrown in our faces, the complicated quality of the scene we'd planned. . . . Beaten under the lash, we were returned to the studio and consulted for a few hours. . . . At ten I went to Billy's and we worked until one.

January 15: . . . Billy was certain we were to be fired and I was so cheerful that I began to think my attitude was entirely wrong and we probably were. Ernst was at the table at luncheon and muttered something about not having felt well yesterday and later told us to go ahead. . . .

January 20: Went to the studio at 12 to start the extensive rewrites with Ernst and then returned to my apartment with Ernst, Billy and our stenographer and work here all day, getting six pages done. And consuming too much coffee for my own good. . . .

January 23: Woke amazingly well and worked all morning with Billy and Ernst, I warning Billy against facetiousness by the way. [Later that day, Brackett reports a temperature of 103, rising to 104, but by the next day, his temperature was normal.]

January 25: . . . At 5:30 my Mr. Weiss [unidentified] arrived with the young Jewish workman who looked very much like David Selznick and they hung the draperies in my living and dining rooms, talking away . . . as is the custom of Jewish workman of that sort. . . . I like the race at its best . . . have received so much more consideration and kindness from it than from other people that I was almost tempted to give the complimentary ad which was solicited from me by the Southern California *Jewish Weekly* while I was at dinner. . . .

February 4: Worked as usual . . . dinner at the Partos' with Billy and [screenwriter] Irwin Gelsey. Billy got a little fresh and I had to smack him down (which I was able to do with authority of complete boredom).

March 6: Worked at Ernst's finalizing the dialog for sequence F at last. Only one more day on *Bluebeard's Eighth Wife*.[1] I've gotten afraid to face the world from a less safe vantage point. . . .

March 9: Went to Ernst's and completed the sequence which had troubled us for so long. Began discussing the final sequence and Billy crashed through with a brilliant idea that would solve the problem. Ernst was so pleased that he let us out of school early and Billy took me to the Glendale antiques store where I bought a tea caddy stand about which I am very dubious. . . .

March 10: Worked at Ernst's blocking out the next sequence and doing a little dialogue. Alice [Duer] Miller dined with me at the apartment, and Charlie Lederer, with great effort, obtain tickets for us to *Lost Horizon*. . . . It was the first bad Riskin-Capra picture I ever saw. The story was evidently beyond their scale, which can make stories dealing with ordinary pictures and events luminous. The love parts were embarrassing. The set of Shangri La had all the quality of [the] Sunset Towers apt. . . .

March 11: Worked at Ernst Lubitsch's until about eleven when on a sudden decision we resolved to not finish the last sequence but make notes for the last sequence—to be finished after the completion of *Angel*. We went to the studio & Manny Wolfe . . . told us our next assignment: to get an original story in shape for Fanchon[2] (the only woman producer in town) in one week.[3] . . . Billy and I went to hear the story from Miss Fanchon on Stage 5. Miss Fanchon as we entered was being bawled out for a suggestion she had made about lighting a scene—she apologized for having made the suggestion (to us as well as the director) before she told us the story which is pretty grim. . . .

March 17: Billy and I were summoned to Miss Fanchon's office to tell what progress we had made & Billy told his half-baked idea for the beginning of a

1. A premature hope.
2. Ruth Fanchon was one half of the brother and sister team, Fanchon and Marco, which produced movie theater prologues and other types of live productions; she produced a handful of Paramount films in the mid through late 1930s.
3. Brackett has added a note indicating the film is to star George Raft.

story & we both said how much we disliked & disbelieved Ted Lesser's story—Ted Lesser being present. At the end of the conference Miss Fanchon having liked Billy's story, Lesser said to us in the corridor, "Are you counting me in on this story or not" in the voice of a relative inquiring where do you buy your beer?

March 24: A little progress on the story. Lubitsch asked me for a line for *Angel* which pleased me greatly....

March 26: ... Luncheon at the studio surprisingly enough with André Malraux ... a young man at the studio with communist leanings having asked me, I supposed because of the Guild activities last spring which have lent me a false aura of liberalism.... Malraux sat with the joyless eyes of a revolutionary, utterly self-absorbed.... The young man ... related a story of Malraux in the South of France. Every day he went to disappear from the hotel, returning hours later exhausted. Someone followed him—saw him sail a little boat out to sea—and when it was far out, dive off, then swim after it, careless whether he caught it or not—a hammy performance, I thought.

March 29: Sat a long time in Miss Fanchons' office reading Kipling to Billy & to myself. Finally she arrived and tackled the story—or rather we all did.... [After lunch] Billy and I went back to our conference, and after a rough story line was blocked out, were ordered to get it done by tomorrow morning. Billy tired by 5:30 & postponed the deadline to twelve tomorrow....

March 30: Worked on the outline of our story until four in the morning. Woke rather groggy & went to the studio & rewrote the awful bilge until about one when I had luncheon with Lillian Hellman at Lucey's—handed in the stuff at two thirty & was dismissed.

March 31: Went to the studio to learn our bit of tepid bilge had not been broadly received save for the ending, which wasn't worked out, but that I had a great literary triumph because I used the word valitudinous again in

the treatment. "I thought at first you are fooling," Fanchon said, "but then I looked it up." . . .

April 6: A ten o'clock conference with Bill LeBaron—highly successful. So successful that Billy and I didn't do another lick of work all day.

April 12: An unfortunate kind of day. Went to the studio to find Miss Fanchon and with a long face because our treatment had been disapproved by the front office. . . . Returned to the studio to see Manny Wolfe who confirmed to us that we were off the story and were to report to the Schulberg lot. Dick Wallace is to direct which we liked and we agreed to the assignment.[4] . . .

May 24: Worked at the picture accomplishing nothing, but a brief love scene in the afternoon. Went to a Screen Writers Guild meeting at Lillian Hellman's, dined home alone and read the script which Bob Montgomery wants me to polish for him and find it very bad and inclined not to take it if it's a rush job.[5]

May 25: . . . had luncheon at Metro with Bob Montgomery, Harry Rapf and George Fitzmaurice and sold him the idea of taking Billy with me, and rewriting the script almost completely. . . .

June 1: Went to Metro, reporting in Harry Rapf's office at nine. Rapf, Bob Montgomery and Dore Schary shuffled in about a hour later and we went into a long dim story conference to which Rapf contributed vagueness. . . . Story conference continued in the afternoon until we arrived at a . . . story line. . . .

June 2: Went to Metro and waited with Bob Montgomery for Dore Schary to appear. Dore had been told he was off the picture. Luncheon with the

4. *Blossoms on Broadway*.
5. Released in October 1937 as *Live, Love and Learn*, with Brackett sharing screenplay credit with Cyril Hume and Richard Maibaum.

Hacketts and Bob, Dore appearing late to say that he is to be with us for three days—distressing news. . . . Consulted Wilder who merely said he didn't like our line—wouldn't want to work on it. . . .

June 3: Horrible day. Working this morning with Dore Schary at the apartment—we were summoned urgently to Harry Rapf's office in a state for fear we had done anything. We told him the outline—he liked it and relaxed—and when I had planned to clear out found myself held till Saturday. . . .

June 5: Worked at Dore Schary's this morning, having luncheon there and being told by Harry Rapf to continue on the script until I have to go to Lubitsch—without credit if I so specified.

[On June 8, Elizabeth and Brackett's daughters arrived by train in Pasadena from the East Coast.]

June 14: Went to the studio at 11 and sat in a conference with Harry Rapf and Bob and George Fitzmaurice and Vincent Lawrence until one. . . . Everyone very pleasant about my stuff.

June 22: Called to a conference at Harry Rapf's office at 11 o'clock. I was requested to work at the studio . . . and was given an office. Worked there until seven. Bob being irritated with [leading lady] Rosalind Russell is sulking and not coming to the studio. . . .

June 29: Read later scenes to Bob Montgomery who approved and learned from Edwin Knopf that [F.] Scott Fitzgerald may come out to follow me on the scripts. I go back to Paramount on the 12th. . . .

July 10: Worked at the studio most of the day—cleaning up censorship nonsense and typing a rough draft of the last scene I am to do. . . .

July 12: Went to Paramount, reporting to Ernst and being told to write a couple of new endings. . . .

July 15: At the studio all day consulting with Billy. . . . After luncheon joined Ernst on the Schulberg stage and had a conference, he rejecting all our ideas. . . .

August 20: Worked with Ernst all morning and a little in the afternoon. Ernst and Billy doing—at the end of the day—their serious German habit of saying, "Now, this scene must be very good. It's got to be riotous. If it's just a straight scene it's nothing." Strangely enough that kind of talk usually succeeds with them—an excellent scene.

September 4: . . . learn that [Theodore] Reeves wants sole story credit on *Blossoms on Broadway*. [Producer George] Auerbach suggesting that we take adaptation credit—as we listened Billy shook his head violently for me to enforce it, and said, an "Adaptation credit means that you have done a lot of work which they couldn't use, so they got someone else's. I don't want it." We said we wanted the matter turned over to the conciliation board of the Guild.[6]

September 8: . . . In the afternoon we were interrupted by the arrival of the *Blossoms on Broadway* script to which we at first belligerently claimed our contributions. . . . Halfway through, we agreed to have our names taken off. It's terrible. . . .

September 11: . . . At the studio Harry Rapf called to say that there was to be a preview of *Live, Love and Learn* at Long Beach. The ending is wrong, would I come and make suggestions? My blood ran cold.

6. The sole screenplay credit on the film, released November 1937, is for Theodore Reeves.

September 12: . . . At seven we started for Long Beach and the preview. . . . Rosalind Russell's performance . . . swell. Bob Montgomery's was equal. Bob Benchley's and Monty's [Woolley] excellent. Rode home with Harry Rapf, Eddie Knopf, Dore Schary discussing possible cuts and continued doing at the Brown Derby. . . .

September 25: We had just started effective work when Manny Wolfe called and told us he was taking us off [*Bluebeard's Eighth Wife*] for a couple of days to work on *The Big Broadcast*[7]—a hurry-up job. Billy and I read the script and talked it over with Mitch Leisen till about five thirty. . . .

September 27: Arrived at the studio to see the part of *The Big Broadcast* which is already shot . . . not as amusing as we'd hoped, and had to write a scene for Dorothy Lamour whose common, hideous voice had particularly unimpressed me. It's a very bad scene. . . .

[Brackett and Wilder continue working on *The Big Broadcast* script until October 4, when the former is scheduled to leave for New York. He postpones the trip to the following day.]

October 5: . . . At four thirty our plane started from Glendale. Paulette Goddard was to have been a passenger but she came to the airport with Chaplin and they went into the cocktail bar and evidently quarreled or made up—the latter from their thundercloud faces as they entered the airport, and she didn't sail. Frances Farmer was in the seat opposite and proved charming.[8] . . .

[After stops in Nashville and Toledo, "we came an odd route," Brackett lands in Newark on October 6. On October 10, he goes to Providence,

7. *The Big Broadcast of 1938*, released February 1938, and directed by Mitchell Leisen; Brackett and Wilder receive no screen credit.
8. Brackett makes no reference to Billy Wilder's also being on the plane.

accompanied by Billy Wilder; the following day to Saratoga Springs; and then to Williams College. With no accommodation available at the College, the two men spend the night at Brackett's Psi Nu fraternity, where "Billy was convulsed to hear me say 'I am Brother Brackett' and horrified at the sheets in the guest room—they were foul and we had to change them." On October 12, Brackett and Wilder take the train from Albany to Chicago. On October 13, they board the train for Los Angeles, "did some work on *French without Tears* and played quite a lot of cribbage, Billy always losing, also snapped at each other petulantly." The following day, Brackett, at the urging of the Screen Writers Guild takes the plane from Albuquerque. From October 15 through October 21, he is primarily concerned with Screen Writers Guild business, culminating with a new constitution being read and approved.]

October 22: At the studio all day, saddened by the fact that my dear Frank Partos left Paramount after six years of solid employment—reason given that his salary had grown too high, result gloom in my heart—He and I worked out a strike clause for the Guild as our last act in his office. . . .

October 25: At the studio all day. Billy excited because he had seen the workmen carry a big artificial fish on *The Big Broadcast* set—our idea—and had watched *Bluebeard* begin and ten extras had laughed. It's a Brackett-Wilder Day, he declared. . . .

October 26: . . . At luncheon, we learned that the *Bluebeard* script is too sophisticated. Went on the set this afternoon and saw Pauline Garon (playing a wonderful French woman) and [Gary] Cooper. Met [Adolph] Zukor for the first time—as dim a [indecipherable] as ever I saw. . . .

[Work continues on a daily basis at the studio with no major problems noted; the primary focus is a screen adaptation of Terence Rattigan's play, *French without Tears*, and a film for Marlene Dietrich, with Brackett realizing, on November 22, "The studio doesn't want Dietrich to make another picture." Is it possible that the two projects are one and the same?]

November 15: Worked at the studio, Billy rather grumpy, and the story not going so well. . . . I got home and was dressing for the opera to which Vivian Lubitsch was taking me, I got a five star marked telegram, opened it in some agitation to read, "Have just learned that you had not only a haircut and manicure but also a massage. What does that mean? Charlie, I am warning you—Ernst."

November 30: At the studio all day, but, unable to have a conference, didn't do a thing but find a quotation from *The Taming of the Shrew* for Lubitsch. . . .

December 1: . . . Returning from luncheon I got in the elevator to find it occupied—a lady with cider colored hair. She lifted her green eyes and I realized it was Miss Dietrich. We greeted each other. "I'm on the picture you know," I said, "It isn't finished." "We've had to make some changes," I stammered and I wanted to be explicit. "Have you a moment?" "I'm late now." Nevertheless I held her for a moment. "You see we couldn't make it the story of an ordinary girl staying in a boys' school—since it was you because you had to explode like a bomb." The green eyes seemed to grow farther apart. Miss Dietrich spoke one word, "Naturally."

December 6: A day at the office during which Billy was surly. Rosalie [Stewart] telephoned to say that Paramount's option on him for next year had been taken up, which made him no better. . . .

December 20: At the studio finishing *French without Tears* hurriedly. At noon new assignment from Arthur Hornblow for *Midnight* and had lunch with him and Mitch Leisen at Lucey's. The story seemed to me as he told it in his office after luncheon to have the traits of all Parisian Paramount comedies. No reality of characters or background—one forced and familiar situation after another. . . .

December 25: First Christmas since our marriage that E. and I have been apart and the first Christmas since Bean's birth that she's been away. . . .

December 28: At the studio all day having no luck with our story. Finally asked Arthur Hornblow for a conference and found that he agreed with me on every point which sent him up in my estimation. He gave us a book on Monte Carlo which I read and read after I came home. . . .

December 29: At the studio—a fruitless day. Billy playing young genius— my nerves on edge. . . .

1938

January 2: . . . Xan and I went to the exhibition of pictures shown by an Italian named [Emanuele] Castelbarco and sponsored by Grace Moore. They seemed to me inferior works but not appalling as a couple of Modiglianis which were also in the gallery. . . . Perrera,[1] Grace Moore's husband, going about being charming, while La Moore, like a tired streetwalker in a red dress and hat, sat at a table with the Countess de Castelbarco,[2] the Count, Kay Francis and Gladys Swarthout. . . .

January 6: Working hard but interrupted by Ernst [Lubitsch] who wants a title, to show that *Bluebeard* takes place on the French Riviera. . . .

January 7: Really progressed with our first sequence. . . . *Bluebeard*'s last scenes were shot today.

January 10: Went to the studio with a suggestion for a change in our first sequence. Strangely Billy didn't resist it hard. We were just putting it down when a call came from Arthur [Hornblow, Jr.] asking us for luncheon and a peek at our work. We completed it, went down, read him the completed first 12 pages. He liked them and took us to luncheon at Lucey's with [writer] Gil Gabriel. After luncheon Billy, true to his motto that he can't work after praise, slacked until 5:00. . . . Came home to dinner with Phil Dunne, went with him

1. Spanish film actor Valentin Parera, whom Moore had married in 1931.
2. The daughter of conductor Arturo Toscanini.

to an SWG meeting and later he came back and talked about Fascism, his ruling passion. Wish I didn't suspect in myself a nasty rightishness, and hope devoutly I never let it make me unfaithful to Democracy, who is really my lady.

January 17: . . . At 5 o'clock we were asked to see *Bluebeard's Eighth Wife* run in the projection room, a rough cut. The projection room silence at a joke is appalling. I wasn't mad about much of the dialogue but the performances are magnificent. If the audiences get into the crazy spirit of the picture we have high hopes for it. I only thought, sadly, as I drove home, "It's just not my kind of a picture."

Dotty and Alan Campbell, just here from New York, and Boris Ingster dined with me and we all went to the Guild meeting, which stayed, fighting on the contract with the Authors' League, from 8:30 until almost 2:00.

January 19: At the studio, working briskly until we decided to consult Arthur Hornblow about our next steps, telephoned down to learn he was in hospital with an appendectomy. Dick Blumenthal, his assistant, would hear our stuff. He did so after luncheon. I ate with Ernst Lubitsch in the commissary. Blumenthal expressed some pleasure, with the customary effect on Billy. . . .

February 2: At the office I found a letter waiting for me from, I think, the National Defense League. It began "Gentiles" and proceeded to blame the economic evils on the Jews, a loathsome, ridiculous letter. I considered tearing it up at once, but knew Marian [Spitzer] would regard that as complete disloyalty and Billy as well, so showed it to them both and there was no work for the morning. . . .

February 8: . . . At the studio—bad reviews for *The Big Broadcast* and I concluded it was my fault, ours rather, till Billy argued me out of the point. . . .

February 13: . . . Now here [at home] to wait until 12 o'clock when Billy is to telephone a report of the preview [*Bluebeard's Eighth Wife*] from San Fran-

cisco. . . . Billy's report was not cheerful. It's fine, he said, in his heartbroken voice. Went over swell all except the Pepinard stuff. [Herman] Bing laid an egg; Claudette must be brought back from abroad for retakes. I did very little sleeping the rest of the night.

February 14: Went to the studio and worked on ideas for *Bluebeard*, which I know will not be used. Brief interview with Arthur [Hornblow, Jr.] in which he threw out our C seq. idea in toto. . . .

February 15: Billy's account of premiere very different from his telephone conversation. All rosey except [Herman] Bing scenes. We polished Seq. A & B and began to discuss C again. . . .

February 16: At the studio, nervous about the *Bluebeard* changes and unable to confer with Hornblow so we did desultory work on *Midnight*. . . .

February 17: Worked on the C Seq. all morning. . . . Conference with Arthur [Hornblow, Jr.] in the afternoon in the course of which he destroyed practically every word in our script, made us ill with his elegance.

Dinner here: Jane Murfin and Phil Dunne dining with me and Boris Ingster joining us later. Afterwards an Inter-Guild Council meeting at Bob Montgomery's, with hard sense from Bob and hysteria from Herbert Biberman and Rouben Mamoulian. The very radical boys are strongly moved with terror at the IATSE[3] [takeover of the Guilds] menace.

February 18: . . . In the afternoon Ernst took us over for the retakes of *Bluebeard*, Ernst very nervous because Claudette won't come back for retakes. . . .

3. International Alliance of Theatrical Stage Employes [*sic*] and Moving Picture Machine Operators of the United States and Canada, organized in 1893, and commonly known as IATSE. It was involved in a bitter territorial dispute in the late 1930s and early 1940s with the Conference of Studio Unions (CSU).

February 23: At work on a scene for [Edward Everett] Horton and [David] Niven, not getting anything to please Ernst till late afternoon, when Iva, our secretary, made a suggestion that pleased him. Don't think much of the scene myself but awfully relieved to get it done. . . .

March 3: At studio, actually completing C Sequence. Luncheon with Ernst. More conscious of the pleasantness of the sunlight than I remember. The Academy dinner was postponed for a week and I hoped to have an evening free. Instead I was summoned to a meeting of the Board of Directors of the Motion Picture Relief Fund, an organization of which I'd been appointed a director last night. It was at Bob Montgomery's. Joan Crawford and Lucille Gleason were there, Ralph Morgan, Phil Dunne, Dudley [Nichols], Leo McCarey.

March 6: . . . Vivian and Ernst ate a nervous supper before motoring down to Long Beach for a preview of *Bluebeard*, which went beautifully save for the scenes introductory to the last sequence. Cards wildly enthusiastic. Only hope for a reaction as satisfactory from Hollywood preview. . . .

March 10: . . . Tried to get Dudley [Nichols][4] to go to the Academy dinner and accept his *Informer* award. This evening went to the Academy dinner with the Partoses, the Hacketts, Boris Ingster and some girl, sitting at a very prominent table where we made an extremely bad showing for the Guild which also seemed to lend a churlish note through Dudley's failure to accept his *Informer* reward. Had to bow as the representative of the Guild and felt inadequate. The gathering of celebrities was interesting and Charlie McCarthy's special award and his speech enchanting. That Zanuck should have received the Irving Thalberg Award struck us all as shocking. I was heartbroken that Spencer Tracy got the reward for Best Acting instead of Bob Montgomery,

4. Dudley Nichols (1895–1960) had won the Academy Award for Best Written Screenplay for *The Informer* (1935), but refused to accept it because of the Academy's opposition to the Screen Writers Guild. Two years after the Awards presentation, which Nichols did not attend, Brackett tries to persuade the writer to pick up his Award.

whose *Night Must Fall* seemed to merit it so incomparably. Also resented that Rainer got the woman's instead of Garbo for her beautiful *Camille*.

March 11: . . . Billy and Ernst in great distress about the downfall of Austria. . . .

March 17: . . . We worked sporadically and arranged the farewell luncheon for Ernst which took place at Perino's at 1:30. Botsford[5] made a funny speech. Ernst made a nice reply. As I drove Ernst home he talked hearteningly about wanting to work with us again wherever he goes. Comments on the picture swell. Some question whether it will be a commercial success. . . .

March 23: . . . Learned in the afternoon I had to speak to the big Guild meeting about the Motion Picture Relief Fund. . . . The Guild meeting was a triumph for the radicals with the divided tendencies of the Guild showing plainly and me playing the heavy. . . . Don Stewart began the meeting on a wrong foot by asking for a vote from the Guild to Thomas Mann, who is lecturing here. The conservatives said, "Sponsored by whom?" "Lecturing on what?" The radicals yelled, "What does that matter? You evidently don't know who Thomas Mann is." I found myself saying to the indignant [Dorothy] Parker and [Lillian] Hellman, "Does it occur to you that our members have a right not to ask who Thomas Mann is, a right to be presumptuous if they wish."

March 24: A day keyed up and dominated by a farcical fact: Thomas Mann staying with Bruno Frank had made one request: to see the new Lubitsch picture. Billy and I spent the day arranging the event, which took place in [William] LeBaron's projection room at 4:00 o'clock. . . . Mann proved to be a charming guest, fifty, Jewish gentleman, Mrs. Mann very cute. The showing of the picture in the hideous projection room silence was horrible to me, I being conscious of every weak spot by now. The Bruno Franks and the Manns

5. A. M. Botsford, executive assistant to producer William LeBaron.

were delightful about it afterwards. "We laughed enough for such very fine people," Mrs. Mann said to Billy when he complained of missing the laughter one gets in a theatre. . . . Didn't accomplish much on the script but had a very pleasant interview with Arthur.

March 27: . . . took Lillian Hellman to dinner at the Cock 'n' Bull, then on to U.A. Studio where she showed a lot of her friends *La Grande Illusion*, a swell (but long) French picture. Afterwards Dash, Lil and I went to the Brown Derby for lemonade.

March 30: . . . During the afternoon Manny Wolfe called us in and gave us a talking-to on the Depression, as he informed us that we were to go to Universal to work on the next Deanna Durbin picture [*That Certain Age*] for four weeks. . . .

March 31: At the studio, working on the final sequence of *Midnight*. Billy feeling miserable. . . .

April 2: At the studio, closing up our offices. . . .

April 3: Conference with Joe Pasternak, the director who is going to do *That Certain Age*, and Billy. Found Joe charming. . . .

April 4: Well, but drained of energy, and, fortunately for me, Billy was ill. We went to Universal, a friendly, shabby little studio with a scaly bulletin board. Met Deanna Durbin, who came from the schoolhouse on the lot, and when I asked her what she'd been studying, said "History."[6] . . .

6. After seeing *Mad about Music* on March 26, Brackett had noted that "Deanna Durbin continues to be a little robustious [*sic*] for my taste."

April 5: Woke feeling fine but got word Billy was ill, so went to his house. He was not so ill as stumped for a story. We talked one out all day, finally getting in [Edward] Ludwig, but with no success. . . .

April 6: At Universal (lost my way there, or rather went past it by two miles), trying desperately all morning to find a storyline. . . . Went to Paramount and got the Sub Deb stories of Mary Roberts Rinehart, in the hope of some hint of problems for that age. . . .

April 7: At the studio all morning. Billy had the germ of an idea. It fitted in with the hint of a situation I gave. Joe not very impressed but Ludwig liked it. Eventually we were told to go ahead. . . .

April 11: . . . Went to the studio and sat stitching together the story all morning. Luncheon at the commissary. At 2:30 Billy told the story, told it worse than he ever told it or any other story. . . . Joe Pasternak and [Edward] Ludwig beat a retreat to an earlier story. I thought it just about as good as the story we had, but at the close of the conference Billy informed me he was stepping out. . . .

April 12: At the studio with Billy, whom Pasternak persuaded to stay on the story for a time, Billy very young genius, with no views. Toward the end of the afternoon, let out a secret: "You had your triumph yesterday—now keep on with it." . . .

April 13: Billy out of his young artist doldrums. Worked on the story idea fitfully. . . .

April 15: Billy is on a storyline which pleases him and Joe and my suggestion of Deanna's singing a song her mother sang to influence her father pleased them both and fitted with the scheme. I suggested "Give Me Your

Smile" and remembered a Mademoiselle Liebert whom I heard sing it first
in Saratoga [Springs]. . . . Had luncheon with Billy and Ed Ludwig at Little
Hungary,[7] a delicious luncheon. Worked on the Lubitsch sketch for the Guild
dinner. . . .

April 19: At the studio all day. A horrible sterile conference from 9 o'clock
until 11:00. . . . Jerry Sackheim suggested that F. Hugh Herbert was working on
the next Deanna Durbin picture. He was called in, told a story which seemed
magnificent to us all. It was accepted as the basis for this Durbin. Billy and
I said we saw no reason we should be called in to work on it. Herbert was
pleased at such professional gallantry. I had lunch in the commissary with
him and his fiancée. Then Billy and I went off together in a calmer mood,
analyzed the story with horror, finding it a Judge Hardy's Children-Jones
Family sort of effort, which must be brought to an entirely different level. . . .

May 5: . . . Dined home alone, then to a Motion Picture Relief Fund meet-
ing which lasted until 12:00, Joan Crawford offering as a contribution her
salary for a broadcast, $5,000. . . .

May 12: At Billy's, sterile and hard-pressed. Conference there with [Ed-
ward] Ludwig. About 5:00 threw out everything we had. . . .

May 13: Went to the studio and had a conference with Eddie Ludwig and
Hugh Herbert, in which Eddie bullied Hugh abominably. . . .

May 20: . . . He [Billy] and I worked till about 5:00 when an agitated tele-
phone call from Hugh Herbert stopped us. Hugh couldn't say what he wanted
to say from the studio. Billy told him to go across the street and use one in a
drug store, which he was doing. So Billy said, "What has happened? Shall I tell
you my hunch? Either they have shelved the picture or another writer is on

7. Located at 1744 North Vine Street in Hollywood, a favorite eating place of Billy
 Wilder at this time.

it—Bruce Manning, probably." When the call came, it was that Bruce Manning was working on it. Great upset for all of us. We meet tomorrow at 9:00 for a conference of war. . . .

May 21: Had to get up at 8:00 and breakfast early and go to Billy's at 9:00, to meet F. Hugh Herbert with his tales of the Bruce Manning menace and Eddie Ludwig's madness. Thence Billy and I went to Pasternak's and into a good, rousing Jewish scene, in which we offered to leave the script and our opinion of Eddie's suggestions. Eddie was called in, was apologetic and placating, as was Joe. Billy went on to his doctor's, I to my bank. We met at Little Hungary for luncheon, asking [writers] Sam Behrman and Sonya Levien if we might sit with them, and had a very pleasant time. Worked at Billy's all afternoon, completing not quite 2 pages. . . .

May 30: . . . At 2:30 we [Billy and I] went out to Arthur Hornblow's for a story conference mixed with an afternoon's play. Claudette and Mitch Leisen were there for the former and Mrs. Leisen and Myrna [Loy/Mrs. Arthur Hornblow, Jr.] to found out [*sic*] the latter. They played tennis and swam and then discussed *Midnight*. Claudette's criticism of it agreeing with mine entirely. After the conference Myrna showed us through the house, then we drove Claudette home and she showed us through her house. . . .

June 3: Worked all day at Billy's, having luncheon at Little Hungary with Ernst Lubitsch, who has no studio commitment, a rather terrifying thought, since one would think that he would have been made quantities of irresistible offers. . . .

June 4: Worked at Billy's all morning completing the script by about 1:00. Went to Universal and read the last forty pages to Joe [Pasternak], Eddie [Ludwig] and Hugh Herbert. Afterwards Hugh made a rather uncomfortable demand that Joe say what the credits were to be. Joe said if our script were used as was, "Original Story by F. Hugh Herbert—Screenplay by Charles Brackett and Billy Wilder." If the script on which Hugh has been working, "Screenplay by Charles Brackett, Billy Wilder and F. Hugh Herbert." Hugh

sulked. Billy said it all depended on the final script—"If you have contributed one fourth of the script." . . .

June 6: . . . went to Paramount where, Billy being in a festive mood, we spent the morning at Bullock's where I bought a suit. . . . In the afternoon conferred with Arthur and read the *Midnight* script, which I loathed. . . .

June 9: At the studio all day, still stuck, and even Billy a little panic-stricken. . . . A visit with Zoe Akins as she ate quail and hardboiled eggs in her office. . . .

June 11: At the studio this morning, a faint gleam of light penetrating the dark recesses of the script for the first time. Not enough to give real comfort of mind, however. . . .

June 14: Stuck on the story, we sought out Arthur Hornblow, finding him on the *Artists and Models* set and upsetting him about the difficulties of our script. He postponed our meeting until 4 o'clock when he (*mirabile dictu*) made an excellent suggestion. . . .

June 17: At the studio where we finished the bedroom scene. . . . After luncheon read the scene to Arthur [Hornblow] who liked it and made arrangements for us to read it to Claudette [Colbert] tomorrow.[8] . . .

June 20: At the studio all day, planning next sequence in the morning, seeing *It Happened One Night* in the afternoon for a similar plot situation. . . .

June 21: Worked at the studio all morning, getting no place. To the S.W.G. office at noon to oversee a bulletin. Hardly had I returned to the studio before I had a call from Phil Dunne that an interview arranged between Dudley

8. Which they did at 11:00, and Brackett reports "she liked."

[Nichols], Phil, myself and the great god Joseph Schenck was to be right away. All very unofficial and secret. Rushed over to 20th Century-Fox and was led with the others into the Presence. Schenck completely charming, said he had no animosity against the Screen Writers Guild. Thalberg had been afraid of it—he wasn't—but the Producers had a certain loyalty to the Screen Play-wrights. If the S.P. could be approved by some generous gesture . . . [ellipses in original] We agreed to his suggestion. After the election. He practically guaranteed us recognition. We left jubilant. I returned to Paramount and read up on French shooting, in the desperate hope that we could something for the part of *Midnight* on which we are stuck. . . .

June 23: At the studio electioneering for [SWG] registration and writing. Cukor, Bots [A. M. Botsford], Brian Marlowe at luncheon. Cukor very amusing on subject of Isa Miranda, who's out of *Zaza*. I hope Claudette is in and that *Midnight* will be forgotten. Had all the Guild members for cocktails at Lucey's before registration. . . .

June 24: At 7:30 the telephone rang and it was the news that Mr. [Charles C.] Van Deusen[9] had died, as distressing a piece of intelligence as I could have had. The morning was spent arranging to go on [back East for the funeral] and at the same time doing a scene for *Midnight*. In the afternoon I voted in the Labor Board election and got more of the scene done. Billy, by refusing to go on with me, is costing me a cool two thousand dollars, but decided he couldn't work on a plane. He has to walk up and down. An anger has simmered in me ever since the studio offered to pay me for the week away if I would sign up for an additional year, but I didn't. . . .

Worked at the studio until about noon, when we read our work to Arthur [Hornblow], who hated it and got so nervous during the conference I thought he'd have a fit. . . .

[At 4:30, Brackett boarded a plane for the East Coast, arrived at Newark, New Jersey, at noon on June 25, and then caught a train to Albany, New York, at

9. President of the Adirondack Trust Company since 1924; died June 24, 1938, at the age of seventy-one.

2:00 p.m. The funeral of Van Deusen took place on June 28. On July 4, Brackett boarded the California-bound plane at Newark.]

July 7: At the studio, starting the E sequence again. Rosalie [Stewart] brought Thornton Wilder and his sister to luncheon at the commissary. Billy and I ate with them (hell, *I* paid) and Billy was enormously impressed with the Aryan quality of Thornton's humor. . . .

July 14: . . . We [Brackett and Elizabeth] went to the opening of *Pins and Needles*, sponsored by the Anti-Nazi League. It was full of engaging songs by people from Germany, Spain, Sweden, etc.—the immigrants who announced they'd come over here and were going to take things over. "You'll hear from us," was the burden of the cry, when the cry wasn't one of sheer self-pity. The performers were the most insultingly ugly crowd of Jews I ever saw. Despite three songs of real charm and gayety, "Sing Me a Song with Social Significance," "One Big Union for Two" and "I Used to Carry the Daisy Chain, Now I'm a Chain Store Daisy," I found it a penitential evening in the theatre and wish I could get a New Yorker to account for its wild popularity. To me it is very funny that the Anti-Nazi League should have sponsored it. They ought to have paid a couple of thousand dollars to keep it out of town. I prefer Tory humor.

July 15: At the studio, working on the second half of Seq. E. . . . After luncheon summoned to Arthur's office, Arthur's brow clouded. "Before I say what I have to say, will you read me this?" I read the beginning of Sequence E, giving it everything. He started to criticize. I said, "Do you want to hear how we go on?" He did and was enthusiastic. . . .

July 16: At the studio this morning, getting only about three pages before Billy tore off to the races. . . .

July 19: At the studio reading our new stuff to Mitch [Leisen] about noon and getting a pleasant response from him. At the commissary I sat at a table

where Constance Collier was entertaining Mildred Knopf and was particularly amused at Constance's saying "It's something one mustn't speak about, but, you know, the former King doesn't shave."

. . . Went to a meeting of representatives of all organizations determined to strike a blow for free speech on the screen. It was brought on by Walter Wanger's picture *Blockade* and was, I imagine, a shrewd publicity scheme of his. He spoke. Afterwards Wanger took Leonard Rossen, Dick Abbott (who presided at the meeting), Mrs. Abbott, Herbert Biberman, and Marquis James to the Trocadero for champagne, also Joan Bennett, with whom I had a very pleasant evening.

July 29: At the studio, still stuck for our final sequence, but a faint gleam came at the end of the day. Lunched at the house of the mother-in-law of Horace McCoy,[10] a great, stunning house. His wife a charming-faced woman who has evidently had infantile paralysis and is very lame. The pool in which she swam is a great oblong with a curved gulf on one side where the shallow water is. I was commenting to Horace on the pleasantness of the arrangement, when Billy said, "Yes, nice for cripples." He was unaware of his frightful gaffe until we got back to the studio. . . .

July 30: At the studio but worked little in celebration of the fact that Billy's option was taken up. . . .

August 4: Most of the morning spent listening to Billy, who read a copy of *That Certain Age* last night. Changes in it sound awful. Conference with Hornblow and Leisen on cast of *Midnight*. . . .

August 7: . . . most of the day was occupied by reading Bruce Manning's script [for *That Certain Age*], which seemed to me flat, dull and commonized. . . .

10. Horace McCoy (1897–1955), novelist and occasional screenwriter, whose best best-known work is *They Shoot Horses Don't They?* (1935).

August 8: Finished our current draft of *Midnight* in the morning. In the afternoon read the last sequence to Arthur, who liked it and was charming. Then wrote a letter to Joe Pasternak, asking to have our names not connected with *That Certain Age.* . . .

August 11: At the studio, getting the first sequence in line with the last. Lunch in commissary. Billy left early. Rosalie [Stewart] came for a call before going down to Manny's office to talk my deal. . . . At dinner Rosalie telephoned that the Paramount deal was through, which sets me for another year, praise be. . . .

August 16: Leisure this morning. Luncheon with the Perelmans, at which I got a little tight. Fortunately, snatched a brief nap before a conference which Arthur began charmingly: *Midnight* was the best comedy script he had ever had, save for the first eighteen pages. We had heard of his technique and so shuddered. . . .

August 17: . . . I read the script and Mitch and Arthur jumped on every line, rewrote a little, then to the Guild office to a meeting of the Shop committee. . . .

August 30: Went to the studio. A moment to tell Mr. [Adolph] Zukor I couldn't do an article which a letter from him had requested me to do. "Writers no longer starve in garrets but, thanks to the motion picture, etc." Found my apologies somewhat thwarted by the fact that he didn't know what I was talking about. Left the tiny, dim little man sitting in his enormous office, like a mouse in a cake box. . . .

September 1: . . . Thought of getting hold of David Lewis, whom I haven't seen for years, for dinner. Didn't, but dropped into the neighborhood drug store and there he was, asking me to dinner. Dined with him and Jimmy Whale, talked for an hour, then home.[11]

11. Subsequently, Brackett had Lewis and Whale for dinner at his house on September 10.

September 10: Went to the studio but had nothing to do as the script was at last being mimeographed in buff. Played some Word Games until luncheon time, saw Claudette crossing the campus and she said she had decided to do without hearing my burning interpretation of the script, would read it to herself. Tried to get her to have luncheon with me but she wouldn't—she had an engagement—so I ate with Harold Hurley, Al Lewin and George Cukor, who was magnificent on the subject of the child in *Zaza*, whom he tried to wheedle into giving a performance for three days, saying things which when overheard in the projection rooms caused convulsions—like, "See, I'm a Christmas tree." All to no avail. Finally he addressed the child, who was seven years old and only came to his hips, and said, "Look here, you're being stupid and idiotic. See, your mother over there is crying, and you've made me lose my temper and Miss Colbert lose her time. This is probably the most important hour in your life, because if you persist in being stupid and not paying attention, I'm going to get someone else to play the part." Whereupon he got a superb performance. . . .

September 15: At the studio all day, kibitzing. . . . Late in the afternoon I noticed a strange constraint in the atmosphere which finally was clarified when Billy told me they want him to stay on the script of *Man about Town*,[12] annoyed at the mystery but delighted at a respite from Billy and will work hard to see, if I'm a good boy, if it can't be made permanent. . . .

September 19: . . . met Charlie Feldman as I left the studio for Lucey's and Charlie said, "I like the script, but Claudette doesn't want to play it right now." I didn't take this seriously until summoned to Arthur's office later to be told officially. . . .

Came home very late. . . . We went to a [Screen Writers Guild] meeting with the Producers which began well, but broke up on their flat refusal to "bargain exclusively with us." Our questions clarified the fact that they intended to perpetuate the Playwrights and have them running perpetually with the Guild. When we heard, we left—left as Zanuck sat reading their counter-proposals at the top of his voice to the emptying room. . . .

12. First reference to this film, released July 1939; Billy Wilder's name does not appear in the credits.

September 20: . . . At noon Blumenthal [perhaps assistant director Richard Blumenthal] breathed a beautiful possibility—of Myrna Loy and Bill Powell in *Midnight*. Billy and Judith had had a night of practically busting up, so she came to luncheon today and they were very carnal over the consommé. . . .

September 26: A day of waiting for Claudette's decision. In Arthur's office all morning, listening to Hitler's puzzling speech, the voice scared and breathy at first, then getting into its demagogic stride. . . . Wrote letters all afternoon and got word at 5:00 that Claudette will not play and the whole thing is called off. . . .

September 27: . . . Billy called in the late afternoon to say Claudette was to play *Midnight* and it was to start at once.

September 29: Day out of hell. Good reviews for *That Certain Age*, which didn't depress me as much, strangely enough, as Billy. Horrible interview with Manny [Wolfe], who threw *That Certain Age* in our faces and the fact that Claudette has asked for other writers on *Midnight*, inquiring if we really wrote *Bluebeard*. Assigned to a first draft of a Jack Benny picture called *The Man in the Dress Suit*,[13] a welter of nonsense. . . . Lunched at the Brown Derby with the Wilders, getting Deems Taylor to join us and finding his presence dreadful.

Came home and read the nauseous Dwight Taylor script of the Benny picture. . . .

September 30: . . . a long conference with Arthur Hornblow at 2:15, wherein he told me of the hell Claudette had been raising about the *Midnight* script, the hell he raised back, the way she was forced into playing it or forfeiting her contract—6 pictures at $150,000 apiece, her request for [Claude] Binyon on the script. Binyon's revelation that she had done the same performance on *It Happened in Paris*, and the final result that Ken Englund is to do some rewriting, which is OK by me. Pleasant of him to have had the talk. . . .

13. Is this perhaps *Man about Town*, which Billy Wilder is working on?

October 11: A morning crackling with good story ideas. On Tony Veiller's invitation I called Johnny Lee Mahin and suggested his lunching with us at Little Hungary. This he did, expressing views which make any junction of the Screen Playwrights and the Screen Writers Guild extremely improbable. Went to the studio and had a conference with Harlan Thompson, as refreshing as a tepidly warm blanket. He now wants Beatrice Lillie on the picture, so we saw *Dr. Rhythm*, a wretched picture in which she seemed to us not in the least funny. . . .

October 13: Worked at my place today, making a little progress through the dim middle part of the story. Luncheon with Lubitsch at the Brown Derby. He gave me a copy of his new script, *Shop around the Corner*. . . .

October 18: . . . Went to a luncheon at 20th Century-Fox for [Harold] Ickes, the Secretary of the Interior. All the town liberals and some producers were there. I sat between Gloria Stuart, dressed as the Queen for the Three Ritz. Bros. version of *The Three Musketeers*, and Dudley [Nichols]. Had a very pleasant time, liking Ickes' homely middle-western speech immensely.[14] . . .

October 24: . . . *The [Hollywood] Reporter* carried a big headline "Brackett Named SWG Prexy." I find I hate seeing my name in the papers.[15] . . .

October 28: At the studio, still stuck. [Screenwriters] Gil Gabriel and Bob Thoeren stopped in in the afternoon to say that they had been asked to look over the *Midnight* script and suggest further changes and they felt our version looked like the improvement of the one Hornblow and Leisen have been working over. The whole episode not conducive to bright concentration on our next story.

Dined at home alone and went to *Suez*, which had the very Phil Dunnish characteristic of being both melodramatic and dull. It was in fact exactly like a report on a committee by Phil (he wrote the picture).

14. That same evening, Brackett went to another speech by Ickes at the Shrine Auditorium, but found it "literary and labored."
15. In fact, Brackett was not elected president until November 9.

October 31: . . . to the studio where I looked forward to another miserable day. Instead, found we were transferred back to *Midnight*. Had luncheon with Hornblow and Leisen, saw *Hands across the Table*, read the current revisions and really looked forward to this job. . . .

November 1: A day of Billy's opening his mouth and putting his foot in it. We did a few pages . . . in the morning, observed changes in *Midnight*. Had luncheon with Arthur [Hornblow, Jr.]. Billy was nasty to me, then disagreeable to Arthur, who bawled him out. We discussed story and Arthur called up Billy, annoyed because he'd advised [Francis] Lederer not to play the second lead, a fact he himself had told to Arthur's assistant . . . after a bite here at the apartment went to Westwood Village Theatre for a preview of Walter Reisch's picture *The Great Waltz*. Had to stand in line for about half-an-hour but got a fine seat and the prettiest secretary at Paramount came and sat beside me. I saw Billy and Judith come to the line, look at it in discouragement and drive away. The picture was swell—a triumph for Walter. . . .

November 3: At the studio, working like mad. Took a scene to Mitch and read it to him, getting a dead pan and the sourest of speeches, then took it to Arthur who liked it. . . . Worked all evening at Billy's not getting home until 12:00.

November 5: At the studio all morning, working and conferring with Arthur and Mitch. The conference had the great advantage that, desperate with boredom at all former versions, our new stuff sounded fresh and they liked it. Luncheon at Lucey's with Francis Lederer, a nice, grave, troubled, real so-young man who was nice and very boring about the script. . . . Dictated after luncheon, came home and thought I'd rest—but was wound up and wrote letters till dinner, then to Billy's and wrote till almost 1:00, interspersing a few games of backgammon.

November 7: At the studio working, harassed by Arthur for more stuff. . . . Visited by Francis Lederer in the afternoon and almost driven wild by his visits. A conference with Arthur and Mitch at 5:00 which lasted until 7:30 when I had to go to a Guild meeting which lasted until 12:00. . . .

November 10: At the studio. A delightful day, first reading the bedroom scene to Arthur and Mitch, who liked it, just as far as we liked it. Then, as we sat in Arthur's office, came a call from Claudette saying she couldn't start the picture tomorrow as scheduled since she had to have three inlays in her teeth! Arthur hit the ceiling. Why should she have waited till she was about to go into an expensive production before she discovered that! Her agent called. Arthur was being severe with Claudette. Arthur replied (he was bolstered with figures) that he was thinking of the stockholders—to have her delay would cost $17,000. He called [George] Bagnall, consulted [William] LeBaron. I had luncheon with Marian Spitzer. When I came back to the studio Arthur informed me Claudette had appeared with a statement from her dentist—and won. Met [John] Barrymore and [Don] Ameche in Arthur's office—Barrymore making Ameche blush with a ribald remark. Ameche extraordinarily naïve for an actor. Did over a scene which is to be in the picture. . . .

November 14: At the studio, Billy late and shaken when he arrived as he'd had an accident with his car. We went on the set and found Mitch delightfully cordial and Claudette in bed, looking like a tousled bronze chrysanthemum. Worked on the party scene. . . .

November 16: Worked over the party scene and waited around to read it to Arthur. Called on the set for a line, and one, by a prop man with cealogical implications, awakened such hilarity that it was put into the picture. Saw some rushes and we were both depressed by them. They seemed slow and Barrymore incredibly hammy. Read scenes to Arthur and Mitch at luncheon—a good deal of changing went on. . . .

November 28: A day of hell. Went to the studio and found they needed bridge lines. Got some bad ones. Billy had a headache and we accomplished nothing in the morning. Luncheon at the commissary, then an afternoon with Arthur, returned from his vacation and destructive of everything. . . .

November 30: At the studio, working on touch-up jobs. In the afternoon rowed with Billy (nerves snapping), then found an excellent cut for the second half. . . .

December 7: By morning I had despaired of leaving at 4:30. Came to the studio, dictated, consulted with Arthur [Hornblow] and Dick, saw some rushes with the company—good. At luncheon read the new A Seq. to Mitch and Arthur who liked it, with minor changes. Had a flurry of rushing between the bank and Arthur's office but caught the plane, Mitch sending me two splits of champagne for which I wired him thanks from the bottom of my serene stomach. Lionel Stander on the plane, talking the ear off myself and two other men on the subject of Spain. . . .

[Brackett arrived in Saratoga Springs at 4:30 p.m. the next afternoon. His diary gives no advance warning of this trip back East. On December 15, he goes by train to Boston, where he dines with Alexander Woollcott and Thornton Wilder and see the latter's play, *The Merchant of Yonkers*,[16] "a distressing play to me, all fake naivete, too, too great a desire to be funny." He and his family welcome in the New Year in Saratoga Springs "with our customary jump with gold in the hand."]

16. Opened in Boston, starring Jane Cowl and directed by Max Reinhardt, on December 13, 1938; opened in New York at the Guild Theatre on December 28, 1938; revised in 1954 as *The Matchmaker*, and subsequently the basis for *Hello, Dolly!*

1939

[Brackett travels by train to New York on January 3. There he meets with old friends, including Otto K. Liveright, John Mosher, Oscar Levant, and Ilka Chase. He leaves New York, by train, for Providence, on January 5. The diary recommences on January 16, 1939, when he is in New York, along with Billy Wilder. On January 18, Brackett, along with Wilder, his wife, and an oil painting they have purchased, boards the train for Los Angeles.]

January 19: Delightful day on the train sleeping late, playing three-handed cribbage with Billy, some word games, a light luncheon nap, tried to get Billy to work but he wouldn't.

[On January 21, Brackett arrives in Los Angeles at 8:00 a.m., breakfasts at home, and then heads for the studio: "at two saw the rough cut of *Midnight* which seemed to me an entertaining medium sort of picture—excellent performances by Don Ameche and by Claudette. . . .". He and Wilder begin the next day on the script for *What a Life*, directed by Jay Theodore Reed. Most of the entries in the diary through March 4, when Brackett reports, "finished the script this morning," are taken up with the mundane matter of writing the script.]

January 26: At the studio discussing the story all morning. . . . At two Billy and I went to see Ted Reed—Billy as is our habit began to do the talking. The first thing he said was "we have found something of the girl" and went into the Routine—which pleased Ted Reed immensely. . . . Sheer psychic hunch

on Billy's part. After the conference, which was over early, couldn't get him to work so I came home. . . .

January 28: . . . at the studio all morning but did exactly one paragraph as Billy thought he was having appendicitis and had a doctor come. . . .

February 6: . . . At the studio at 8:30—Oblath's at least—where I had breakfast. . . . Billy and I were seated with the script until 11:30 when Ted Reed called down. Went with an unusual feeling of confidence in the script and found that he liked not one comma of it. . . . In the afternoon we were supposed to go on until Ted made an outline of what he wanted—we went as far as we could. . . .

February 7: . . . At 10 we went to Ted Reed's office and he handed us a few typed pages which wiped away our tears—they were so unbelievably dull and awkward. . . .

February 10: Quarreled quietly with Billy most of the day—I being irritated because he had what I considered a light case of snuffles & he diagnosed as incipient pneumonia. Worked from nine till 12 and in the afternoon had a long conference with Ted Reed reading him what we've done. . . .

February 11: . . . Got a telephone message from Ernst [Lubitsch] asking Billy and me to his house and went after taking a brief nap. There he gave us a brief and prejudiced summary of the script that has been done for him—*Ninotchka*—he felt it very bad. He gave us the script—we came to my place and read it and the dialogue is enchanting and the situations—halfway through (as far as I've gone) excellent.

February 12: In the morning Billy and I finished the *Ninotchka* script and discussed it. [After luncheon] I had to go to Lubitsch's to meet Ernst and Billy, then to Bernie Hyman's for discussion of the story which lasted until six.

February 14: ... to Long Beach—in separate cars to the preview [of *Midnight*]—it went miraculously well, better distributed laughter than in *Bluebeard*—though the picture is inferior to *Bluebeard* in style. ...

February 15: ... Mitch [Leisen] particularly ecstatic over the picture—says he never felt so nervous before a preview as he has made two stinkers in succession and that this unsuccessful one would usher him out of the business. ...

February 20: Arrived at the office at nine. Billy arrived a few minutes later with a small wooden Bulgarian flute which he played all day. Had a pleasant conference with Ted Reed—felt the need of proceeding with more speed and when Billy played his flute I took it and smashed it across my knee. Billy's face turned scarlet, he rushed from the room and came back in a very bitter mood. ...

March 2: ... Tea with [F.] Scott Fitzgerald—newly come to the corridor. He seemed burned out, colorless, amazing when one remembers the blaze of his youth. ...

March 4: Finished the [*What a Life*] script this morning. ... [There were later meetings with Ted Reed regarding the script and rewrites on March 9–11.]

March 8: ... went back to the studio and worked with Billy until five, a little scared by the fact that Billy's luck was so good. He got his raise, he got his option taken up, he got his job which Lubitsch promised him. ...

March 13: Went to Metro [to work on *Ninotchka*] at 10 and worked all day with Ernst, Billy and Walter Reisch—didn't really work—recorded their struggle. ...

[Work on the *Ninotchka* script continues off and on through July.]

March 21: Studio all day planning future scenes more than writing present ones. . . .

March 24: At the studio sweating at the boy meets girl scene—Ernst very nervous and a good scene finally accomplished. Hedda Hopper called up to ask if Ellen [Hunter] was a member of the [Screen Writers] Guild why should she have been scribbling notes all through the meeting [which had taken place the previous two days]. A dangerous labor agitator you know.

April 3: At the office all day—with Ernst and Walter pounding away at each other with Teutonic stubbornness. After luncheon Ernst presented us each with a chocolate Easter egg in apology for his behavior. . . .

April 4: At the studio from nine until four—the story going badly—perhaps due to Walter's [Reisch] sad face—he being allergic to jokes. . . .

May 4: . . . In the morning had the ecstasy of hearing through the office window, Louis B. Mayer who stood outside giving tips to Mickey Rooney on the character of Andy Hardy—incredible words issues from L.B.'s shark's mouth, "I see him with a heart as pure . . . as a girl's, but burning with Americanism . . ." The kid stood, properly abashed that an elderly party should be making such a spectacle of himself . . . [ellipses in original]

May 8: Long day at the office. Billy thought he had tumor of the brain and spent the afternoon being X-rayed.

May 10: Day at the studio, Ernst distant and little progress, all tired and watched the clock constantly.

May 18: Worried about Billy's nervous breakdown which seems to be serious. He plans a trip away for a couple of weeks. Fear from Judith's attitude that he may have had a suicidal attack.

May 20: Billy appeared for a moment [and returned to work on May 22] but I continue to think his condition grave. . . .

May 31: At the studio and on the set at 10; Miss G [Garbo] not present as she fell off the roof and will be out for four days. . . .

June 3: My last day on *Ninotchka*—took my typed suggestions for changes to Ernst & got some words of praise from him which were very sweet to me. . . .

June 5: Back at Paramount at 10 o'clock—but 10:03 assigned to do a week advisory & touch up work on *Portrait in Diamonds*.[1] . . . Spent the day reading the script—which is pretty bad.

June 12: . . . Had a call from Ina Claire, asking me to stop in on my way home—she talked about various changes she wanted made—told her I'd telephone Lubitsch—that if he wanted me to spend an evening with Claire & update the changes she wants in a memorandum I would do so, but she must guarantee to play the part. . . . When I called Ernst he roared, "Tell her I don't want her in the picture. She's trouble . . ." [ellipses in original]

[The next day, Brackett records that Walter Reisch had told him that Mady Christians was to play the part, to the sorrow of both him and Wilder. Ultimately, the role of the Grand Duchess Swana in *Ninotchka* was played by Ina Claire.]

June 24: . . . went to Metro with Billy & saw the stuff shot for *Ninotchka* which is lovely though Garbo looks less radiant than she should. . . .

1. Released April 1940 as *Adventure in Diamonds*; Brackett and Wilder receive no screen credit. Brackett and Wilder worked on the script through July 22. Brackett records finishing his work on the script on July 22.

July 7: Worked on the bedroom scene [*Adventure in Diamonds*] all morning, some of the time in the outer office of the dentist who was filling Billy Wilder's teeth. . . . Came back to the studio where I completed the scene and read it to him before going . . . through the script with Miss [Isa] Miranda—for lines she found it hard to pronounce.

July 9: . . . Took Billy to a Dr's to deliver a package of excrement—his [diarrhea] is now galloping away. . . .

July 12: . . . Arthur [Hornblow, Jr.] related the success of *Midnight* in Paris and that [Sacha] Guitry said he'd like to work with me—when Arthur suggested my name as a possible collaborator for picture on a deal that fell through. . . .

July 16: Discussion of a new assignment with Billy—read him *Shall We Join the Ladies?* [a 1928 play in one act by J. M. Barrie]. . . .

July 19: Went to Metro carrying an additional Swana speech . . . waited on the set long enough to have a glimpse of Garbo . . . and found her a little haggard-looking. . . .

July 24: Reported at Metro and spent the day reading the three Noel Coward plays aloud to Billy plus the outline Jacques Théry had made of the three, which was terrible. [Brackett read another Coward play to Wilder the next day.]

July 27: Day at the studio trying to work on *Ninotchka*. Violent quarrel with Billy whose manners are [words have been scratched out] & from whom I fear I shall have to part company, much as the thought of working alone now terrifies me—reconciliation—but I doubt the value of any reconciliation with him. Conference with Lubitsch at five.

August 2: Finished the *Ninotchka* rewrites and crawled over to Paramount to bootleg . . . advise on a story Arthur [Hornblow, Jr.] considered buying for us—a story about a town on the Mexican border in which foreigners unable to get visas or quota numbers live. We read it in Bill LeBaron's office, were much moved, & recommended it enthusiastically.[2]

August 9: At the studio the story jelling in the most unexpected manner—jelling so well that Billy took 3-1/2 hours for his lunch period. . . .

August 13: Most of the day at the studio spent trying to find a title for *Ninotchka* —"A Kiss from Moscow" now favored. . . .

August 19: . . . went to Pomona to the first sneak of *Ninotchka*. Never saw Ernst so nervous as he was at supper and on the way out—the picture began slowly, then caught on and went well with a lively audience lots of kids there—like a house on fire. . . .

August 21: Much progress on H sequence. . . . Saw Jimmy Roosevelt for a brief interview regarding a Code of Ethics he may draw up for the producers. He asked whether the Guild would cooperate with him if he were called on to do so. I agreed. . . .

August 26: . . . out to Long Beach for a second and disappointing preview of *Ninotchka*—possibly the changed situations weight against it [the Russian-German pact in Europe], possibly some bad cuts, but the response was not enthusiastic. . . .

2. This would appear to be the Ketti Frings story *Hold Back the Dawn*, which was directed by Mitchell Leisen and scripted by Brackett and Wilder for September 1941 release.

September 1: Billy *hors de combat* with justification as his mother is in Cra-kow—reported under [Nazi] bombardment . . . and his grandmother on the Polish border in the line of German march. He and his friends spent most of the day listening to the radio. . . .

September 2: At the studio almost completely kept from working by Billy's feeling that Poland had been betrayed by England—which announced itself as waiting for a reply to an ultimatum. . . . As we came home, we learned that the reply to the ultimatum was due at 2 AM our time [midnight in Lon-don]—evidently no reply from Germany has been received. . . .

[Brackett reports hearing Neville Chamberlain's declaration of a state of war between England and Germany on the radio that day, but the speech was not broadcast until 11:15 A.M. London time on September 3, which would also been September 3 in Los Angeles. That same day, the *Athenia* became the first British ship to be sunk by the Nazis. On board was Lu-bitsch's eleven-month-old daughter Nicola, whose safety was confirmed on September 5.]

[Brackett's diary reports continuing work on script, which must be, one as-sumes, *Ninotchka*, despite its already having been previewed.]

September 11: A workless Monday. Called to Bernie's office. Bernie [exec-utive Bernard Hyman] informed us he had read the sequence and was sick—because he couldn't have us. We said it might be worked. Bernie and Sydney went to a Producers meeting. We had an idea and interrupted it to propose that we offer Paramount an extension of our contract for the remainder of the job. After the meeting it was suggested that we go to Paramount with that suggestion. We did so. Found that Pinky Langton had no objection to let-ting us stay if Arthur would. We lunched and Word Gamed at the table. Billy had an inspiration and telephoned Bernie to telephone Arthur Hornblow, with the result that L. B. Mayer himself telephoned Arthur and an extension for 3 weeks was arranged. Went back to the studio exhausted with intrigue. Watched *Ninotchka* being scored. . . .

September 12: At the studio, doping out Sequence B. At noon all of us who sit usually at the [Frances Goodrich and Albert] Hackett table went to Dave Chasen's to a luncheon gotten up by George Opp[enheimer] to surprise the Hacketts. It was very good fun, though Frances astounded me by saying sadly that she was sure Germany was going to win the war. At the studio till 5.

September 15: . . . Got a letter from poor Cora Witherspoon asking for a loan to get her back to New York—she's been refused by the M.P.R. [Motion Picture Relief Fund] because she refuses to take a cure for her drug habit. . . .

September 16: . . . At the studio was greeted by the word that [Sidney] Franklin wanted to see me. Rushed upstairs to find that all he wanted was to be reminded of the book I had mentioned to him as a good vehicle for Greer Garson, *A Lost Lady*.[3] Billy and I worked on the one sequence between the lovers on the terrace, a revision of Sequence A. . . .

[Later that day, Brackett drives his wife to Pasadena, where she takes the train for the East Coast.]

September 18: . . . At the office, finishing out changes in Sequence A. Completed an outline for A, read our changes and discussed the outline with Franklin. Had luncheon at the [Writers] table next [to Aldous] Huxley, asked him if he would dine with me. He said he wasn't dining out, which served our hero-worship right. Worked in the air-conditioned office to which we moved when we found the bungalow unendurable, until 5.[4] . . .

September 22: Boiling hot still. Worked feverishly to get our sequence laid out before 4 o'clock, when we had an appointment with Franklin. . . . Got the sequence blocked out and had a highly successful conference with Franklin. . . .

3. Presumably the 1923 Willa Cather novel.
4. Los Angeles was experiencing a heat wave, with Brackett recording a temperature of 112 degrees on September 20.

[That evening, daughter Bean leaves by train to join her mother in Saratoga Springs, New York.]

September 23: At the studio all morning, but no work at all from Master Wilder, who resents going to work on Saturday. . . .

September 25: Worked all day with some success. Drove George Cukor, whom I met coming out from the studio, home. Had one of Stella's[5] wonderful dinners and went to a Guild meeting, which began badly with John [Howard] Lawson, who was one of the anonymous members who put the advertisement in *Variety* and who came acting injured and showed him the bulletin had been unfair to the members. Went on to discussion of the Labor situation. I have omitted to state I was called from my luncheon at Metro to Eddie Mannix's office where Eddie and [Y.] Frank Freeman talked nervously of the Labor situation, a strike threatened by IATSE. What would our members do? I said I couldn't speak for our members but I myself would walk through the picket lines of a racketeer union gladly. They shook their heads over war conditions. We discussed the general situation at the meeting, resolved to try and get an Inter Talent Council meeting. I went to the [Elliott] Nugents to a party to greet the [Robert] Montgomerys—Bob excited about the situation, rarin' to take the helm [of the Screen Actors Guild], George Murphy, James Cagney, Elliott and John Cromwell all agreeing.

September 26: At the studio working, save for the lunch hour, which we spent at Lucey's lunching with Arthur [Hornblow, Jr.] who told us our next assignment. . . .

October 2: A day of good work, rewriting a scene which was dull. . . . Dinner at home with Carter Lodge, a Guild meeting notable for the appearance of a member with a persecution mania who pronounced the sentence, "Gentlemen and Miss [Mary] McCall, I've been coldcocked by the producers." . . .

5. Stella Greene, who had first worked for the Brackett family in Providence, Rhode Island. She has been described as "a tiny wizened creature with the patience of Job and the technique of a four-star chef."

October 6: Microscopic progress. Luncheon with Jane Murfin and George [Cukor], the Atkins, Kay Francis . . . went to the official preview of *Ninotchka*. It seemed to go all right. Not the heart-warming laughter that greeted *Midnight*. Marc [Connelly] actually reserved in his praise. Kay somewhat reserved but charming about it. . . .

October 7: Went to the studio early, as I'd agreed with Billy, before I had breakfast, and we breakfasted in the commissary, reading reviews, which were wild raves. Eddie Mannix called me then to give his congratulations and all morning our office was filled with congratulators, or the voices of congratulators telephoning. Lubitsch appeared beaming. I had luncheon at the table with Billy and Don Hartman, went to Paramount to pick up my mail and get a letter from Poland which had arrived for Billy. Billy knew it was there but was too anxious to get to the football game to get it. . . .

October 8: . . . Marc Connelly and Garson Kanin came to luncheon. Garson left shortly thereafter. He made one very wise comment on *Ninotchka*, saying that Garbo got a little more than was in her role and Melvyn Douglas a great deal less than was in his. . . . Find myself hellishly depressed.

October 9: . . . Worked all day and further discussed the possibilities of becoming a Writer-Producer unit. Talked to Rosalie [Stewart], who seemed to think it feasible and advisable . . . then a Guild meeting with statistics from the various studios on writer-employment, more encouraging that we thought. . . .

October 11: Another day of good work. Was dictating in Lubitsch's office when Maggie Sullavan came in. I said, "What a swell script you have." She pretended to think I was planted there by Lubitsch as she had come to complain it was dull. . . . Found I'd forgotten Ernst's *Shop around the Corner* script which I was supposed to read. Drove out to the studio, picked it up, came home to dine gloriously alone. Finished reading the script and went to *Nurse Edith Cavell*, which left Nurse Edith Cavell exactly the same good, wooden little figure she had been in my imagination before.

October 12: Billy at home ill. I got the script revised up to date and just started to write ahead when Ernst Lubitsch came in and visited for an hour before we drove out to Warner's to lunch with Harry Warner and discuss plans for the Community Chest Campaign. Ralph Morgan, [J. P.] McGowan[6] and I represented the guilds. Had never met Harry Warner before and liked him, amused by his comment on Labor, "That's what gave me my ulcers." Back to the studio, dictated, had my hair cut, came home and napped. To the Atkins', to the Beachcomber [Don the Beachcomber] to dinner with the Wells Roots, thence to a meeting of the Anti-Nazi League, which was supposed to make startling revelations and made the Anti-Semitic propaganda it reported seem childish and futile. Refused to contribute and went with the Paramores to [C. C.] Brown's for lemonade.

October 16: Read *Ways and Means* [presumably the poem by Lewis Carroll] on arriving at the studio, then went into conference with Franklin, who was a little jubilant. "You must hurry this up, boys. I'm getting married, really I am." He has a trick of forgetting writers' names. In the afternoon he said to Billy, "What do you think, Hans—I mean George." Later he said to me, "Hand me that, Walter." I had one of my curious, brief brainstorms and said, "My name is Charles Brackett—Charles. If you call me anything else I go through that door and never come back."

October 18: A grim day, starting with a conference with Franklin wherein he bemoaned the fact that he'd driven us with too loose a rein, a conference which moved to Bernie Hyman's room, to find that he disliked all our suggestions and substituted a half-witted one. A flutter of mystery about the script of *Ninotchka*, Franklin sending out the last Franklin script, Bernie the completed script. "An unpleasantness has arisen." I pictured credit protests. All afternoon we were supposed to see Hyman and didn't, kept waiting until 6:00, then home to a brief nap and my dinner clothes for a birthday party at Miriam Hopkins'. . . . At the party Ernst explained to Walter and me the *Ninotchka* mystery: . . . a Berlin stage director was looking desperately for a job. Ernst suggested that Hyman send him the Franklin *Ninotchka* script to see if

6. J. P. McGowan (1880–1952), former actor and director, executive secretary of the Screen Directors Guild, 1938–1951.

he had any suggestions. He sent back a letter of generalities, and seeing the picture claimed that his stuff had been used and he not given a job—complete drivel.

October 20: Back at Paramount. An agreeable conference with Arthur, who asked me to read a couple of things over the weekend. . . . In the afternoon wrote out our outline of *We Were Dancing*[7] and went to Metro and dictated it to Evelyn. Came home and changed and went to the Lubitsches for a small dinner. . . . Drove Claudette [Colbert] home. . . .

October 21: At the studio most of the day, reading the expanded treatment for *Memo to a Movie Producer*,[8] which is not as good as the original. . . .

October 23: A long conference with Arthur wherein it was decided that Billy and I should do construction on *Battalion of Death*[9] for a week, then move on to *Memo*. . . .

October 29: . . . In the afternoon finished Christopher Isherwood's *Mr. Norris Changes Trains* and began *Imperial Twilight*.[10] Went to see *M* and found it disappointing after all the raves I'd heard about it. Not fair to see a "great" picture after seven years. . . .

October 31: At the studio, work somewhat interrupted by the consummation of a sale of an original by Billy and Jacques Théry called *Ghost Music*, a sale involved by the fact that they thought the agent who arranged it and cashed the cheque was a crook. . . .

7. Released by MGM in April 1942; Brackett and Wilder receive no screen credit. It is based on various plays by Noel Coward, to which Brackett makes earlier reference.
8. Released as *Hold Back the Dawn*.
9. Unidentified and presumably unproduced.
10. The following evening, he entertained Isherwood for dinner at his house.

November 1: A curious day, devoted to good works. In the morning we worked at the script but became so interested in a story Tom Monroe and Brian Marlowe are working on that we completed it in our own way and told it to Arthur, who was extremely interested. Lunch with Bill Edwards of the Publicists Guild, hearing their troubles and advising him. In the afternoon Arthur asked me to write some stuff for the Polish Relief Fund. Then I had to work on some Community Chest copy sent out by [Harry] Warner. . . .

November 7: Voted on the way to the studio. . . . In the afternoon worked and had a conference with Arthur. Haircut, shave, then home until George Cukor called for me and took me to the Beachcomber, picking up Vivien Leigh and Laurence Olivier on the way. Other guests were Mr. and Mrs. Aldous Huxley, their niece, and Anita Loos. Found Mrs. Huxley particularly charming.[11] After dinner we went to *The End of the Day*, a French film at Esquire, about home for old actors, very . . . charming. Afterwards George and I stopped at the Leigh-Olivier ménage for a few minutes before coming home. . . .

November 9: Went to the studio exuberant with release, to find a "touch" from Cora Witherspoon in New York and one from [actor] Merril Matheson, which took the edge off the morning. Worked at the letters which Arthur wanted, explaining our changes for *The Battalion of Death*. . . . Finished the letter to Arthur. He was pleased with it. . . .

November 10: Drove with Billy to see to his naturalization; to the studio to get our assignment, to Al Levy's for an Inter-Talent Guild Council. Five directors, five writers, two actors. . . .

November 11: At the studio, Billy and Walter Reisch asked me to help a refugee in Providence get a job, and I wrote Elizabeth on the subject. . . .

11. In later years, Brackett added the note, "wish more about the dinner"—a sentiment we might all echo.

November 18: . . . Dined at Claudette and Joel's [Colbert's husband, Dr. Joel Pressman]. I arrived promptly at 8:00. Mary Taylor a few minutes later. Then Vivian and Ernst, whereupon there was a concert long even for Hollywood, and finally Joel telephoned the Hornblows, who had been asked and accepted but forgotten and eaten their dinner at home. Claudette was angry, Vivian indignant. We went out to dinner. Arthur called, asking if they might come after dinner. Yes. But Vivian had discipline in her eye. They arrived. Arthur stayed with the men, but poor Myrna [Loy] had to join the women. The men talked a long time together and then joined the ladies. Myrna has survived her gauntlet very well. We talked. I stopped talking, started glancing at my watch. Two o'clock came. The Pressmans were dim with fatigue. Arthur talked on, just talked on. At 3:15 we broke up and came away.

November 20: At the studio, chipping away at *Triumph over Pain*.[12] Am reminded that *The Hollywood Reporter*, my enemy sheet, had a headline "Pain for Brackett."; the *Daily Variety* had one "Triumph for Brackett." . . . went to a long, tautologic meeting of the [Screen Writers] Guild board, most of which I spent writing a Community Chest letter. . . .

November 24: . . . Luncheon with my dear Ruth Waterbury at Perino's. She told me that she had some paragraphs in her editorial for *Photoplay* crediting Brackett & Wilder with part of the success of *Ninotchka*; was pleased but asked her to strike it, for mixed reasons of truth and policy. . . .

December 5: Arthur back. Waited around to see him all morning. . . . In the afternoon read Arthur my stuff. He was extremely enthusiastic. I was pleased. Later stopped in at Tony's to take him to tea. He informed me exuberantly that I would be on *T. over P.* long as it wasn't to be made, to my infinite depression. . . .

December 6: . . . Brief, pleasant conference with Arthur in which I got him to let Billy work with me for a week, for Billy's sake and the sake of speed. . . .

12. Released as *The Great Moment*.

December 12: A day of rewriting Preston Sturges' part of the script [*Triumph over Pain / The Great Moment*] and finding it so excellent that nothing had to be done save compress it, which is always saddening. . . .

December 14: At the studio, working like a fiend until plane time. Luncheon at the commissary, a final conference with Arthur [Hornblow, Jr.], delayed by the presence of [Charles] Boyer. Finally saw him. He was enthusiastic about the final scene. Went to the airport. . . .

[Brackett flies East for the holiday season and a reunion with his wife and daughters; he arrives in New York at 11:25 a.m., the next day, and takes the 12:03 flight to Boston, where he gets a train for Providence.]

1940

January 11: A depressing day at the studio of listening to Jacques Théry go over and over various storylines. The ghost of Keene Thompson[1] seemed to have risen from his grave. Luncheon at the commissary with conversation and no word games. More conference until 5, when Billy and Jacques began to play Casino. . . .

January 12: At the studio working hard and with some success at opus till a telephone call from Pinky informed Jacques that he was to be off on Monday and we were to go back to *Polonaise*. Billy and I streamed down to Bill LeBaron, who said he wanted to keep us but he couldn't snatch writers away from Arthur. We went to Arthur and it seemed Billy had promised him to urge me to do *Polonaise* rather than *Ghost Time*. Left defeated. Dined at Dick Halliday's, a big, dull dinner made enchanting for me by the presence of Kenneth MacKenna's mother, Mrs. Mielziner, an enchanting elderly woman,[2] and Dame May Whitty, also the guest of honor, Margaret Webster. We had to wait a long, long time—till 1 o'clock, to be exact—before Mady [Christians] and other members of the *Hamlet* company came in to supper.

[The diary is missing for the period January 15 through August 5, 1940. From April 5 through August 14, Brackett is on the East Coast, visiting Saratoga Springs, Providence, and New York. On August 14, he leaves by plane for Burbank, but it is diverted by fog and lands at Long Beach the following day.]

1. Keene Thompson (1885–1937), actor turned screenwriter, largely associated with Paramount, where his last film was *Artists and Models* (1937).
2. Ella Lane McKenna Mielziner, a successful writer and contributor to *Vogue* magazine.

[The diary does survive for the remainder of the year, but there is no transcript and it has proved difficult to decipher the majority of Brackett's entries.]

August 19: Unprofitable day at the studio discussing [Charles] Boyer possibilities.

August 21: . . . Lunching with Goldwyn, who wants us to do a picture for him—and was very friendly in discussing our work—a frankness I did not return in regard to his recent product. . . .

October 12: At the office Billy very averse to work, finally said It is the punishment of God on a Jew for trying to work on Yom Kippur. . . .

October 28: . . . Billy left to San Francisco this evening for the game. Dined at the Goldwyns with Elza and Edwin Schallert[3]—a delicious dinner—Edwin gave lecture afterwards through which I slept.

[Many of the entries in November, such as those for November 28 through 30, repeat the word "sterile" in reference to the work day.]

3. Elza (1892–1967) and Edwin (1890–1968) Schallert, parents of actor William Schallert. Edwin joined the *Los Angeles Times* in 1912 and was its film critic and film editor from 1919 to 1958; his wife Elza was a fan magazine writer.

1941

[On January 2, Brackett makes the first reference in the diaries to James Larmore, whom Xan has invited to dinner. On January 25, Brackett notes that Larmore is staying with the family; and there are frequent mentions of his trying to obtain acting jobs for Larmore at Paramount.]

January 3: Went to the studio thinking we would start to work. Billy had attitude all day, and we did nothing but dictating. . . .

January 6: . . . At the end of the day, Gary Cooper came to the office to be told the story *A to Z*.[1]

January 15: At the studio from nine in the morning until eleven at night. Making real progress on the script. . . .

January 18: Billy arrived at the studio pale, haggard—eloquent and sleepless. He had gone to see *Night Train* and glimpsed *Second Chorus* and [costar] Paulette Goddard had kept him awake. He was all for refusing to finish the script. . . .

January 20: A day of adjustment to our new assignment at Goldwyn's . . . Stopped at Billy's & rode to the bleak, chilly studio with him. . . . Read through

1. First reference to *Ball of Fire* under this title.

his original *A to Z* & got offices & a secretary, had an interview with Goldwyn in which he told us that *Arise*[, *My Love*] had been very much criticized. . . . He said he wanted nothing that could be criticized. I said that was simple, complete mediocrity would do it. He worried we would quarrel. I said Sam, the floor of this office will run red with blood. . . .

January 22: At the Goldwyn studios all day, save for luncheon at the commissary at Paramount, accomplishing nothing. . . .

January 23: . . . still nothing accomplished. . . .

January 24: At the studio all day working like crazy. . . . Dined at home and after dinner went to Billy's where we worked until midnight.

January 29: At the studio reading *Arsenic and Old Lace*[2]—the first excellent act aloud to Billy, and seeing *Tall, Dark and Handsome*—a very entertaining B picture. . . . Tea with Goldwyn and a sketchy conference. . . .

February 2: At Billy's suggestion met at Mitch Leisen's at nine o'clock. Billy turning up at 9:45 for further conferences on *Hold Back the Dawn*—conferred until about twelve when we disbursed. . . .

February 5: At Goldwyn's all morning, discussing *A to Z* and cutting *Dawn*. Lunched at the Paramount commissary and dictated our changes, back to Goldwyn's . . . back to Paramount to dictate. Then to Lucey's for dinner. By that time, I had begun to feel lousy, and sat by the fire apart from Billy and some merry friends at the bar . . . went to Paramount where we discussed the ending for *Dawn* until eleven. I felt as miserable as I have ever felt in my life and contributed less than nothing. . . . Crawled to my room and my castor oil bottle.

2. Brackett finished reading it the next day.

February 6: Awoke feeling far better than I had any right to expect, but stayed in bed drinking liquids and working on my income tax records. Got a call from Olivia De Havilland who likes the script and thinks she's set for it.

February 7: . . . to Goldwyn's where Billy and I sat really trying to concentrate on *From A to Z*. . . [Playwright and screenwriter] Howard Emmett Rogers called me to help him start a committee to get some ambulances for England,[3] and later Sam [Goldwyn] summoned me to write a speech for Tyrone Power to thank those helping in the Greek Loan Relief broadcast. . . .

February 9: . . . to a conference at Mitch Leisen's . . . the stormiest ever. Billy's idea for the frame of the picture being turned down & some reviewing requested—we rather successful in getting over the idea I have nurtured which was balm to my ego which has been badly battered by his wildly changing ego lately. . . . Back to Mitch's to discuss until five, when we separated to utter confusion. . . .

February 11: At the studio by 9:30 and worked completing the Goddard-Boyer meeting. Took it to Paramount and had it typed, then drove out to the Warner studios to a luncheon for the Special Awards Committee of the Academy—suggested [journalist and World War II correspondent] Quentin Reynolds for a special award [which he did not receive], voted against Gene Autry . . . and for the man who photographed the Tacoma Bridge.[4] Back to Goldwyn's, accomplished nothing in the afternoon. . . .

February 15: At Goldwyn's discussing the sequence all morning. Joined by Jacques Théry who was . . . yesterday getting his final citizenship papers, an advance, $12,000 for a story and a contract at $1,000 a week. . . .

3. Brackett has a luncheon the following day with various individuals to discuss the matter further.
4. Barney Elliott, who photographed the 1940 collapse of the Tacoma Narrows Bridge using 16mm Kodachrome.

February 22: Worked at U.A. all morning. . . Went to Paramount to *Dawn* stage where we heard [character actor] Walter Abel giving a coloratura reading of Hammock which sickened us . . . to the projection room where we saw rushes. . . Goddard pretty good. . . .

February 24: At Goldwyn's all day—most of it searching for the right slang word for our Professor to read. . . .

February 26: Lazy day. Lunched at Paramount where I saw yesterday's rushes, sitting with Olivia who made a pretty picture of nervousness, and said she found it difficult to act with Boyer because he was so terribly attractive. . . .

March 1: At Goldwyn's all morning, arrived finally at a slang word for the picture which satisfies us both: hoytoytoy. . . .

March 5: Wrote *A to Z* until Billy was called aside by the Orsatti Brothers[5] who wished to proposition us—suggesting . . . that they would buy up Rosalie's [Stewart] contract. They are gangsters—the least respectable of the agencies, and nearest to which we need. We are now considering the matter. . . .

March 6: Hard at work at Goldwyn's all morning but angry at notice of the *Dawn* credits—"Screenplay by C.B. and B.W., from a story by Ketti Frings."[6] Lunched at Paramount, Billy at Lucey's, where he ran into [Charles] Boyer who was shabbily dressed. Billy (in his accent) asked what scene they were doing. . . . "The cockroach scene?" suggested Billy. "I don't like cockroaches. We are not doing the cockroach scene."[7] "It's in the script, isn't it?" Billy asked. . . . I had heard from Joe Sistrom of Boyer's refusing to play a scene where he or-

5. Orsatti Talent Agency, run by Al, Ernest, Frank, James, and Victor Orsatti.
6. Brackett and Wilder claimed not to have used Ketti Frings's story as the basis for their film.
7. The scene involved the Boyer character talking to a cockroach in a hotel room; it was not filmed.

dered [the fish] pompano because he didn't like pompano and couldn't put his heart into it. I suggested a maneuver and we announced, "No cockroach scene, no end of the picture, and not just a casual cockroach scene, a well done one." Mitch got mad—fumed. "I don't think it's such a charming scene." We yelled at him, "It's not supposed to be charming. You've shot the charming scene . . . this is a lump of black in contrast to that." Back at Goldwyn's and worked until Ernst called us to join him for coffee, told us that he is signing a three-year contract with Twentieth Century and doing as the next picture before that contract starts—*Margin for Error*.[8]

March 7: Stopped at the Orsatti office on my way to the studio, was depressed by the striking mausoleum décor and the "Where do you buy the beer?" gangsterism of Orsatti, though he seems to me to have a kind of vitality which might be needed. At the studio learned that Boyer had not made the cockroach scene and started to raise more woe. . . .

March 8: At Goldwyn's all morning accomplishing very little. . . . Billy and I went out to Leo McCarey's. Billy told *A to Z*. I read as much as we have done. It didn't go very well with McCarey. . . .

March 10: Hell of a day. An angry call from Goldwyn in the morning—we were dedicating the whole day to cleaning up *Dawn*. We began at nine in the morning and finished at Paramount at 3:15 in the following morning. Luncheon a sandwich at the Goldwyn coffee shop, dinner a snack at Lucey's enraged by the fact that Boyer was there and Billy wouldn't speak to him, embarrassing me. . . .

March 11: Slept very little—getting to Paramount at nine and going over the stuff, before Billy and I went over it with [assistant to the producer] Dick Blumenthal. Billy called the studio only to learn Mr. Goldwyn had called. He said we would come right over . . . we raced expecting a dressing down. Goldwyn was charming, liked our stuff very much, as did Frances [Mrs. Goldwyn]. . . .

8. Filmed by Otto Preminger in 1943.

March 17: . . . a call from Goldwyn demanding a new title which we haven't. . . .

March 20: Wrote hard. Lunched at the studio, Claudette joining the word game at the writers' table and throwing everyone off string. I had the worst score ever. . . .

March 21: At the studio working hard—but not accomplishing anything. Billy's terrifying neurosis that everything isn't crystal clear to the audience coming out very strongly. . . .

March 27: In the morning . . . the last sequence for *Dawn*, took it to Leisen's to read to Arthur and Mitch in its entirety—They didn't like it at all. Worked on it all afternoon—but unable to give it the drama they seem to want. . . .

March 28: Got the last sequence of *Dawn* completed—satisfactorily to Arthur and Mitch.

March 30: A day on which I expected to work—but Judith called to say Billy was "having a nervous breakdown" to my horror & relief. . . .

March 31: My little Manic Depressive had one of his depressing days. . . .

April 1: All morning discussed the continuity of our story nervously. At noon, we went to RKO & the dressing room of Ginger Rogers, waiting there till she came from the set—We had luncheon together, she on a coffee table before a couch. Billy and I on a card table, then Billy told the story of our picture, after which I read her the script as far as it goes—she seemed to like it pretty well, and the idea of playing with Cooper better. . . .

April 2: Tried to digest the addled plot we told Ginger and found it more and more indigestible. Lunched at the table at the commissary & found Claudette sitting there playing the word game. In the afternoon, Sam [Goldwyn] telephoned us to tell Leland [Hayward] the story, which we did. Sam's explanation was difficulty with Ginger—she wants to play a lady. I tell him ladies stink up the place. . . .

April 3: A humiliating day—Leland called to say Ginger would not play the girl. . . . Billy suggested a consultation with Ben Hecht which Sam arranged for tonight. . . . Very kind & made some suggestions. There is a fifty fifty chance that Billy will be well launched in a nervous breakdown by tomorrow.

April 4: Wrong about Billy's breakdown—he was on time and fairly gay—we discussed story, worked a little on a scene for *Dawn*. . . .

April 8: Grim day. Conference with Sam at nine—he liked nothing, but was kind and nervous. . . . Appointment with Bill Dozier at 2:15. He made an amazing notification: Both of us wanted Billy to get a raise, it could be brought about he was sure, but only in one way. If I signed for two years straight before Billy was given his raise. It was against company policy that employees should dictate terms—In fact, as it developed, I went to the hiring person with my suggestion of Billy's raise—Bill LeBaron, and I should have gone to [Henry] Ginsberg. I said I did not regard my suggestions as dictation. . . . Pointed out that Billy and I were not Romeo and Juliet—that I could face with equanimity a year of his getting the same salary. He asked if this meant we'd do inferior work—I told him we'd give him the best we had in the shop, we were that kind of writers. He said, "I wish you would have confidence in me and the company." I said, "Let's see who said that to me last, sitting in that chair . . ." [preceding ellipses in original]. . . .

April 10: The desert hell continues as far as our work is concerned. . . . Went to Paramount and delivered a final scene—final really I hoped. Lunched at

Lucey's with Ernst Lubitsch and he came back to our office and really tackled the story with us and was useful—bless him.

.

April 15: Start a new volume of this journal with a sad realization that instead of making entries which catch some unique facet of the day they record—I made every record of the routine events. No diary—and certainly not mine—should be written every day, but unless I write it every day I am sure not to write it at all. So I will undertake on these pages the logical successor to those of my boyhood diaries.... The British Empire seems to be cracking, and America in a fair way of being left friendless in a greedy world. In the afternoon coffee and naps—Billy let his wild imagination run wild on the subject of what is in store for the Jews of Hollywood—Ernst noting the storm troopers at his door with a friend and a profoundly funny wisecrack, Louis Mayer being smuggled towards Mexico in the rumble seat of Arthur Freed's car, Sam caught and slaughtered in Bakersfield, etc. He himself was to find refuge on a ranch and [unidentified] and I were to send him 65 cents worth of supplies a week.

April 17: Today the story seemed to slip into shape, thought still is far from the right word-jolt into some kind of wild architecture like an ice jam, but I am infinitely relieved that a shape has emerged acceptable to everyone....

April 18: Went to the studio feeling fresh and alert. Billy arrived extraordinarily chipper, and things hummed. We began our line treatment and from it evolved a title we like: *Dust on My Heart*.[9] At noon went to Pesterre's[10] for Billy to try on a coat, then back to the studio lunchroom. Bette Davis, all made up and in costume, was at another table, looking like an extraordinarily ugly bisque doll....

April 19: Finished our outline of *Dust on My Heart*. Incidentally Goldwyn has decided, or more probably Frances has, that the title is no good....

9. Unidentified film project.
10. Exclusive Beverly Hills clothing store, specializing in handmade items, often imported from Europe, and catering to both men and women.

April 21: We hoped to begin the actual writing of this draft of the picture but were stymied by our affection for stuff already written. . . . Ernst [Lubitsch] took us over to the coffee shop and told us an idea for a picture I thought grand and titled *The Self-Made Cinderella*. . . . Went to an open Board meeting of the [Screen Writers] Guild. It began with the new Guild lawyer speaking of legislation dangerous to the cause of labor, some of which seemed bad but most of it excellent. The leftist, unsympathetic-to-the-war attitude of the majority of Guild members present seemed to me depressingly obvious. They see the thing as a forward step in the class struggle for which they are waiting, smacking their lips. Frank Partos, Sam Lauren and I took Mary McCall to the bar and we all viewed with alarm and I laughed with Mary about the portrait of her Budd Schulberg did in the heroine of *What Makes Sammy Run*. "I want it distinctly understood," she said, "that I did *not* sleep with Norman Krasna."

April 22: Billy arrived, very cheerful, but remarked that he imagined in about six months he would no longer be allowed to write motion pictures because of his Jewish blood. Later I called in Ernst [Lubitsch] to cheer him up and say that such talk was dangerous. Ernst said, "Oh, I think it's highly probable if England loses the war."

April 23: A day of completing the design for the first sequence. Leland came in and read what we have, then I tried to get him to cheer Billy, and his prognostications were gloomy beyond anything I have heard. England gone, anti-Semitism so rife that with class hatred he expects some kind of revolution in America, invasion possible. . . .

April 27: . . . About 5 Elizbabeth and I went to the Melvyn Douglases to a party for Mrs. Roosevelt. It was held on their terrace, and as we entered Dotty [Parker] and Alan [Campbell] Yelled "Spies, spies!" Melvyn introduced us as Loyal Opposition. Mrs. Roosevelt was exactly as I had known she would be—tired, charming, gracious, a plain woman with beautiful gray eyes, dressed in Ida Carletonish clothes, so accustomed to seeing people that she no longer sees them. A dear, nevertheless. We stayed only a short time. . . .

April 28: Day of solid dialogue work at the studio, only semi-successful. In the afternoon a Leftist with a diabetic tongue upset and angered me with his delightful prophesies of a revolution. This is a way when the laborer has to take it all. After the defeat of England, Russia is to take over. For some mysterious reason they feel no compunction about accepting blindfold the beneficence of a nation which has shown beneficence to none. The class war—for them it dwarfs any national problem. They seem to me to be working towards an ideal as unworkable as Prohibition, and I know no positive things to say about the system I love which they will ever hear. . . .

April 30: At the studio at 9, but Billy forgot our appointment and wasn't there until 10. He and Sam had a conference with Howard Hawks in the evening and sold him the idea of directing this picture [*Ball of Fire*], but Sam summoned us, shaken by an objection of Hawks' that the heroine had been the villain's mistress under our set-up. . . .

May 1: . . . Niven Busch came to our office and not only pleaded for our 25 pages a week but threatened "Goldwyn can break anyone in this town." We worked hard at our second sequence all day. . . .

May 6: The first really hot day of the year. Billy and I worked like demons on the script (we're always better in hot weather, I think). . . .

May 9: A day of hard work, leading to a reading of the first fifty pages of the script to Sam, Niven and the publicity man at 4:30. I approached it nervously but they were all pleased though Sam said, rightly, that the beginning of the script was overwritten.

May 12: Billy upset by the fact that Willie Wyler, to whom he told the story yesterday and read the script as far as it has gone, with a view of getting him as a director for it, wasn't interested. Partly as a result we accomplished nothing. . . .

May 14: . . . At 1:00 went to Paramount . . . to projection room 5 to see the long rough cut of *Hold Back the Dawn*. Billy and I both thought it to be a pretty bad picture—jerky, undistinguished in writing, [Walter] Abel sadly lacking in menace—not a disgrace, but nothing to crow about. . . .

May 15: Worked all day with some success. . . . Arrived home to find that Billy was sitting here alone, Goldwyn having told him that the interview with [William] Wellman was out. [Howard] Hawks had the direction of the picture. . . .

May 19: . . . In the afternoon worked till we had to tell the remainder of the sequence to Goldwyn and Niven [Busch]. Neither very enthusiastic.

May 24: On the way to the studio at 9 o'clock heard on the radio—the terrible news of the sinking of *The Hood*, one of the capital ships of the British Navy. Had luncheon in the commissary with Billy, Spiegel, Abel Fink and John Garfield—all Jewish. Was never so impressed by the complete absence in the Jewish nature of an instinct like our feeling of patriotism. Their curious detachment from this disaster to a country which has done more for them than any mother country. . . . Perhaps my perceptions were sharpened by the fact that Garfield, a complete stinker, spent the luncheon airing his hatred of England and his passion for Russia. . . .

May 25: . . . E., the kids and I went to a British War Relief party at C. Aubrey Smith's place on top of Coldwater Canyon. It was a large party filled with professional and non-professional characters parts, and it was a grave troubled party—none of the British arrogance so irritating in times past, which would be so welcome now. I had a feeling that it was an odd and touching way to see an empire shake, if not crumble, at a garden party in Hollywood. . . .

May 26: At 9:30 read the last finished part of the script to Sam who was pleased with it, so pleased that we declared the day a holiday, went down to Bullock's where Billy spent some money for shorts, as usual. . . .

June 2: . . . I went to the office and Billy and I were starting to work when Sam [Goldwyn] rang up. I answered and said "How was your trip, Sam?" "Terrible," he answered. "I have never been so disappointed in my life as when I got back and didn't find the script you promised. You lead me into expense I can't face—I wish I was out of the whole thing—I wish I had never started it." I listened a certain length of time, about five minutes I should say, then asked him who was finishing the script, as we were quitting as of this morning, and rang off. Three minutes later Niven [Busch] was in our office, asking us to go to Goldwyn's so he could apologize. . . . We relented to the extent of continuing on the picture but were too agitated for more work during the day. . . .

June 5: Got to the studio at 9 to see *Dance Girl Dance* with Hawks. He arrived about 10. We viewed it to see Lucille Ball, who seemed to me ideal for Sugarpuss, but Hawks thought her essentially a second lead. Hawks, Billy and I then had a thoroughly unsatisfactory conference. "The trouble is the script is too funny." . . . Judith, Billy and Eric Charell dined with us and we motored to Long Beach to see *Hold Back the Dawn*. Never approached a preview with more agony, agony aggravated by the fact that Jimmy Britt, whose conducting me to previews is a rite, was late, so we had to be driven by J. Larmore. The picture began with bad title cards, some music borrowed from *Arise*. The story began, and the audience was absorbed from the start to the finish—an almost tangible absorption, which was catnip to the worried hearts. The cards were excellent and I drove home in high good humor. . . .

June 6: A day of consultations with Hawks and no accomplishments, by which I guess I mean nothing was written. We lunched at Lucey's with Arthur, Mitch [Leisen] and Doane Harrison—an exuberant group, all comparing the terror we felt last night when Olivia put on her eyeglasses to look at Boyer at the second act curtain and discussing cuts. Was in the first sweet moments of my nap when Goldwyn wakened me to read a letter from Carole Lombard saying that she found neither our story nor the role of Sugarpuss interesting. . . .

June 10: Another day of looking towards the horizon with Howard Hawks' pale blue eyes and finding nothing. . . .

June 11: Waited for Hawks till about 11, when he came in and talked about *Citizen Kane* (which he didn't like) for an hour and for half an hour about the matter not in hand. Sam asked Billy and me to lunch with him and Somerset Maugham at the commissary. Maugham was very old seeming, very intelligent, very hesitant of speech. He too talked of *Citizen Kane*: "I thought it so curiously undramatic" and of *I Wanted Wings*: "It was so profoundly immoral." . . .

June 12: . . . Lunched at the commissary and before I could nap was summoned to read the Sugarpuss scenes to Ginger Rogers, who loved them, I believe. Then Howard Hawks talked to me about the follow-up and Billy and I were summoned back to try and tell her the ending and fell back on our one-line outlines, and it was terrible. Later, Billy, Howard and I were grilled by Sam as to what state the script was in, what we were doing, and finally he groaned and let the problem go till Monday.

June 13: . . . I spent the morning with Billy and Howard, lunched with them, then joined by Lubitsch, tackled the problem of the final sequence and came to some conclusions—at least seemed to convince Hawks of the soundness of our story. . . .

June 19: At the studio, Billy has done a Penelope[11] during the night and we had to start our planning afresh. Lunched with Arthur at Lucey's and afterwards Arthur spoke to me about plans for when Billy takes on directing, which made me very sad, as I hate change. . . .

June 25: Another busy day which resulted in the completion of the longest telephone scene known to celluloid, but one of our best. Lunched with Niven and Greg Toland at the commissary. . . . E and I and Alan Campbell dined with Somerset Maugham and . . . his rather grisly secretary whose once good looks are now hidden by deep lines, whose deep, loud voice rings out hollowly—a creep in fact. Maugham amused me by saying of the Russian

11. A self-critical mood.

situation:[12] Of course they've shot all their generals. It wasn't a good idea to shoot their generals.

June 27: Another neurotic obstacle presents us going ahead. Suddenly "How does she fall in love?" has become an unsolvable agony to Billy. Lucille Ball was tested for Sugarpuss today. I thought her very right, a saucy, clowning face and a great chrysanthemum of blondined hair. . . .

June 30: Held up because Howard Hawks was busy with Goldwyn. (At this particular point an earthquake occurred, a really solid trembler.) . . . Went to Lucey's for a farewell luncheon with Arthur, who is going on a vacation and who talked about resurrecting *Polonaise* with Billy directing it.[13] Hawks appeared after luncheon, could give us no time but asked to see tests of Betty Field[14] and Lucille Ball. Both tests were played too petulantly, but we were pleased with the scenes themselves which wasn't the point of seeing them. . . .

July 1: At 10 o'clock went to Howard Hawks' house for the most miserable of conferences I have yet experienced in the town—a day of fighting fog. Howard liked our scene so well he apparently wanted to abandon the entire picture and it. It was as though nothing had been written so far, only vague plans for scenes that might be. . . .

July 3: Today it was Billy's neurosis which kept us from rewriting our sequence. He wanted it virtually new, with a new emphasis which he couldn't find. As a result nothing was written and our nerves were in fringes. . . .

July 9: At the studio. Suggested an introspection scene for Sugarpuss which isn't particularly good but is useful. Writing it took all day because most

12. On June 21, Russia and Germany had declared war.
13. *La Polonaise* was the story of an American athlete who goes to Warsaw to visit his grandmother and gets caught up in the war. It was suggested that William Holden might have played the lead.
14. Only reference to this actress being considered for role of Sugarpuss in *Ball of Fire*.

of our time was occupied by a stream of visitors and telephone calls. . . . I lunched with two Bob Hope writers who told me a lot about working for him, which seems a fate worse than . . . [ellipses in original]

July 14: (No longer Bastille Day). Another hellish day. It began with Howard Hawks in the office when we arrived, reciting Goldwyn's agitation and his inability to sign anyone for the picture until his script was finished. He had put the fear of God in Billy, put his finger on him—and the day was a sterile effort to find our very last episode. Jacques [Théry] sat in on our struggle in the afternoon. . . .

July 21: Arrived at the studio at 9 and we completed the Sugarpuss-Bill break scene, rather successfully we thought, with Sugarpuss, who had been trying in vain to write a letter, showing a blank piece of paper to Potts and saying, "That's all the excuse I have." We then started the next sequence when we were summoned to Howard's office and found him singularly glum. He was troubled by the Sugarpuss-Potts relationship in the former stuff, troubled about the New Jersey trip. . . . We went in Sam's office and for three hours the script, as far as it was written, was mauled and worried over by Goldwyn and Howard. I read the new stuff to Goldwyn. During the argument immediately following he said, "Why should she show him a letter when she can tell him what's in it?" . . . The "motel" sequence, which is charming, was loathed by Goldwyn, as I knew it would be loathed, because of his horror at the . . . word motel. I had warned Billy, which gave me some satisfaction. For some reason the whole interlude, instead of depressing me, gave me a sense of the absurdity of life and my business, which made me very gay. . . .

July 21: A day at Howard Hawks' is always a day of hell. He applied his fabulous anti-architectural methods to the script all morning. . . .

July 30: . . . went to a mysterious producers' luncheon at the commissary, which proved to be for the Fight for Freedom Committee, to raise funds. We all heard the pleas enthusiastically, then Sam Goldwyn turned to the poorest salaried person there, one of the Bob Hope writers, and said, "What are you going to give?" He stammered in agony and finally said, "one week's salary."

Most of us protested and he lowered it to half a week's salary, $250. I finally had to say that I thought it disgraceful to blackjack money from people in such a way as by asking that question of the lowest paid man present. Sam very angry. . . .

August 1: Dull day. Spent a good deal of the morning in Howard's office, interviewing Barbara Stanwyck,[15] a pleasant, heavy-faced girl, very wrong for Sugarpuss. . . .

August 5: Uneventful day. Devoted to arguing Howard into a scene where Sugarpuss gets a big diamond ring from Joe Lilac [gangster boyfriend played by Dana Andrews] and accepts it like a jubilant golddigger. Gary Cooper in Howard's office, a little wistful when we suggested a starched collar and cuffs, but acquiescent. . . .

August 9: This morning at the studio a difficulty caused by the insertion of the new morning-after-Sugarpuss's-arrival scare came to light and I have never seen a human being as miserable with impatience at supervisorial stupidity as Billy. His face a thundercloud, he sat and emanated hatred. Finally we managed to get the scene done with some improving touches and he went away happier. . . .

August 18: A day of rip-snorting work, from 9:00 with a brief lunch, to half-past 7. Then dinner at home, then the reading of two sequences to Goldwyn, who looked a million years old and very sleepy. With the reading he woke up, however, and was enthusiastic and flattering. Said he was delighted we had improved and put emotion into one scene which we had not changed, and hinted that Howard Hawks was laying claim to a lot of the writing. . . .

September 3: A day of cutting and polishing, climaxed by a long session with Goldwyn, demanding more cuts, accepting our suggestion for an im-

15. First, and abrupt, reference to Barbara Stanwyck's playing Sugarpuss.

portant one, then trying (for some sentimental reason) to argue us into be-
lieving in the cut . . . [ellipses in original]

September 12: A day of hard work all on the "coffee house" sequence.[16] We
lunched with Arthur at Lucey's and with us was Ginger Rogers, very cute, very
plain of face, very gay of spirit. . . .

September 15: Put the final touches on our tag and read it to Goldwyn. . . .

[That evening, Brackett flies to New York. At midnight on September 29, he
takes the train for Providence, returning to New York on October 1. The fol-
lowing day, he takes the train to Saratoga Springs, returning to New York, by
train, on October 4. On October 9, he returns to Saratoga Springs, via Albany,
flying back to New York on October 14. He begins his return flight to Los An-
geles on October 16, via United Airlines, on "the crummiest air vehicle I have
seen for years." His diary entries are full of references to old friends, but none
are worthy of referencing.]

October 19: Breakfasted early and got to the studio at 9:00. Billy concurred
in some scenes I'd sketched out, had a complete suggestion of his own and
we had our task finished and approved by Hawks & Goldwyn before lun-
cheon. . . . At 6:00 E. and I went to see *Sergeant York*, a good picture, even a
noble picture, but something of a bore. . . .

[On October 20, Charles Brackett and family move temporarily to the Cha-
teau Marmont.]

October 21: Slept until 9 . . . went to Eddie Schmidt and picked out the suit
Sam Goldwyn is giving me (one also for Billy) for the script. . . .

16. An expression given by Billy Wilder to the nightclub sequence, on which the pair had
 been working since the previous day.

October 22: . . . met with Arthur and Billy at 3 and discussed our next picture—what it should be, Arthur leaning toward the resumption of *Polonaise*, Billy bringing forth his old passion for *Eighty Days around the World*. . . .

October 23: . . . Arthur, Billy and I saw a few reels of *Louisiana Purchase* to see if Zorina, God help us, would do for the role of the girl to be inserted in *Polonaise*. The answer was no, and the reels were awful, the halting play having been photographed intact. . . .

October 27: Back at Paramount after an absence of 9 months. Spent the morning in desultory conference with Billy and Arthur and lunched with them at Lucey's, then napped and talked with Billy and worked with him till after 5. . . .

October 28: At the studio all day but too nervous about our *Ball of Fire* preview to do any effective work. Luncheon at the commissary. In the afternoon, to relieve his nervousness, Billy ran through *Ball of Fire* verbally, commenting on every scene. At 6:15 the Wilders and Walter Reisch came to dinner and all of us, Bean and Jacques compris, motored to the Academy Theatre in Inglewood for the preview. It went well, slow at first, then getting into its full stride for a grand old-fashioned movie, with yells of laughter from the audience. Drove home with Billy and Walter, dropped the latter and went to Sam for a session of cut-planning which lasted until 1:30 and was for me a great deal of fun. Find myself feeling the pleasure of a complete amateur let in on momentous doing when involved in such conferences.

October 29: A curiously unpleasant day. Wrote a foreword for *Ball of Fire* which everybody who saw it rewrote a little, as always happens in these last-minute things. Went to Sam's and worked on the slang titles, seeing Hawks, whom I detest as cordially as ever. Luncheon with Sam, Hawks, Billy and Lubitsch, who refused to give Larmore any job in his [unidentified] picture *Too Soft*. Back to Paramount to try and get something for the end of *Polonaise* and Billy's dislike of this story crystallized. Discussed *The Traveling Saleswoman*[17]

17. A film of this title was made by Columbia in 1950.

idea with him and later with Jacques Théry, who had some brilliant suggestions at the tip of his tongue. . . .

October 30: Billy and I discussed *Polonaise* for an hour or two and at last marched on Arthur with our objections to it. He proved magnificently reasonable on the subject. . . .

November 1: . . . Bean and I went to our second preview of *Ball of Fire* at Long Beach. It went better than the first even, though Goldwyn seemed more nervous. . . .

November 2: Had to go to Sam Goldwyn's for a rehash of the picture on which he threatens drastic cuts (second preview nerves). . . .

November 3: Worked on a foreword for *Ball of Fire* all morning, went to Goldwyn's where Sam approved it, gave us lunch and showed us the parts of the picture which have been cut, and beautifully cut. . . .

November 4: . . . went alone, save for Jimmy, to a preview at Glendale, the kids going to see Lily Pons. Arrived at the big, crowded Alexandria Theatre early, saw a "March of Time" and a war short, which I had seen before, then came the drawing for a Packard which stood in the forecourt. From a machine like a great popcorn-popper slips were drawn, the numbers transmitted to other theatres by telephone, told to us by the master of ceremonies in person. No one in any of the theatres included claimed the first or second slip. Then the third was drawn and claimed by somebody in Pomona and the crowd tossed away their tickets in a great cardboard blizzard and the manager announced a preview—and then, receiving a communication, told the audience that the supposedly winning ticket had been a false alarm and another drawing must take place. Thereupon there was a wild scramble for the old tickets. The new drawing began, the manager hinting in his patter that he had his troubles. Some person not in our theatre won the Packard, thereupon the manager took the audience into his confidence: they were to be denied the preview because of one man in the audience—a man from *Variety*. Said

man from *Variety* had been asked to leave but had a ticket and refused to go. Mr. Goldwyn refused to show the picture where a representative of one trade paper was and not of the other. Thereupon the audience went mad, dangerously, roaringly mad, so that detectives had to come and stand beside the intruder. We of the preview party all retired to the lobby to learn that this was an employee of [*Variety* editor] Art Unger's who had telephoned Art that his presence was known and received instructions to stay or lose his job. A man with a small salary and a dependent family, he stayed. Billy Wilkerson, editor of the rival paper [*The Hollywood Reporter*], was in the lobby grinning with delight at the mess. Frances Goldwyn very charmingly told the offending reporter from *Variety* that she did not blame him personally. About 10 o'clock we proceeded to Pasadena, went to the U.A. Theatre, saw a Pete Smith short, another short, then a Schlessinger cartoon, then *Ball of Fire*—and it laid a dreadful egg. It was like a version of the picture we'd seen before, seen in a nightmare. Playing it was like rowing upstream in a river of molasses—every speech became interminable, the sure-fire situations proved not to be sure-fire. There was some laughter but comparatively little and while the preview cards were all "Good" or "Fine" or "Excellent," Billy, Sam and I were at the bottoms of despair. The old legend that pictures play alike to all audiences was definitely dispelled. Nothing had been cut, the different lay only in the preference of the audience.

November 5: Billy, pale and shaken, but didn't want to discuss our disastrous showing last night. Preferred to go on to new things, but we have no new things to go on to. . . . Jacques [Thery] and I went to yet another preview of *Ball of Fire* at Huntington Park. It went far better than last night, in fact turned back into the picture we had thought it to be.

November 6: At the studio all day, thinking of nothing but the story about the girl who, to go home half-fare, dressed as though she were eleven, finally sold the idea to Arthur, if we can find some idea for a last act before Monday. . . .

November 21: . . . a luncheon with Sam Spiegel and Boris Morros, wherein they tried to get us to smuggle our services to them for an episode in *Tales of*

Manhattan. A conference with Buddy De Sylva in which Billy told our outline and Buddy approved it. . . .

November 24: Billy came to the studio with a charming idea for the last act and we found what I think a charming title, *The Major and the Minor*.[18] Our luncheon with Ginger Rogers was on.

November 26: My 49th birthday. . . . Billy and I worked on the story all morning, went with Arthur and Leland to Ginger's dressing room and told it, to her apparent and expressed amusement. . . .

December 1: A nervous day, due to a press preview of *Ball of Fire* slated for the evening at Glendale, and an interview between Arthur and Ginger which was to settle her being in the picture once and for all. . . . Joe Sistrom appointed an A producer, which pleases me. In the afternoon Billy had a nervous stomach-ache and neither of us had any thoughts of moment on the script. At 5 we told Arthur what little we had. He parted from us rather dolefully, we all agreeing to meet at Mocambo. I went to a Guild meeting devoted to the consideration of bargaining, and a wire from New York asking us to take a stand in fighting censorship by pressure groups such as the League of Decency—and as an example the censorship of the Garbo picture. I think it a vital issue for picture-makers but the rest insisted that it depended on the picture. They had heard the Garbo picture was bad. Meeting lasted until 12, when I repaired to Mocambo, to find Billy there, elated—a beautiful preview, and word from Arthur that Ginger had accepted. . . .

December 2: Great reviews in the trade press, though *The Reporter* laughed about Potts' use of "Neither of us have," a mistake made on the set which I was told was covered with another take. It was not, and I had to telephone Gary and ask him to dub in a line, which he consented to do. Regret its having been released as it was. My old fault of thinking it only necessary to say something is wrong, not yowl until it is corrected. Luncheon at the [writers'] table. Billy

18. First reference to *The Major and the Minor*.

had been distraught all day. In the afternoon the reason came out: domestic situation about to reach a crisis. At 5 he went home for an interview. About 7 he appeared here—Judith is getting out, leaving the baby with him, wants no money. He dazed and unhappy. . . .

December 3: Quite a day. At 10 Billy and I went to his house to talk to Judith and Maybelle or, rather with [Judith's mother] Maybelle [Iribe], for Judith sat, a silent figure of something—hate, perhaps—while Maybelle talked wisely, charmingly, civilizedly, suggesting that Billy remain in the house with the baby, that she live in the little studio. Judith wanted to go away—where, she didn't know—someplace where no one should know. Except for one bitter remark from Billy about Judith's artistic yearnings and the ridiculousness of thinking him jealous of them—it went off with great style. We went to the studio, told Arthur the state of affairs, discussed the matter most of the rest of the day. I lunched and Word Gamed at the commissary. Came home at 5 and about 7 had a call from Billy that Judith had found him at Lucey's, broken down completely, confessed her jealousy of his career, of all the interests that take him from her, been suicidal, said that her family loved his success, that it was what she hated. The happiest time of her marriage had been his breakdown when she really possessed him. Billy in a state. I knew no advice to give him, counseled sleeping on the question. . . .

December 4: Billy at the house while I was dressing, to report further on his conversation with Judith, which was followed after the concert by stopping at his house for some things and staying the night there. Today he was still trying to decide whether to resume the relationship permanently or not. . . . "You know my claustrophobia." But, having reduced Judith to a state of complete abjectness and told her to go away for a time and think it over, was pretty happy. We worked all day, actually starting to write. . . .

December 7: Billy and I had planned on working today but as I was at breakfast he telephoned to say he had been out until 6 in the morning, could not work. Rather pleased, I settled down to [his unpublished novel] *Alms for Oblivion*, doing a few pages. At about 12 Billy was on the telephone again: Japan had air raided Pearl Harbor, a hundred dead, some three hundred

wounded—Manila bombed. The startling belligerence of the country became monotonous, the shocked references to the treachery and surprise. . . .

[After America's entry into World War II, many of the diary entries, particularly in 1942, contain references to Brackett's volunteer wartime activities as an air-raid warden and fire watcher, and to the occasional blackout affecting Los Angeles. To Lubitsch's daughter, Steffi, in an October 1950 letter, he recounts, "Walter Reisch . . . reminded me of the famous air raid when Mr. Reisch had forgotten to close his blackout curtains and Ernst Lubitsch, the air raid warden, called, in that accent of his, 'Walter—your lights! You have forgotten!' and Walter replied, 'Ach, yes, was gibt?' Mervyn LeRoy, hearing this, yelled from his window, 'German paratroopers have taken over!'"]

December 8: A day of general excitement at the studio. No work for us at all, save some brief consultations with Arthur. An hysterical SWG meeting at noon (Ralph had decided we must have a temporary contract to freeze the points under discussion during the national emergency—nice stunt, it he can work it). . . .

December 9: Billy made up a little story about thirty Japanese fliers on their way to bomb San Francisco, who used the President's speech as a beam to guide them, were so moved by the speech that they turned back and bombed Tokyo. This went pretty well, so he telephoned it to Herb Stein, the columnist of *The Hollywood Reporter*. . . . Came home in time to hear the President's magnificent speech: "All I can tell you is that none of the news is good." Though he gave no details, the rumor is that the disaster in Pearl Harbor was far worse than any of us suspected. . . .

December 10: A loathsome day. Billy and I were beginning to discuss our script when Sy Bartlett, now Captain Bartlett, strode into the office, full of the confidence of a uniform, and began to try to get Billy to go to Washington on a Signal Corps job. He bragged of his own contributions to national defense, naming an instance which alarmed me with its foolishness, and seemed about to stay, when I said to Billy, "Don't you think we ought to do a little work?" Whereupon there was a scene. I was standing in the way of national

defense—he hadn't expected that of me! Billy was upset. I regretted having offended the ass. The morning was lost. Lunched with Billy gloomily at Lucey's. We did a microscopic bit of work in the afternoon. The war news was terrible—two great British ships lost, possibly a third—the Japanese streaking all over the map. At the end of the afternoon Joe Sistrom and I had a talk in which he predicted Russia's making peace with Germany, failing to declare war against Japan (as it has up to now) and seeking to profit by the general war, to set up a new economic system and grow rich. . . .

December 11: Woke to the news that Germany had declared war on the United States and Italy.[19] We declared war back on them, and sank three Japanese battleships. Billy and I were very gay but unproductive. . . .

December 13: Worked at Billy's all morning, getting a few lines on paper. The Wilder marriage is patched up, incidentally, and working better than ever. . . .

December 15: According to the new daylight schedule adopted for wartime, I arrived at the studio at 9 o'clock but Billy didn't get in till 10, a fault I condoned with particular grace, as he loaned me $900 on my income tax. We dictated some of the stuff we had done and worked ahead. I lunched R.W. [Ruth Waterbury] at Perino's and dined at home with the family, then went to a gigantic Screenwriters-Publicists-Newspaper Guild meeting to mobilize writers for defense work—a triumph of empty talk and futility, I thought.

December 21: Was working at some Christmas letters when a call from Billy got me to the studio to go over the Ginger Rogers episode in *Tales of Manhattan*, which we promised to inspect for [Sam] Spiegel. It was pretty bad. . . .

December 23: Another unprofitable day at the studio, a day devoted largely to being Fourth Floor Air Warden and explaining to everyone on the Fourth

19. On December 10, 1941, Germany and Italy declared war on the United States.

Floor what to do in case of an air raid, and finally getting additional rather agitated instructions from Abe Hilton with the rest of the Air Raid Wardens and finding it incredible that I could be sitting in California taking part in such goings-on seriously. . . .

December 26: Billy very funny on the subject of his Christmas Eve and Christmas Day, which ended in his taking Eva Gabor home from a party at the West Side Tennis Club, to which Arthur had invited him. He was a little tight and about to make a beautiful moving-in speech, in fact had started it as he swung his car around a curve, when he turned to find the seat next to him empty. Miss Gabor (also tight) had neglected to close the door and fallen out on the road, sustaining no injury but a bump on the behind. We accomplished very little all day. . . .

December 27: Worked steadily all morning. Lunched with Alan Campbell at Lucey's, discussing the Ginger Rogers sequence with him for *Tales*, then went to 20th-Fox and saw the reels already shot and found them way above average, distinguished in fact. . . .

December 30: A good day as to script. Bad news from Leland about the deal he proposed for us with Paramount, and one stroke of great fun. Billy and I were working away hard for a reading to Buddy De Sylva at 4 o'clock when a telephone call came from Arthur that the long-awaited chance to have a test made of Bean had arrived. I was so excited and agitated I couldn't ask the right questions of Arthur and he was excited and agitated too. After a few calls back and forth it was arranged for Bean to be at his office at 3:30. We had the reading for Buddy at 4:30 and he seemed pleased. . . .

December 31: The studio came through with no salary adjustments, which leaves me in a hell of a position with regard to March 15th [tax day]. Arthur called about 11 to say I could see Bean's test. He, Billy and I saw it and it seemed to me extraordinarily lovely and to them excellent. Her eyes photograph magnificently. . . . We went to Sam Spiegel's for a New Year's Eve party—more champagne than I care to count. . . . At midnight as always we jumped into the New Year with gold in our hands. . . .

1942

January 2: A funny, nervous day with little accomplished. . . . Bean came, saw her test and almost died of horror at it. Billy learned from Arthur [Hornblow, Jr.] that Arthur is going to Metro, which breaks up our unit, to my regret. . . .

January 4: . . . Bean, J. and I went to *Louisiana Purchase*, which Y. Frank Freeman pronounces the best picture Paramount ever made. It is appalling—dull, repetitious, not enough music, Zorina terrible. Vastly cheered, I came home to a supper E. had been preparing for us here.

January 5: A day of hard work at the studio, followed by an evening of consultation at Billy's—Sam Spiegel, Boris Morros, Alan Campbell, [Julien] Duvivier present. Duvivier, whom I met for the first time, fantastically French, feline impersonal. Billy in great form. . . .

January 10: Today the second act of *The Major and the Minor* seemed to kaleidoscope itself around into place, just in pattern, of course. . . .

January 13: When Manny Wolfe sold the original of *Ball of Fire* to Sam Goldwyn he had had an offer on the property from Warner's for $7,500. Sam wanted to pay only $7,500. "Why should I sell it to you for what I can get from another company?" Manny asked. "I want $10,000." "Well, if it turns out to be a good picture, I'll make it $10,000," Sam answered. Today Billy

and I lunched with Sam at his studio at his request, a luncheon that began all lyric love, then Billy reminded Sam of the $2,500. To pay it would cost Sam practically nothing, because of income taxes, the story cost of *B. of F.* was extremely light—but something deep in Sam planted its straight legs deep in the earth, twitching back its ears and looked at Billy with fiery eyes. "When I make a promise," Sam said, "I make it in writing." An atmosphere of chill and constraint fell over the luncheon table. Suddenly Sam was saying that the original story wasn't much good anyway, that on its holdover weeks, the picture wasn't doing much business. Billy once said of Sam, "We have known each other for 6,000 years." The comprehension was a little far-stretched. . . .

January 17: Woke to headlines: Carole Lombard Lost in Plane with Twenty Other Passengers—news which was confirmed during the day, the burned bodies having been found towards evening. She was returning from a bond selling tour, killed on active duty. I remembered the last time I saw her on the *To Be or Not to Be* set, improvising conversation for a Mickey Rooney supposed to be the conqueror of Norma Shearer: "Holy Toledo, that was keen!" It was a sterile day as to script. . . .

January 21: Did a little more revising of B. Read B & B [*sic*][1] to Ginger and Leland—not a good audience, or the script isn't up to our standard. Ginger said she liked it, with a few small exceptions, and proved as much by breaking off an RKO commitment—but there was none of the fun and bounce that one gets from reading a script to Claudette. I regret to say she looked monstrously plain. . . .

January 24: Got a little work done this morning, far too little. Lunched with Rosalind Russell and her agent and Bill Dover of the Feldman office and [Frederick] Brisson. We had offered to act as consultants on an act for Rosalind and [unidentified individual] to do in the camps and found it switched to Rosalind and [Reginald] Gardiner[2] and limited to acts which would appeal

1. *The Major and the Minor.*
2. Reginald Gardiner (1903–1980), British-born comedic actor, famous for an eccentric monologue regarding trains.

to an audience which has to have explained to it that a play consists of three acts and that when the curtain is lowered it isn't time to go home—an audience which it seemed to both Billy and me will find Reggie Gardiner an object for hoots and cat-calls (as indeed I think him myself). We proved of no value whatever....

[In the intervening diary entries, Brackett records work on the script at the studio.]

January 30: A long day of work but no actual writing. Arranged the scenes we have planned on a bulletin board with push-pins and then rearranged them. Lunched at the table. Joe Sistrom told me Ginsberg said he couldn't see why I should be willing to break up the most successful team in Hollywood, a disturbing remark which I reported to Leland and he pooh-poohed....

[In the intervening diary entries, work is completed on Sequence B, and Brackett and Wilder are stuck on an opening for Sequence D.]

February 4: Started writing the D sequence. Thank God. Lunched at the table, dined at home and took Bean to the shorts showing of the Academy, but at 5 in the afternoon had an epic meeting of the committee to decide whether *Here Comes Mr. Jordan* should be eligible for the Original Story Award. Clearly it was not,[3] but Richard McCauley and I were unable to convince the committee, consisting of Frank Partos, Jane Murfin, Allan Scott, Talbot Jennings, Dick and me. Supposed to meet Billy to work on the script after the showing, but it lasted so long that he tired out and left before I arrived.

February 10: . . . We lunched with Ginger and Arthur at Lucey's and afterwards read her the sequences. Then Hillary Brooke came in to be inspected (and approved), side by side with Ginger, then Dolly Loehr,[4] then I proofread the stuff for mimeographing....

3. Brackett is absolutely correct, as it is based on an unproduced play, *Heaven Can Wait*, by Harry Segall.
4. Hillary Brooke does not appear in *The Major and the Minor*, but Dolly Loehr does, using her new name of Diana Lynn.

February 11: ... We spent a great deal of the afternoon seeing Ginger in her childish hairdo, looking over hats, materials, etc. ...

February 12: At the studio all morning, doing preparatory odds and ends to our trip to the desert. We lunched with Arthur at Lucey's. About 3 o'clock he and I started for the B-Bar-H Ranch, arriving there about 6. Myrna on a bicycle was the first person we saw. Billy and Judith had arrived just before. Billy and I played some cribbage (I lost). We all dined and went for a walk. As I had no coat Judith and I ran ahead to get warm. We got so far ahead the others thought us lost, got the car and went searching for us while we walked straight back to the cottage without difficulty.

February 14: Breakfasted with the Hornblows, worked all day going over the remainder of the script, at least until 4, when Billy went into Palm Springs and the Hornblows, Judith and I did some bicycling (good run) and sat in the bar. At 7:30 we motored to Palm Springs ourselves, dined at The Doll's House, getting a little tight.

February 15: Worked on the final sequence all morning. Arthur, Billy and I. Listened to Churchill's magnificent speech announcing the surrender of Singapore, snarled at Billy for blaming the English because our Navy was obliterated at Pearl Harbor. We lunched at the ranch, I napped. At 4:00 Billy, Judith and I started for home, arriving at 11:00, overwhelmed to learn that we were Arthur's guests. ...

[In the intervening diary entries, there are references to continued writing on the script, looking at tests, sets and wardrobes, etc.]

February 23: Billy's first day of directing in America. I went on the test stage and found him nervous but supported by Dr. Zinner. Doane Harrison reported that when he first called "Action" his voice was a clear soprano. ... Nat Deverich came to the office and told me Paramount's offer ($1,750 a week, 2 years, 40 weeks guaranteed), not a brilliant offer nor so good as I expected. Missed seeing Billy on the Test Stage in the afternoon but he reported Dolly Loehr as a brilliant child. ...

February 24: . . . Nat Deverich suggested that, while Billy shoots I might take a job at RKO on the Milton Holmes story at a fantastically flattering price, $50,000. Doubt that it could be obtained or that Paramount would want me to go. . . .

February 25: . . . Got to the studio at 9 and dictated our stuff. Billy and I worked like snakes all day and at about 5:30 read Arthur the sequence. My RKO chance, I was informed by Nat Deverich, fell through because of the fact that I couldn't get to it before four weeks. . . .

February 26: Almost finished correcting the E sequence with Arthur. Lunched at the table. The afternoon seismographically disturbed by the approach of the Academy dinner. We were up for *Hold Back the Dawn*, Billy up for the original of *Ball of Fire*, two of our actresses—Barbara and Olivia for best performance. . . . Not one of our candidacies or near-candidacies were chosen. . . . Our evening was greatly mitigated by the fact that Cecil B. DeMille, referring to the Chinese Ambassador, who had made a fine, graceful speech, called him "The Japanese Ambassador." [Wendell] Wilkie spoke, his inexcusable diction . . . again.

March 2: In the morning Billy and I completed the departure scene. . . . We then read the departure scene to Arthur, who liked it not at all. Production problems (shots at the station, Ginger's wardrobe) frittered away the afternoon. At 5:30 I went to 1141 Tower Road, the house we loved best of any we ever had here. Eleanor Boardman, its co-owner (King Vidor, her ex-husband, owns the other half) was there and showed me through. I used to pay $650 for it in the luxurious years. I suggested a small down payment and a large mortgage with interest at 6%. She looked at me with handsome adrenal eyes and assured me that she was only renting it, and renting it for $650 a month. Investments and percentages made that necessary. "I can't bargain," she informed me. "I am not a Jew." "Nor am I," I said. "You're New England. Same thing." . . .

March 3: . . . discussed contract and contract terms with Nat Deverich, Paramount having offered me 2 years straight at $1,750 and $1,850, with the

privilege of taking 10 weeks off if there is outside work I want to do. It isn't brilliant but goddamned adequate and rather than uproot myself I'm going to accept, though I know it would be better for me to stop relying on Billy, as I have come to do. Came home to find E. back but emotional and miserable and convinced that I am being sent away for the Army, which is not the case, though the guns of Bataan Peninsula would seem soothing to me in comparison with the studio's red glare. . . .

March 4: Busy at the revision all day, with Billy during the morning, alone of the afternoon. The final details of my contract were . . . : $1,800 for 2 straight years, 8 weeks of layoff, . . . were told me by Nat and Leland.[5] . . . Went back to the studio this evening to see the little girl performance of *Kitty Foyle* and *Roxie Hart*, the superb and delicate performance of Kitty militated against the slapdash Bill Wellman Roxie and everyone hated it. I defended it as best I could. Afterwards Arthur and I stopped at Nat Finston's house and saw a party of which Stokowski was the center. I had disliked him on the screen so heartily I was surprised to find him extremely pleasant and fun.

March 7: A day of hell—work interrupted this morning by seeing costume tests and back projection stuff. Halted entirely this afternoon by our failure to have the right facts-of-life scene.[6] . . .

March 11: Sniped away at the script with Billy absent on the set and at a production meeting most of the time. . . . Billy told me he could use J. [James Larmore] in one of the minor parts, two or three weeks at $175. I told J. who was in heaven.

March 12: Up early so that I could be on the set at 8:00 and watch the first shot, in the Grand Central Station. It was so typical of Billy, whose element is tumult. It went well. He wasn't particularly nervous and one sees his confidence grow with the day. Lunched with Arthur at Lucey's and in the

5. The contract was signed on March 26.
6. Finally read to and liked by Arthur Hornblow, Jr. on March 9.

afternoon met the representatives of the Censor [Production Code Admin-
istration] and conquered the most of their objections, feeling the revulsion
that always comes from meeting representatives of the Legion of Decency,
with their envious Catholic faces. Luraschi irritated me by defending our
Foreword as criticism of the "profit system." Shortly thereafter the feasibil-
ity of Larmore's playing one of the professors was taken up by Arthur, who
decided the professors must be older men. To my acute irritation, as it doesn't
matter if they are played by anything above the level of a Mongoloid ape. I
came home and told J. who was heartbroken but brave. . . .

March 13: The second "Friday the 13th" this year. I got to the studio at 8:30
to see the rushes, which were excellent—unaffected, direct. Had to do a few
lines for Billy, complete the censorship revisions. . . .

March 17: One felt St. Patrick must have blushed this year. At the rushes,
which were good, though I thought just a touch too funny (the writing came
over as heavy). . . . Did a little desultory work and lunched with the Inter-
Talent Council, a luncheon to forward a project by Lester Cole of getting
people of the industry to buy Defense Bonds. Ernst Lubitsch was there and
walked to the set with me, telling me of a story at Fox and suggesting that I
work with him during the rest of the shooting, a proposal that pleased me
very much. Expected to work tonight but a telephone [call] from Billy called
off the project and sent us to *The Palm Beach Story* preview at Westwood.
This is the latest Preston Sturges opus and the weakest—disagreeable people,
unappetizing situations, exaggerations. . . .

March 18: . . . went on the set, to find distress: Ray Milland giving a dry,
wooden performance (his usual performance to speak the truth) but a little
more obviously bad, in contrast to Ginger's miraculously good one. . . .

March 21: Finished a draft of the final sequence, got some personal cor-
respondence off. Joe Sistrom came into the office to ask, in confidence,
whether I wanted to go to Washington with Frank Capra while Billy is
away. . . .

March 29: . . . A consultation with Billy, Bill Dozier and Buddy De Sylva about *Eighty Days around the World*, a favorite project of Billy's. No enthusiasm. . . .

March 30: A bad day at the studio—the rushes dull, with Dolly Loehr inadequate in the dialogue scene she had to play. Spent most of the day rewriting it and taking telephone calls. Lunched very pleasantly with David Lewis, who urged *Frenchman's Creek* on me, a job towards which I lean. Arthur nervous, excited about the quality of the rushes, dubious of Billy's directorial powers. Billy abysmally depressed. Saw the stuff assembled at 6:00 and it looked very bad. . . .

April 3: The rushes. A morning of dictation, conference with David, being on the set, being with Arthur. Luncheon with Eddie Mayer, who told me what he had concocted on *Frenchman's Creek* in his six weeks' employment—a friendly, gracious thing to do. A long nap, Jacques, a call from Frank Freeman about *Frenchman's Creek*, a call from Allan Scott for a camp show for Claudette. . . .

April 7: An utterly incredible day. After the rushes, word from Jacques that Preston Sturges had gone to Dozier on his behalf and said "Six years ago Manny Cohen sat in that chair and said that I should never work in Paramount because I was a phoney. He isn't sitting there now." "Are you threatening me?" Dozier asked, growing pale. Jacques thought all was well. Later, Lewis appeared, pale and distraught, saying he could fight Dozier, not the whole studio who had ganged up in arms against the pressure Théry's friends were putting on them. A summons to Dozier's office, to hear that I had been taken off *Frenchman's Creek*—no recrimination. Lunch and Word Games at the table, then an astounding telephone call from Nat Deverich that I was to be loaned by Paramount to RKO to do *Bundles for Freedom*,[7] which I refused to do at almost double my salary. . . . Worn out by the drama of events. . . .

7. Released May 1943 as *Mr. Lucky*; Brackett receives no screen credit.

April 14: The rushes, which were good. Then it developed into one of Those Days.... A notification from the front office on *Triumph over Pain*,[8] on which I once did a good job, "Written and Directed by Preston Sturges." Evidently he has taken out every comma of mine, as I expected but not pleasant....

April 20: ... proceeded to RKO, a horror of a day save for the luncheon interval ... [David] Hempstead, my RKO producer, pleasant but not bright, Milton Holmes, a little tenacious Zombie who is under the impression that his script must be photographed sentence by sentence—neither common sense nor vitality in the discussion....

April 24: ... Lunched my beloved Alice [Duer] Miller, who came on from Tucson for the weekend to see her three friends, Charlie Lederer, [Richard] Haydn, and me, to the delight of all three of us. She looked a little frail, tells me her operations proved the growth not to be malignant ("or so they tell me"), recounted the glorious story of her days just before the operation.... A dream woman....

April 25: ... to the studio to a morning of Milton Holmes, who cannot realize that his poor story is a B picture sincerely told and must be radically changed. Alice [Duer Miller] lunched with me at Lucey's. We went on the set and saw Ginger, who hadn't lunched, go through the switchboard scene in rehearsal and (utterly improbably) be called to the telephone for a fan—who was so astounded at her success in getting her that she could only gasp....

April 26: ... registered for the draft of oldsters, a curious condition for a kid of my age to find himself in.... Said goodbye [to Alice Duer Miller] with a feeling of tenderness for her. Took E. home, picked up [Robert] Benchley and took him to Arthur's for a conference on the A Sequence, uneventful save for Bob's bitter hatred of the tag line, "And the worst of dandruff." ...

April 28: ... I was working at RKO when a telephone call from Arthur warned me of trouble on the set. I raced over to find Billy sweating in an-

8. Released August 1944 as *The Great Moment*.

guish, Ginger a marron glacée of Christian Scientific hurt sweetness. The scene which she expected to be radically rewritten had not been rewritten. She just couldn't play it, she didn't understand it. What was she to do? Would Billy act it out for her? Bob [Benchley], to whom the scene belonged, was beaming and genial and not one shot had been taken. Arthur was superb as always in a crisis, handled the irritating little bitch beautifully, took Billy out and gave him a double Bacardi. Nevertheless the cameras didn't turn until 4:30 in the afternoon. . . .

April 30: Longer rushes today, and I thought them pretty good. Had an unfruitful day at RKO. Lunched at the table, napped in my Paramount office, and wandered to the set just in time to learn I was being called frantically. Arthur felt the omission of the cocktail-drinking by Ginger in the Osborne scene unfortunate. Stayed around, prepared to write an alternative line. Finally Ginger, Billy, Arthur and I went to a theatre, saw the rushes, whereupon Arthur got up like an illustrated slide lecturer and argued with Ginger as to why the gulp of a cocktail would improve it—without argument, but with the anguished bitterness of a really stubborn nature, defeated Ginger yielded. Arthur, I may say, did a beautiful job. This occupied most of the afternoon, but I got a little writing done. . . .

May 1: . . . [At] 5:00 . . . joined Arthur and Billy for a feverish discussion as a scene was shot. During the scene Ginger dropped a compact and broke a mirror to bits. I gave her a lily-of-the-valley in mitigation, but she sailed above superstition on a wave of Mary Baker Eddyism. . . .

May 4: Slept so late that I saw only the final moment of the rushes. Billy, having seen the rough cut last night, was pleased with it. . . . Went on the set and saw Ginger doing the last scene not very well, making herself, as mother, too old. Elizabeth Bergner there. . . .

May 5: The rushes. Ginger not brilliant in the last scene. She was trying to give an Academy Award performance of an old lady, not the straightforward performance of a girl in love, forced to hide as an old lady. Worked at RKO all day. . . .

May 11: A rather memorable day. Milton entered wild and disorganized and argued some point passionately, which I now (as fifteen minutes later) find impossible to remember. Billy came in and I read him my treatment. As always he kept improving scenes—effective but useless to try and blend with them. A feeling of ineffectuality such as his vigor and conviction always induces. . . . A nap and an afternoon of work incorporating Billy's best suggestion. . . .

May 14: Wrote on the story. At 11:00 Billy telephoned me and I joined him at Paramount and discussed story line. I lunched R.W. [Ruth Waterbury] at Perino's, went back to Paramount and saw the rough cut of *The Major and the Minor*. It was O.K. . . . the direction not brilliant but all right. Billy had had lunch with Milton and was full of talk about how I had mal-treated him. Discussed possible cuts till about 5:00. . . .

May 21: A morning spent at Paramount, working on the Foreword, in what seemed to me juvenile attempts. Lunched with Billy and Arthur and Jules Furthman at Lucey's and shanghaied Billy for consideration of *B. for F.*—a disastrous proceeding, as Billy was sleepy, wanted to change not only every scene but every character and behaved like a complete ham—leaving me and Milt [Holmes] discouraged but amused. . . .

May 22: Woke early and worked for about an hour on a Foreword for *The Major and the Minor*, finding one at last which seemed to me just about right. Hurried to Paramount, to find Billy and Arthur in a projection room, where they had just inspected some Wisconsin stuff (disappointing, because the building of St. John's which had seduced Arthur's fancy and led him to choose that school as a background, turns out to have burned in 1938). Offered my suggestion, knowing that it would get no consideration—and I got none. . . . Left in a mood, but set to work on my RKO stunt with some vigor. . . .

May 27: Studio all morning, talking with Milton and writing. Was to have luncheon with Billy but we were called into Buddy De Sylva's office and I was told I was to be a producer—Billy and I to produce, direct and writing

being the idea. Billy and I proceeded to Lucey's and ate with the Anne Shirley Lunch Club, a small group founded around Budd Schulberg, who stood disconsolately at a bar one day saying "I've been stood up for luncheon by Anne Shirley." Other gents who had been took him to their tables: today Anne Shirley was to lunch with them but didn't show up! Don Hartman, Collier Young, Budd, Billy and Eddie Mayer were the group. Felt curiously depressed and didn't much enjoy myself and after my nap had a solemn half-hour of weighing myself in the balance and finding myself wanting. . . .

May 29: At the studio, Billy appeared, in top form. He, Milt and I discussed the story. He made some small suggestions, had a conference with Hempstead, lunched at Lucey's, seeing Oscar Hammerstein there, who told about his new project—an all-Negro *Carmen* called *Carmen Jones*, which sounded to me so enchanting I offered to put up a thousand, as did Billy. . . .

June 5: . . . very agitated to a sneak of *The Major and the Minor* at the Alex in Glendale. Not enough preview seats, so Bean and I sat down front. The picture went excellently save for the scene between the two women, which was a touch over-dramatic. The man next to me was a wonderful audience, yelling with laughter, breathing with apprehension when the plot was tense, saying "There's something wrong" when Ray left Ginger. When the picture was over I turned to him and said, "What did you think of it?" "All right," he replied. . . . Stopped at Lucey's afterwards where were Ginger, the Collier Youngs, and a few others—discussed the picture for a time. . . . Cards few, but very good. Front office pleased.

June 6: At 10:30 had a long session in Buddy De Sylva's office about cutting. I agreed with every suggestion save the cutting of the final scene, which I felt played marvelously well. We then adjourned to Arthur's for a musical session (the scorers, etc.). . . .

June 11: Woke feeling well. . . . When Rex Cole, the business agent Billy has hired (he is Arthur's and Bob Montgomery's as well, and Ernst Lubitsch's) came, settled himself down and stayed until 4 or 5, blanching at my financial

follies, as well he might—but I detested it and him and his advice (probably wise) about the financial conditioning of the young—but hired him. . . .

June 13: Worked in bed all morning.[9] Lunched at Lucey's with La [Ilka] Chase and Mitch Leisen, a boy who certainly makes one appreciate reticence. . . .

June 15: At the studio and got a noble version of the last sequence done. Not good, but faintly recognizable as something . . . was called to Paramount for a consultation as to whether I should go back there Monday (which I thought a foregone conclusion) or Billy should come to RKO as a writer for 6 weeks and then we start. . . .

June 19: . . . proceeded to the studio where the dynamo outside my window roared all day. Had a long talk with Milton and David, who came in with the news that Casey had telephoned Billy to promise to do a picture for us at Paramount if Paramount would let Billy direct *B. for F.* Lunched at Paramount and napped there; went back to RKO and tried to work, but the dynamo drove me back to my own office at Paramount. About 4 I looked in on the Hacketts and suggested tea. David Lewis was there with them and after waiting a few moments, thinking we'd all go over, I saw David was reproving me for interrupting a conference and retired. . . .

June 20: . . . go to a party David and Jimmy gave for Judith Anderson back from *Lady Macbeth*. Spent most of my time there with Dame May Whitty, who was in rare form and had pointed out to Louella Parsons that despite Merle Oberon's recent elevation to Lady Korda, she, Dame May, was the ranking Englishwoman here. Got a little tight and stayed on to dinner, talking to Judith and Mary Servoss, who remembered my review of her in *Street Scene*, and to Aileen Pringle, a damned attractive woman.

9. Since June 7, Brackett had not been feeling well, with a sore throat and a cold, which his doctor advises was the beginning of pneumonia. Billy Wilder and Arthur Hornblow had left for New York on June 6.

June 22: Billy back. I went to his house to see him before the local machina-
tions got under way, then to RKO. Met Billy at Para at 11:00 and we went to
Ginsberg's office and he said O.K. for Billy to come to RKO if Cary Grant was
in a position to make a commitment—a gigantic If. . . .

June 24: Today Elliott drove me to the studio,[10] to an utterly do-less today.
Nothing had contradicted my previous orders so I went to Paramount. Billy
ambled in about 11, we talked for a while, went to Ginsberg's office. He told
of the failure of negotiations with Grant and asked me to luncheon, taking
me to Romanoff's[11]—where I paid for lunch. . . . At Romanoff's I found him
very companionable and good fun, got back about 3, napped, was wakened
by Wilder who had a record of a song written by a friend of his, "Next Time,"
which we played in the Music Dept. We saw some bits of *The Major and the
Minor*. Milton descended on us with news that Cary Grant was coming to
make a definite offer of a picture for us next year. . . .

June 25: Another footling day, Billy not arriving until 11, some search for
a new office. I hate to leave my old one and detest the side of the building
on which our new suite is located. . . . Napped, wrote letters, talked briefly
with Billy, heard some dubbing, wasted a hideous amount of the company's
money, getting no definite word about the RKO business. Finally came
home to dinner with E, X and J and went to see *This Gun for Hire* in projec-
tion room 8 at the invitation of Dick Blumenthal. Thought it swell, excit-
ing, preposterous, double-twisted, coincidental trash. On the way home we
stopped at Will Wright's for sodas, a charming little boite which I'd never
seen before.[12]

June 26: Another imbecile day. . . . Luncheon with the Inter-Talent Coun-
cil to consider the proposed conservation of film measures. George Stevens,

10. Since June 16, Brackett and Elliott Nugent had been carpooling for the war effort, or,
 as the former describes it, "our Share-a-Car movement."
11. Located at 326 N. Rodeo Drive in Beverly Hills; opened in 1940 by a character who
 called himself Prince Michael Romanoff; closed in 1962.
12. Ice cream parlor and soda fountain Wil Wright's was to feature regularly in Charles
 Brackett's diary henceforth.

Frank Tuttle and [J. P.] McGowan of the Directors Guild, Sheridan, Sidney, Val Burton and I from the Writers. The luncheon consisted of an ill-tempered tantrum on the part of Stevens at the idea of giving up screen credits. Screen credits as they stand tend to magnify the director and subordinate every other talent to his, and it is a position they will not yield. Stevens argued that the saving of film from the cutting of credits would be small. Either the government should cut the making of motion pictures entirely or else . . . [ellipses in original] I came to bed and find myself fretting at the prospect of becoming Billy's stooge producer—a prospect I detest. To be a Hollywood producer has never been an ambition of mine, and to be an imitation of one I find peculiarly repellant. So I must admit, do I find any possible vistas that open to me in the industry—and as I appear stuck in the industry, I'd better drift with the tide.

June 27: Drove Elliott to the studio. Billy and I really discussed the story most of the morning. We both lunched with Ilka and gave suggestions as to the interview she is to do of us on the air next Saturday.[13] After luncheon I walked back to Paramount with her, on Claudette's set, back to Lucey's to her car, then I went back to Para and had my hair cut. . . .

June 29: Moved into our new offices, installed Helen Hernandez as our secretary. . . .

July 2: Worked most of the day on Ilka's radio broadcast, brightening it up, we thought. I lunched at the table . . . and was summoned to the table of Ginsberg and Freeman to account for *The Reporter* article that we were to have Russell, Dietrich and Harpo Marx in our cast.[14] Freeman reminded me, with tears in his voice, that Marlene had cost the company four million dollars and her name was mud to Paramount executives. I explained that we didn't know the source of the article, which had undoubtedly resulted from indiscreet talk. . . .

13. July 4 on NBC.
14. The front page item in *The Hollywood Reporter* (June 30, 1942) is headed "Dietrich, Russell, Marx for Para. Pic" and reads, "Marlene Dietrich, Groucho Marx without his moustache and Rosalind Russell are slated for the star roles in Paramount's 'Men's Wear,' yarn by Charles Brackett and Billy Wilder, which is scheduled for early production."

July 7: Spent the morning trying to squeeze atmosphere from our story expert, Mrs. Julie Baum of 20th Century Frocks, Inc., a vigorous lady who brings out all the anti-Semite in Billy. . . . I had a drink at Oblath's and then Elliott drove me home just in time to gather up my family and meet Ilka and Richard Haydn at the Cock 'n' Bull for dinner and drive to the Academy at Inglewood for another sneak of *The Major and the Minor*. It went very well, most of the cuts being highly successful. Chase said to Haydn at the beginning when Ginger appears, "Isn't she vulgar?"—and then realized that Ginger was directly behind her. Possibly it is the vulgarity of Ginger's attitude that makes the first scene bad. The rest of the picture is enchanting, if I say it.

July 9: Slept well. Elliott took me to the studio and Billy and I worked all morning, getting a scene or two a little clearer. . . . In the afternoon Miss Baum gave forth atmosphere. Dined at home on the terrace . . . then E. and I went to *The Magnificent Ambersons* and *The Mexican Spitfire Sees a Ghost*. I found *The Magnificent Ambersons* a muddy picture, better than the book, to which it was exceedingly faithful. It omitted the worst parts but failed to supply connection for the rest, so that I should think it highly mystifying for the public, but E. tells me that [housekeeper] Stella and our cook loved it.

July 14: . . . Billy came across this story: The Potato family was at dinner—Pa Tater and Ma Tater, when Sweet Tater came in and said, "Ma! Pa! I'm engaged, I'm going to be married." "To whom?" Ma Tater asked. "To H. V. Kaltenborn,"[15] Sweet Tater replied. "It cannot be!" shrilled Pa Tater . . . "It cannot be! He's only a Commentater!" [preceding ellipses in original]

July 19: . . . About 11:00 the telephone rang and Stella answered it. It was Bean asking if Xan had come home (we had all taken it for granted she was in her room). . . . Within half an hour a telegram arrived from James [Larmore] from Las Vegas saying that he and Xan had been married last night and would be back for luncheon if all were forgiven. . . .

15. H. V. Kaltenborn (1878–1965), one of the best known of radio commentators, heard on CBS from 1928 and on NBC from 1940. This is such a hilarious story and one which few readers will comprehend because of their lack of familiarity with H. V. Kaltenborn.

July 20: . . . The trade papers mentioned the event: Charlie Brackett's daughter elopes to Las Vegas with James Larmore. I was surprised. Expected them to read: Billy Wilder disturbed because of elopement of daughter of collaborator. Everyone a little tentative in congratulations, not certain whether I was approving. . . .

July 22: Another sterile day, though we discussed story consistently all day. . . . Dined at home with E. and went to the premiere of *Mrs. Miniver*, an absorbing and superb picture. Felt Greer Garson's performance was thin and artificial and didn't much like Walter Pidgeon, but the picture itself so good that individual performances didn't matter.[16] . . .

July 30: A day with some progress on the story. Luncheon with the Hacketts in the commissary. Billy rather horrified them with his hatred of Communists in America, a curious slant on Billy. . . .

July 31: . . . Lunched at Lucey's with a large party of Grant Mitchell's friends. . . . Found myself finding the conversation of the Eastern Republican ladies uncomfortably Fascist. When I returned to the studio Billy had, at lunch, mentioned his Imperial Hotel idea[17] to Bill Dozier and Preston Sturges who were so enthusiastic that he was on fire again. We went to Buddy [De Sylva] and Billy had practically sold him the idea when I urged him to see the [original] picture. The second showing seemed to me even worse than when I saw it first, but Buddy gave a now less enthusiastic Yes, and we start a treatment tomorrow. The team is in a bad way, over our heads absolutely. We can't decide where we want to go. I am abysmally depressed.

August 2: Slept until 10:30 so Billy came here instead of my going to his house. We concentrated on our Imperial Palace story and it seemed to me his ideas and mine were miles apart. He sees a Vichy French girl as the heroine, a

16. For the next two days, Billy Wilder is too much under the spell of *Mrs. Miniver* and unable to work.
17. Which was to become *Five Graves to Cairo*.

quarrelsome relationship with the hero which grows into love. I am in a panic lest the same glue of indecision bog us on this one, wonder definitely whether our successful collaboration is over—not from any quarrel or difference of opinion, merely from having on our hands the choice as to where we should go and being unable to decide. . . . Sat sadly totting up my invisible balance sheet, regretting bitterly that I ever left my beloved Saratoga [Springs] where I think—oh, well, why fool myself.

August 3: . . . When I came from the studio went to a garden party at Greer Garson's for Dame May Whitty and Ben Webster. . . . La Garson charming to me, which made me feel that my criticism of her had been churlish, if just. Saw David Lewis leaving when I was and asked him to dinner. He stopped in for a drink and instead of staying here took me to his place for an excellent dinner and an evening of dull conversation.

August 5: Worked at the *Hotel Imperial* story and found what I think Hitchcock calls the McGuffin—a pretty good one. Billy has come around to my tart heroine—I insisted on either a tart or a virgin, which left the odds on the tart. . . . Went to the opening of *Tales of Manhattan*. . . . The premiere was gigantic, crawling with stars, very long and successful, though not as successful as I had expected it to be. I asked Bob Hope how he liked the picture. "It was very episodic," he said enthusiastically. Particularly struck by the rip-snorting beauty of Hedy Lamarr.

August 6: In the morning we went to Buddy De Sylva's office and told our *Hotel Imperial* story as we conceived it, discussed possible casting. (He suggested Zorina and Paulette Goddard for our slut heroine, but I held out for Simone Simon) and got his approval, and his urgent request for a title—so urgent that my mind dried up at once. . . .

August 8: This morning we ran *Dishonored*, an old spy picture with Marlene Dietrich, directed by von Sternberg. Billy admitted, after seeing it, that all his respect for von Sternberg was gone since he could ever have made such a horror. . . . David and Jimmy, at David's suggestion, came in for tea and some

bridge. It was quarrelsome bridge in the afternoon. Then we adjourned to their house for dinner and more bridge—and every card Jimmy played was the signal for a violent scene with David, with Jimmy lashing back occasionally. Finally E. and I were so nervous we couldn't either of us play a card. We left early. . . .

August 11: Settled on the title, *Five Graves to Cairo*, told it to Bill Dozier at the table and Word-Gamed successfully. In the afternoon we were summoned to Buddy De Sylva with Bill Dozier, told Buddy the title. He didn't like it. The word "Graves" would keep people away from the theatre. Before we left he had accepted it. We mapped a plan of publicity—that the studio is to have given us carte blanche—no one but ourselves to know anything about the picture. . . .

August 12: True to our resolve, we wrote Fade In. It was almost all we wrote, but we blocked out the opening shot completely. . . .

August 13: A day of actual writing, praise be. The first three pages of script finished—good, grim pages—and a surprise to Helen, our secretary, who thought she had gone to work for a comedy team. . . .

August 19: . . . We worked at it all morning. Ruth Gordon lunched with me at Lucey's, as entertaining as always. In the afternoon we ran *Sullivan's Travels* so Billy could see Veronica Lake and *Morocco* so Billy could absorb African atmosphere, the first I had seen recently and it was incredibly boring on second sight. The second I remembered as very good, and it is empty, without story, with characters whose dialog seems to emerge from their lips like bubbles in glue. . . .

August 20: Tackled the series of dissolves which has been arresting our progress but, like all series of dissolves, they prove hellishly obdurate. We could almost get something down on paper, then stop and beat our brains for a really good idea. When it appears on the screen it will be a not very arresting blur of episodes—in all probability, but one hopes. . . .

August 22: Tonight when we got in there was a telegram from Harry Miller: Alice died early this morning in her sleep. Next to [John] Mosher she was my dearest and closest friend, and while I had expected the news am glad for it, find myself crumpled up inside, remembering her at Antibes, at the party when I first met her and quoted her works to her, which I knew by admiring heart—(whose party? I don't remember), in the Providence house which she loved, the blue room was copied from her room in New York, the visit when she taught me backgammon, long games of cribbage at the Island, at the bottom of the Depression, when she won and won, her distress at winning and her amusement at it; the summer I wrote my play which, God forgive me, I read her three times, I think, if not four; her unfailing encouragement; her lovely, gay, detached wisdom; the apartment in New York, always waiting with fire and tea and cards; luncheons at 21; a cottage she had at Watch Hill—Denny, who was always the gold young man of her short stories; the White Cliffs, which she wanted to read me and I didn't let her; and read only when it was already beginning to be a triumphant success. The last time I saw her, when I knew it was the Last Time and there were quantities of impersonal people about and no significant word between us. . . . Otherwise a routine day. . . .

August 29: . . . Georgie Opp[enheimer] called about six and we went to see *Holiday Inn*. . . . We were both bored by *Holiday Inn* which is the type of picture which, while not unpleasant in the least, makes one ashamed of being connected with the pictures. Afterwards we stopped at Romanoff's and there Jerry and Eve Kern sat. Jerry looking the sweet, frail old musician he distinctly is not. George walked up to him, "I'm so glad to see you, Jerry—I've enlisted." "As what?" Kern asked, "A hostess?" "In the Army," George answered. "You mean to tell me you're going to carry a gun?" "No," George said. "Well what are you going to do, dig latrines?" "I am waiting to get a commission," George said. "Well, why didn't you tell me you were a profiteer."

September 3: At work on the script when a telegram marked Urgent was given me: "JOHN MOSHER DIED UNEXPECTEDLY THIS MORNING. HAROLD ROSS." Despite the profound inner conviction I have had ever since the first news of his heart trouble, it was a crushing blow. I'm afraid I bawled in the office, and as I drove home for luncheon cried all the way down Melrose and Wilshire. For myself again, because I'd begun to miss the

wittiest, wisest friend I've ever had or will have. Elizabeth was crying for him too. We had lunched together with Bean. I napped there and drove back to Paramount. Billy and I completed our three-dimentionalization of the scene we were working on when word came that David Lewis was called to the Army and going at once. He wants me to take over the productions he has started. Whether the Front Office will wish it is problematical.[18]

September 23: Finished our test scene for Simone [Simon]. Lunched with Harry Ginsberg, congratulating him on the acquisition by Paramount of all David Selznick's properties (scripts, actors and directors) which is not an accomplished fact but which if it goes through will make Paramount the biggest company in town. It is now the biggest money-maker but weak on talent. In the afternoon Simone came in with a new hair-do and Phyllis Loughton,[19] whom we've hired to coach her, and I, read over the scene and Simone said how she longed to have Phyllis work on her accent but not on her acting, as she might spoil her style, and there was a general bristling of feline spines. . . .

September 27: . . . Someone told George Jessel's great remark about Major Capra, Major Litvak, Lieutenant-Colonel Warner, etc.—"If those guys have been made into that, they ought to make me a fort." . . .

September 28: . . . In the afternoon Simone, for her rehearsal for her test— adjournment to Stage 10. She acted like hell, embarrassed . . . , tending to put the blame for every misreading on Phyllis Loughton. Utterly amateurish and discouraging. Nevertheless after the uphill effort, plus an indignant visit from Phyllis Loughton, we did a little more. . . .

September 29: While Billy shot tests of Simone and Franchot, I worked with Dodie [on the script of *The Uninvited*], lunched her at the commissary

18. The following day, Brackett recorded the decision went against him, "to my great relief."
19. Phyllis Loughton (1907–1987), dialogue director, who was also the wife of director George Seaton and the first female mayor of Beverly Hills.

and got the opening of the picture doped out with her. The end is still in the mist. . . .

September 30: The script went only quite brightly. Lunched at the commissary. In the afternoon we decided to go to the Salton Sea to re-inspect a possible location on Friday,[20] and about 5 we saw the tests, Simone better than I had been lead to believe. If she were a fresh discovery we would have marveled. As it was, she was only a good spare, comfortable to know we could fall back on in case we got stuck. She wanted to see the tests, made a scene over the telephone. It is fantastic how she alienated every human being from the hair-dresser to the cutter during the test itself. As a result, the atmosphere in the projection room when the test was shown was distinctly unfriendly. . . .

October 3: . . . I spent the morning with Dodie Smith, ostensibly talking story, actually discussing life. We lunched together at the commissary. "Dick Halliday says I shouldn't tell anyone," she told me, "but you see my husband is a conscientious objector. He has no religion or religious affiliations and he may at any time go to jail or prison camp. That's why we can't go back to England." And how she longs to go. . . .

October 7: . . . In the afternoon Billy was to see Buddy De Sylva about some project of Erich Pommer, asked me if I didn't want to go along and suddenly I heard him proposing that he direct a remake of *The Waltz Dream*, giving a few plot ideas. It was somehow to be produced by Pommer and me. Fortunately for our partnership, Buddy was not enthusiastic. There was no treachery in it, just his complete absorption in a project when it interests him. When I called it to his attention afterwards he said, "That doesn't matter, all that matters is getting a good picture." An Olympian point of view, I assured him I did not share. . . . We had a drink at Lucey's, then I met Bean at Grauman's and we saw *Somewhere I'll Find You*, Clark Gable's last picture, and making it must have made joining the Army a pleasure. . . .

20. Brackett chose not to go on the October 1 trip after learning that Billy Wilder planned to take his wife, Judith, along.

October 8: Billy amazed at *Somewhere I'll Find You*, expected me to think it endurable, and we thoroughly enjoyed dissecting it. . . . We had luncheon with Ingrid Bergman, a big, lovely girl—object: seduction into *Five Graves to Cairo*, result: a kind of Scandinavian impartiality. She seems to me very wrong for the role and surely if she plays it the name must be changed from "Mouche." I suggested "Elephant." Pottered along all afternoon, dined at home with X. and J. and went to the studio to see *The Smiling Lieutenant* which Billy was having run—a vulgar heavy-handed picture with a lovely score and no singers—Chevalier charming, but over him was the ghost of his collaborational present, over Miriam Hopkins the ghost of her horrible, drunken, discontented present self. Claudette amazingly was far plainer than she is now, excruciatingly plain, in fact, and acted very badly.

October 14: . . . I stopped at Dodie's [Smith] and talked a little about her first 27 pages [for *The Uninvited*]. Took her a sketch of what I think Woollcott should say at the beginning of the picture. Met her husband, her two dalmations, and received a sack of sugar as a gift. Went to the Motion Picture Academy dinner at Chasen's, principally amused at a proposal of old Charles Coburn's that the Academy heartily recommend that the colleges employ actors to teach acting, which Donald Crisp resisted, with my support and Jimmy Hilton's as untimely and which Coburn defended as practically a war measure. It was defeated. . . .

October 15: The day an agony of indecision about the Dodie Smith problem. Should I put Frank Partos with her, Jacques Théry? Billy of no value because his idea of doing a book is to change it completely. . . . At about 4:30 I stopped at Dodie Smith's, conferred with her, to her rousing indignation— her hurt cries of "You're worse than Sidney Franklin—he only changed one scene." I didn't point out that he didn't shoot any of them. I asked if she would work with a screen collaborator—cries of No—and I realized that to get anything out of her no go. . . .

October 16: Went to the studio and when I heard Dodie Smith was on the telephone, was sure she was resigning. Instead she was there to apologize and

say she thought I was right about her screenplay. I hope she meant it and didn't just want to stay on her job. . . .

October 17: Worked at the studio all morning, Billy and I are in disagreement because I think Jacques should be employed as story advisor, both on *Fives Graves* and *The Uninvited*. Billy wants him on *The Uninvited* only and I feel that, generous as he is to most people about credit, he is extraordinarily mean to Jacques who really helps him more than anyone. . . .

Jacques Théry appeared around 4:30 and I gave him *The Uninvited* and he gave me a lecture that Brackett pictures might be different but must not be inferior to Brackett-Wilder pictures, a very cute talk. He took the book to read. . . .

October 20: Worked on our revisions pretty hopelessly this morning. Took Erik Charrell to luncheon at Lucey's and he made some good suggestions for *The Uninvited* (the sound of heart-beats, a fire that goes out, petals that fall from roses, ectoplasm climbing the stairs). Jacques came in in the afternoon in his Penelope [self-critical] mood, destroyed all the morning's work. . . . At the end of the session with Jacques I went to Bill Dozier and tried to get him for *The Uninvited*—no soap—soap flung in my eyes, in fact. . . .

October 22: A day spent battering our heads against the problem of our boy-girl relationship. My application for Jacques turned down. Lunched Chasey [Ilka Chase] at Romanoff's, our farewell, as she leaves tomorrow. An application by Billy to get Doane Harrison as a production assistant turned down. . . .

October 24: A day at the office which seemed slightly to clarify the Cairo story. A consultation with Bill Dozier about a constructionist for Dodie Smith—no one available. . . . Xan and James came to dinner and Jimmy Whale and David afterwards for bridge. David got as wild and disagreeable

to Jimmy as usual. After X and J left, he and Jimmy talked to me about *The Uninvited*, Jimmy giving a brilliant idea or two. Wish I could have him, but again De Sylva doesn't like him.

October 27: . . . In the afternoon a British captain[21] came in to give technical advice on our first sequence. Not very bright. (He didn't gather than the tank crew was all dead save our hero), painfully honest (he was in agony that Sidi Barrani should be represented as having an hotel with a French chambermaid and a Swiss waiter, which Rommel could use as headquarters. "It's just not so. I must inform you that it's just not so."). . . .

October 29: . . . Ernst Lubitsch told me that an order has gone out from Washington that no salary cheques are to be paid, which would bring the payee's salary in excess of the salary he received last year—an order I had heard hinted at by black Oscar, the boot-black, who said to me, "Lot of trouble at the window about them big cheques, they ain't handing out them big cheques, ain't that terrible."—with a big milk-chocolate laugh. "Yes, that ain't right, hah, hah, hah." Find myself excited by the news, which is a financial bombshell but not alarmed. Hell, an adventure. . . .

October 30: Ernst was right. Not quite, but a retroactive limitation of $25,000 net on all salaries paid has been issued by the Govt. I am well over the gross amount $67,000 but have various exemptions. What I will do for the remainder of the year I'm not quite sure—scratch along somehow. Billy, I am sorry to say, after pretexting perfect equanimity, announced that after this picture he was going into the army, in a "That'll show 'em" voice. . . . Luncheon at the table, enlivened by Johnny Farrow's account of how he broke the news to Loretta Young. She was in her foundation makeup, black Jersey cream ghost. He said, "Have you heard the news?" "Have we lost the Solomons?" she cried. "Oh, no." "Another battleship sunk?" "Oh, no." She looked infinite relief. Then he told her and in the longest take in history, she registered despair, calculation of her exemptions. . . .

21. Identified later in the diaries as Captain Bull.

November 2: Most of the day spent discussing the decree. Mitch Leisen said, "If we're going to cut out the profit motive—I mean what are we fighting for?" Joe Sistrom replied, "Are you fighting, Mitch?" A million conferences about the trip to the desert. . . . In the afternoon we had to meet Dan Shea, David Selznick's representative at Lucey's. Billy gave a little outline of how he thought the interview (which concerned getting Ingrid Bergman) should be conducted. Hearty indifference was the note he suggested, no truckling. We'd be delighted if we could get Miss Bergman on our terms, not heartbroken otherwise. Before the colloquy was over, to my horror I heard him suggest that Paramount loan himself and me to do a picture for David in exchange for Miss B!!!

November 4: . . . At tea at Oblath's Dick Halliday found Dodie and me and told the amazing story of Muriel Bolton[22] who was in the next booth. She is a plump, pouter-pigeon of a little woman who was on the fourth floor while I was there but with whom I could never establish any connection. Dick tells me she is exactly like the woman in *You Can't Take It with You* who wrote plays. She loved writing and just sat in her Chicago home turning out plays and novels, not knowing what to do with them, not bothering to inquire. One day she saw in the paper that the University of Chicago was offering a prize for a play so she went to her well stocked shelf. She had ten by then and sent the first one she had written to the contest. Some weeks later she learned it had won. Somebody at the University told her of other contests, She sent off three of her other plays and they all won. One was being performed in Santa Barbara. She decided to run out for two days to catch two performances. Standing in the lobby she heard two men speaking about the play so flatteringly that she thanked them. One of them, Sam Marx, asked her if she had any idea for a certain kind of picture (Dr. Kildare). She said she'd think about it and next day appeared at his office with a 52-page treatment. Sam thanked her, said he'd let her know in a few days. She said no, she had to go back to Chicago that night. He said he'd write. Muriel Bolton said no, she'd read it to him. Against all his protest she did. Metro bought the treatment and put her on the screenplay. One day Dick Halliday got word that she'd heard he was an

22. Muriel Bolton (1908–1983) was active as a screenwriter for film and television from 1942 to 1962.

agent and she'd been told she should have an agent. When he was at Metro would he drop in? He found her distressed. Kenneth MacKenna had told her she was through with her assignment, he hadn't another right now but she must regard Metro as her home—and there was no need to discuss it with anybody else. She was puzzled by that. No need to discuss what with whom? She'd asked a fellow writer she met in the hall who told her she should get an agent and mentioned Dick's name. Dick brought her to Paramount. Bill Dozier asked her if she had an idea for a Henry Aldrich story. Instantly she gave him one beginning, middle and end, all complete. Bill asked if she had another. Instantly she came out with a second. She was hired and has been there ever since. . . .

November 10: . . . At 5 we had to go to David Selznick's and tell him the story of *Five Graves*. Billy told it and did so quite badly and I think David had decided before we arrived not to let us have Bergman. Anyway, he postponed his decision for a couple of days but said since she had been in *Casablanca* and is in *For Whom the Bell Tolls* perhaps another type of role, etc. We stopped at Leland Hayward's and discussed the possibility of Garbo with Nat Deverich—not much hope—and suddenly I realized we were handling our project like incompetent amateurs. . . .

November 13: . . . I omitted to record yesterday that David Selznick had refused us Ingrid Bergman yesterday, covering his refusal with a whipped-cream of patronage which was pretty revolting. We had an excellent story, but not exactly one on the scale he wanted for her after *For Whom the Bell Tolls*. . . .

November 14: A morning of actual writing, or rather rewriting of that first sequence of ours—not much, but something, and high plans for a week of concentrated effort. Billy at last seems to have the wind-up. I lunched Hitchcock at Romanoff's, took him a copy of *The Uninvited* and asked him to read it and say if he was interested. He is a monstrous egotist who, when I mentioned the need of having real people and real emotions in *The Uninvited*, suddenly said, "My pictures have always been weak on real people and real love stories," as though I had been hinting at that fact. I found him funny

and likable. He told one glorious story of an English actor's funeral: a very, very old actor was at the grave and someone said to him, "How old are you, Charlie?" "Eighty-nine," he said. "Hardly seems worthwhile going home, does it?" was the rejoinder. . . .

November 18: Completed the blasted revisions. Went to the studio for luncheon, saw Buddy De Sylva for a few minutes re leading lady. He was very unenthusiastic about Anne Baxter (Billy's faute de mieux choice), as am I, and very bitter about David Selznick and his tergiversations. . . .

November 21: Went to Wilder's but we moved on to the studio for a session of absolute hell. His belief in our big scene of the 2nd act completely gone. His confidence in the whole project shaken. I lunched with Hitchcock and Mrs. Hitchcock at Romanoff's. The deal David Selznick made with Fox has completely cut off the chance of getting Hitchcock for *The Uninvited* but he was generous with suggestions, one of which made my bowels yearn towards him, and I for one had a very good time. . . .

November 22: . . . Billy worked all morning. He is like a chess player working out a great move, sure that it exists, not yet clear as to how it goes. I know he'll get the move eventually, but whether it will come in time remains a shuddering mystery. . . .

November 23: Billy and I worked here, agreeing on an ending for the picture. We now lack about three focal scenes in our outline, one which prevents us from writing because it must be prepared by our earlier scenes. . . .

November 25: The last day of my forties. Billy and I worked like nailers [*sic*] on the problem of how Bramble gets the secret of the four graves, and didn't solve it. Smashing our heads against a solid wall all day. . . . Came to bed early, feeling all of half a century old, inadequate to the constant and illimitable economic pressures of the times.

November 27: . . . At 7 I had to go to act as busboy at the Hollywood Canteen, the 7 to 9:30 shift. I had pictured it as kind of fun. It wasn't disagreeable but it was grueling work, picking up the trays of the boys who had eaten, taking them to the kitchen . . . dish-washing and drying. I haven't much of an impression what the boys were like. There were knots of autograph-seekers around Irene Dunne and Hedy Lamarr. . . .

November 30: . . . a session with Buddy De Sylva in which Billy got him to consent to Anne Baxter as leading lady—as dreary a little piece as I ever saw. . . . Tonight I am playing with the thought, ecstatically, of casting off the utterly foolish pretense that I am producing *Five Graves to Cairo* and going back to my office on the fourth floor. I daresay I never will.

December 4: . . . at 7:30 was at Chasen's for a dinner meeting of the Academy Board, a long one concerned principally with an Army row which involves the investigation of the Research Committee of the Academy, all engineered by Warner Bros. in revenge for some failure to get commissions for the Warner sons-in-law.

December 10: Best single day of work we've had on the picture. No script, but the story line of the whole next sequence put down, scene by scene. Luncheon at home with no butter. When Billy left around 5 I went at E's suggestion for a walk, a walk around the block. When I got back Buddy Coleman and a man from the Estimating Department were here with figures. Billy assured Buddy De Sylva the other day that our picture wouldn't cost more than $600,000. He had based this on comparison with *The Major and the Minor* which had Ginger's huge salary, Ray's large salary, and Arthur's tremendous salary tacked on the other costs. The figure the boys gave me was $920,000. Billy had counted without added expense of having an epic, with large legion, to the Salton Sea. I digested the figure as best I could, took the boys to dinner at the Cock 'n' Bull and then we all went out to Billy's. He too was hit on the head, made some suggestions which lowered the cost below the $900,000 level. . . .

December 11: . . . the most important men of the company—Buddy, Frank Freeman and Henry Ginsberg, abetted by Berthelon, pounded at us, the ex-

travagance of our budget for a weak cast and a title which wasn't a business getter. Finally, since the budget could be only very slightly pared and the cast was set, all that energy went to belaboring the title, which it was decided to change. . . .

December 16: Another day of hell. There are times when I look at Billy, the best dramatic mind with which I ever came in contact, with the appalling feeling that his mind is dropping apart before my eyes—its brilliant decisiveness crumbling to utterly foolish indecisions. We lunched at Romanoff's with Anne Baxter, who proved to be a charming Indiana girl, as plain as a pikestaff but nice. . . .

December 28: By virtue of Bean's alarm clock I woke at 5, dressed in the darkness and drove through black streets to the studio, enjoying some glorious moments of coasting all the way from the top of the hill to Wilshire and several other stretches uncoastable in daylight. Syd Street arrived at the studio shortly after I did and we had coffee and doughnuts at the Log Cabin on Melrose. Billy and Doane Harrison and Ernst Fegte appeared and also had coffee and we then started to drive to our Salton Sea location, a murderous drive at 35 miles an hour. We got there at 11:00, inspected the set which is O.K.—distinctly not inspired. Lunched at the camp, wandered about the set while Billy picked set-ups with Doane and I eliminated picturesque touches which didn't look Oriental to me. Finally started back about 3, saving our reasons by playing cribbage. . . .

December 30: The hurly-burly of interviewing actors, seeing about details of props . . . , seeing a few feet Fritz Lang had made of a boy we considered (not good); hearing the boy. Lunched at the table. A long Production meeting. Eberle very nice on the whole. More interviews. At 7:30 at Chasen's a dinner given by Walter Wanger to the Academy Board for Darryl Zanuck, back from the wars. . . . Zanuck talked about what he's been doing in Africa, predicts a long, hard way, respectful of the Germans: "How do they do their camera work?" "Better than we do." Then the rules for Academy nominations were read, and an 11-page letter of protest from David Selznick, in grammar as bad as that used by Zanuck in his talk. Got out about 12:30, in a very heavy fog, but not as heavy as the fog that pervades David's letter.

December 31: Arrived at the studio at 9 . . . we completed the final scene of the picture. We lunched at the table, talked with Major Lloyd, sent out from the British Embassy as technical advisor. Had a call from Henry Ginsberg, dictated the stuff, all the crew appendages gathered in the afternoon. Got tight and made sweet and touching speeches of loyalty, and I love them a great deal. Finally signed Peter Van Eyck for the excellent role of Schwegler, faut de mieux. Came home about 6. . . . We played bridge until almost 12, then equipped ourselves with champagne and gold and jumped into the New Year—quite a plunge, that, into—

1943

January 1: Didn't sleep too well. . . . In the afternoon Dodie [Smith] and I went over her changes in the script [for *The Uninvited*]. . . . I am rather disappointed in her revisions, which are always small and niggling. Probably I should take her off the script and put a professional writer on at once but haven't really time to make the complicated arrangements before I go. . . .

January 2: Left the house about 9. . . . a rather dim James drove me to the studio. Buddy Coleman had forgotten to pick up Billy, which delayed our start to the Salton Sea, but we got off about 11:00: Buddy Coleman, Doane Harrison, Billy and I. Doane and I played cribbage all the way down, arrived and installed ourselves. Billy and I were in a separate bungalow cum hot water, toilet, etc. The set was looking far better—fine in fact—and we had an excellent lumberjack dinner in our 400-guest commissary. . . .

January 3: Slept sketchily in a strange bed and this disagreeable desert air. Wakened by the shrilling of a siren, breakfasted, went to the set. It was still dark and very chilly, and the effect of the early light on our hotel is superb. Billy spent most of his day on the set. I came to the bungalow and worked on the final scene. . . . Dined at the commissary with Lt. Lumpkin of the Tank Corps, who has arrived with a stunning bunch of equipment which should make this production into a new *Intolerance*. . . .

January 4: Wakened by the siren at 6 o'clock, showered, breakfasted and got to the set in black cold, punctuated by a new moon carrying the old

moon in its arms. At the set, agitation. The watering of our homemade highway had made it look like a watered road with puddles—not like a metal-surfaced road. Men with brooms were sweeping off the wetness, others tamping down the puddles—it looks as though the day were lost. Then the sun rose and the excess water dried and the shooting began. Franchot [Tone], running towards the town, Franchot seeing the town, rising to his feet, starting his run, Franchot addressing the imaginary sentry. . . . The time for shooting was brief, due to the direction of the hotel, which has the sun on its face for three brief hours. Lunched at the commissary, the point of interest being F.T.'s appetite, which is prodigious. . . . I napped, worked on the final speech, wrote four letters, then wandered on the set to see Franchot do his crawl to the road, his eerie laugh as he saw the town. Walked about while Billy, Doane and [cinematographer] J. Seitz picked set-ups for tomorrow. . . .

January 5: . . . The wind was blowing a little as we walked down to Sidi Barrani, blowing constant rivulets of sand over the black road. It was a beautiful George Inness[1] kind of dawn, flamingo and pale gold, and the crumpled hills on the other side of the Salton Sea were deeply purple and old rose. After looking about I came back to the cabin to work, finding anything preferable to the boredom of between set-ups. The wind increased with the day. I went down at noon, to find a real sandstorm, the tanks lunging about in the sand, almost colliding, scaring the hell out of me. . . . Wilder utterly unaware of the possibilities, as though the tank drivers were stunt men, not American soldiers loaned us rather gingerly. The effect will be superb in our montage. In the afternoon, [Akim] Tamiroff and [Fortunio] Bonanova arrived, two plum puddings of rich actorhood. I completed a synopsis of *Five Graves* and sent it back so the studio could circulate it in the search for a new title. After dinner we went into Indio and saw the rushes of our first day's shooting—saw it with a full audience, between performances, with the audience yelling with laughter at the preposterous repetitions, at situations torn from context. In addition, the long shot of the road seen from Bramble's angle was terrible. It suggested a slushy street between snow banks, not a metal-surfaced road between moving sands. It must be retaken, with the texture of the road the first consideration, not the light on the hotel. . . .

1. Reference to American landscape painter of the 1800s.

January 6: The plum puddings appeared at breakfast and talked at length about *For Whom the Bell Tolls*, in which they both appear. We went down to the village for the shot of the British prisoners in the dawn, got the first one in the right light but with too much wind machine, the second in too bright a light, with better-modulated wind. . . .

January 7: The retaking of Sidi Barrani (or Halfaya) by the British. Billy's nerves, somewhat at edge, broke when I made a suggestion to him which Buddy Coleman had just made twice. "That is the way they do it in *Life* magazine," he cried, throwing his hat in the dirt. "God damn it, you can take me off the picture if you want!" A funny and quite endearing outbreak, which embarrassed him. . . .

January 8: . . . The Sebastiano-Bramble scene in front of the hotel occupied most of the morning. I find my interest in a script evaporated the instant it is on paper, to hear actors going through those worn-down lines sickens me in the liver. I left after the first take and took a long nap. Mine has been a mighty profitable week's salary for Paramount to pay. In the afternoon Tone did the graveyard scene and did it beautifully. Tamiroff, who had only to walk to the grave with him, inspired my great respect. His squat little figure passing between the graves became an embodied elegy. Buzz [Burgess] Meredith came to see Franchot and we had some talk with him before they went into Indio. . . .

January 9: . . . Immediately after luncheon we started back to Los Angeles—Billy, Doane, Syd and Buddy Coleman in the car. We played cribbage for a time. . . .

January 10: At the studio all day, in a flurry of activities—inspection of the set, picking out furniture in place of the furniture that was there, meeting von Stroheim at the Western Costume Co. when he was having a uniform fitted (according to a provision in his contract, allowing him final say in regard to his costumes). He was excessively polite, saying he had heard so much with regard to me and Billy (meaning Billy) from so many people. . . . In the

afternoon more set fussing, the rushes from Saturday, and Sunday (excellent). One day's rushes are lost between here and the Salton Sea, a rather alarming fact. . . .

January 12: . . . In the afternoon Franchot Tone resumed his curious, quiet, automatic argument over every comma of the script. It's not that he really objects to the stuff, he just argues—uninterestingly, seemingly for the sake of conversation. I offered to give him a lecture on the subject but Billy said not yet, "but it is going to get on my nerves." . . .

January 14: . . . Waited to see Peter Van Eyck act and thought him dangerously soft, as did [actress and now writer] Anne Wigton. Went out to Billy's for dinner and an hour or so of work on the lacking sequence.

January 15: . . . Saw yesterday's rushes which were good, Van Eyck covering up his softness with roaring. . . .

January 16: . . . Had a long talk with Richard Haydn, whose proposed marriage is to be postponed till after the war and who is acting actorish, unreal, and just like an English play about love.[2] . . .

January 18: . . . After lunch, instead of calling Buddy De Sylva and reading him *The Uninvited*, I read it to Lew Allen who has been going over the script for Buddy, and Lew paled at its slowness of pace—rightfully, I think, and advised a revision before it is shown to Buddy. . . . Billy and I dined at Lucey's. At the next table Ginger Rogers and the young soldier she has eloped with (some columnist called them The Rogers and the Minor). Touched by

2. When Brackett arrived back from the Salton Sea on January 9, his wife had told him of Haydn's proposed marriage. The lady is later identified as Maria Manton [Marlene Dietrich's daughter Maria Riva]. By February 20, Brackett records the "madness" is over, the twenty-year difference in ages being the main complication. In friendship, Brackett tried to persuade Paramound to cast Manton in *The Uninvited*.

her eager pretense of being a character she plays on the screen, an adoring young girl. Not a very nice guy, I have an impression. Billy and I worked until 11, accomplishing practically nothing.

January 21: . . . Worked on a quicker, gayer opening for *The Uninvited*. Saw the rushes—good today except for Tone—dined at Billy's and discussed until 10, his phobia against writing being stronger than any living emotion.

January 22: . . . Billy hysterical in his outbreak against the studio for wanting to change our title. In the afternoon I napped, dictated my changes to Helen, went to the set and saw the reason for Billy's agitation: von Stroheim's slowness, lack of sureness, inability to remember his lines—his elderliness, in fact. Stayed on the set till the rushes, which Billy thought fine. I only fair . . . [ellipses in original] slightly ridiculous, in fact. . . .

January 25: . . . Saw the rushes at 6 and for the first time they were bad. Bonanova incredibly artificial, turning the piece into bad musical comedy. It must be retaken, as Billy agreed. Tomorrow, have to interview Buddy De Sylva on the subject, get Phyllis Loughton to coach Bonanova, and then tell Bonanova—a pleasant series of gestures. . . . The papers full of Alex's [Woollcott] death. I thought about him a lot, but after the loss of John [Mosher] and Alice [Duer Miller] his is a minor loss. He was a superb friend and the most interesting of human beings, but his life was so crowded one couldn't but feel like a member of The Ensemble in it.

January 26: Had to go on the set . . . found Tone objecting to the line "Like Kind Uncle 'Erbert on Christmas Eve." Listened to his argument that he, as an American playing an Englishman, didn't want to have to play an Englishman imitating a Cockney. Suggested some lines, heard his objections, and had one of my old-fashioned ground-fits, from sheer boredom—which scared the hell out of Tone and should prove valuable to Billy in future. Went to Buddy De Sylva's office regarding the Bonanova stuff and told Buddy I thought it very poor and that it should be retaken. Buddy agreed, sight unseen, suggested Lew Allen to coach him in the lines, but I suggested that as a formality

he see the stuff before the decision was made. He did and quite liked it. (Apparently the whole front office laughed at the stuff) but Lew and I were able to persuade him it could be improved. . . .

January 28: A day with no more strenuous agitation in it than a white satin pajama top of Erich von Stroheim's, against which I had to protest. . . .

January 29: A quiet day. I went on the set for a glance at von Stroheim's pajamas; saw that they were lusterless and conservative, and left. Did some puttering with *The Uninvited*, and got a call from Buddy De Sylva about it. The company wants it produced in March. Maybe it is possible. . . .

January 30: . . . Both *Time* and *Newsweek* in their obituaries of Alex quote a line from *American Colony*. . . . I remember so well Alex saying about *American Colony*, "I want to be in this one." "All right," I said, "But fair warning—the buttons are off the foils." And he loved it, with that masochistic passion he had for caricatures of himself.

February 3: On the set quite frequently, once for an asinine publicity photograph of a teletype machine supposedly installed on the set for Billy and me—embarrassing, but an idea dear to the Publicity Dept's heart. . . . At von Stroheim's request gave him a snort of whiskey in the office. Had a talk with Frank, read of a lot of *The Uninvited*.

February 5: . . . We saw *Rebecca* in the morning and it overpowered me with its assurance, its evidence of money, its general excellence. . . .

February 6: . . . Told Lew Allen the possibility of taking him on as director for *The Uninvited*. He was in seventh heaven. In the midst of our conference a wire summoned me to Erich von Stroheim, who had been writing away at his script and wanted my approval. Took him to the set, where Billy was having a hard time with every shot, interrupted by sounds—coughs, sneezes, etc. We had to wait until after the rushes before Billy heard Eric's suggestions. He

agreed with me in cutting most of them. Billy, Walter [Reisch] and I dined at Lucey's, went to our office and went over the remainder of the script inch by inch, Walter being extraordinarily helpful. On the way home I told Walter the plot of *The Uninvited*, which he seemed to find good.

February 8: . . . Got up at 7, raced to the studio. . . . Frank [Freeman] and Lew appeared. We discussed the story. I went to Buddy's and told him I'd accept Lew to direct the picture. He said we'd consider the matter a little longer, but I think he will go for the arrangement.[3] . . .

February 13: Billy and I had anticipated difficulty with Buddy De Sylva about reshooting the Bramble-Mouche scene. When we broached the subject he said, "I'm glad you suggested that he played it like Hamlet." We then told him Billy's Garbo–Bob Hope idea,[4] to his amusement and pleasure. I lunched with Henry Ginsberg, who was worn out from a night of gaiety and was leaving the studio early. Then Frank Freeman took me into his office and tried to convince me that Brian Donlevy, Clark Gable and Dotty Lamour are the answer to the exhibitors' prayer. . . .

February 17: . . . Had a consultation with Buddy in which he seemingly urged me to take Lew Allen and make a budget picture putting across a new girl on the strength of the book's sales. . . . And when I was ready to accept, said, "Think it over for a time—until this afternoon," which left me in a state of jitters. Curiously, my own instinct as to what would be fun to make is a low budget picture with a new director without the set ideas of Mitch [Leisen]. I suppose the picture won't be as good or as profitable but I'll have more fun making it. . . .

February 19: . . . Erich von Stroheim made a brief appearance to discuss absurd changes in the dialogue which he wanted. . . .

3. On February 11, without explanation, Brackett notes that he had been hoping for Mitchell Leisen as his director, and the following day writes that Leisen has been rejected and "Lew Allen inevitable."
4. First mentioned in the diaries on February 10, but with no explanation as to what it is.

February 20: Worked on the outline (or rather treatment) of *The Unin-vited* all morning. Lunched at the table, napped, then went to Stage 17 and in the bedroom of the Italian general completed the script. Neither of us could believe that it was actually done. Worked some more on *The Uninvited*, dic-tated the stuff to Helen, who came at 6 o'clock from the shops exhausted, as there was a rumor that clothes rationing would begin at midnight tonight and every feminine clothes department was a stampede. . . .

February 21: Savored the unspeakable rapture of not having to work on *Five Graves to Cairo*. . . .

February 23: . . . Buddy De S. called me and again offered René Clair on a silver platter, but I turned him down. He's too intelligent and delicate minded for the job. . . .

[At this point, the diary entries become concerned with the casting of *The Uninvited*.]

February 26: Studied the outline for a final time before having it mimeo-graphed. Saw *Lucky Jordan* with Frankie, in order to see the girl who played the lead, who was appalling (Helen Walker is her name)—long-necked, awk-ward, and a wretched actress.[5] . . .

February 27: Worked with Partos for an hour. Sidney Greenstreet arrived at 11 and for an hour I acted out the script for him and sold him the part of the Commander. . . .

February 28: . . . to the Chateau Elysée where Cornelia and Emily[6] gave a party for Marian Anderson, who sang here this afternoon, a very beautiful,

5. On March 1, Brackett saw some tests of Helen Walker, "whom I hereby swear not to have in the picture."
6. Cornelia Otis Skinner and Emily Kimbrough, co-authors of *Our Hearts Were Young and Gay*, filmed by Paramount in 1943 for 1944 release.

wondrously kind black face, the sweetest of manner. I wish I were better at meeting colored people, didn't feel the detestable smile of patronage creeping over my face. No, I can't say it was that this time—she was a great woman, I knew that—but I had and could have no communication with her. I may add that I can have no real communication with any musician. Miss Anderson left quite early. . . .

March 2: Got in early enough for a little dictation, had a Spec. Effects Budget Meeting at 3 and decided to dub in the spooks. At 11:00 Dodie appeared and I read her the treatment, to her very general approval. She was afraid of the job of writing out scenes skeletonized by Frank [Partos], but is going over our first sequences, seeing if she can approve them and if so going to work. . . . Saw the unspeakable Helen Walker . . . go into Lew's office. At 2:30 the rough cut of *Five Graves* was shown in its entirety. No one but Frank Partos and Joe Sistrom in the projection room who was not involved with the picture. It is stunning but the curious attitude of the hero going back to the dead girl with his present for a live girl puzzled everyone. It was a difficulty I had feared, and Billy had talked me out of it. . . .

March 4: . . . At 6:30 went to the barbershop, rushed home for a change of clothes, then E. and I rushed to the Chateau Elysee for Cornelia [Otis Skinner] and Emily [Kimbrough], then to the Ambassador where the Academy dinner took place. It wasn't as fruitful of anecdotes as other years. The hammering of gratitude to Mr. Mayer by M-G-M-ites became farcical and when Bill Goetz presented him with an Oscar, a peculiarly tasteless speech was made. E. had just commented on how much better women spoke than men on such occasions when Greer Garson made an ass of herself with a long, pompous, arty speech.

March 6: Consultation with Buddy about giving Bramble a reason for thinking Mouche could have survived. Consultation with Meiklejohn: Greenstreet seems to be lost to us. . . . Napped and worked on the script till after 4, when we could see the rough cut of the Helen Walker test. Lew Allen proved in it that he can get good acting performances. Helen Walker is as ill-suited to the part as a human being could well be, but comes off creditably. . . .

March 8: A Budget Meeting with Eberle (Lewis being too docile about paring down budget) was interrupted by the running of the rushes, which lasted an interminable time. I didn't go and finally got Lewis's report that Helen Walker's test was a great success and was run over and over. Meantime I had heard Dr. Rozsa's stunning music for *Five Graves* played by him on a piano but with orchestral magnificence. . . . Called Eleanor Boardman about the possibility of her playing Miss Holloway. She is to come in tomorrow and meet Lew Allen. . . .

March 9: . . . A singular lack of candidates for the role of Stella made me go to Buddy De Sylva's office and state that I thought Helen Walker adequate and nothing more. Buddy put heavy pressure on me to have her. I remained obdurate. Finally he said "If you find no one better, will you have her?" To which I replied, "We will find someone better!" . . .

March 11: Worked with Billy from 10 to 12, the banal viscous drops. At 12 Donald Crisp appeared with his agent and I told the story of *The Uninvited* at length. I lunched them in the commissary, went with Lew Allen, Hans Dreier, Ernst Fegte, Syd Street and Buddy Coleman to Metro for an English [set] and found a combination of two which will suffice us. Came back to the studio. . . . Eleanor Boardman appeared and I told her the story again at length, to interest her in the role of Miss Holloway. No soap I fear. "I have two growing girls. I don't know that I want them to see me as a murderess." . . .

March 16: . . . Billy got a telephone call and consulted me about *Double Indemnity*, a story Joe Sistrom suggested to him which he wants to do, not leaving Joe out. I got the hint and talked it over with Leland and we decided Billy was having a touch of claustrophobia at being tied down to working with me, so I told him to go ahead with Joe. After luncheon, however, when he confided the plan to Buddy De Sylva Buddy nixed it, saying that we should stay together, it was none of Joe's business to suggest such a thing. Hope Billy's claustrophobia didn't clutch him harder at those words, which were I confess a great relief to me. Got together a test scene for Miss Holloway. Interviewed Agnes Moorehead as a possibility, saw the retakes for *Five Graves*. . . .

March 18: . . . I went to the studio and watched Cornelia rehearse for her test, the crew and Lew Allen all crazy about her. Buddy telephoned me to say that Joe was to do *Double Indemnity* with Billy. I had thought I'd be depressed by the news but as the day wore on I felt vastly relieved by it. Gravely doubt that I can ever bring myself to work with Billy again. At the moment the idea of doing so takes all the joy out of life. Worked on the script, lunched at the table. In the afternoon Eleanor Boardman was tested but I didn't see the test. . . . Interviewed and hired Barbara Everest for the maid, instead of Lucille Gleason. Got a gleam of hope that Geraldine Fitzgerald may be free to play Pamela. If I had a Stella and a finished script would feel reasonably happy.

March 19: A little work on the script, a great deal of work on the production. . . . The plans for Cliff End are finished, and the exterior stunning except for two Hollywoodian wings Ernst Fegte added. Saw Cornelia's test which was excellent, and Eleanor Boardman's, which was no good for Miss Holloway but showed her to be a stunning woman for her age, with a distinctly Billie Burkeish quality, none of her menace shining through. . . .

March 24: Lew back from his location trip, very blue about our lack of a Stella and of a Pamela. Read the troublesome first sequence to Billy, who purported to like it. . . . Interrupted in my napping by the arrival of June Lockhart, who read Stella like an angel, was Stella. Nevertheless, in deference to the fact that the front office would not think her pretty enough, looked at some dreadful film on Barbara Britton and on returning to the office I think it was Lew who found in the casting book a Paramount contract girl named Gail Russell, asked to see her. Lew, Frank and I were all knocked over the head by her extraordinary beauty. Went and saw some Henry Aldrich film on her and she wasn't bad—not a brilliant actress but something which can really dazzle the beholders, if Lew can squeeze any kind of a performance out of her. Bill Meiklejohn told the story of how he found her: he picked up some high school boys one night on his way from the studio. They asked what he did and he told them he was a talent scout at a picture studio. "You ought to see the Santa Monica Hedy Lamarr," they told him and said that all the boys in Santa Monica were crazy about her but she wouldn't have any part of them and that her name was Russell and she went to Santa Monica High. Bill got in touch with the school. There were four Russell families with daughters in

them. He got all the daughters to come to his office. All four of them were dogs. He thought he had been kidded and the next time he got some Santa Monica kids in his car, said as much. "Oh, no," they said. "You mean Gail Russell. She goes to such-and-such a school." He sent for the child and signed her at $70 a week. . . .

March 25: . . . saw the model of Cliff End and was disappointed in it because it looked like a Long Island country house—red brick and tidy. Had an outburst and as a result Ernst Fegte changed the brick to stone, and the effect is superb. The pictures Sid and Lew brought back from location are wonderful. After trying to memorize a scene yesterday and being rehearsed all morning Gail came in and tried to read a scene with Lew before me—and blew her lines and mispronounced her words and, in an odd way, was Stella—frightened and inhibited and beautiful. Lew is making a test tomorrow, thought he says he should get $10,000 bonus if he has to bring her through the part. . . .

March 26: . . . Took some of Bean's evening dresses to Wardrobe for Gail Russell (as they hadn't a very becoming gown for her and she had no evening dresses of her own). The coach at the studio, who adores her, told me that she said she was terribly afraid of Mr. [Sidney] Lanfield but that she wasn't afraid of Mr. Allen or Mr. Brackett or this part. Billy arrived, shaken with rage because Hedda Hopper had an idiotic item in her column that Geraldine Fitzgerald was to be my leading woman and Eleanor Boardman's test was so good that Billy Wilder was interested in her for *Double Indemnity*. . . .

March 29: Waited impatiently at the running of the tests at 11:00. Sat with Bill Meiklejohn. The [June] Lockhart test [from March 27] a complete flop. After the Russell test I said to Bill, "Isn't that gal grand?" He said she had a common voice, was inexperienced, and most of the people in the projection room agreed with him. Even Lewis not hearty in his support. I stuck to supporting the girl and it was finally agreed that she should have diction lessons for three days then make a recording of the speeches. Lunched Dodie and Alec at Lucey's and discussed the script. Dodie is coming back on and made some justifiable criticisms. Feel that we will come to blows mostly. Took them, Helen and [secretary] Opal . . . to the projection room after luncheon and showed

them the Helen Walker test and the Gail Russell test. They all four much preferred Helen Walker, thinking her beautiful . . . resigned myself to the idea that I am insane to consider Russell, which brought on a depressed mood.

March 31: Worked with Dodie all morning, she getting so exercised about the seasick scene that she delivered an ultimatum that she would take her name off the picture if it remained. It was difficult to tell her that I didn't give a hang whether her name was off the picture, and the rehearsal of Gail Russell provided a welcome break. It proved surprisingly better than anyone had imagined it could be. A recording of her voice in the scene was carried to Buddy De Sylva by Allen and Buddy began our interview by telling us how much better off we'd be with Helen Walker. In her we had insurance against a bad picture, etc. He then listened to the recording, approved Gail Russell and we had a rather three-cornered conference wherein each of us said he was responsible if she turned out no good, Buddy taking full burden upon himself at the last. . . .

April 2: Curious day. . . . In the afternoon Henry Ginsberg called me with an inquiry about whether I had . . . Ray Milland. Instantly my blood froze and I knew there was trouble brewing in that quarter. Zeppo [Marx] dropped in (Ray's agent) and I learned that Ray was mad at not having had a script, at being given an unknown director and an unknown girl. Evidently there had been violent scenes. I tried to talk to Ray on the phone, couldn't get him but told Zeppo the story with, I think, great success. . . . Jimmy Britt, by special arrangement, drove us to the preview [in Glendale of *Five Graves to Cairo*] and sat with us. The picture was less successful than any Billy and I ever had previewed except *What a Life*, I think, and was confirmed by Buddy De Sylva that it was due to the score, which is magnificent and distracting—so overpowering that often one didn't realize what the scene under it was about. The picture became a background for the score, a highbrow, non-melodious score. The jokes didn't go, the story was out of proportion to the montage, and the long, desert shots . . . [ellipses in original] Nothing that can't be cured by cutting, I believe, but drastic cutting is indicated and it's a rather long picture as is. Cards were, in the majority, good but a few cried out against war pictures, "We're getting too many of them!" It hadn't the ring of a smash. Billy less crushed than I expected. . . .

April 5: Billy and I wrote an introductory title to *Five Graves*. I had a valedictory feeling about the gesture. We're no good together any longer. There's no stimulation in the relationship. In Billy's manner there is a carefully groomed suggestion of the brush-off. And why the hell shouldn't he brush me off. He's done the major part of our work for the last three years, and the fact that I made considerable effort and financial sacrifice to get him his director's job has been amply repaid. Also I am happy in the belief that, while not as good without Billy, I'm pretty good—and more self-respecting. . . .

April 9: . . . second preview [of *Five Graves to Cairo*], at Pasadena this time. The picture played infinitely better without the omitted music, save for the sun-struck scene which seemed to need it. The ending was truncated and awful. The audience was completely absorbed in the story, and the picture isn't a great success. It has no real warmth, partly due to Tone. It is taut and contrived. Wish to hell we'd made anything but a war picture.

April 12: A fantastic day, in that it began with interviewing dogs, cats and squirrels. Finally chose a Cairn terrier who was in *Air Force*, a cat which goes any place it's told, and a squirrel who's been in the business 8 years and has a double. . . .

April 14: . . . Interviews with cats, a crisis over Ruth Hussey's hair and over Ruth Hussey in fact, because Buddy De Sylva thought she looked like a hag in the makeup test. Lew and I didn't think she looked so badly. Buddy confided to me that there had been trouble yesterday. What kind? I asked. "Did you see *Desert Victory*?" he asked. "Well, that suggests the row that went on here." Then I knew that Milland had been raising hell about the picture and finally been beaten into shape. Saw Milland on the lot but when I greeted him he pretended a terrific cold and hurried on. . . .

April 15: [First day of shooting on *The Uninvited*] Got to the studio just at 9 and rushed to the stage in some trepidation lest Ray not be there, but he was. He behaved beautifully all day, was sweet to Gail (who didn't play today) and cooperative with Lew. He told me he had a row with the front office but it

had nothing to do with this. I waited about for the first take and Dodie came in as Charlie Lang was long lighting the set. I had time to fret wildly: our characters were wrong; they wouldn't have been left in a house; the house was wrong; the lines were wrong—enough to take any pleasure out of the project. Hussey looked well, read the lines a little too fliply. She and I went to my office and read through the remainder of the scenes she's completed and I heard her idea for the end, which may be an improvement though I doubt it. . . .

[The diary entries relating to the filming of *The Uninvited* are very lengthy and detailed. However, included here are only "items" which are particularly entertaining and informative as to the filmmaking process. Most days, Brackett views rushes, and his response varies from enthusiastic to despairing.]

April 17: Crisis when I arrived at the studio: Ray couldn't slide down the banister. I thought of us wearily replacing the scene, using the dog as a dissolve. Gave it to Lew and went to the other sets with Ernst Fegte. Rick's bedroom has been saved and the bathroom improved, and when I got to the stage where they were shooting, the dog wasn't cooperating on the scene and they had Ray's double slide down the stairs—and I was glad, as the little gaiety is pretty necessary in there. . . .

April 19: A day of trouble. Costume problems with Edith Head. Went to MGM with Syd, Doane, etc., taking Dodie Smith, as my own bit of English advice and inspected the English village, which looks very well with its background of boats. . . . Had a budget meeting at 6 o'clock in which we were told the uncomfortably high costs of everything, and tried to get our schedule stretched from an impossible 42 days to a possible 50. No success. . . .

April 20: At the studio early, bearing Uncle George's best inkwell in the desire to give our poor living room set some profile. Somehow the set had pulled itself together better than I dreamed it could, and by the time Charlie Lang had lighted it, it looked mighty fine. I stayed on the set most of the morning, watching breathlessly while Whiskey [the cat] went through a scene, which he did twice like an angel, aided by a dish of fish and cries of "Kitty, Kitty, Kitty" between the dialogue. . . .

April 22: Got up intending to go to the studio, but the urge to see what was happening on the set was too strong and I went to Metro and watched the company work in the English Village there. It was not a very rewarding trip as I saw hardly a shot taken. It was either a shade too misty, a loud truck on the highroad, or planes overhead. . . . Became enthusiastic over the idea of Orson Welles as commentator and mentioned it to Buddy De Sylva who was also enthusiastic. . . .

April 23: . . . My idea for Orson Welles as commentator came a cropper, however, in Henry Ginsberg's office. If we had Orson W. no Hearst publicity, which isn't a risk the studio would care to run. Dodie came in with her final batch of stuff and saw the rushes which were disastrous—Gail Russell in hideous clothes giving an amateur and adenoidal performance. Dodie didn't help the sad conference afterwards by her "I never liked her first test, you remember," etc. Also she has now driven Ernst Fegte, [set decorator] Steve Seymour and many other artisans connected with the picture almost mad, with her criticisms. . . .

May 3: . . . Word came of reactions on the set. Gail in tears, etc. Rushed over to find a lot of men worrying as to whether it was the wrong time of month for her to have worked. Bill Russell telephoned her mother, who reported that she had waked with a sore throat, had had a sore throat last week. It turned out that she was sulking because Lew made her wear a hat in a scene where she didn't want it. . . .

May 4: . . . Spent a lot of the day on the set. Gail in a good mood, but the rushes for yesterday show her cross, pouty, thoroughly unattractive. God help the directors and producers who have to handle her in the future. . . .

May 8: . . . Today on the set it wasn't Gail who had trouble but Ray, who required eleven takes. . . .

May 9: After breakfast I found in my pocket a letter to Walter Reisch, thanking him for a congratulatory note, so I walked to his house with it—and

there, visiting with him, was Billy Wilder. We had a talk, mostly about Billy's trip, then Billy drove me to Martha Smith's to pick up ice cream for the family. Into the shop as I waited for it came John Boles and a young daughter, then Mrs. Morrie Ryskind, full of politics and concern for America more than the rest of the world. Then Freddie Brisson, beaming with pride about the boy baby born last week. I liked the village quality of these casual meetings. . . .

May 10: . . . Find that the pleasure I have been taking in *The Uninvited* has been completely poisoned by Billy's return and my pleasure in life as well. . . .

May 24: Worked a good deal at the script during the night, consulted Billy in the morning and reworked it. Lunched Cornelia [Otis Skinner] and Hedda Hopper at Lucey's and Hedda twice in one week is distinctly too much. Felt I should be disinfected afterwards; had a yearning to turn Communist, to divide my goods and give them to the poor. Cornelia enchanting. . . .

May 25: . . . told Billy I was getting another office. He protested the move, fearing I think that he'll lose the office if I move. . . .

June 1: . . . During the course of the afternoon a representative from *Life* came to consult Billy and me about a spread in *Life*. Billy began to flutter like a June bride with eagerness at the prospect. . . .

June 5: . . . Billy and I discussed the possibility of *Yolanda and the Thief* [7]— Jacques Théry and [Ludwig] Bemelman's original which has so much charm. I distrust it. . . . Waited for the rushes, which were excellent. The improvement in Gail has been amazing. . . .

June 7: Billy and I discussed *Yolanda* and did a touch or two on the exorcism scene. . . . Went to the tank where our big cliff scene is and

7. *Yolanda and the Thief*, filmed in 1945 by director Vincente Minnelli, and starring Fred Astaire.

watched a double for Stella drop off the cliff, or rather be dropped off the cliff, which is a breakaway. It was only a rehearsal and couldn't have been better. Unfortunately, the girl and Milland's double weren't in costume and it must be done again tomorrow. Proceeded to the Ext. Windward House and saw the dog and squirrel shots. Sad that they had already photographed the squirrel going in an opened window instead of a broken one as in the script—the sort of minor point on which Lew Allen falls very flat. He was annoyed with me that I criticized it and some minor things in the rushes. . . .

June 8: Discussed *Yolanda* with Billy and suddenly realized that to do it or anything else with him was going to be an unmitigated bore. Suddenly the project had to be so extraordinary, so utterly different from any musical ever done—completely Wilder, in fact—that a vista of conferences at which I had to register bedazzlement rose before me and I filled with nausea. We went down to Buddy's and Billy paced the floor and expatiated on his idea that it was all to be done in couplets. Oh God, Oh Montreal! Buddy seemed as impressed as an executive in the throes of a censorship problem on *Frenchman's Creek* could be. . . . After luncheon I napped and when I woke learned from Helen that the cliff had broken away, that the girl clinging to the tree root, had been unable to cling and fallen to the net amid a shower of stones which almost killed her. I raced to the set to learn the facts: she had fallen, but the rocks weren't real rocks and though her neck was cut and her arm injured, she'd wanted to make the shot again. Suggested to Lyle Rooks, our publicity woman, that the true facts be publicized. George Brown, head of the department, said no publicity. Telephoned Dorothy Stickney and asked her if she was bored out here and wanted to do a morning's work for her favorite charity, playing Miss Bird, which only an important and successful actress could do. She said she might be, and I left her the ms. and now deeply regret having done so as I'm afraid she'll be offended at the suggestion. . . .

June 9: A morning made miserable by the fact that Billy and Joe ran *Mr. Lucky* and it was pretty bad and quite a lot of the badness was due to me—a non-coagulated story. . . . When I got back the blessed news that Dorothy Stickney would play Miss Bird. . . .

June 11: . . . Billy began actual writing on his *Double Indemnity*, though as yet they have no actor to play the male lead. . . . Saw Dorothy Stickney do Miss Bird gloriously. . . .

June 12: Winding-up day for the picture (although it dribbles over into next week unofficially). . . . In the afternoon ran *The Light That Failed* (so did the picture) to judge the value of the Victor Young score. It seemed to me a little thin. Had a long talk with Buddy De Sylva. He was I think about to yield on the subject of *Yolanda* when I told him Metro had bought it. I discussed a remake of *Shopworn Angel*, a musical version of *Mme. Sans Gene* for Betty Hutton. He seemed interested, seems acutely unconscious of my limitations, which is embarrassing. . . .

June 14: . . . At 10 went rather quakily to the rough-cut showing of *The Uninvited*. It seemed to me to play pretty well, though I made a great many notes—most of them on top of each other, due to a failure to turn a page in the dark. . . . At half-past five saw the rushes, but before had an interview with [Luigi] Luraschi re *Yolanda* (which has not been sold). Billy and I argued for a long time, but it's his point that if we show South America with what is charm to us, South America will resent it. Finally we said to hell with South America and gave up the project. . . .

June 15: The final day of real shooting on *The Uninvited*. Most of it Ray and the ghost. Billy and I have decided to try and get the studio to buy Molnar's *Olympia* from Metro[8] and make a musical comedy of it. Incidentally, the snarls of our relationship have been miraculously ironed out in my mind by my personal perusal of my diaries. . . . The vicissitudes through which Wilder and I have been together struck me forcibly and made other things negligible. . . .

June 16: . . . arrived at the studio rather late, to find Lew reshooting the wrong version of a scene which he tried to blame on Nesta, the new script girl. I went to the dubbing stage and had my illusion as to what the alchemy

8. On July 15, Brackett records that Paramount has bought it for him and Wilder.

of the dubbers could accomplish in redeeming an ill-read speech shattered. Usually a bad reading is bad because of its timing, which can't be altered by dubbing.[9] . . .

June 21: . . . At 2 we ran *The Uninvited* for Buddy De Sylva. After a time he said, "What reel is this?" We told him the fourth, a bad sign. . . .

June 25: Went to the studio happy with the knowledge that at last I had the Foreword. . . . was called to the projection room to see a magnificent cutting job done by the great Doane on the drop over the cliff. He's managed to use the really terrifying one where the girl really fell and blend it with a take of the girl being pulled up the cliff, in a incredibly credible way. . . .

June 26: Stopped for Dodie on the way to the studio . . . and the rough cut of *The Uninvited*. She was irritated beyond speech by changes in her material, particularly the return of the original version of the tobacconist scene. She had suggested withholding the information regarding the house until the studio scene, and I agreed. Then she hands in the tobacconist's, so dull that we had to return to our original version. On the whole she was cross and spotted some of the failures to make knockout scenes, which I had noticed hopelessly. It would have been wiser to have kept her on the script throughout but it would have killed Lew—not a bad thing, perhaps. . . .

June 27: . . . Forgot to mention a gift I got yesterday: two ties from Ray Milland with a card saying, "Please wear these when I am around. Those you wear look as though your tongue were hanging out"—a reference to the shortness of a tie when double-tied a la Wilder.

June 30: . . . Had a curious discussion of the *Olympia* possibility with Billy in which I did not commit myself to do it with him. Lunched and Word-

9. In the morning, Brackett worked with Ruth Hussey on the dubbing stage, and in the afternoon with Ray Milland. Apparently, Gail Russell tackled her dubbing the following morning.

Gamed at the table, amused by the fact that Billy knew from my expression before I read my words in the Word Games that I was trying to get away with murder. Wonder if he has read all my recent thoughts about him as easily. Lew, Doane and I ran the picture, ostensibly for Victor Young, who is to do the music. He is a pleasant, odd-looking illiterate but not unassertive little guy who has just completed the score for *For Whom the Bell Tolls.* . . .

July 2: In the dubbing room all day. . . . Gail began and dubbed pretty successfully until about 4, when her voice gave out. The change in the girl is fantastic—her assurance, her poise, which have replaced that abnormal ingrown shyness. . . .

July 6: . . . had a talk with Billy about the possibility of getting Garbo for *Olympia* (Walter Reisch's suggestion). . . .

July 10: . . . At the studio I saw a run-through of *The Uninvited* with dubbed-in speeches and proper dissolves. I am at the point where I detest the picture, but the reaction of those present seemed highly satisfactory. . . .

July 12: . . . Got . . . to my office to find that Ginsberg has called me. Napped, to be summoned to his office by telephone. There were he and Bill Dozier, agitatedly asking me to help them out, help the studio by doing a brief writing job, with or without credit, on the Leo McCarey picture. . . . Went immediately to a conference with McCarey and learned that the story for Bing Crosby was about a priest, a singing priest. Got the ms. and read a few pages, finding it was the kind of Catholic propaganda that makes me throw up. . . .

July 14: . . . In the afternoon had a brief valedictory conversation with McCarey who evidently is offended at my attitude about his picture. . . .

July 18: After late breakfast drove to Billy's. He lay moaning and groaning in a jungle of thermo-dynamic devices, but in a very good mood, and he

discussed an idea for [Bob] Hope which I had already toyed with: a comedy to be laid in 1955, among all the new inventions and devices after the war. He must of course have something to do with sex and find that among the Four Freedoms is no freedom from the bed. . . .

July 19: . . . In the afternoon ran *The Ghost Breakers*, then ran the weak stuff of ghost stuff [*sic*] in *The Uninvited* for Hans Dreier, Ernst Fegte and the technical staff. They admitted the inadequacy of the present stuff and will set to work. . . .

July 21: Billy in high spirits today, for some manic-depressive cause beyond my understanding. We tried to get an appointment with Buddy De Sylva, to talk over the Hope project, but couldn't. . . . Went on the DeMille set (with Joe Sistrom) and heard DeMille bawl out his assistant director for not having heard some actors read their lines, and when the director made an excuse, heard DeMille yell, "Oh, an alibi! Please never give me an alibi. I've been in this business a long time, long enough to know all alibis." A beastly performance before a crowd of a hundred or so people. . . .

July 28: . . . At 2:30 Victor Young played us his "Stella by Starlight" song, which I found very disappointing—a pretty enough, featureless song without distinction. . . .

July 29: A rather busy day. A hurry call from Bill Dozier to read some material which I didn't much like, a consultation with Lew about the music. (Decided we couldn't do anything about the song and better encourage Victor Young than dishearten him with criticism.). . . . Called with Billy into Buddy De Sylva's office, told Buddy our idea for the Bob Hope picture, which he liked. Consulted him on other projects until Billy had to leave. Incidentally, Billy has made such a point of getting Doane Harrison on his picture that Buddy De Sylva has said yes rather than have a row with Billy. . . . While I don't get half the pleasure out of Lew Allen's company that I get from Billy's, I feel a kind of impersonal disgust at the performance. . . .

July 30: Went to the studio and had a few words with Billy, who had decided the futuristic idea for a Bob Hope story lacks warmth, an impression I've had myself for some time. Dropped around at Leland's and discussed my general situation and the possibility of getting a story-by-story job at other studios. . . .

July 31: Spent the morning on the special effects stage with the technicians and a Henry Aldrich stand-in named Charlie who was dressed in black tights, black gym shoes and sweater and black gloves and had a sack-like-looking contraption put over his head, ventilated from the back so that he wouldn't smother from the fumes of the cobweb machine which sprayed him with cobwebs. . . .

August 6: Billy and [Raymond] Chandler called me into consultation this morning. They are in Second Act trouble and I was of very little use. . . .

August 12: . . . stopped at Leland's office and surprisingly enough found him there. . . . He assured me Billy Goetz of 20th has asked for me on any terms. . . .

August 13: On dubbing stage No. 2 at 9:30 and spent the morning there, getting screams for Lizzie, a wailing whine for the dog (a man did it), some moans for Gail (Gail did them) and dying gasps for Donald Crisp (the dog man did them). . . .

August 17: . . . Lunched [Norman] Corwin at Lucey's—talking over with him the possibility of his writing a screenplay with an authentic radio background, a field which I feel has been sketchily and foolishly covered by pictures. . . .

August 18: . . . didn't reach the studio much before 10. Scoring of *The Uninvited* had already begun. I stepped over to the scoring stage to listen to the first part and spent most of the day there. Victor Young has done a superb

score, save for the séance, which is a little weak, the title theme turns out to be a knockout when done by a large orchestra and the whole picture seems to gain immeasurably from that flood of wonderful sound. Apart from the scoring stage I helped Billy and Ray Chandler a little (Billy is in a phase of turning to me for help, having no reliance on Ray, etc.). . . . I heard Lew's fuming at Gail, whom he kicked out of *Our Hearts Were Young and Gay*, but readmitted after she had wept and promised to be amenable. . . .

August 23: A day on the dubbing stage. Victor omitted scoring the Rick-Stella break scene which, more than any other piece of film, cries for the merciful shadowing of music, and when I had the ladies laugh I gave them a line in improvised Spanish, "Oh, mia carina," which turns out not to be Spanish or anything else. I didn't think it mattered as we wouldn't use the words, but the laughter is good with the words, no good without, so the preview audiences will have to hear the pig-Spanish. . . .

August 25: Dubbing room again, the ghost laughter poor but non-improvable with the stuff we have on hand. Billy's former light-o'-love, Anne has gone over to Bill Dozier and in his exuberance of relief Billy told me the charming gift he wished he had sent her—the charm of these Mittel Europeans. . . . *The Uninvited* is a pretty good picture, whether it proves laughable to audiences or not, with one dreadful sequence—the boat ride, which lets the fey heroine turn into a well-balanced, normal girl, which she should never be, a weak finish, Lew's bad direction and some appallingly acted scenes and appallingly read lines, a few of which can be cured by redubbing, but most of which are beyond recall.

August 27: . . . Jimmy was here to drive us to Inglewood [to *The Uninvited* preview]. The Academy Theatre was familiar. We got in for a newsreel. The title was flashed on the screen—wild applause for Milland's name. The commentator's voice inaudible. Amusement at the squirrel chase, interest in Gail, a cackle of laughter for the fading flowers, some nervous laughter for Milland's waking and the whole haunting scene—then beautiful, breathless absorption in the story—gasps, screams as Rick tried to reach Stella before she got to the cliff—as satisfactory a reaction as a preview ever got! Drove

Dodie and Alex and Helen home—no request from Dodie for the removal of her name. E. and I embraced happily.

August 31: Woke early in the morning hours and stayed awake, revamping the Foreword. Got to the studio at 9 and checked some expressions I'd used with the Oxford dictionary and had the changed version typed. At 10 Ray began recording the speech and worked till 1, when he'd made as many versions of the retake as he would do. . . . I went to the dubbing stage and emitted the groans which are supposed to come from Crisp in the empty house. Gail came and redubbed a fantastic amount in a very brief time. . . .

September 3: . . . to Glendale for the second preview. The audience was slightly more moronic than last time, filled with children and sailors and kids given to whistling. They spotted Ruth Hussey, who was there before the picture began, and Gail, and began a scramble for autographs. The picture began and I thought we were going to have trouble, then the picture started to grip them and played just as well as before, possibly a shade better. The cards were superb, mentioning Gail over and over, and I drove home with a curious feeling of degradation, as though I'd succeeded in scaring the hell out of a school of backward children. . . .

September 9: . . . Ginsberg gave advice couched in his usual double talk, to the effect that I shouldn't try to sell a story to Paramount. (It was my idea that Paramount could give me a bonus by the simple expedient of buying a story), that I should arrange a schedule of production and build up my position as an assistant producer. It was my feeling that it was damned well built up—a thoroughly disheartening and depressing talk. . . .

September 12: . . . had a long talk with Walter Reisch about his future plans, which are to come to Paramount and work with Billy and me. . . .

September 14: . . . Raymond Chandler had failed to appear. When Billy spoke to him he said he was talking to his agent about something Billy would

learn in due course. . . . Joe appeared, talking with Chandler over the phone, went to see him, came back and reported that Chandler bitterly resented Billy's treatment of him but that Joe had managed to straighten it out. Billy was completely mystified and when I pointed out that his manners were at times "brusque," denied it. Joe and I yelled with laughter at that and in due time Chandler appeared. . . .

September 15: . . . An interesting conversation with Joe [Sistrom] approving various directors, Joe saying that Billy would never be top-notch because he thought too much, never let emotion really carry him off his feet, and that Lew Allen never let it touch his feet at all. . . .

September 16: . . . Spent most of the morning with Billy and Ray, worrying at the script of *Double Indemnity*. . . .

[From September 16, Brackett spends considerable time with Dodie Smith, discussing ideas for a new film and viewing various older Paramount productions for ideas.]

September 20: . . . Billy and Ray in an ecstasy of torture at composing a foreword to satisfy the Hays Office about *Double Indemnity*. . . . At the studio had a glimpse of the rushes of *Our Hearts Were Young and Gay*, because Emily [Kimbrough] was in them—Emily looking for all the world like Marjorie Main, perhaps a little grimmer.

September 24: . . . At 3 Billy and I went to Leland's office and shortly after our arrival in came a lady, not too young, her face somewhat lined, hair the simplest of hair-colored hair—and she was Garbo and she was magic and her eyes were the color of the *Oxford Book of English Verse* and her eyelashes an inch long. She hadn't seen any picture we mentioned, didn't know Ray Milland even by sight, wasn't, to be frank, very bright. Had the manners of a shy, lovely child and slayed us both. On the way home we jabbered about her like school kids. She gave no commitments about being in *Olympia* but held out some hope. . . .

[On September 30, Brackett boards the Streamliner for the East, in company with John Van Druten.]

October 1: I know now why Dodie Smith talks about John Van Druten's "sleep of death"—meaning his naps and his sleeps. I never saw anything as eager as his approach to sleep, as reluctant as his departure from sleep. And his relish of his dreams, which it appears may be relied upon within a certain exquisite range.

[Brackett leaves the train at Albany, New York, on October 2, and then heads for Saratoga Springs, moving on to New York on October 7.]

October 11: . . . to the Paramount Theatre . . . to the preview of *The Uninvited*. It seemed to me to go pretty well, beginning more quietly than the Hollywood preview but working up to the same gasping excitement and even yellings at the climaxes. . . .

[On October 14, Brackett leaves by train for Providence, returning to New York on October 18.]

October 20: . . . Met Janet Flanner at 21 and we had dinner with cocktails and wine and talked about [John] Mosher. I find I dislike her picture of him acutely, swoony and mincing, not the Mosher I knew. She asked me, when somewhat flown in wine, "He was your dearest friend—wasn't he your darling friend?" I said, "He was indeed"—and realized later that her question probably had for her a significance I hadn't given it. What possible difference?—and yet I distinctly hated the idea. . . .

October 22: . . . at 6 went up to the rooms of [Ferenc] Molnar in the hotel—rooms bright with red brocade and Gauguin, with a rubber lifesaver on the desk chair. Most old gentlemanly of conferences. There was Molnar, stubby and elderly and frail, with an excellent gift of English, and enchanting.

He talked of the great luxury court theatres of Vienna and Budapest. "It was very hard to have a failure there." Of *Olympia*: "It doesn't much matter who plays the girl, it is Kovacs who matters." He told how the big angry scene between the two was played—Olympia looking disdainfully front from her chair, Kovacs hating her, a tantalizing devil. "What quality do you require for Olympia?" He burlesqued her for me. I asked what quality in Kovacs. "He is a revolutionary," Molnar said and suddenly glowing with a wildly exciting theatrical remembrance, "It is not a mere scene between them, it is a rape—a rape perhaps by a Negro." Earlier he had said, "The Hapsburgs were not anti-Semitic. You see, they saw no difference between any people who wore ordinary clothes. They were all part of the [indecipherable]." He didn't like the suggestion of von Stroheim for the father. "[Albert] Basserman, if he were younger—a kind, distrait, stupid man." . . . He gave me some volumes of preparatory reading and I left him in a fine glow of enthusiasm. . . .

[Charles Brackett left New York by train on October 26 and arrived in Los Angeles on October 29, going immediately to the studio.]

October 31: Spent the morning reading a serial Wilder asked me to read: *Dark Waters*, I believe it was called, and an arrant piece of trash. . . .

November 1: . . . Spent the morning with Willie Wilder and Joe Sistrom and Ray Chandler. . . . Billy asked me to read a scene he and Ray Chandler had written. I found it heavy and false and said so to Chandler and agreed to come back for discussion of it tonight. . . . After dinner went back to the studio and discussed the double murder scene with Billy, Ray and Joe. They overruled me on most points but will change it a little, I hope. . . .

November 4: . . . Tried to get on Billy's set during the afternoon but was barred; they were rehearsing that famous scene. Billy finally appeared, to beg me to work on one line, which I proceeded to do. The Hacketts came in, distraught about the second half of the picture [*To Each His Own*]. They can't make it join together. Comforted them and promised to work with them on it tomorrow. . . .

November 5: Took a speech he needed to Billy. Lew Allen showed me *Our Hearts Were Young and Gay* which is a weak sister, though it may play to an audience better than it did to an almost empty projection room. The story weaknesses we had both spotted show painfully. Had a brief conference with the Hacketts, who want to get the complete line of the story before they start, and very rightfully. . . . greatly impressed by Albert's clarity of mind and theatrical judgment. . . .

November 6: A morning devoted to the difficulties of the Hacketts in finding a last act, difficulties I didn't succeed in resolving. Lunched at the table, went to Billy's set where he, as I knew he would be, was finding reasons for not using the lines I did for him and not using them. Made a date with him for tomorrow, as I want to tap that superb dramatic intelligence of his.[10] . . .

November 8: . . . saw the rushes on *Double Indemnity* when Joe saw them and found them a little monotonous in their single note of brutality. . . . Saw more rushes on *Double Indemnity*, more monotonous stuff. . . .

November 10: When Helen told me that the Hacketts wanted to see me I knew what was up and sure enough they came in, asking to be taken off the story, Albert looking absolutely haunted. I begged them to think better of it and they are staying on for the rest of the week. . . . went to the 10th anniversary meeting of the SWG, to which all of us retired presidents were commanded. Leonard Spiegelgass (lieutenant or captain) made a loathsome patronizing speech about the members in the service and what they were going to do after the war. Maybe it wasn't so much the speech as his personality. [John Howard] Lawson emphasized the new Statement of Policy, which I conclude is the Party Line emphasis and Robert Rossen the Writers' Mobilization, which I judge is the party baby.

November 13: . . . Walter Reisch appeared, according to appointment, on the tick. I told him the story stumblingly and uncertainly, as the state of it is.

10. Brackett wanted him to listen to the story of *To Each His Own*.

He said it wasn't good enough, was any story in a woman's magazine, needed an additional twist of character or what-have-you. I agreed shakily and then suddenly and ex-tempore he suggested a brilliant end part, a twisting-around so that the mature Jody thinks she is to have a week of being the mother of her boy on leave in England—and finds out when she goes to meet him that the last thing he wants around is a mother. He's been reveling in his freedom, wants a girl he has met and only when the girl turns him down and he is left alone does he turn to Jody for companionship. My happiness at this lifting of the soggy relationship knew no bounds. . . .

November 15: Told the Reisch ending to the Hacketts, meeting with singularly little enthusiasm. They want me to have the two mothers and the boy together at the end, which bores me. I think that relationship has been worked thin. . . .

November 30: . . . I . . . went up to the Hacketts who told me they'd been on the story five weeks and hadn't accomplished a thing and weren't being good and should be taken off. I lunched and Word-gamed at the table and walked from the commissary to his office with Buddy De Sylva, who advised telling *To Each His Own* to both Olivia and Ginger immediately, to be sure and get one or the other. . . . At 4 o'clock Billy ran *Emil und die Detektive* an old German picture of his, fifteen years old and still charming but not so good as it has been reported to me. . . .

December 2: . . . Lunched with Mitch Leisen at Lucey's discussing a possible picture for Claudette. (I think Mitch had been sent to inquire whether *To Each His Own* would do for her) and at 2 o'clock went with Billy, Joe, Doane and Lee and Ray to see *Double Indemnity*, which I enjoyed very much, rather the more because while a good picture, it is not a great one, being extremely one-noteish and rather drab than tragic. I think it will have a success d'estime or de shock, but doubt that it will be much of a money-maker. The direction is uneven and some of the writing extremely poor, and my black heart sang like a bird. . . .

December 3: Met at the studio by the news that the Hacketts had been asking for me and I knew what it meant. Sure enough they were bowing out.

They felt they hadn't contributed anything, were very sad. . . . At 2 o'clock Mitch came to my office, heard the story and liked it and said he'd like to direct it for me. Had another interview with the Hacketts and went in to Dozier and broke the news to him, then to Buddy De Sylva, who urged that the Hacketts be retained and suggested a "frame" for the story which made me ill—i.e. that Jody be questioned by her husband as to the young flyer she was seeing and tell the story in explanation. . . .

December 7: . . . I lunched with Frank Partos at Perino's. The plan was that it should be Frank Tony Veiller and I. With Tony came Frank Capra and the Hacketts. Capra's presence took the joy out of it for me, as I dislike him heartily. Tony was saying that one missed the railings around the parks in London. Capra said, "Those were to keep people out—a good thing to have them go"—the kind of socially conscious remark which he insisted on putting into his few bad pictures. I asked him whether he had met the King and Queen while in England. "No," he said. "I'm not interested in people like that. Royalty—to hell with Royalty." . . .

December 8: . . . spent most of the afternoon with Billy. Buddy De Sylva had suggested to him that we put Bob Hope into *Olympia*. It immediately ceased to be *Olympia*, so we looked around for some real Bob Hope story, pawing over our stock of odds and ends with very little result save the renewed conviction on my part that I'll never be able to work with Billy again . . . my consciousness that, after years of partnership, his first free act was to stab me in the back . . . my conviction that he's turned into a second-rate director . . . my knowledge of the awful thinness of his mind, his stupidly limited interests [preceding ellipses in original].[11] Alas, alas. And my knowledge that I am as little stimulating for him as he is for me. . . .

December 13: . . . Billy and I listened to Lux Theatre broadcast of *Five Graves to Cairo* and found it pretty good, though Tone, bad enough in the picture, was infinitely worse on the air. It was not, to our ears, effortless and lovely, but sweaty and effective. . . .

11. These comments on Billy Wilder were crossed out by Brackett when he reread the diaries in 1950.

December 17: . . . had a talk with Billy, who symptomatically has taken to calling me "lover" in the *sturm und drang* of his present mental state. . . .

December 20: . . . Frank Waldman was running *Bluebeard's Eighth Wife* so Billy and I and Billy's current Miss Dowling went to see it—and it is terrible! Screwball comedy, long sequences to almost practically no dramatic purpose, climax sequences so brief as to be choppy—a really embarrassing picture, but it brought back a lot of fond memories of Lubitsch. Afterwards, while we were having tea in Lucey's, an agonized Meta Reis appeared with an urgent cry for a speech for Olivia De Havilland to make to service men in hospitals. I was able to squeeze one out. Nat Deverich called me to tell me my option had been picked up. I felt no vast excitement at the fact as jobs of my sort are plentiful at the moment, but when I thought that it drags a gross $208,000 I couldn't but be pleased. . . .

December 21: . . . Called on Buddy De Sylva in recognition of my contract and happened to collide with Preston Sturges, just going into his office. Said to Buddy, "Thanks for the Christmas present my agent tells me about. It's a pleasure to be with you." Buddy said, "It's more of a pleasure to have you with us." Preston went into the office with him. Went on to Dozier's office to learn that Preston is leaving Paramount. Had a dreadful feeling that, in Preston's eyes, that three-cornered meeting at Buddy's door will represent the cozy medley of Patronage, Genius and Mediocrity. Not sure that he isn't right. . . .

1944

[The number of projects with which Brackett and Wilder are involved during the year is quite confusing, with many film proposals mentioned only once.]

January 2: ... We gave a luncheon party to which we had looked forward, so brilliantly chosen were the guests, such specialists in observation and wit and conversation. It turned out, as was inevitable to be, a little disappointing, considering the cast: Dottie Parker, Kay Brush, Michael Arlen, George Cukor and Jimmy Moore. Dottie arrived too bright of eye and after a few drinks developed that hunger for a quarrel which seems to attack her at times. Too much time was spent bypassing that quarrel, for real gaiety. Kay was plain depressed by her job and Hollywood. Once when she spoke of it seemed near to tears. George was richly amusing, as he always is. I felt that Michael was not quite up to his best, expected it all to be more Riviera than it was. Jimmy Moore stayed on with Bean and they drove me to the airport at 6 o'clock. ...

[Without explanation, Brackett is on his way to Washington, D.C. for meetings in regard to an Office of War Information short that he had been working on since late 1943. No title is provided at this point, but it is later identified as *Skirmish on the Home Front*. He arrives in Washington, D.C. on January 6, and among those he socializes with are Archibald McLeish and his wife and Robert and Madeleine Sherwood. On January 9, he leaves by train for New York, primarily to visit with Xan, James and their baby boy, "Tigger." He leaves New York on January 11, arriving in Los Angeles on January 14.]

January 14: Arrived about 2, went to the studio and the news that Frank Freeman and the New York office have turned thumbs down on Garbo for

Olympia—so no *Olympia*. . . . Billy and I called on Buddy De S., suggesting the possibility of doing *The Count of Luxembourg* with Bob Hope. Met rather a dubious reception from Buddy and, frankly, I'm not mad about the project. . . .

January 15: . . . a certain gent from the Government appeared and told me in deep secrecy that the Govt would like me to go to London about the 1st of February on an extremely confidential job. I replied that nothing could suit me better, that it all depended on my studio situation, if there is enthusiasm about *To Each His Own*, and they wish to proceed with it. . . . I told him *To Each His Own*, with gestures, and met with wild enthusiasm. He didn't feel that Ginger was right for it, nor Olivia, and suggested Garbo. Now either to have a Garbo picture in the offing or a trip to England and a useful job seems to me an agreeable situation—preference on the latter, I admit. . . .

January 17: . . . a summons to Buddy De Sylva . . . came about 5. I started telling him the story and got resistance—didn't tell it as well as I have told it, but perfectly adequately. He hated the entire frame, thought the love affair between two middle-aged people uninteresting and too easy—not enough psychic obstacles. In fact, freedom for London opened before me and ever since I have been trying to get hold of Mr. [Sydney] Harmon to tell him I accept with pleasure. . . .

January 19: . . . In the afternoon Billy and I were summoned to Buddy De Sylva's office and given a talk on getting in two pictures this year—one before the Bob Hope one. Gives me a curious feeling as I shall not be here and couldn't tell Buddy so

January 25: Spent the morning finishing *Thieves Like Us* (with an eye to Alan Ladd)[1] and beginning *Amok* [2] (same eye). . . . In the afternoon, after

1. Brackett had started work on it on January 22. It was eventually filmed by RKO, with Farley Granger, in 1949 as *They Live by Night*.
2. Unidentified.

some conferences on the OWI short, went with Seton Miller to see *Corvette 225*, a picture Howard Hawks produced (not directed) which I found as dull as Howard Hawks. . . . While I was gone Buddy had summoned Billy and me. Billy answered and was told to give up the Alan Ladd project, concentrate on Bob Hope. . . .

January 27: Billy at the office when I arrived with the information that he had been kicked out of the house by Erik Charell[3] [who] said *The Count of Luxembourg* would never be done, to which Billy replied that it would be done a damn sight sooner than the remake of *Grand Hotel* on which Erik is working. Whereupon Erik fell to screaming that he was putting a curse on the work that meant his bread, issued the command to leave. Billy in a high state of glee as this means he won't have to work with Erik on *Grand Hotel* any longer.

January 28: . . . dined and hurried to the first sneak of *Double Indemnity* and, as edited and scored, it is an absolute knockout of a picture, the most flawless bit of picture technique imaginable. The awful giggling-kind audience was held spellbound and those who knew pictures were set back on their heels and I am to report in myself a kind of rejoicing that it was such a superb thing. E's comment was "It's flawless," And she was right. . . . The cards weren't as hearty as some we've had and it may not have the superficial audience appeal, but it's a success d'estime of the most esteemful kind.

January 29: . . . When I got to the studio Billy was arriving, pretending that none of his friends had liked the picture, that the cards had been bad. . . . Most of the cards had been superb. His friends had made minor criticisms and the front office was wildly enthusiastic and the cuts suggested were minor. Alackady, our future looks dark. With a mild success it would have been entirely possible. With this—!

3. Erik Charell (1895–1974), prominent German stage and film director, working at this
 time in Hollywood as a writer. He and Billy Wilder were apparently working on a
 remake of *Grand Hotel*.

February 1: . . . saw Helen peering up and down the streets and knew that Buddy had called me. . . . It was to tell me he was worried about *To Each His Own*. . . . How did I feel about it? I like it better than anything else I've worked on, I said, but I want you to be satisfied about it. I'll turn in an outline Monday. If you like it O.K.—if not, we can sell it, I think without loss to you. My emotions in regard to the scene were considerably controlled by the fact that Harmon, to whom I spoke today, tells me that he thinks the London call will go through any day—it would have gone through before but for some change in high strategy. . . .

February 2: . . . At the office I told Billy about my London plans, unable to hold it back any longer, in decency. Billy said he'd had a bid too but hadn't said yes because of me. . . .

February 8: The preview Joe and Billy had last night didn't go as well as the first one. There was laughter when [Fred] MacMurray shot Stanwyck and consequent excitement. A long telephone call from Ernst urging Billy to make certain retakes (most of which he's mistaken about).[4] . . . De Sylva said he liked the new outline and to go ahead with the project. . . .

February 16: A final word from Harmon blasted my hopes of London, but I was told to call Phil Dunne in New York as he had something of great importance for me to do in this country. It was to work with him and various naval officers on a documentary regarding the offensive in the Pacific—an important job, God knows, but one at which I would absolutely stink. I cannot deal with the abstract. It is not my gift. Also I couldn't work with big, nice, abstract Phil Dunne to save my ears, so I temporized and tomorrow must say No. . . .

February 21: . . . Drove Walter Wanger to the Academy meeting and heard with some horror the plans of Mr. Marco[5] for jazzing up the Academy pre-

4. There was a third preview of *Double Indemnity* the following night, "which went extremely well."
5. Of producers Fanchon and Marco.

sentations. "And then if some pretty page girls could hand Miss Russell the awards . . . [ellipses in original] and then Kay Kyser's band and Al Jolson singing . . ." [ellipses in original] Most of the committee shared my horror at his suggestions.

February 22: A day at the studio, occupied for the most part with the OWI short. Finally we got Betty Hutton's consent to play in it, Miriam's refusal, and through an inspiration of Joe's, the near certainty of George Burns and Gracie Allen to play Molly and Herb.[6] . . .

[On February 28, Brackett's daughter, Elizabeth Fletcher Brackett, married James Moore. After the church ceremony which began at 8:00 p.m., there was a reception and supper at Chasen's, where guests included Arthur Hornblow, Jr., Hedda Hopper, Michael Arlen, Alan Napier, Dame May Whitty, Preston Sturges, Alan Ladd, Ruth Waterbury, Charles Lederer, George Cukor, Anne Baxter, Robert Nathan, Harpo Marx, Lenore Coffee, and Monty Woolly. Conspicuously absent from the list of guests recorded in Brackett's diary is Billy Wilder, but it is highly possible that he is New York. Of the wedding, Ernst Lubitsch said, "when father and daughter came down the aisle, no one looked at the bride, no on looked at the bridegroom or the best man or the bridesmaids. Everyone looked at Charlie. He was the perfect father."[7]]

March 2: . . . The [Academy] Awards ceremonies went smoothly and for the first time I am left by them without an anecdote or a point of interest. The entertainment by Kay Kyser, Red Skelton, etc. was dreadfully third-rate and dull but Jack Benny as Master of Ceremonies of the second half was excellent. None of the awards was very surprising. . . .

6. The thirteen-minute short concerned with wartime economic stability began shooting on March 3, and was released in May 1944, featuring Alan Ladd and Betty Hutton as Harry W. and Emily Average and William Bendix and Susan Hayward as Herb and Molly Miller.
7. Quoted in Lincoln Barnett, "The Happiest Couple in Hollywood," *Life*, December 11, 1944, p. 112.

March 7: . . . A long talk with Y. Frank Freeman on the campus was disheartening—the cast draw of Dorothy Lamour being his motif, as usual. Told Lew my feelings about her work, indicated them at least. . . .

March 8: . . . Billy arrived from New York with a new set of enthusiasms and the information that the *Count of Luxembourg* rights are so complexly held we'd better give up the project. Took him to Lucey's for a champagne cocktail, then we lunched at the commissary. In the afternoon I pitched into a book called *The Lost Weekend* for which Billy has a passion. It has not gripped me as yet. . . .

March 11: Billy and I went to Buddy De Sylva's office and discussed future plans, *Count of Luxembourg* out because of trouble about the music rights. *Olympia* back on the schedule if we can get Ingrid Bergman to play opposite Ray Milland. . . . A meeting of the Writers' War Mobilization, all steamed up because Senator Reynolds has introduced in the *Congressional Record* a semi-anonymous letter praising the Hollywood Alliance [the right-wing Motion Picture Alliance] for its activities. . . .

March 13: . . . I took Walter Wanger to the Beverly Wilshire to a meeting of a group of eight more or less liberals, with eight representatives of the M.P. Alliance to reprove them for their statements which have embroiled the whole industry with charges of communism. They were healthily awed by Eddie Mannix, Dave Selznick, Mendel Silberberg and Walter and agreed to make a retraction of their misleading statements. Had a good time with Dave Selznick who agreed that [Lela] Rogers and [Morrie] Ryskind were honestly scared of communists and Jim McGuinness (the brains of the group) was having the time of his life scaring them more. . . .

March 18: . . . Billy and I consulted about *Olympia* in the morning. We lunched with David Selznick at International, told him the story of *Olympia* with an eye to getting Ingrid Bergman. He was interested, promised to give her the play to read and try to get her promise to do it as soon as she has finished Sarah Bernhardt and if that proved impossible, suggested Joan Fontaine, which we leaped at. . . .

March 30: No commentator [for *Skirmish on the Home Front*] and . . . the decision that I must do it became final. . . . I sweated the dread two pages as hard as I could and still haven't them very well. . . .

March 31: Was wakened at 7:30, got to the studio at 8:30 and spent most of the day in front of the camera with everybody being charming and that friendly feeling which is Paramount at its best all about, helping me through what would otherwise have been hell. The fact that I didn't really know my words and had to read them from an oilcloth scroll which the blessed Jack Golinda had constructed, stopped it from being fun. Lew Allen directed me . . . and to tell the truth, it was grand fun. I think the bit of film will be immortal. They can use it for years to clear theatres in case of fire. . . .

April 1: . . . I waited for the rushes of my commentation to come through. I awaited them with dread and saw them without relief. . . . I photograph as mean and pinch-faced as Calvin Coolidge, and the reading of the stuff creates an insane effect, so that I look like a mad capitalist bitterly fighting for his lost world. Helen (the cutter) commented, "Well, I still love you." . . .

April 3: . . . Saw the OWI short with Lew Allen and had decided to make some retakes of me but showed it to Billy, who voted it perfectly passable, a verdict which I finally accepted. My own self-consciousness evidently corrupts my judgment.

. . . drove Walter Wanger to a meeting of the Academy, at which Harry Warner appeared and made a speech at once disorganized, abusive and fascistic and smug, and John [presumably John LeRoy Johnston] made a superb support on the Academy, its present state and possibilities. Warner is certainly the type of ego-ridden Jew that the Jews of the country should most deplore.

April 11: Developed a sore throat last night which was worse by morning. Billy and I discussed *Olympia* with [art director] Hans Dreier and [producer] George Berthelon. We lunched at The Savoy with Joan Fontaine. . . . I saw the minute Billy met her the signs of a profound animosity. He told the story badly. I couldn't have told it at all, and she went into a routine about having

to see script before she could ever decide a part, about her style of acting, how Mitch outraged it—she couldn't be treated rough, must be directed by kindness. We made note of script to be sent to her when we have about thirty pages, but Billy and I knew we'd never send her a page of script, that for him to work with her would be impossible. . . .

April 22: Dictated a good bit of the first sequence of *TEHO*. Billy in the midst of femme crisis, not very concentrated on *Olympia*, which is getting nowhere and for which I have given up hope. . . .

April 25: Saw the first reels of *We Were Dancing*,[8] which Billy and I worked on, and saw them butchered up and made ridiculous by Norma Shearer and Melvyn Douglas, playing the embodiment of Young Love. . . . Billy was still too nervous to work. . . .

April 27: Met Billy on Sunset, where I left my car. He and I discussed *TEHO* most of the way to the studio and part of the morning. Then began discussing his Sonja Henie story[9] and *Olympia* was forgotten for the day. . . .

April 28: Wrote on *TEHO* until 3 o'clock in the morning and, as Billy had said he was going to dictate his Sonja Henie story, stayed home and rewrote all morning . . . got to the studio in time for late luncheon and some word games, napped at length and when I got up found Billy wanting to begin dictating *Of Ice and Women*, which took most of the afternoon. Managed to get in a few words about *Olympia*. . . .

April 29: The final nub of *TEHO* won't come right, and in my despair I ran *Ruggles of Red Gap*, which also ends in a restaurant and with music. I didn't get much help and the picture is not my dish, utterly improbably farce, slightly

8. Released by MGM in 1942; and Brackett and Wilder receive no screen credit.
9. First reference to this project instigated by agent Leland Hayward, which according to the April 28 entry is titled *Of Ice and Women*.

humanized, but I suggested to Henry Ginsberg that it be re-issued, principally because of the Anglo-American angle, which is done appealingly. . . .

[It is in May 1944 that the diary first begins to reference Brackett's grandson "Tig" spending time at his grandfather's home. The hours "Tig" spends with his grandfather grow into days, and by the time of shooting *A Foreign Affair*, Brackett is taking him with him to the studio, much to the obvious irritation of Wilder. While Brackett is clearly concerned that the boy's parents are not perhaps capable of taking care him, an argument might also be made that, with two daughters, for Brackett "Tig" represents the son he never had.]

May 3: . . . Billy and I worked at *Olympia* until Steve Brook telephoned that Lincoln Barnett was here to have luncheon with us and start a series of interviews for the articles he is do about us for *Life*.[10] We went to Lucey's, all four, had French seventy-fives[11] and luncheon. I napped and Billy read his chess magazine, then Lincoln came in and we decided we should do the interviews separately, Billy first. . . . I saw Bill Dozier . . . and told him I was going to hire Richard Haydn[12] to go over the English part of *TEHO* and possibly somebody to put in some special work on the little boy. Billy left, I took Linc to Lucey's to avoid the agony of being interviewed and then told him awful globs about myself, he taking notes—an awful process, but less painful than I could dream. . . .

May 4: Worked with Billy on *Olympia* all morning, lunched with Charles Jackson,[13] Billy, one of Leland's men and Leland himself at Romanoff's— Jackson a charming, shy, incredibly naïf person; identifies himself with his hero without an hesitation, is as innocent in his admirations as a Babbit, has begun to be in love with Hollywood. . . .

10. Barnett's lengthy and heavily illustrated piece, "The Happiest Couple in Hollywood," would appear seven months later in the December 11 issue of *Life* magazine.
11. A cocktail made with gin, champagne, lemon juice, and sugar.
12. He was hired for four weeks.
13. Charles Jackson (1903–1968), whose first novel was *The Lost Weekend* (1944); it was followed by two further novels, *The Fall of Valor* (1946) and *The Outer Edges* (1948).

May 6: Worked at *Olympia* in the morning, somewhat infuriated by the political discourse and activities of Billy, the worst citizen I know—typical of all immigrants, who immediately want to improve and oversee the running of the country. . . .

May 7: . . . Ernst Lubitsch gave me great pleasure today by calling to congratulate me on *The Uninivited*. . . . At about 5, Richard Haydn turned up, looking lean, brown, and a little less nervy that I ever saw him look. . . . I read him some of *TEHO*, which I want him to work on, and while he thought it hadn't any of the actual feel of present-day London, he thought he could readjust it so that it could have. . . .

May 9: Billy and I in . . . cheerful mood, spent most of the morning talking about *TEHO*, *Double Indemnity* and the world in general. . . . In the afternoon Billy and I got down to brass *Olympia* tacks and I have the impression that we solved our boy-girl encounter, which is our great problem. . . .

May 10: Billy decided his solution for the opening of *Olympia* was no good, and again all morning we were at sea. At 12:30 I met Olivia and Bert Allenberg at Perino's. Olivia and I had frozen daquiries and Bert a vermouth. I ordered vermicelli al broma and turkey Marco Polo and they ate theirs while I talked and told the story scene by scene, speech by speech, and it took me till almost 3 o'clock and my shirt was wringing wet and my forehead dripping. And they liked it. Olivia's face contracted with pain at some of the miseries of Jody; Bert admitted to almost crying, and their interest was constant. Olivia will play it if we can arrange the legal thing and get a director. I went back to the studio and fell into a nap so deep that I thought I was home in bed. . . .

May 14: Richard Haydn started work for me today, with excellent ideas and diligence. Otherwise the day was filled with irritation, probably unworthy. Weeks ago I began parodying a series of advertisement by David Selznick, saying "*To Each His Own*—the most important words for the motion picture industry since 'Let There Be Light.'" Billy heard this without a blink, but later announced that he would take an advertisement for *Double Indemnity* with

(still following the Selznick pattern) a letter from Mr. Oblath, the proprietor of the hash-house across the street from Paramount. Since then I had to work with him on the letter, making it semi-factual, and compose the tag-line, "*Double Indemnity*—the two most important words for the motion picture industry since *Broken Blossoms*." Billy ostensibly (and I think honestly) didn't realize where the thing came from and I felt nothing but amusement until today, when the advertisement appeared and I hear him, very patronizingly, say to congratulatory friends, "Oh, Charlie and I write everything together." The fact of the matter is that my mild joke would have gone nowhere, that he built it up, exploited it to the very fullest, and amused the town with it. But to be gracious, and in a tone which proclaimed "I include good old Charlie in this, though you know it's only generosity on my part" has proved too much for my equanimity. Naturally it is the kind of thing that, to mention, would have been an indignity . . . [ellipses in original]

I lunched Cukor at La Rue's and started to tell him *TEHO*, which he purported to like, but he had to hurry away to an interview with Zanuck. In the afternoon Billy suspended work on *Olympia* to shoot a test with a 50-cent tart who is now Milton Holmes' mistress, so that the afternoon was lost. I spent it with Richard and the latter part with Lincoln Barnett. Linc is going away and I assured him that if his article didn't appear in *Life* it would make no difference to me. In fact, though I didn't tell him, I'd be rather pleased. Unfortunately Charlie Jackson had asked E. and me to dinner tonight and Billy was the other guest. Wilder-poisoning being complete.

May 15: . . . Had ironed the annoyances out of my soul and spent a morning of hard work with Billy. Word comes that Selznick is in a towering rage about his advertisement, had fired people from his publicity department left and right. Lunched at the table, taking Richard and introducing him to the group and the Word Game. In the afternoon, having crystallized our difficulty (or we hope) into the fact that the difference between a Princess heroine and a Captain (untitled) hero is too pastel for the grasp of an American audience, we set about finding a job for Kovacs. Considered a Ford car salesman, but gave it up for a Victor phonograph salesman with Master's Voice fox terrier.[14] Had a conference

14. With these few words, Brackett intimates that *Olympia* will become *The Emperor Waltz*.

with Richard about the beginning of *TEHO* and a talk with Leland in New York about the chances of getting Ginger. He is arranging an interview with her. . . .

May 23: Discussed *Olympia* all morning. Lunched at the table. Had resumed discussion when a call came from Buddy that he'd like to come over. It was to discuss cast for *Olympia*. We told him the requirements. He said [Ann] Sheridan, even if we could get her, wouldn't justify a $2,600,000 budget. [Irene] Dunne was a not very startling possibility; Fontaine still a chance. Billy said if we can't get Fontaine at the right time, how about our doing *Lost Weekend* first, then *Olympia*. Buddy seemed pleased at the prospect. It didn't elate me very much, though it could be quite a success d'estime. . . .

May 30: . . . After my nap went to Ginger's house, a hard one to find, and funny and unbelievable and elaborate and uncomfortable when one got there. Sat on one of two pale salmon-colored couches before a log fire and told her *To Each His Own* and, bless her heart, she loved it. Drank it in with exactly the reaction I had hoped, said she wanted to play it but needed a whale of a director. She said she'd been in enough mediocre pictures, this she thought could be superb. We embraced and I drove like a bat out of hell to Joan Crawford's to have a cocktail with Joan and Phil. A cocktail proved to be two singularly strong Daiquiris in a room with a log fire, on a pale satin couch—all much more knowing than Ginger's but of the same general sort. Two little blonde adopted children were put through their mannered paces—much . . . saying of elaborate prayers. Joan was incredibly beautiful, the molding of her face being beyond anything of the sort; and Phil was pleasant . . . told an anecdote of his broadmindedness with an admiring homosexual, which I titled *How to Drive Your Fairy Friends Nuts*, and we really had some fun. . . .

May 31: . . . A call from Roy [unidentified] informed me that Ginger had doubts about *TEHO*. I talked with her; she explained her hesitation: should she play an older woman at this time? Should she play a sad picture? A couple of little story points . . . [ellipses in original] I saw there was no use demanding an immediate decision, as it would be No. So I said I'd hold it open. It is the old trouble with Ginger: she hasn't a very good brain, but insists on using it. . . .

June 2: . . . In the morning I had a brief conference with Buddy re the possibility of Greta Garbo for Jody. . . . I lunched Eddie [Edmund] Goulding at La Rue's and while I think he might do a fine job of direction, my blood curdled at the awful café society vulgarities of the guy, the basic tastelessness. Billy and I read and discussed *L.W.* during the afternoon. . . .

June 10: . . . Telephoned John Van Druten to ask if he would direct *TEHO*. He was pleased, said he'd never been so flattered by a request but had written two plays and a review, doubted if he could manage, would write. . . .

June 11: . . . to a luncheon party of Ernst Lubitsch's . . . sat with Anita Loos, Eva and Zsa-Zsa Gabor and had a quite good time. Later everybody at the party sat in one circle and talked. . . . I said Billy and I had always thought a picture with Mae West and Mickey Rooney would be good, noticed unhealthy laughter at the other end of the circle. . . . [ellipses in original] Miriam Hopkins said she'd never seen Mickey Rooney on the screen but had been at a party and found him very objectionable. As she talked the laughter became uncontrolled and I realized, and warned her, that the beauty must be Ava Gardner, Mrs. Mickey Rooney. Miriam said "But you're divorced—you don't have to live with the horrible little thing now." . . .

June 13: . . . Billy had an amusing idea for the making of *Olympia*: the hero's fox terrier in love with the heroine's borzoi, and I suggested a topper: a fox-terrier-Borzoi puppy for the fade out. We called on Mitch Leisen to see his new office, which is Directoire with a Directoire stove like an urn, from which sprouts an iron palm tree; a baby grand piano; a wall of crazed mirror; an air of such chi-chi that we returned to our office full of ascetism and gratitude to God. . . .

June 14: Finished the reading of *The L.W.* today and saw stretching before us the long murky reaches of script-to-be-written. . . . Henry Ginsberg called us in to veto Cary Grant as Don Birnam and replace him with Ray Milland. We didn't much mind. . . .

June 22: Billy's birthday, which didn't interrupt our vastly interesting work on *Lost Weekend*. Think I have found a beginning in a bottle suspended outside the window of the Birnam brothers, which will be effective. . . .

July 5: . . . Billy and I worked all morning as well as we can work in the studio. . . . It was in the afternoon that Buddy called to talk over cast for *Lost Weekend* and make the [Paulette] Goddard-Mitch suggestion. I didn't throw a fit, said I'd seen her work in *Kitty*. . . .

July 6: . . . In the afternoon Helen raced to finish the typing of *TEHO* and after Billy and I had put in an afternoon of fairly honest talk I took copies to Frank Freeman, who was out, and Ginsberg, who is in a mood. Stopped in to see Buddy and say that there is a faint chance that Olivia is about to be available in about 60 days, as I learned from Bert Allenberg. . . .

July 10: . . . We spent the entire day in earnest conference, trying to find an effective way for Don to drink his first drink. Leland Hayward lunched me at Lucey's. In the afternoon at last the decision of The Powers came through: Henry Ginsberg is slated to run the studio, not a convocation of persons, of whom I was suggested by many to be one, and I am more glad than I can say, as I should have been very bad at the job. The only stir regarding *TEHO* came from Bill Dozier, who liked it very much and made a couple of very helpful suggestions. . . .

July 11: . . . We worked at *LW* all morning. Henry Ginsberg asked us to luncheon, told us the new set-up: himself in charge, Joe Sistrom and Frank Butler overseeing the product. Henry offered Billy and me straight seven-year contracts without options—Billy not interested in the last. At my age it is a distinct temptation. . . . Buddy De S. saw me in the hall, said, "I wrote you a love letter about the script"—so I looked forward to getting his communication, which proved to be a sour note saying he thought "the story" began too late and was slow beginning.

July 12: . . . worked on *LW* all morning and in the course thereof Billy had one of his real ideas: that Rick see the bottle hanging outside the window and

pour out the whiskey before Don, instead of Don's drinking it when alone—
an idea which means revision but real improvement. Lunched at the commis-
sary and Buddy told me he had sent a note to Ginsberg or Freeman re *To Each
His Own* that if Paramount didn't want it, De Sylva Productions did, which
gave me great satisfaction. . . .

July 14: . . . E., Bean and I met Charles Jackson at Romanoff's for dinner. . . .
After dinner Charles came here and we talked all evening. As I drove him back
to the Beverly Wilshire he said there were all sorts of legends about him—one
that he had stopped drinking because of a scare in connection with the Nancy
Titterton murder.[15] I said I'd heard it [from Ruth Waterbury] but knew he'd
have told us if it were true. "Oh, it wasn't true," he assured me. "Of course I'd
spent the day before the murder with Nancy and was held and questioned for
three days by the police, but that wasn't what stopped me drinking. I wasn't
scared out of drinking. I stopped because I made up my mind to. I hate that
story. It's discreditable."

July 19: . . . I dined with Charlie Jackson at the Bev Hills and we discussed
various problems. I ran into Bill Dozier with a patch over his right eye. He
told me everyone was saying Paramount had taken everything but his left eye.
He goes to be a production guide at RKO.

July 21: Joe came in with the idea of Jean Arthur for *TEHO*. I don't want
her. Billy and I worked at *LW*. We lunched with Charles Jackson, [writers]
Sally Benson, Roy Meyers at Lucey's, came back to the studio and had a long
session of discussing the script, during which Sally Benson made one admi-
rable suggestion: Helen's bringing Don a drink when she knows he's bought
the revolver. . . .

July 27: . . . got a telephone call from David Selznick suggesting Jennifer
Jones might play Helen, at which we leaped. He would give her to Paramount

15. Charles Jackson was implicated in the 1936 murder of New York writer Nancy Tit-
 terton when it was suggested her killer might have been an alcoholic or drug addict
 with whom she was friendly.

in exchange for either of us. We told Henry Ginsberg this and had a brief conference with him. . . .

July 28: Billy in one of his troubled self-pitying moods. How can-one-work-under-these-conditions kind of thing when I learned from Henry that he doesn't expect to be able to get Jennifer Jones. . . . E. and I dined with the Goldwyn's, a curious group of people—Jock Lawrence's wife, Gene Kelly and his wife, Niven Busch and Theresa Wright (pregnant), Charles Chaplin and his little wife (pregnant) [Oona O'Neill]. I found Gene Kelly charming, intelligent, mannerly. We had a foolish discussion about eating fast before dinner. I said "I bet I out-eat you at dinner." He said "I bet"—and then had sense and manners enough to entirely ignore it. He talked admiringly of Thomas Mann and Thomas Wolfe, both of whom bore me as wordy. Teresa Wright looked very lovely and was very shy; little Mrs. Chaplin said that her doctor was called Dr. Paine, and when the ladies laughed said that her first doctor had been Dr. Gore. Chaplin seems to me as repellant a human being as I've ever been in the room with—a thin, reedy voice, a show-off-hog face, and hysterical protestations of liberalism. I am not smug in my judgment of him by recent events. I was, it would seem, almost alone in not liking his old silent pictures, never having felt the world- weariness of that significant and wistful figure. . . .

August 7: . . . In the afternoon Bill Meiklejohn asked if we really wanted Jane Wyman—she costs $40,000 for the picture (of which she only gets twelve). Lamour is free. I thought he was joking on that last point, but he wasn't. Billy and I discussed the matter, a little frightened. . . .

August 8: The morning was devoted to calling the Wyman deal off, since Warner's demanded to read the completed script before she could be loaned to us. Thereupon we started searching for another gal—looking at Joan Caulfield and Natalie [unidentified] test and feeling very relieved when the prospect of getting Miss Wyman opened again. Charlie Jackson came to luncheon and we took him to the commissary. Frank Freeman sat down between Joe Sistrom and me, and such is his fabulous dullness that I was unable to keep my mind on his conversation, though his topic was one of the most absorbing in the world to me: Paramount's plans for setting up a pension system. . . .

August 15: . . . After luncheon I had to meet with [Geoffrey] Shurlock and someone else from the Breen office about *TEHO* and I was driven to a frenzy by their high Catholic attitude towards Jody's "sin" which was condoned, which was allowed a happy ending (after twenty-five years of emptiness of life). I wanted to have a ground fit and yell "I'm a protestant producer in a protestant country and I resent this extraordinarily!" . . .

August 18: Worked all day at *LW*. Lunched Kay Brown at Lucey's. Kay comes from New York bearing messages to *Lost Weekend* from two sources. Both are watching the project with bated breath: (1) Alcoholics Anonymous, which fears we may indicate that a psychiatrist is essential for a case of alcoholism, which they say would bring about hundreds of deaths. (2) The distilleries, which are afraid that *LW* as screened will be an argument for Prohibition—the Uncle Tom's Cabin of Prohibition indeed. I was able to assure Kay that we would not make a psychiatrist necessary to Don's cure. And that she could tell the distilleries that we are highly bribable persons who, if we receive a case of Scotch a week in perpetuity, will manage to make the spectators lick their lips. . . .

August 25: Worked on *L.W.*, a final revision of that damned first scene. Had a tantrum when Luraschi informed me that [Joseph] Breen had read the script of *TEHO* and would not permit the ending or the abortion scene. Later had a fit at Joe Sistrom on the same subject. Feel that my position is different from that of other irritable producers because moral right is on my side. I'm not trying to get away with anything as producers usually are. . . .

Jane Wyman lunched with us, quite attractive, attractively dressed. My blood ran cold when she said she was bringing over some man to do her clothes, and I didn't at once tell her she wasn't, which she's not. Read her the script and I think she was moved by it. . . .

August 28: . . . I am reminded of a Billy anecdote worth recording. He had a letter from one of his lady loves. He didn't read it to me but I judge it was tiresome with passion, jealousy and reproach. He tore it up—but before he threw it away saved one of the scraps—it had been written on gray paper which was just the shade he wanted for his living room.

August 30: . . . A curious and by now familiar excitement was in Joe [Sistrom]. Billy hurried away. I asked him what was up. He said they had figured it out that to get the most out of us there must be one picture together, then one apart—like *Double Indemnity* and *The Uninvited*. They thought the combination of Walter Reisch and Billy would be the answer. Went home depressed, though I've long felt a parting of the ways was inevitable. Sorry it is to happen when Billy is in so entirely agreeable a mood. . . .

September 4: Worked with Billy all morning, solving an agony he had developed about the pawning of the typewriter. He began to think it was anti-Semitic. I think I got a gag which eliminated that danger. E. and I went to a knockout luncheon party at the Walter Wangers' for Senator and Mrs. Claude Pepper. It was the most star-studded gathering I've seen for years: Claudette, Norma Shearer, Roz Russell, David and Irene Selznick, the Goetzes, the Nunnally Johnsons, Elsa Maxwell, Ernst Lubitsch—why have the names of the other stars evaporated? I told Louella Parsons that [son-in-law] Jimmy Moore had been awarded the DFC and she told someone he'd been given the D.O.S. We arrived a little past 1, were given strong rum-and-cocoanut milk cocktails and left in the sun for almost two hours—and I for one was drunk as a mink and have an impression I said something gauche to Mrs. Pepper, who was charming. After the party I came home and fell into a dreamless sleep which lasted until 7 o'clock. . . .

September 11: A rather dreary and extremely busy day. We tackled *L.W.* about ten o'clock, worked on till it was time to take Jane Wyman to luncheon with her agent, and I took Richard Haydn along. It was a luncheon where everyone tried to be funnier than he was feeling, which makes for a dreary gathering. . . . I came home and was called by David Selznick, who wanted the names of Republican writers, which occupied me trying to round up a few. Haven't yet managed to get any. Billy and I worked at the studio until a quarter past 11 and I am as dull as this diary sounds.

September 14: . . . At 5 Henry Ginsberg had called all the producers of the new setup, together with Chuck West, [George] Berthelon, and others and made a long involved speech with one gem in it: "You will no longer be

known as associate producers but will appear on the screen after 'Produced by'"—a sentence we all heard with great pleasure. . . . Cribbage . . . until it was time to go to David Selznick's to a dinner meeting of Hollywood Republicans. The guest of honor was Governor Warren. We were an odd collection of people: Morrie Ryskind, Sam Wood, Mr and Mrs. Ray Milland, Mr. & Mrs. Fred MacMurray, Ginger Rogers and her mother, Preston Sturges, Jeanette MacDonald, Ann Sothern (very pregnant), Walt Disney, Neil Martin, Herman Mankiewicz, George Murphy, Adolphe Menjou, Donald Crisp, Lionel Barrymore, etc., etc. After a very late dinner David made a speech and the Governor made an excellent, modest, pleasing speech, and Lionel Barrymore was elected head of a Hollywood Republican Committee and Ginger Rogers Vice President.

[On September 18, Brackett boards the train for a journey East, arriving in Cedar Rapids on September 20. There, he attends a memorial service for his close friend Elizabeth Ford. On September 23, he leaves by train for Chicago, where he meets up with Billy Wilder, Doane Harrison, Buddy Coleman and others for the trip to New York and location shooting for *The Lost Weekend*. The diary records the various locations used, the dates of filming and other related matters: On September 23, there is a location tour of Third Avenue and 58th Street, and later in the day, Brackett informs Joe Sistrom by telephone that he and Billy do not want to do a film with Danny Kaye at this time. On September 25, there are costume discussions with Edith Head and a meeting with the head doctor at Bellevue in regard to the possibility of the leading character's escape from there. On September 26, wardrobe for Jane Wyman and Ray Milland is purchased from various stores. On September 27, there is an inspection of location for Don's apartment (unidentified), and later that day, Brackett obtains permission to film at St. Agnes' Church on 43rd Street. On September 28, Brackett, Wilder, and company visit Bellevue and there are further discussions there. Helen Hernandez arrives the next day and there are script conferences. On October 1, Wilder shoots Don's escape from Bellevue, with Milland wearing an overcoat he has borrowed from Brackett, and there is further spotting of locations on Third Avenue. On October 2, those locations are filmed with Ray Milland, using a hidden camera. On October 3, there is further shooting on Third Avenue. Bad weather prevents filming on October 5. The following day, Brackett leaves for Saratoga Springs, returning to New York on October 8. The following day, he and Wilder inspect Wick

and Don's apartment which has been built on the roof of Hahn's Warehouse. On October 14, Brackett reports, "About 2 Billy and the whole crew here from California saw the rushes with me and found them very good. After some additional, undescribed filming, the company leaves by train for California on October 15. Wilder and Brackett continue to work on the script, arriving back in Los Angeles on October 19.]

October 20: A day of pleasant occupation that precedes a picture. Phil Terry wardrobe consultation; the set dressing of it to be overseen and redone. . . . In the afternoon hair and makeup tests for Jane Wyman, a stubborn resistance to having her hair parted and done simply, all kinds of excuses: it was too short, her face was too wide. Finally, by being more stubborn than the lady I got it done and I thought as did most of the other man on the set that she looked stunning that way—a purity of face and a gravity of beauty no one would suspect in that cutie-pie girl. . . .

October 21: . . . Had an interview with Henry Ginsberg and Joe regarding future plans—put *Olympia* on the shelf definitely, moved up *Count of Luxembourg* and *Bill of Goods*.[16] Lunched Arthur Hornblow and Joe and Billy at Lucey's, came back and saw the Wyman tests, her curly hair is rather more becoming but her parted plain hair makes her the perfect Helen. . . .

October 25: Met "Miss Fontaine," the mother of Olivia and Joan, took her on the set and Billy and I decided she would do for Mrs. St. James. Hired a Paramount actor named [Frank] Faylen as Ben. . . .

Had a talk with George Cukor about directing *TEHO*. He sounded interested. Saw the rushes, which were excellent. Jane Wyman sat beside me and after she'd seen herself in several scenes said "I like that girl. You were right." . . .

November 1: Steve Brook greeted me with the news that Linc Barnett's piece on Brackett & Wilder is set for *Life* in three weeks' time and the rest of the day was devoted to Helen Morgan, Peter Stackpoole (two *Life* pho-

16. First reference to this unidentified project.

tographers) who had a great list of pictures of Billy and me to make. What was left of the day was spent on the set, watching Ray battle with the speech beginning "It shrinks my liver, doesn't it?—it pickles my kidneys—but what does it do to my mind?" etc., etc straight into Shakespeare's "Purple the sails, and so perfumed that—" He did it with difficulty at first, made knockout of a shot with his back towards the camera (his face did show in a mirror) just before luncheon and in the afternoon was down and couldn't get up during the innumerable takes I watched. . . . Then my nap had to be photographed and later an embarrassing photograph of Billy and me working, I without my shoes—all very chorus girl and silly. . . .

November 6: . . . Went on the set, Stage 18, and saw Doris [Dowling] play Gloria, as woeful an exhibition of amateurish Lady-Come-to-See as ever I saw. The damned fool is playing it elegantly, and Billy is too afraid of her to tell her so. Saw the rushes of yesterday and they were fine. Afterwards told Billy I thought Doris amateurish and he was very offended, kept referring to Gail Russell as amateurish, which God knows she was. Nevertheless she gave a remotely acceptable suggestion of the kind of girl we wanted. . . .

November 8: . . . Worked on the Bellevue sequence till 4:30 when I saw the rushes of Doris and found them surprisingly good. There were takes when she really played it tough that were all right. The part could be better played but it is perfectly acceptable. Told Billy, who rejoiced. . . .

November 11: A call from Henry, troubled over many things—the finishing of our script. Billy was shooting 2.1 pages a day instead of 2.5. Who was this Dodie Smith who had been put on *TEHO*? She hadn't worked for a year and why was her salary the same as last year? Could she just work two weeks? . . .

November 13: . . . went to Billy's and worked all evening. At the end of the evening Billy put on a real scene: the neurotic genius at the end of his rope— needing Jacques to help a little on the final scene. . . . Will I put him on the payroll as doing a treatment for *Bill of Goods*?—so that we can smuggle in a little of his help. It was the most palpable ruse of a stubborn person bent on achieving what he wants. I have two choices: to yield gracefully, to continue

the kind of life buffered against the difficulties of Hollywood by B. Wilder—
or to end our association, without animosity but in exhaustion. Am I fooling
myself when I say that were I ten years younger, I'd do the latter? Yes, I'm
afraid I am. I'm shy of the battle of Hollywood and always was.

November 18: . . . got a call from Billy that Clarence Muse, who was to
be our attendant in the night club, had appeared with a beard, which he
wouldn't shave because he was supposed to be in another picture. Another
actor, named Snowflake,[17] was on his way, I hurried back to confirm Snow-
flake, who proved to be better than Muse. . . .

November 20: Dictated to Helen, got a wire from Charles Jackson to call
him in New Hampshire, lunched at Lucey's . . . —the first day Lucey's func-
tioned under its new management. When the call from Jackson came through
it was to say the United Liquor interests were trying to make him (insist on
doing), or consent to do a prologue for *Lost Weekend*. Then a long list of criti-
cisms of stuff in the picture he had thought too articulate. It included all of
the more effective speeches. I offended him deeply when he used the term "ar-
ticulate" by saying "Oh, you prefer the 'Well, I mean' sort of tradition?" We will
change none of them. Most of them would have been shot anyway. He then
worried as to whether people would know flashbacks were flashbacks. . . .

November 24: Arrived at the studio to find that the schedule was thrown
out by the wind, which made shooting on the street impossible so that the
revelation scene in the apartment was being begun. As this is the scene I feel
most unsatisfactory of all the scenes yet written, I spent the day working on
it, consulting Jacques who also feels it isn't right. Lunched at the commis-
sary, Henry Ginsberg sitting with me and uttering a few words of double talk
about wanting me to do a picture alone. Rather uncomfortable. . . .

December 1: . . . About 4 saw all the cut stuff on *Lost Weekend*. Impressive
but gloomy. Saw the rushes which I liked better than Billy did. . . .

17. Prolific African American character actor whose real named was Fred Toones
(1906–1962).

December 2: . . . Lunched at the commissary with Henry Ginsberg, Frank Butler, Sonny Tufts and Joel McCrea. Surprised to find Joel a very funny boy. He said to Henry about *The Virginian* in which he's appearing, "Have you got to the point when you see the rushes of saying 'What a picture it would be if we had [Gary] Cooper in McCrea's part?' Well, just remember it could be worse—you might have had Randy Scott in the part." . . .

December 12: . . . In the afternoon Henry called me to say that they were dickering for two with Olivia, that she might do *TEHO* in March and the other first, as they wanted to do a picture in January. I asked what [was] the other picture they were offering her. It turns out to be *The Well Groomed Bride*.[18] (Ray has read the script and said he wouldn't do it if they kill him.) I had a bit of a tantrum when Henry said "We've got to consider whether we should do *To Each His Own* at all," yelled at him that I thought it had greater commercial possibilities than anything in the studio. . . .

December 13: Lay awake half the night planning angry speeches to Henry Ginsberg. Almost as soon as I got to the office I was called in for about the pleasantest conference I have ever had with him; *TEHO* (depending on Olivia) set for February or March, possibly Mitch directing, possibly John Berry. . . .

December 14: . . . After my nap I hurried to the Music Dept. where they were showing the rough cut of *LW* to Rosza, as I thought. Chuck West, Lew Lipstone, Roy Fjastad, George Dutton, Friedrich Hollander and a couple of others were there and I never heard such silent attention when it was running, such praise when it came to an end. Even Doane Harrison, who knows the cut stuff better than I, admitted to being moved. Friedrich swore that he wept a couple of times. . . .

December 23: . . . Billy and I distributed liquor to the crew on the *Lost Weekend* set. . . .

18. Released by Paramount in May 1946, starring De Havilland and Milland.

There was a big party in Henry Ginsberg's office and one in Buddy De Sylva's, with a sign on the door "Better drinks in bigger glasses." Some tipsy guest of an executive, a woman, got into Buddy's and said to him tipsily "Are you Mr. Ginsberg." Buddy replied "I used to be" which must have floored her. . . .

December 26: Spent most of the day on the set, checking final changes in the final scene and emending a scene that was being shot . . . [ellipses in original] Leland lunched me at Lucey's, wildly enthusiastic about Billy and me doing *Luxembourg* on Broadway before we do it for the screen. There was a great flurry from the Censorship Department about Jane Wyman's wearing a white sweater which they claimed was too revelatory. One of the censors said it looked as though Helen were trying to cure him of the bottle by the nipple. We pooh-poohed this, in all innocence, as we had not thought of her costume as revelatory or sexy. We'd been too absorbed in the emotion of the scene to notice—but when we saw the rushes we had to admit that there was some truth in the observation and it may require a retake. . . .

1945

January 2: . . . Ginsberg . . . asked me to give the *TEHO* script to Mitch Leisen, which I agreed to do though he wouldn't be half as good for it as Cukor. Thereafter Danny and Sylvia Kaye and Lou [unidentified], their agent, appeared to talk *Count of Luxembourg* and we went to Ginsberg's office and an hour and a half disappeared in double talk. All of us want to do *The Count* as a play first and I hope we laid the foundations for that project. . . .

January 3: . . . The first full rough cut of the picture [*Lost Weekend*]. . . . I have begun to hate the first part and see nothing but its faults; the second part looked very good to me. Billy very depressed about the whole thing, finds it vastly inferior to his hopes. Joe [Sistrom] thinks it so good that he suggested not trying to make the March date, which will mean paying additional tax, but give Rosza time for his score . . . [editorial supervisor] Doane [Harrison] and [assistant editor] Lee [Hall] time for their cutting.

January 4: Spent the morning talking over the rough cut of *Lost Weekend* with Billy, Doane and Lee. Charles Jackson's letter arrived (a five-page agony of hatred of the final sequence). It sounded so repetitious it was like a loop. . . . After I'd finished reading it aloud Doane said quietly, "I gather from between the lines that he didn't like the ending." . . .

January 5: Spent the morning at Billy's working on *Bill of Goods*, which is taking shape at last. . . . Took a taxi to Dodie's for luncheon. I think Dodie's

in a bad nervous shape, really terribly homesick and cut off. Somebody said, "If Dodie cared as much for people as she does for bugs, she'd be a saint." Another suggested that maybe she was working up from bugs. Christopher Isherwood said "She hasn't gotten up to Americans yet." . . .

January 22: . . . was called to Henry Ginsberg's office with Billy and given a great slice of his double talk. He has almost decided that Billy and I must work exclusively on very important mutual productions, *TEHO* too expensive, won't justify, etc., etc. as Paramount had failed to name *The Uninvited* among the suggestions for Academy Awards—which added to the gaiety of the morning. My boredom with the regime was pretty strong. . . .

January 26: . . . Jose Ferrer came to see Billy and we sat with him while he ate an early supper at Lucey's and talked about *Dr. Knock* [unidentified project] which may be a possibility with him in the lead. . . .

[On January 30, Brackett, Wilder, and company take the train to San Francisco for a preview of *Lost Weekend*.]

January 31: . . . It was a disappointing preview—none of the lip-smacking delight that a smash preview gets. No wrong laughs of any importance but all the comments had a slightly forced enthusiasm. I'm afraid it's too highbrow for general audience, not quite highbrow enough for the critics, although it may be a great critics' picture. . . .

February 1: . . . went to Burlingame for our second preview, which seemed to play better to a sparser and graver audience, but had rather a high percentage of bad cards. We have a stunning picture which it's going to be hard to get people to see. . . .

[Brackett, Wilder and company returned to Los Angeles on the overnight train, leaving on February 2 and arriving the following morning.]

February 5: Spent the morning in a conference about cutting *L.W.* Billy so elated by the mention of Academy nomination that went to *Double Indemnity* that he didn't mind as much as I expected some suggested slashings. . . .

February 6: . . . Jose Ferrer came in, utterly disorganized as to plans, delighted to be importuned by us, and to give a very offhand "No." His hopes of a European tour supersede all idea of a very unimportant (to him as he dramatizes himself) picture career. . . .

February 7: . . . went to a board meeting at the Academy. Brought up the subject of Buddy De Sylva for the Thalberg Award, to the annoyance of Y. Frank Freeman and Mark Sandrich. . . .

February 9: . . . napped, then came a bout of work with [Jacques] Théry who was in a vile mood, which has characterized him for days. He had been extraordinarily efficient about this job of condensing *TEHO* and heightening the value of certain scenes. He has contributed not one character, not one situation, but has worked so hard, so efficiently and with such enthusiasm that I had about decided to give him credit on it. This afternoon, in an ugly, demanding scene, he asked for credit, which I assured him he would have if this script we are doing is shot—but I find myself resenting it and detesting him. . . . Certainly he has got less for his penny of talent than anyone I know. . . .

February 16: Billy and I worked on captions for the pictures of our featured players to put before *L.W.* but at the last moment Billy had the excellent idea of showing pictures with the characters speaking a word of dialogue, a kind of futuristic beginning which I think will whet the minds of the audience. . . .

February 19: . . . Must finish with Jacques this week. Talked *TEHO* with Billy all morning. He wasn't very helpful. . . . Saw *L.W.* run with the cuts that have been made, somewhat better but dull and repetitious in the bar. . . .

February 21: Breakfasted with Mervyn LeRoy in his handsome house with its few revelatory articles—the too elaborate plate glass cellarette, the plate glass clock, both curiously out of taste. Read him the 50 pages, to his great interest.[1] Went to the studio and reported to Henry, only drawback being Mervyn doesn't like Olivia, which kills me—prefers Jean Arthur.... The utter ridiculousness of this frantic activity of mine and for a salary which is [indecipherable] to a grain of pepper should amuse me, but doesn't. I am actually filthy of hair and scraggy of finger nail and whiskery and unbarbered, to try and get something done for Paramount....

February 23: This morning I was called into Ginsberg's office. Mervyn [LeRoy] was there. He was doubtful about the bootlegger angle in the script, about whether Jody would give up her child. In fact, he wouldn't sign till he sees the remainder of the script, which means that we lose Olivia. After he left it developed that Olivia wants to do another film with [Sidney] Lanfield, who has been engaged to do a comedy at RKO. In fact, all looks black.... Billy and I wrote and got Ray to record a new ending for *Lost Weekend*....

February 27: A day of vast humiliations. Sidney Lanfield, wretchedest of directors, read *To Each His Own* and said, in his arrested development voice, "It doesn't get me, Charlie. It doesn't hit me in here." And Olivia [De Havilland] has decided that she'd better make a comedy next. Lunched with four director nominees for Academy Awards, plus Mark Sandrich,[2] and heard what they wanted done for the directors' clip at the presentation. Directors, it seems, are vastly underestimated by the public and some whisper of their function must reach the outer world. It seems I have to write the stuff....

March 1: Was at the studio, talking with Billy, when he got a call from the O.W.I [Office of War Information] offering him the job of directing all propaganda in Germany-Austria during our occupation, a job he can't and

1. Brackett returns to read a further twenty pages to LeRoy the following day.
2. Mark Sandrich (1900–1945), director of the best of the Astaire-Rogers musicals; he died within days of this meeting while directing *Blue Skies*.

shouldn't turn down and which he is superbly fitted to fill. Feel very widowed at the thought but give my instantaneous blessing, as did Judith [Wilder]. Lunched with Henry King[3] and discussed the director speech [for the Academy Awards presentation]. He is a nice, rather dull and fantastically egotistical man.

Came out to the house about 3, got in a car with Doane and Chuck and started for Santa Barbara . . . and had a preview of *Lost Weekend*. . . . With the Foreword, the light parts of the picture got infinitely fewer and weaker laughs—but I thought the audience was absorbed and the cards were excellent. Henry Ginsberg was obviously extremely disappointed in the picture, in the failure of the audience to applaud at either end of it. . . .

March 5: Wakened by a call from [George] Berthelon on the telephone with the news that Mark Sandrich died last night . . . got to the studio and the inevitable happened and the burden of the Academy Presentations fell on me. Had to go to a luncheon for the people preparing the films and afterwards spend the afternoon in a frenzied committee meeting getting things straightened out as best we could. During the morning I spoke to Charles Jackson, whom I'd consulted about an ending and who announced that he had one which would run five minutes longer, whereupon he told me an additional reel. . . .

March 6: A day in frenzied committee with Mrs. Gledhill [Margaret Herrick] of the Academy. . . . I went to Mark's funeral, found myself asked to be a bearer, impressed into it indeed though I should have been working on the Presentation performances. . . . At the end of the service [at the Wilshire Temple] everyone filed past the open coffin of the weariest man I ever saw, a man shockingly unlike himself. . . .

I rode back from the ceremony with Frank Freeman and Barney Balaban, Balaban referring to a gift he'd made the Library of Congress which turned out to be the original Bill of Rights. A charming guy, by the way, brainy, pleasant, intelligent. . . .

3. Henry King (1888–1982), prolific director from 1915 to 1962; his meeting with Brackett is in connection with multi–Academy Award nominations for *Wilson*.

March 7: . . . went to the Academy . . . and explored the possibilities of the Chinese [Theatre] until noon. Went back to the studio to get the glorious word that Bob Hope would be Master of Ceremonies, while we are on the air, which was received just in time because Joe [Sistrom] called up to say Capra had received word from Washington that he was *not* to appear on the air. . . . In the afternoon I went out to see Bob Hope and told him what we wanted of him, went back to the office to learn that there were hellish financial difficulties about getting an orchestra, that there were hellish legal difficulties about clearing the film for showing on the air. . . .

March 13: [Academy Award] Presentation problems which don't wholly occupy one's mind but do wholly fill one's time. The Irving Thalberg Award proved a piece of maudlinity spoken by Edward Arnold, which we couldn't use. I had to tell Carey Wilson who wrote and directed it and who began at once to throw blame on me. Hal Wallis jockeyed himself into giving the Best Picture Award, though it's going to cause hellish trouble with Jack Warner who won a foot-race to the stage with Wallis last year when *Casablanca* was announced as the Writing picture.

. . . to Pasadena, to a sneak of *Lost Weekend*. The first sneak for which it hasn't rained. The first at which the film hasn't been preceded by a dreadful card saying that it was experimental and unusual and asking for constructive suggestions. The difference in audience reaction without the Foreword was fantastic. Laughs at just the right places, surprise and interest later. Good cards. On getting home Joe [Sistrom] and I had to go to Grauman's Chinese to a rehearsal for the [Academy Award] Presentations which lasted until 4 o'clock in the morning.

March 15: Up at 7, at Grauman's at 8 and spent the whole day there. . . . The show went like a dream save for the live show, or rather—to be exact—[radio comedian] Ed Gardner, who laid a terrific egg . . . Hope wonderful. . . .

March 20: Worked on *TEHO* all day. A strange possibility has loomed as a director: John Farrow, associated with tough, all-male pictures. . . . Ran the reels of the picture [*Lost Weekend*] that we hadn't inspected before and I

agreed about cuts, but I had an outburst about the ending, which I think has proven that it's unworthy of the picture and slick-finish in the worst way. . . . Incidentally, Jackson never sent on such suggestions as he had for the last scene, evidently holding out for a trip to the Coast—which makes Billy so angry that he frothed at the mouth about him—and rightly.

March 28: Today the studio sent mimeographed instructions to each employee as to what to do on VE Day—that work would be suspended for the rest of the day if the news came in the morning, for the following day if it came in the afternoon or on Sunday. Some work on *TEHO*, an official refusal to consider Farrow by Olivia. . . .

March 29: A fantastic day. . . . I was summoned to Ginsberg's office. Olivia was committed to do the picture if Mitch would do it. Mitch on the wire gave a half-hearted promise to do so. I promised to send on the script tonight—an insane promise. . . .

April 4: . . . A call from Joe [Sistrom] . . . Mitch had read the script through, thought it well done—a fine woman's part and the kind of sentiment that made him sick—not what he should do at all. He was all for brilliant, light, brittle comedy—but if the studio insisted . . . [ellipses in original] I said how much confidence I would have in his direction and Joe said the studio insisted, and then Henry sent a wire chiding the studio's insistence—and I have a reluctant director and a panicky star. . . . One additional fact: Mitch announced that he hated children and couldn't work with them. . . .

April 6: Hedda Hopper announced in her column that Billy Wilder was spending a good deal of his time on Stage 9. Was it the picture he was interested in, or a certain brunette[4]—which made for a dandy day for Billy. Joe asked me to read *It Had to Be You*,[5] came and suggested that I produce it or that he offer it to Ginger with the idea that I produce it. I agreed, though I

4. Doris Dowling.
5. Released as *The Trouble with Women* in June 1947.

see no possibility of its being a good picture—then reconsidered during luncheon and told him I couldn't. . . .

April 11: . . . Billy entered with the news that Arthur had called him with the news that there was a rumor that Roosevelt was dead. We turned on the radio and it was true. . . . It is a tragic loss for the country at the time. There is no man on his scale to sit with the Big Three. Truman is, from all accounts, a nonentity and a Southern nonentity at that. I try to draw comfort from the parallel of Chester A. Arthur who went into the White House a dubious ex-comptroller of the Port of New York and made an excellent president. My friends and my friends of the extreme left are shaking with apprehension. I, who have always felt a strong dislike for the shiftiness and the patronizing ways of FDR, wish devoutly that his political wisdom was to guide this next few months. . . .

April 15: Went to Billy's after breakfast and said goodbye to him with curious qualms. I have learned, from Arthur, that Doris [Dowling] goes East on the train with him. Have a hunch that the marriage will smash up shortly—he's angry at Paramount unreasonably. . . .

April 16: My first act was to clean the clutter out of the big office and restore it to a state of purity and emptiness reminiscent of the days of Arthur Hornblow. I don't know whether it was doing so that made me miss the wild young Wilder excessively all day. . . .

May 1: . . . Today I saw Mitch, decided on the architecture of the Pierson house and discussed cast all day. Can't sell the idea of Sylvia Sidney, however, and am generally depressed by the casting although John Lund sounds superb for Cosgrove and Don Castle all right for Alex. . . .

May 3: . . . Got word from MCA that they think they can get Clive Brook[6] to play Desham for $40,000. Told Meiklejohn and Henry of this and have or-

6. Clive Brook (1887–1974), prominent British-born leading man of stage and screen.

dered MCA to go ahead. Wrote an elaborate description of the part for Brook and left it with Leland's secretary. . . .

May 9: . . . went to a very bad preview of *Lost Weekend* [in San Bernardino]— a preview where a wrong reel was put on because the operator was apparently drunk. The audience didn't like the picture at all and the ending—this was the briefer one—was proven definitely too abrupt.

May 11: . . . After luncheon had a long session re *Lost Weekend* in which drastic cuts were suggested. Fear Billy's wrath. . . .

May 15: A day largely involved with *LW*. At breakfast E. and I tried to work out a substitute for "The early morning sunlight hitting the grey tin of the ashcans" lines. . . . In the afternoon Joe, Doane and I talked with Billy in New York about our proposed cuts and Billy purported to be suicidal about them. . . . He now claims that we cut the hell out of a wonderful picture which he left. . . . Doane Harrison, exhausted and ill almost to the point of unconsciousness, showed me the reshuffle of the walk which he'd made. It is a little choppy and inelegant and we decided on a slightly longer version and I've got to talk to Rozsa about the music, which must have an excitement it now lacks. . . .

May 16: . . . Saw all *LW* with the music and dubbing departments and Rozsa. I must say I've seen that bit of celluloid quite enough to suit me. . . .

May 18: Nervous kind of day . . . Maybelle Iribe had approached me last night at the Basil Rathbones[7] on the subject of the role of Desham [in *To Each His Own*]. It seems Mitch Leisen had offered it to him at a party when tight and reaffirmed the offer the next day. Fortunately, Herman Citron[8] is

7. Basil Rathbone (1892–1967), English-born actor of stage and screen, best remembered for his onscreen portrayal of Sherlock Holmes.
8. Herman Citron (1905–1987), agent, primarily associated with MCA; clients included Charlton Heston, Alfred Hitchcock, and James Stewart.

Rathbone's agent and was able to tell him that we had made a firm offer for Clive Brook and that he mustn't consider the job seriously. If Clive Brook doesn't come through it presents a frightful complication, as I wouldn't dream of having Rathbone in the picture. He would be what I call DeMille casting. Not for years has he vaguely suggested a human being. The whole performance makes my blood run cold. . . .

May 21: Dictation to Helen, a session of casting with Mitch—Mitch very reasonable about everything, admits his Basil Rathbone gesture was in desperation. We agreed on Betty Field for Corinne, if we can get her. I showed him the John Lund test, warning him that it wasn't good, but even so he was disappointed, mostly in the boy's looks, I think. . . .

June 1: . . . Mitch and I went at the script until 3:30 when we went into a production meeting which lasted until after 7:00. Amazed at Mitch's vast technical knowledge on everything connected with the picture save story. . . .

June 6: A morning with Dodie, who is making some suggestions as to the English stuff. A final glimpse at a couple of *LW* reels. . . .

June 8: . . . went to Proj. Rm. 5 where a gathering of people anxious to see the picture [*Lost Weekend*] had collected [including Joan Crawford and Ronald Reagan]. . . . If I am a judge of reactions the picture went beautifully. Not a false laugh, a sense of mounting tension, a feeling that it was the realest picture to be made in Hollywood. I was delighted. . . .

June 11: . . . Had a talk with John Lund, in from New York and not as handsome as I wish he were though it was not my idea to have a pretty boy by any manner of means. The set of Lund's eye disturbs me, his rather meager Swedish features—in fact, am disappointed. . . .

June 13: . . . Saw the test of Lund, who is going to be all right—not handsome, or only moderately handsome, but strong. . . .

June 15: . . . about 4:00 . . . I rushed to a reception which E. and I were invited to by telegram only this morning, the wedding reception of Judy Garland and Vincente Minnelli. Judy was changing when I arrived. Vincente was white as a sheet and terribly nervous. We spent most of our time talking about *The Clock*. It was a very small reception. I was most flattered we'd been asked and sorry E. couldn't come. The only guests I knew were Ira and Lee Gershwin. Ira was best man. And Irene (the dressmaker). . . . Judy reappeared, looking smart and frail and she and Vincente started for the Super Chief in a cloud of rice, the neighborhood children yelling good luck—a press agent beside the chauffeur. . . .

June 18: . . . Luncheon at Perrino's. I got back too late for my nap and in the elevator coming up to Mitch Leisen's for the almost full cast reading of the script, John Lund gave me a No Doz . . . [ellipses in original] The reading went extremely well, with almost no cuts or changes suggested. . . . Mitch continues to be obsessed with Lund's lack of good looks. The reading lasted until an elaborate tea. We then looked at tests, Olivia superb as the older Miss Norris with no gray in her hair, no shadow of real old age, but a completely middle-aged look. . . .

June 20: Day of hell. E. ill. A turn-down, and a very chilly one from Clive Brook. . . . Mitch and Phyllis got worried about Phil Terry. . . . The test of Alma, Mitch's cutter, as Belle proved to be cute but felt that an amateur in the cast will be an additional worry. Olivia's 1924 costumes are charmingly beautiful and rich. . . .

June 22: . . . The test of John Lund in blond hair but slightly dark makeup quite stunning. All the gals seem crazy about him. . . .

June 24: . . . Sam [Brackett's doctor] tells me he's found one person who didn't like *Lost Weekend*: Joan Crawford. . . .

June 26: . . . had a satisfactory session with Luraschi and a highly unsatisfactory session with David Rose, of London Paramount, but a man who

apparently saw nothing of the war outside of Claridge's and the Savoy. He told me, or told Meiklejohn in front of me, that Roland Culver[9] was free. . . . In the afternoon ran two pictures with Roland Culver in them (John Lund sat in with me as I saw them) and consulted Ray Milland about him. Liked Culver better and better with every picture and after the rushes showed a couple of reels to Mitch and the assembled group. Mitch was cross about the first shot because he thought Olivia looks too old in it as did Olivia, but he agreed to Culver, rendering me happier than I have been for some time. . . .

July 5: . . . when I got to the office Mitch sat in Helen's room, twitching with irritation . . . [ellipses in original] Olivia, John Lund and Phyllis [Loughton] were in my office going over a scene—the airplane scene, which Mitch claimed wouldn't play. He wanted to go back to the first sketchy version, which I wouldn't allow, and he swished away saying crossly "All right, I'll direct it, but it'll stink."—and my day was somewhat thrown off. . . .

July 19: . . . Lunched with Sheila Graham and Harry Mines at Lucey's, an interview, Mines being there as chaperone. Sheila Graham was Scott Fitzgerald's last love and the woman who helped him through the unhappiness of his last years, but she is supposed to be completely bitchy and unreliable in her column. She drank milk with her luncheon and I had already told her the story of the milk scene in the script before she told me she was pregnant. She told me nothing of particular interest about Scott. Apparently she poured out her heart and all her bedroom memories to Charlie Jackson, but it was a pleasant luncheon. In the afternoon I had a long visit with Henry G. about Billy, whom he believes to be returning, but he thinks he's using a device about getting Paramount to make a picture about a German girl's regeneration through love of an American soldier as a graceful exit. Neither Henry nor I feel much enthusiasm for the project. . . .

July 28: . . . Monty [Woolley] came for a long visit, and an account of Cole Porter's current passion. . . . It seems Cole has had a sixty-foot flagpole erected

9. Roland Culver (1900–1984), busy actor on screen in his native U.K. and Hollywood from 1931 until 1982 retirement.

in his garden (of steel) and on it he puts a different flag every day. Today it was Eire; tomorrow probably Albania, and under it a house flag he's designed for his house, with C.C., which stands for Camp Cole. From this he gets vast amusement and probably will during the rest of his stay here. Afterwards flags will be forgotten until found among his effects after his death. We were all under the impression that flags were a little hard to get these days, that with all the other shortages there was a bunting shortage. Cole, it seems, has not allowed his life to be restricted in any way by the war—meat, cigarettes, building materials, whatever he wants he's had. He still keeps his apartment at the Waldorf Towers (where his secretary stays), two homes in Williamstown, one for Mrs. Porter, one for himself (with a big pool built since the war). The place out here, with five men servants. We considered him a phenomenon of nature—his curious ability to hold people by a kind of fear. Monty says the fear that they'll lose him and never see him again. I myself find him as dreary a little androgyne—as ever there was—willful, ill-mannered and little more openly depraved than anyone else, but his power over paper is unquestionable and his fantastic social sense. I understand there have been some stormy scenes at Camp Cole, some beatings-up by surprised service men. Of those things Monty doesn't speak. . . .

August 2: Mitch left the set with another cold, causing panic in the front office. Roland Culver went over the English sequences with me and I think we've blended it into probability. . . .

August 6: Mitch on the job and feeling better. . . . In the afternoon Mitch asked for three pages of dialogue from the soldiers coming from the train. I saw yesterday's rushes and Johnny Coonan's little daughter Deborah is so resistant to Olivia that the whole farewell scene must be retaken with a friendlier child. Dear Mitch is leaning to the beautiful, steel-gray and silver wig which will take all the poignancy out of the ending of the picture. . . . I dined alone and went to a SWG meeting to consider another meeting to re-educate our members in regard to the strike—an excellent thing if most of our members didn't distrust the radicalism of our board. . . .

August 7: The morning filled with getting ad lib speeches for the boys coming from the train at Euston Station . . . , to learning with relief that

Mitch had decided on dark hair for Olivia.... Virginia Welles, the Paramount contract girl Roland Culver has been training for Liz, forgot her very first call to the set this afternoon and delayed the station rehearsal. Mitch warned me the rushes of Bill Goodwin's scene with Olivia would be bad—they were excellent....

August 8: ... Olivia very depressed at being thick and middle-aged and yet not so transformed that the extras didn't look at her, astounded, thinking My God, how she's fallen off. In fact, Mitch gave all the extras a little lecture about the story, at her request, to stop all pitying misapprehensions....

August 14: ... lunched George Cukor at Lucey's.... Showed him a couple of reels of the film and the test of Lund, whom he is considering for the part of the young idealist in *The Razor's Edge.* He is also considering Olivia and from her and Phyllis [Loughton] I gather that it's a horrible script, but like all directors and producers with a product to sell, George thinks it a non-pareil and can't imagine anyone turning it down.... [Later that day V.J. Day was announced and all work at the studio ceased.]

August 30: ... Mitch in a doodah all day because he didn't like the scene (in Miss Norris's apartment), doesn't like Lund, is irritated by his jokes and the fact that getting his face in the camera isn't the most important thing in life to him.... Forgot to mention that shortly after dinner Henry Ginsberg called me and amazingly offered $15,000 as some kind of bonus. My first instinct was to accept gleefully. My second, which I'll act on tomorrow, was to refuse it as inevitable end of a good relationship with Henry.[10]

September 1: ... Spent the afternoon on the set save for a barbershop interval. After shooting, Mitch moved to the restaurant set, got in a great doodah about now knowing how to shoot the scene. It was difficult, choppy. He made a complete ass of himself, in fact, because he's been too lazy to study the script until now. There was a temperamental moment when he said, "Oh, I can't

10. The following day Brackett accepted the bonus after Ginsberg explained to him that it was a readjustment to his salary thanks to the lifting of a price ceiling.

work it out—I'm going home. I'll do the best I can Tuesday." But he changed his mind and got down to cases and we at last have a workable design of a last sequence which I'll write tomorrow, about a half hour's work. . . .

September 6: . . . Most of the afternoon went in the preparation of an elaborate party—all the gigantic crew on Stage 9: gifts from Mitch, gifts from me, and finally a speech from Mitch about how Paramount makes pictures for the far future and *TEHO* probably wouldn't be released till Olivia was really forty-five, so, taking time by the forelock, he was giving her an Oscar that would be really useful. He thereupon drew a curtain, revealing a six-foot gold Oscar which startled Olivia out of her wits when it smiled at her—some pal of Mitch's, gilded. . . . [Work on the film did not finally conclude until December 26.]

September 11: Greeted at the office by a nasty little note from Charles Jackson. I had addressed him as "Birdbrain" in a telegram, something I could do to any friend—but an unsafe term to use to a man five feet tall. It said I could ill use the term after the mistake about his name. He wouldn't make such a mistake about my name and he hadn't read *American Colony* as many times as I had *Lost Weekend*, nor would he care to. Did I think I was Woollcott? I was almost as fat as he, but I wasn't. Telegrams at Orford were not delivered but were telephoned and he had found himself addressed as "Birdbrain" by an inferiority-complex-ridden local man who hated him for his communications with New York and Hollywood, etc. A rodent letter which to my delight eliminates Mr. J. . . .

September 12: . . . Jackson called me at the office and I ducked him. But he called me here and E. talked to him. I was in the tub just now and the telephone rang insistently. I wrapped a towel around myself and answered it. A voice said "Charlie?" "Yes." "Mr. Brackett?" "Yes." "This is Charlie Jackson." I interrupted him: "I got that letter of yours," I said. "I don't want to hear your voice. I don't want to hear your name. I am just Goddamned bored!" With that I hung up. Will soft-hearted qualms twist me in the night? If they do, damn me!

September 13: . . . drove to Long Beach to a showing of *TEHO*. The title of the picture and the name of Olivia got not a ripple from the audience.

The audience was puzzled at seeing her first in makeup. The church played pretty well, the fall pretty well. The officers' club dragged a little—and then suddenly we were in business, with the audience hanging on every word straight through to the end, liking Lund enormously, loving Culver. There was applause at the end, more than any picture I've had for a long time. . . .

September 15: . . . This morning, happening to waken early, I called the St. Regis at 9 o'clock N.Y. time. Billy [Wilder] wasn't there. I called again at 11 his time, no answer, so I judge either Doris is in New York or some new gal. When I got him he sounded gay and excited, told about seeing *Lost Weekend* and *Double Indemnity* in London with Rex Harrison who hadn't seen *Double Indemnity*. Billy went out, came back and said jokingly, "Have you fallen asleep?" and Harrison had. At the end of the conversation Billy said he would be here next Saturday, that he had some news for me he wouldn't give me over the phone. Divorce from Judith, I imagine. . . .

September 16: Wrote in bed most of the morning, toiling at my Foreword—then realizing that the greatest master of the Foreword was just up the road and might be amused to help, I drove over to Ernst [Lubitsch] and consulted him. He made a charming suggestion. . . .

September 18: . . . spent most of the rest of the day at the telephone or on the set where Mitch was re-shooting the John Lund–Olivia scene in the Prescription Room, or interviewing babies who, with one exception, regarded me as Frankenstein's monster. Seem to have found one who will do nicely. He has a father who can make him smile at will. . . . I lunched Katherine Anne Porter[11] at Lucey's and we had a grand long talk. I may put her on *Mme. Sans Gene* with Théry. . . .

September 23: Billy arrived—vital, delightful, bubbling with anecdotes and heavy with presents: a repousse silver traveling sock case for me; a small silver scent-box marked E.B. for Elizabeth. Jacques' prophecy that he would

11. He had met the writer at a cocktail party on February 25, and noted, "I admire the lady's work so passionately that I couldn't judge her as a person at all."

come back a Communist entirely wrong. He's come back a rugged individu-alist if ever there was one. Had a grand visit with him. . . .

September 24: . . . Billy tells me he and Judith are separating in all friendli-ness, divorcing. "You see, I have learned to live alone—I am not afraid of it any more."

September 26: . . . Morning with Billy, discussing his Berlin story. . . . Then Joe and Billy dragged me over to the Bill Goetz studio [20th Century-Fox] to a luncheon supposedly with Orson Welles and [producer Sam] Spiegel, but which turned out to be all the executives on the place and one thrown out of a seat because I was there. I sat between [writer] Nunnally Johnson and Bill Goetz and enjoyed detesting Welles who was at the other end of the table, showing off in a hyperthyroid way I've never seen in anyone else but Preston Sturges, who is far more intelligent and likable, but also curiously devoid of humanity—both of them seem trying to make a loud, brave noise in the vacuum which surrounds them. . . .

October 3: . . . found Billy . . . turned away from his Berlin project. Told an old story of ours—one suggested by *Olympia*, in which a traveling salesman for phonographs in 1905 tries to get the endorsement of the Emperor Franz Joseph and wins the heart of an Arch Duchess. He came across with a glori-ous, exciting casting idea: Crosby as the salesman; Garbo as the Duchess. We went to Harry Tugend with the project. He was delighted and to H. Gins-berg who was relieved and delighted. We lunched with Nat Deverich and Herman Citron who had fantastic plans for my future. Billy wants to sign long-term straight contract. They talked about a 7-year straight contract for me at $4,000 a week, though they warned me that to get one isn't probable. The very idea is kind of pleasant, however. . . . At 6:30, Dodie, Richard H., Jacques, E. and Xan and I dined here and motored in a studio car to Ingle-wood to a second showing of the picture [*To Each His Own*]. . . . There was a great deal of applause at the end and superb cards. . . .

October 4: . . . From the office I called Phyllis and Olivia about last night, then settled to work on our Crosby-Garbo yarn, looking up the history of

phonographs, etc. Henry asked us to lunch with him at Lucey's and as we sat there Harry Tugend called to say that Bing was in the studio—so we all rushed to join him and Harry at the commissary, took Bing to the office and Billy outlined our project, to Bing's great pleasure. . . .

October 5: Spent the morning with Billy, tossing about ideas for our picture. Billy as usual needs the architectural, scene-moulding qualities of Jacques and I had to put it up to Henry to put him on *Sans Gene*, with that in mind. Henry, to whom I explained the exact situation, did so for six weeks, but offered to put him on the payroll under contract as a consultant at $500 a week, which I think he'd be wise to take. . . .

October 6: . . . Billy got a letter from Chas. Jackson of Euripidean intensity, saying that he couldn't get over "that night"—said night being the one when I snarled at him over the telephone. He couldn't work, couldn't sleep, etc., etc. My emotions on reading it were complex—deep regret that I'd upset the nasty little neurotic so much, and a horrid smugness that I'd been able to do so. Billy, Jacques and I really tackled the problem of the new picture, and kept at it all morning. . . .

October 12: . . . Lunched at the commissary, napped briefly. A little further discussion before Fefe Ferrer arrived to say we were to meet Garbo at 1048 Benedict Canyon at 4—please not be late. The address proved to be Elsie Mendl's—neutral ground. No one there but Garbo, Fefe and ourselves. Garbo incredibly lovely in shorts and no hair-do at all. Fefe suggested vodka in memory of *Ninotchka*. Billy had three glasses, the rest of us one. Billy, rather nervous and feeling for his vodka, told our story, as it stands. He told it with charm and insouciance and I think it went well. I put in bolstering words. We promised Miss G. infinite things in the way of privacy, wardrobe, etc. We talked of *The Lost Weekend*. She said she'd been asked to go tonight, thought now she would. I told her that the Webbs [Clifton and his mother Mabelle] were dining with me, would she come along? She hesitated. I left it open.

Xan and E. were goggle-eyed at the possibility of Garbo's arrival. We went to Lucey's. Dotty and Frank Craven joined us, Charles Russell, Gladys Cooper

and her daughter Sally. Finally the Webbs, with Garbo, who sat one side of me, Mabelle the other. We ate an enormous dinner, got to Proj. Room 9 very late and other guests had started the picture. I had to stop it and they had to see the beginning over again. (They included Joan Fontaine, John House-man, Henry Fonda, Jimmy Stewart, Lew Wasserman, Moo, Moyna McGill, the Cromwells.) Usual proj. room reaction to the picture.

October 15: . . . went to the first meeting of the new Academy Board and nominated [Jean] Hersholt for President. He was elected and proceeded to demonstrate what a very dull president he will make. He is the King of the Unfinished Sentence. . . .

October 16: . . . We drove to Pasadena and had a preview [of *To Each His Own*] which seems to me less good than the other previews, possibly because we followed a comedy. We haven't before. Many poor cards. . . .

October 17: A morning of discussion of *TEHO*—first with Billy, who as was to be expected, didn't like it very much; then with Chuck, Doane and Alma, who were in complete agreement with me on everything. . . .

October 19: . . . At 2:30 Billy, Jacques and I moved over to Proj. Rm. 7 and joined by Miss Garbo and Clifton [Webb] and [his mother] Mabelle saw Leo McCarey's *Bells of St. Mary's*, an utterly delightful picture, for my money bet-ter than *Going My Way*. Funny, tender—everything a picture should be. Billy also was absolutely hit on the head by it, and we spent the remainder of the afternoon in sheer admiration. . . .

October 22: The papers informed me that Paramount was being picketed shut [by the Conference of Studio Unions], and Helen Hernandez confirmed it while I was having breakfast. I went to Ernst's and Billy and I worked, or rather discussed the story with Ernst all morning. . . . I came home and slept unintermittently most of the afternoon and felt the confusion and disheart-enment thousands of other men shut from their factories must feel. . . .

October 23: Spent the morning at Ernst's with Billy and Jacques. Ernst before he left had one tantrum at Jacques' communism and I had one in the afternoon. . . .

October 25: . . . Spent a morning working hard at the script. Billy and I met Leland at Lucey's for luncheon and he dropped a bombshell: Garbo says No. She liked us, she likes the story; she is crazy about Bing. But she's afraid—a pathological fear. I haven't given up hope, but Billy has. . . .

October 29: A blackly discouraging day. Billy arrived, full of vitality and enthusiasm, eager to do another picture quickly on the tail of *Pomp and Circumstance*,[12] *American Tragedy*, with John Lund and Joan Caulfield. . . . I happened to say to Billy: "After all, Joan would be better as Sands-Fuckley, the rich sassiety girl." Billy said promptly, "That must be played by a bitch. That's Doris [Dowling, his mistress]." Whereupon the whole thing became clear. . . .

October 31: . . . Katherine Ann Porter was put on *The Duchess of Suds* and I lunched her at Perino's. After luncheon she saw *Incendiary Blonde*. . . .

November 1: . . . Billy and I and Fefe Young lunched Ingrid Bergman at Lucey's. She was charming, admiring, gay, gentle, and firm as steel that she didn't want to play in another picture with Bing—not so soon after *Bells of St. Mary's*. . . .

November 4: . . . I had to pick up Dotty Parker, and Dotty was the old Dotty—sullen, contradictory-drunk, over-polite, over-mean—in fact, the crashing bore I remember all too well. . . .

12. This title was first suggested by Billy Wilder on October 26, but Brackett provides no additional information as to its proposed storyline. Katharine Hepburn was apparently to be the star.

November 9: *TEHO* dubbing problems and pretty intense work on *Pomp and Circumstance*, which is getting to the writing stage. It has been moving towards it at a most majestic pace, they feel in the front office. Some discussion of what writer to put on *An American Tragedy*. Billy wants Irwin Shaw; I prefer Mel Baker. A discussion with Nat Deverich about a term contract for me. Paramount has renewed its endeavors, it seems. They are talking on a basis of five straight years, with options for two additional years. . . .

November 12: . . . Billy was struck by the idea of having Crosby in Vienna with an animal act, a very bad idea it seemed to me and to Jacques, but we lost the day discussing it. At 12:30 Paul Stewart dubbed in a voice for Major McNair[13] and proved to be a pretty bad actor. . . .

November 13: Billy is undoubtedly the seventh son of a seventh son. As we were interrupting our discussion of *P. & C.* to look at a bright fox terrier which had been suggested for our purpose, his owner said proudly, "He's just played the Victor dog in a Pasternak picture"—and there lay *Pomp and Circumstance* in ruins around our feet and the only comfort Billy's suggestion of yesterday that Bing play a man with a dog act, not a phonograph salesman. Nonetheless, or only a little less, my spirits sank, not to rise again. . . .

November 23: Billy arrived with a very comical idea for an advertisement in *The Lost Weekend* section of the trade papers. David Selznick (his favorite butt) has been running an advertisement for *Spellbound*—a picture of Ingrid Bergman holding Gregory Peck close to her bosom while behind her back he clutches a big old-fashioned open razor. We had the Prop Shop make up a big open razor and posed in the same pose except that two pictures were shown, one showing Billy holding the razor behind my back; one showing me clutching a razor behind his back. . . . Herman Citron and Nat Deverich lunched me at Lucey's and discussed the new contract which it seems is a straight 5-years at $3,000 which does not add up to $800,000, as previously noted herein. They advised me to take it however and I said yes. . . .

13. Played by Dick Winslow in *To Each His Own*.

November 29: . . . To Billy's, where we worked all day save the luncheon interval, actually getting a little writing done. Lunched in the commissary and had a talk with Harry T. [Tugend] and Dick Mealand which definitely put the kibosh on the *American Tragedy* plan and seemed to shut the door to any possibility of pictures of originality, distinction, or interest apart from comedy interest. We drove back via Hollywood Blvd. to see if there was a queue in front of the Paramount where *Lost Weekend* opened. There wasn't. . . .

December 4: While I was at breakfast an agitated call from Miss [Katharine] Hepburn, who arrived last night. . . . I got a taxi and raced to Billy's. . . . We saw her in the big room at 1141 Tower Road. She was charming, alert, her shiny small face interested in the story Billy told and told rather badly. Cukor arrived and when she went to greet him Billy and I looked at each other, a rather "busto-crusto" look. Cukor came in and kidded us all and after he'd left it turned out that she'd liked the story and we planned a campaign to make it possible. . . .

December 20: . . . motored to Huntington Park to an interesting preview [of *To Each His Own*] with the score which proves a most undistinguished score and one which cut out the tension and reality of several scenes. The new doctor's scene worked superbly. The going-away scene isn't much helped by retakes, and the rodeo is. The new music injures the effectiveness of the ending and is to be replaced by the old; music under the prescription room scene is to be eliminated. The audience was on the brutish side, chary of laughs, but apparently completely held by the story of the picture. The cards were excellent. . . .

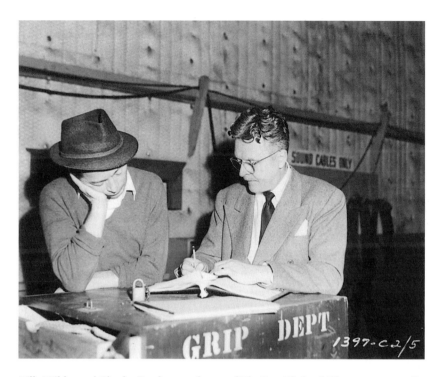

Billy Wilder and Charles Brackett on the set of *The Lost Weekend*. They are supposedly rewriting a scene.

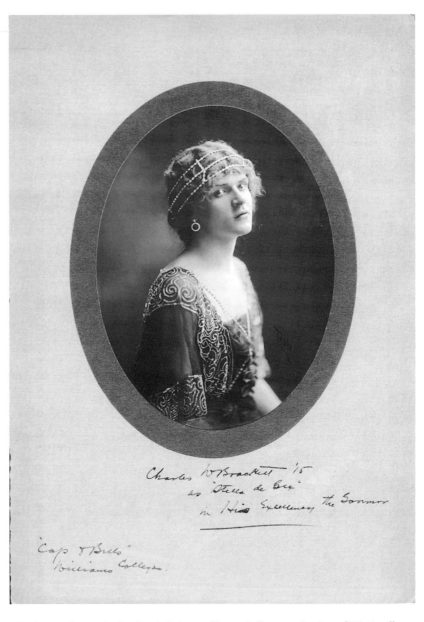

Charles Brackett as the leading lady in a Williams College production of *His Excellency The Governor*, circulated by Alexander Woollcott as a Christmas card in 1935.

Elizabeth Brackett (*right*) on the beach at Antibes with Sara Murphy in the 1920s.

Neysa McMein, one of Brackett's closest female friends.

Frank Partos, Brackett's first collaborator at Paramount.

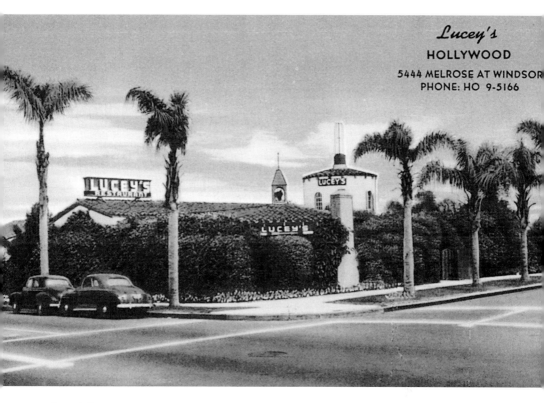

Lucey's Restaurant.

Hedda Hopper and Monty Woolley, both of whom feature prominently in the diaries.

John Mosher, film critic of *The New Yorker* and possibly Brackett's closest male friend.

Five Graves to Cairo: Charles Brackett, Billy Wilder, and Doane Harrison.

Five Graves to Cairo: Billy Wilder, a quizzical Erich von Stroheim, Anne Baxter, and Franchot Tone on the day before shooting was to begin.

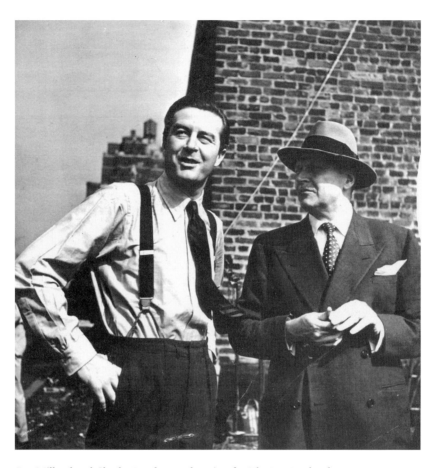

Ray Milland and Charles Brackett on location for *The Lost Weekend*.

At the Trocadero in West Hollywood, May 3, 1945. *Left to right*: Alexandra "Xan" Brackett, her husband James Larmore, Elizabeth "Bean" Brackett, and her husband Clifford J. Moore, Jr.

The Emperor Waltz: Billy Wilder, Charles Brackett, Joan Fontaine, and Edith Head.

Charles Brackett, a very bored-looking Myrna Loy, and Paramount executive Henry Ginsberg.

Charles Brackett and Richard Breen.

A Foreign Affair: Billy Wilder blows his own horn, watched by technical advisor Col. C. A. Murphy and leading man John Lund.

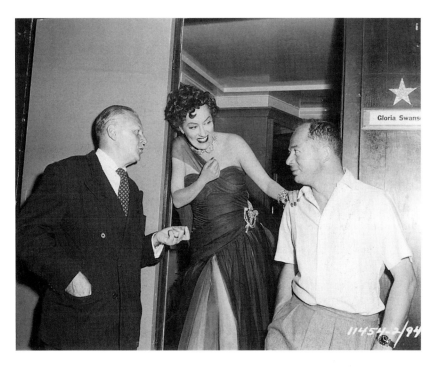

Gloria Swanson outside her dressing room with Charles Brackett and Billy Wilder.

1946

January 20: . . . we went to Westwood and the preview [of *To Each His Own*] played better than the picture has ever played before and I was happy as a lark till the preview cards came in, which were, God knows, the worst we've had, although I think the majority were excellent. . . .

January 26: . . . Billy and I lunched [Joan] Fontaine at Perino's. She had come determined to like the story anyway. She was doing it all, very conscientiously, "for the man she loved." But when it came to the "Now you bite me" scene, her interest became absorbed and I think she was honest in saying she'd be tickled to death to do it. While she's good for the role we went back to the studio rather depressed at not having K. Hepburn, whom we'd had in mind as we wrote. . . .

January 21: . . . Billy and I worked all morning. I lunched at Perino's, napped, and we were starting to work again when a conference of people on the campus outside our window drew our attention. It was a mass meeting of all the carpenters and painters in the studio, calling for Mr. Freeman or Mr. Ginsberg to explain the discharge of a lot of elderly men who have worked a long time on the lot. Freeman came out and explained that they'd been discharged in accordance with a A.F.L. agreement the studio had signed. The meeting had none of the smouldering dangerous quality of such a meeting if it had occurred in Italy. It was more like a New England town meeting. A picturesque detail was Betty Hutton in a window above the mob, looking troubled, but troubled I feel sure only about how to steal the scene. . . .

January 23: . . . A glorious actor anecdote. Dick Maibaum is producing
O.S.S. which will star Alan Ladd. Ladd said to him, "Just for a change can I
have a finished script before I start? I'm tired of having 30 or 40 pages thrust
at me and being told I'll get the rest." Dick, appreciative of his artist's desire
to get the line of his part, said he'd do his utmost and would promise Ladd a
finished script at least the day before shooting. Alan breathed a sigh of relief:
"An actor likes to know what wardrobe he's got to have," said he.

January 28: . . . The studio, and an idea for an opening scene from Billy
which appeals to us both: the dramatization of silence, broken by a phono-
graph record playing "The Stars and Stripes Forever" . . . [ellipses in original]
Bing Crosby came in. Billy had announced his policy of stoutly opposing
[Johnny] Burke and [James] Van Heusen as the songwriters for our picture.
They have written a series of weak songs for Bing which neither of us liked—
but when we discussed song writers and Bing suggested Burke and Van Heu-
sen, I heard Billy complying instantly, to my incredulity. Later he said that it
was to force me into "I Kiss Your Little Hand, Madame," which I oppose as
too wildly anachronistic—but I know that it was really an irresistible rever-
ence for Bing. . . .

January 30: . . . Olivia called me to say how pleased she'd been with the fi-
nal version of *TEHO*, which she saw, that Curt Siodmak, her new director (for
whom it had been shown) had cried and her mother had been so overcome
that she'd had to leave . . . a rather disquieting bit of information, that last. . . .

February 1: Got to the office about 10 and very shortly thereafter Bing,
Burke, Van Heusen and [composer Fritz] Spielman assembled to discuss
score. Spielman played the piano, pushing himself as much as he could under
Billy's specific instructions regarding pushing himself. All was smooth until
the discussion of "I Kiss Your Little Hand, Madame"—which Bing, Burke and
Van Heusen thought as awful as I do, but Billy went into one of his childish
agonies and I gave up my fight against the damned thing and won't mention
it again, though my enthusiasm for the picture is pretty much evaporated be-
cause of it. Rather imagine that Bing may simply refuse to sing it, which will
cause a most unpleasant situation. . . .

February 7: . . . We lunched Ruth [Waterbury] at Lucey's . . . to get material from us for our spot on Louella's program,[1] but it was pretty impossible to get anything from Billy, who quite honestly thinks he does his pictures single-handed, which doesn't make for a successful interview on a collaboration. . . . Went to an Academy meeting marked by the reading of a long letter from David Selznick about the Academy Awards, that the Awards should be revised to make a producer of one picture or a director-producer eligible, or anyone who had made some great contribution to the industry. Bill Dozier fell on this like a terrier on a root and made it an opening wedge for Leo McCarey to get the Award. I know that the chances of my getting the Thalberg Award were slight—no long record of brilliant productions—but had a curious resistance to seeing McCarey get it, and then thought of a man who should get it because he really eased pictures along the road to literacy: Ernst Lubitsch. After the meeting I mentioned this to Harry Brand (press agent for Fox) and he loved the idea. It was Harry who told me the idea behind Selznick's letter: he's paving the way to get the Academy Award for next year for *Duel in the Sun*, the single picture he'll produce in 1946.

February 20: . . . Selznick invited me to a dinner for Henry Luce of *Life* and *Time* which was one of the most entertaining evenings I've ever spent in Hollywood. It was at The Club and the guests were Walter Wanger, Nelson (Luce's advertising editor), Jimmy Somebody-or-other, Frank Capra, C. B. DeMille, Ernst Lubitsch, Jack Warner, George Stevens. I made it a point to arrive on time to see whether David, the latest of all possible guests, would be there on time. He was with Luce, who congratulated me on *Lost Weekend*. He hadn't realized his name was mentioned until he happened into a theatre and heard it for himself and he was pleased. . . . We were through dinner when David announced the purpose of the gathering: to challenge *Time* and *Life*'s policy of picture reviewing and their attitude towards picture people. Most of the people fell on Luce heavily and without much justification save that they thought the critics didn't know how much money was involved in the picture they panned unthinkingly. Certainly not a fair squawk. Selznick had, as he said, a personal grievance. *Time* had attacked his advertising policy with regard to *Duel in the Sun* and it was the one publication in which the advertisements had appeared. Luce said there was and could be no control

1. Broadcast live, but scripted, on NBC on February 17.

of the editorial end by the advertising end. That any such contract could be imagined. . . .

Jack Warner pointed out that bad reviews made only a ten percent difference in the earnings of a picture in big cities, no difference elsewhere. George Stevens made the smartest point of the evening: didn't the lack of knowingness and fairness about their picture reviews have a tendency to shake the confidence of *Time*'s readers in other *Time* statements? He himself remembered accepting everything some commentator used to say (Arthur Brisbane) about world affairs as gospel until that commentator wrote that Carpentier was a better fighter than Dempsey. Luce admitted the point was well taken.

Luce's advertising man said he was just back from the Italian–North African theatres of war and that American pictures were bad propaganda there—B pictures, all Westerns, etc., etc. Ernst Lubitsch said "Just one question. The hero of these pictures is usually American?" "Yes." "When the audience leaves the theatre, do they like him or not?" "Oh, they like him." "Then these pictures are good propaganda for America." It was the second very well taken point. Certainly the whole evening was a slightly unusual way to entertain a guest. . . .

March 1: A weary, footling day—Billy's divorce (or rather Judith's divorce) went through, to his infinite depression. . . .

A gloriously beautiful sunset tonight. I drove up Vine on my way home and the great mountain behind town was a luminous, half-transparent dark blue and against it the letters of the electric sign shining delicately like the most exquisite jewels, Broadway Hollywood [department store at Hollywood and Vine]. As I turned West the sky was orange as a bonfire.

March 7: Academy Award Day, and after a first cursory discussion of our scene Billy and I knew we wouldn't be able to do any serious work and turned to cribbage. Ray Milland came in, so strung-up that his words weren't always in the right place in sentences. I said, "Ray, I promise you that if you don't get the Award I will commit hara kiri." And he quite surprisingly and untruthfully said, "Oh, I'd rather have you around than the award." . . .

We arrived at the Chinese just as the orchestra was starting to play. The show was a little more cumbersome and pretentious than last year but good. The clips began and the Technical Awards and Johnny Seitz didn't get the Camera Award and Doane Harrison didn't get the Film Editing Award. At intermission I whispered to Billy "This isn't going to be any walkaway," and he whispered back something about the power of Metro. And the intermission was over and . . . Bette Davis reading a horrible quotation from John Cowper Powys about writing, and then she got the envelope filled with the winning writers' names—and suddenly, before she's opened it, I who had been taut as a fiddle-string, knew that it was all right. And then she read "Best Written Screenplay of 1945—*The Lost Weekend*"—and I wasn't in the least surprised but was mighty pleased.

Billy and I walked up and got the Awards, they photographed us a little, then the Directing Award clip was on and "Best Director, Billy Wilder." We were being photographed some more and missed hearing "Best Picture of the Year, *Lost Weekend*." Henry [Ginsberg] took the Oscar from Eric Johnston, though I believe it ought to go to me. There was the breathless wait for the next-to-the-last award: "Best Actor, Ray Milland for his performance in *Lost Weekend*." The final award for Best Actress went sentimentally to Joan Crawford, who was at home ill.

There were a million congratulations and photographers in the crowded backstage, a Paramount party at La Rue's, very warm and sweet . . . and a compliment from Hedda which went right down to the dark springs of snobbism and pleased me mightily, something to the effect of "It's so wonderful you should have overcome the disadvantages of gentle birth and come to this. . . . I looked at all the other people on the stage and there wasn't another top-drawer person among them, male or female." . . . It was an excellent party and I brought the Oscar home . . . , and it stands on the table beside me, strong, ugly, preposterous . . . [ellipses in original] Billy got bad news while we were at the party—that our dear Ernst has had another attack.

March 8: . . . At the studio the writers' fourth floor had garlanded its windows in commemoration of our triumph—garlanded them delightfully with a row of whiskey bottles suspended from every one. . . . John Lund's wire was the funniest, "It couldn't have happened to a sweeter, more wholesome pair of girls" . . .

March 9: Stopped at Billy's for his Oscars, which were to go with mine to be marked [inscribed]. Charles, his colored butler, let me in and I said, "I'm calling for two Oscars, Charles." "They're in the living room," Charles said, opening the door of that apartment. The Oscars weren't there. "They were last night," Charles said. "Mr. Wilder must have taken them up to bed with him." And he had. . . .

March 11: . . . We'd promised to lunch with the Paramount writers table and turned up at 12:30 to find the usual Paramount writers' dining room thrown into the other private room, a very long table stretching down the two and every writer, director, producer on the lot present. Billy was at one end; I half a mile away from him at the other. There were fine gay presents, concocted by the Prop Department. Mine was a whiskey bottle with four live roses stuck in it under a tent of cellophane, over which were hung sleeping tablets, a tube of morphine, a hypodermic syringe and about which were piled bills from sanitariums, with items like "one broken strap," "refund for whisky confiscated," etc. . . .

[On March 14, Brackett's daughter Xan, husband James Larmore, and son Tig begin moving into their new apartment above Billy Wilder's garage. In March 1948, Brackett wrote to his youngest daughter, Bean or Elizabeth, "Xan and James have transformed Billy's garage so completely that Billy said when he saw it, 'I feel as if I'd struck oil on my property.'"]

March 19: . . . A luncheon for Joe Breen [of the Production Code Administration] was given by the studio, all producers requested to attend. In quite a good speech Joe warned of storm signals in his correspondence—more letters of complaint received in the last eight months than in the previous thirteen years in which he has held his office. He has codified the subjects of complaint—open-mouth kissing, drinking, low life (*Double Indemnity* and *Scarlet Street*), needless brutality—most of the drinking not necessary, simply put in because the writer couldn't think of anything else for the characters to do, sheer laziness. I asked if *Lost Weekend* had been the cause of much criticism. He said *au contraire*. . . .

April 1: . . . In the afternoon Billy and I heard Burke and Van Deusen play "Get Yourself a Phonograph" and the words Burke has written to "Chambre Separe," and I thought Billy meaner than the devil in his comments to Burke, mean and unwise. . . .

April 5: . . . Our offices are now a shambles, due to the fact that the lavatory of the big office is being made into a bedroom for Billy—"in case he should work late at the studio." So all the furniture is in corners, covered up by sheets, etc. . . .

April 11: . . . Spent the morning at the studio in a whirl of wild activity. Billy and I lunched with Leland at Lucey's and talked the chances of a percentage deal. We then came to Billy's and tried to write a simple connective scene and Billy paced up and down moaning that he was unhappy about it and we didn't get far. His desire to have every syllable a laugh has become, to me, pathological and boring. . . .

April 18: . . . At the studio had a pettish, nasty little quarrel with Billy, his fault not mine, and due to my fifth-wheel function as Producer on a picture which is essentially his, as Director, an Austrian, an empty function which I find nerve-wracking. . . . Immediately after the rowlet, a million casting and similar problems arose. We lunched at the table. I napped and Billy performed service for Elliott Nugent. Elliott in *Welcome, Stranger* had a scene between Barry Sullivan and a medical examiner which he couldn't cast to suit him, so he cast himself and asked Billy to direct the scene. Elliott had himself made up as me—graying hair, gray moustache, and while Billy was directing, when Billy called for Elliott's stand-in, Elliott yelled, "Brackett! Where's Brackett? That's what he's supposed to do."

It was quite a tricky little scene and Billy got his pace in it, which I should think would fight bitterly with Elliott's leisurely pace. . . .

April 23: . . . At the studio we inspected the dogs. . . . Big Bill Tilden came in and would have loved to play the chauffeur, were it not that his tennis dates

conflicted with our schedule. I lunched Katharine Brown at Perino's and heard about Charlie Jackson's next book, which seems a lulu. A real shocker, with an effective but phoney ending.[2]

In the afternoon a long conversation with Henry Ginsberg about *EW* & *Alice*[3] and general studio matters. He agreed that I'm to put James [Larmore] on the payroll as my assistant on Monday. . . . I thought of trying to get Elsie Ferguson to play the Archduchess. . . .

April 24: Production details all day long. Settlement of when we begin shooting, May 24, and where—Canada. . . .

April 26: . . . in the midst of casting, costume and other problems, I was summoned to Henry G's and given a wire from NY saying *TEHO* could go into the Music Hall if five or seven minutes were cut, as the Music Hall couldn't play a picture longer that two hours. To get a picture in the Music Hall is a great commercial coup and carries a lot of kudos. *TEHO*, according to our figures, was 2 hrs, 1–1/2 min. long, I promised to do our best. . . .

After luncheon after urgent call from Henry, so Doane, Chuck, [editor] Alma [Macrorie] and I sat down and scrapped a minute and a half out of the film, with agony but without much loss to the film. As we sat in the projection room, Henry called to say that, on his representation, the deal had gone through and we open there the 16th. It's the first picture I've been on to play there since *Ninotchka*. . . .

April 29: . . . It was James' first day at the studio as my assistant and a day of confusion and mystification, I should think, with a dozen conferences whirling around him. He took it well, however. . . .

2. *The Fall of Valor* (Rinehart, 1946) has a homosexual theme.
3. *Alice-Sit-by-the-Fire*, which Brackett was involved in as producer, with Albert Hackett and Florence Goodrich as principal writers, and Mary Martin as star. Mainbocher was to design the costumes. The production was shelved prior to beginning of filming.

James and I lunched at the table. In the afternoon there was a meeting with the musical side of the studio, to discuss our numbers and Van Heusen was a squid, pouring black hatred on us, and Burke a pretty sizable portion of hatred too. . . .

May 4: . . . Most of the morning was devoted to the costumes worn by Fontaine and [Lucile] Watson. The technical man and Edie Head are at loggerheads. Edie is ill and tired, and Billy is so unconscious with the boredom that he won't even listen to the problems. Finally we doped out a surefire romantic dress for Fontaine, if our yellow proves unfortunate and another for another scene to be worn by Watson. . . .

May 13: . . . Joan Fontaine appeared for fittings. We had been singularly neglectful of her recent marriage, and she entered saying "Thank you so much for the flowers and wires and champagne," to which I replied how could we send things? I've been painting flowers on chiffon for your dresses and Billy has been sewing up the hems." And Billy said "Wouldn't you rather have an Academy Award anyway!" . . .

May 16: . . . Went to a SWG Writers luncheon meeting which was very occupied by the fact that the writers who write Westerns or B's are underpaid and unprotected by the buffets of fortune. Francis Faragoh said that it was certain that people without pressing, enervating worries wrote better, and I said yes, that was what was the matter with the son-of-a-bitch Keats. We had a budget meeting at 2 o'clock which lasted for two hours. Our budget on the picture is between $2,800,000 and $2,900,000. The highest budget ever accorded a Paramount picture, except *Frenchman's Creek*. . . .

May 17: . . . The morning was devoted to sets. Lunched at the commissary and went to the sound stage where Bing recorded "The Kiss in Your Eyes" magnificently. He made eleven takes of it, which is unusual for him. Usually gets a song in three. . . .

[On May 19, Brackett, Wilder, Doris Dowling, Doane Harrison, Buddy Coleman, and assorted Paramount personnel leave for Canada by train. On May 21, they arrive in Vancouver, and the following day, take the train for Edmonton, Alberta. On May 23, the company arrives at its destination, Jasper, where initially they are housed in the Athabasca Hotel until the Jasper Lodge opens for them on May 28. On May 31, Joan Fontaine, Roland Culver, and others arrive. It is unclear as to when Bing Crosby arrives, but certainly not until early June. The time is spent not only in filming but also in scouting location and working on the script. Rushes are screened at the Chabas Theatre. Brackett notes that Wilder and Dowling often quarrel. On May 24, he writes, "Their relationship is surely the strangest I ever saw. I sometimes wonder if at the base of it isn't Billy's feelings for his mother. She was a shrew and he never cared for her, so he says, but he's found Doris, another shrew, and his great pleasure and passion is in her—very often in disciplining her." On June 30, the company, now numbering approximately eighty, leave by train, arriving mid-afternoon in Los Angeles on July 3.]

July 4: . . . Richard Haydn arrived and we went to Lubitsch's. There has been an appalling change in Ernst. He seems to have shrunk, his lips were blue and he talked wildly and incessantly in a thin, throaty voice that wasn't his voice. . . .

July 8: The first day of shooting at the studio. . . . Billy shot three and a half pages (ten set-ups). . . .

July 12: . . . Today I perfected a full slogan for Paramount: "The Strawless Brick Company Doesn't Make Better Mousetraps."

July 18: . . . back to the set to find Billy in despair about Karlweiss.[4] He was thinking longingly of Haydn. I confirmed that we could get Haydn. He

4. Actor Oscar Karlweiss, who was to play the Emperor Franz Joseph.

finished the day's takes, slapdash, and we'll see the rushes on them before we decide. Meantime we threw out the shooting schedule to avoid the Emperor for several days. . . .

July 20: . . . Went back to the studio and saw the rushes and heard the record Karlweiss made with me and it was pretty bad and the rushes were bad. Doane says of Karlweiss, "The worst I've ever seen." We made our final determination to get rid of him. . . .

July 21: . . . Billy in a state of collapse. About 5 in the morning he was attacked with the savage pain of kidney stones, stumbled downstairs and telephoned for [Dr.] Sam who came and gave him morphine. He was in bed, fairly cheerful when I arrived but had another attack which eliminated all possibility of work. . . .

July 22: At breakfast Billy was seized with another violent attack. I went to the studio to shoot the Baron-Johann scene with Doane and we'd just arranged the first set-up when Billy staggered in, pale and bloated, to see the scene through. I concluded the wretched business of telling Karlweiss he wouldn't do and took care of various other things. . . .

In the afternoon Doris drove Billy to the hospital to be X-rayed and a phone call came to the set where Doane and I were laboring, to say that he had a kidney stone blocking one kidney. . . .

July 23: . . . got to the studio before 9 and all day Doane and I struggled, photographing the Johanna-Scheherazade night scene. The psychoanalysis scene had rendered Scheherazade camera-nervous and it was straight hell to get the shots but by 6 I think we'd succeeded. Joan Fontaine was an angel.

Haydn came and was fitted with a Franz Joseph wig, he's not as accurate a reproduction as Karlweiss but he has a look of strength, and wit, and weary majesty which is just what we want.

Reports came that one of Billy's stones had emerged and the other would give him no further trouble. He'll be out of the hospital by tomorrow. There was a great drive by the front office not to take Haydn as he doesn't fit in with their fictional schedule which was wished on us and which is already in tatters. . . .

July 25: Breakfasted with Billy at his house and went to the set with him when he got to the studio and heard him telling his assistants how much better a director he is than Doane and I. . . .

Went on the set and had a talk with Hedda Hopper there. Joan was having a curious spasm of thinking a perfectly grammatical sentence was ungrammatical. Had my hair cut and saw the rushes of the stuff Doane and I did and they were pretty good. Had a meeting about the music problems of that detestable song, "I Kiss Your Little Hand, Madame." . . .

August 8: . . . Billy and reshooting the scene Doane and I did, and instead of shuddering and acting like an imbecile, Scheherazade was doing exactly what he wanted in every take. She's no longer in heat and it seems her morale has been restored by being allowed to kill some rats and mice. . . .

August 9: Billy feeling poorly, it was planned that he and I should work all evening. I went to his house to dinner and Arthur Hornblow came in and stayed all evening. . . . I stayed at 704 N. Beverly all night. Billy was voiding blood and his face looked swollen and feverish and I spent a pretty wakeful and troubled night worrying about him and our picture too, I must confess.

August 10: Billy wakened me with the news that he'd been called about 2:30 by Buddy Coleman and informed that Joan Fontaine was ill and couldn't be on the set. . . . Dr. Ryskind called for Billy about 8. . . . We went to the Cedars of Lebanon . . . and . . . the first X-rays were taken. They proved Billy's stone to have moved at least five inches lower, into the neighborhood of his bladder. They also proved that his kidneys were functioning perfectly. . . .

August 13: . . . George Brown said that *Life* was sending Cecil Beaton to do some drawings on *The Emperor Waltz*. I said Billy and I wouldn't have him on the set, due to his anti-Semitic activities, but found later that Billy had no objections whatever. . . .

Returned to the studio, saw with Billy and the group the retakes on the night scenes that Doane and I took. They were distinct improvements. As Billy and I walked from the theatre he said, somewhat unattractively, that the retakes were a hundred percent better. "Ten percent," said I—infuriating him.

August 14: . . . Went to Billy's for dinner and an evening of work. Billy had evidently brooded about my ten percent speech yesterday. Just before I left there was a long, quietly ugly speech about how old and cranky I had become.

August 27: . . . Billy spoke of possibility of not making a picture for a year, wanting to be free to travel, if he wished. He would have a sense of responsibility towards me unless I did other pictures. Long later, it occurred to me that this might well be one of Billy's brush-offs, which are always complicated affairs. The whole business left me depressed. . . .

September 3: . . . At 5 went to Billy's finding Bing and Doris there. Nevertheless we got to work and finished the script. At the end Billy sank on his knees, making obeisances to God, and said attractively to me, "Now I won't have to see you around on Sundays any more." . . .

[On September 6, Brackett leaves for New York by plane, arriving the next day, when he takes a plane for Providence, Rhode Island. On September 10, he leaves by train for New York, and that evening flies to Burbank, California, arriving the next day, and coming to the studio in the afternoon, "a little tired and cross."]

September 26: . . . Billy has decided to fire his servants as too lazy, a decision not difficult to understand as they have refused to cook his breakfast

on Thursdays, leaving Wednesday night for their day off. He consulted Judith. She said she'd find him another colored couple. He demurred, saying he thought all Negroes were lazy. Judith flared up. "You can't say that any more than you can say all Jews are shysters and cheats!" "In fact," Billy replied, "the only generalization one can make is that all capitalists are sons-of-bitches." . . .

September 29: . . . went to Billy's and talked to him about *Emperor Waltz* which he likes much better than I do and about our first production under our own aegis which I'd like to be with James Mason. . . .

October 4: A day on the dubbing stage. When I met Billy in the office I knew he was in one of his moods, and his mood proved to be the persecuted one. The Rebel discriminated against. This comes on him now and then—he craves occasional persecution as animals crave salt. With the passing of years, however, and his great success, it's getting goddamned hard to find any persecution. The best he could do today was that John Farrow is allowed to drive his car on the lot and that whereas Bing Crosby is given $25,000 for saying one syllable on the screen, he and I were asked to speak two lines in *Variety Girl* for nothing. At first he said he would do so for an automobile, then only if $125,000 was given to the Jewish Blind. I may add that I've never known the Jewish Blind to haunt his conscience before. Result: *Variety Girl* will have to stagger along without Brackett and Wilder. . . .

October 8: . . . E. and I were talking when the telephone rang, Herman Citron, trying to make an appointment with me and Billy for tomorrow. I called Billy. He was setting out for San Francisco at 6:00.[5] Finally it was arranged that Herman, Lew and I should go to his house at once. Lew had talked with Henry and had a firm offer of 25% in 10 pictures in the next 7 years, some to be produced by me apart from Billy. Lew didn't think this is a high enough percent, is willing to settle for 35% or 25% including *Emperor Waltz*. I sug-

5. The diaries do not indicate the reason for the San Francisco trip.

gested that Billy and I incorporate and Paramount buy $250,000 worth of shares in the company, to give us some working capital if Henry and Balaban refuse us the 25% of *E.W.* These percentages are to be entirely apart from our present salaries, which Paramount will continue to pay. We broke up, all pretty elated. . . .

October 14: . . . Dined at home with E. and went to a meeting of the Hollywood Republican Committee. Was appointed the head of the writers' committee. Heard with horror the radio project of Adolphe Menjou which consisted of calling all Democrats Commies. Found that David Selznick and Buddy Lighton and Leo McCarey shared my sentiment and stayed checking of the announcements with them and Adolphe and Morrie Ryskind and Howard Emmett Rogers.

October 16: Wakened by a telephone call from Billy. As he returned from San Francisco he had a puncture about a block from his house and would I pick him up? I did, with the pleasure it always gives me to see that ill-mannered, egotistical, vital, slightly mad creature after a separation. He was entertaining on the subject of his trip, excited about a new car he got today. We drove to the studio. Most of the morning passed in catching up with the mail, the news, and getting action on the background of the title and the lettering. . . .

October 18: . . . I did a power of political telephoning before Billy arrived. We then discussed projects and decided that a picture about Hollywood would be the thing which would interest most. (This evening I read that Zanuck is doing a picture called *The Hollywood Story*, but I think that's safe competition.). . . .

November 6: . . . Helen telephoned to say that there was quite a crowd of strikers outside Paramount and that they'd shouted insults at her and she'd already telephoned Billy, who said he couldn't bear to look at my face today anyway. . . .

November 14: . . . We [Wilder and Brackett] talked at length on a wild project he has, and an interesting one, a story against the background of modern Palestine.[6] . . .

November 27: . . . drove to Long Beach for the preview of *The Emperor Waltz*. It was the right kind of a first preview, not breath-takingly enthusiastic but proving that we have a solid fairy-tale kind of picture if the terms be not contradictory, a mousse with a reliable skeleton, which will be infinitely improved when the minutes are cut from it. One song "Get Yourself a Phonograph" laid a complete egg and must go. The violin concerto is too long, the style of writing of the titles is appalling—illegible. Some official jokes don't warrant their laugh, but the whole thing is going to be all right. Everyone from the studio seemed pleased with it, Frank Butler having a couple of excellent suggestions, D. A. Doran alone maintaining the non-committal smile which has meant employment to him for thirty years.

November 29: . . . Got to the office about 9:30 and the morning was spent in a conference of Billy, Doane, Chuck and Lee about cuts. It seemed to me a highly intelligent conference and one set off on exactly the right track by the lukewarm preview. . . . After luncheon I finished re-reading *Mortal Coil*, Huxley's script on *The Giaconda Smile*. I had read the original last night. The script still avoids the great story for a couple of minor stories. At 3:00 Zoltan Korda, who owns the story and for whom Huxley has written the script, appeared. We had a distinct meeting of minds on various aspects of the project and he's coming again with Huxley.

At 4:30 we saw the cuts as we'd planned them this morning and most of them looked extremely well. . . .

December 3: A morning with Billy who was in a fine, companionable mood, and no one can achieve a better one. . . . A long talk with a Dr. Hortense Powdermaker, who is working on a study of Hollywood from a purely an-

6. There are several references to a Palestine project but no indication as to its storyline at this point. While ill at home, on November 25, Brackett mentions reading *Thieves in the Night*, "a novel about Palestine which is interesting but appalls me by

thropological point of view. At 4:30 Zoltan Korda and Aldous Huxley appeared, without the copy of the script they'd promised, but in a mood for business. Korda's face was slightly swollen with some kind of skin disease and his beard was of a 5-or-6-day vintage.

I've met Huxley before, but let me restate him again: tall, elegant, in an utterly careless way, quite beautiful of feature despite the one silvered eye and utterly beyond my power to like. Helplessly aloof from one. I remembered his hero who "needed a dragoman with life." He badly needs one with me. Frankly, I detest this writer, whose work I worship. . . . Jokingly I say, "I expect the best thing since Euripides from you." He smirks, and I realize that this goes into his experience as a comic saying of a Hollywod producer. . . . He and Korda both say the script is much improved, much tightened and simplified. We all agree on the casting, but if I go into the project, I go with dread of the association with that pair. . . .

December 4: The revised Huxley script (so-called, it's principally rear-ranged) and I read three of the flat narrative opening scenes to Billy, to his horror . . . [ellipses in original] I lunched with Joe Sistrom at Lucey's, Billy, Bert Allenberg and Jimmy Townsend joining to eat and kibitz as we played cribbage. Bert, who after years of superb service to Olivia [as her agent], has been fired, was chuckling over a story of Mr. Goodrich[7] and the picture editor of *Life* who wanted to lunch with her and if possible work out a scheme for her to appear on the cover of *Time*. To this Mr. Goodrich replied that Mrs. Goodrich didn't go to restaurants with newspapermen, that if there were any questions they wanted to ask, let them ask in writing and Mrs. Goodrich would answer them. The Award chances get thinner with every such episode.

At 4:30 we started in a studio car for Riverside . . . and saw the second preview, which, *mirabile dictu*, went much better than the first. The cards were about the same and not wildly enthusiastic but the audience enjoyed that picture thoroughly.

the unattractiveness of the life. It's as unattractive as the life of the Pilgrims at Plymouth—oh no, far, far more so to the Gentile perceptions, but surprisingly like it."

7. Marcus Aurelius Goodrich (1898–1991), novelist and screenwriter married to Olivia De Havilland (1946–1952).

[On December 5, Brackett leaves by plane for New York, arriving the next day. On December 8, he takes the plane for Washington, D.C. to visit with daughter Bean and her husband. He leaves on December 10, by plane, for Albany, New York, traveling on by train early the next morning for Saratoga Springs. On December 13, back to Albany by road, and then by plane to New York for the day, before heading on to Providence. He returns to New York, by plane, on December 16, leaves for Los Angeles on December 22, and arrives the next morning.]

December 23: . . . Billy and I had a long session about the script of *Sorry, Wrong Number* and I had a talk with Doane about *The Giaconda Smile* which Korda is asking, with his service, $300,000—an absurd price. Billy also discussed his Palestine picture project. I am perfectly aware that he doesn't really want to make it but wants somebody on whom to place the blame—but I have no intention of bearing the blame. So I was of no help to him. . . .

Billy and I were summoned to Henry's and got his definite no on MCA's demand with regards to us. Billy made a plan which Lew Wasserman, in a conference approved. Our deal is to be 33-1/2% if taken up now. With the lapse of every six months it will go up .05%. I asked Lew how long the present regime could go on. He said, "Oh, another year." He remembered Olivia's as the best performance of the year, and Billy's instant reaction of "Oh, no, no" was the most flattering thing that's happened to me in a long time. . . .

December 26: Billy came, the Palestine project still in his mind. Whether it is an honest wish to do something for his race or an inability to give up a pose which he fancies, I don't know. . . . In the afternoon called on Henry G. and talked to him about *Wrong Number*. He's agreed to let Billy take time off the lot to make the Palestine picture—me, too, if we add it to our contracts. . . .

December 27: . . . I had a conference with Frank Butler and D. A. Doran, who were wildly enthusiastic about *Sorry, Wrong Number* and also eager for me to go ahead with *Giaconda Smile* which they felt as do I will require much more work. . . .

December 30: A morning spent with Billy, discussing *Sorry, Wrong Number* and discussing it with him and Henry. In that session Billy made the possibly unwise suggestion that Eve Arden would play the woman lead and Henry leaped at it like a trout. Might be brilliant, might be disastrous.

I had to attend a luncheon meeting of the Academy Awards show committee and had a little brush with Mervyn LeRoy who had asked Jack Benny to be the master of ceremonies instead of Bob Hope, ostensibly because Bob exhibited "bad taste" in his remarks about Eric Johnston—really because Benny is a friend of Mervyn's. I defended Bob and Mervyn snapped, as he always does, "All right, you take over the show." Later Mervyn revealed that he's trying to get Jolson to sing a song. Ugh, ugh, ugh!!!

. . . set out for Sam Spiegel's New Year party, which is now the established New Year's Eve event of Hollywood.

The street in front of his house was lined with cars, both sides, from Santa Monica to Sunset—most beautiful tribute since Valentino's funeral. The mélange of people present was incredible: David Selznick, Irene (a New Year's kiss before all the world), Greer Garson, Richard Ney (he carried her in gaiety to their car), Hedda Hopper, Willie Wyler, Joan Harrison, Billy and Doris, the Johnstons, Charlie Russell, the German contingent en masse, Herbert Marshall, Walter Pidgeon, Eddie Mannix, the kids, Bo Helsel, the Charlie Vidors, Frank and Marishka [Partos], two million people I didn't know—a Sam Spiegel looking troubled and saying helplessly, "Too many people—too many!"

1947

January 2: Billy and I discussed *Sorry, Wrong Number* most of the morning. About noon we saw new stuff for the main title [*The Emperor Waltz*], none of it what we had ordered, nor any attempt at it. I had words with Gordon Jennings [responsible for special photographic effects] on the subject and I have seriously concluded that he is color blind. . . .

January 7: A body blow this morning. Billy and I were summoned to Henry's office to be informed that we'd lost *Sorry, Wrong Number*. Litvak's manager had asked $200,000 or a percentage, [Jack] Karp, according to Billy's instructions had offered $100,000 but said that he'd go "a few dollars higher." Next Litvak's lawyer called to say that the property was sold elsewhere. I was sick about the business. Billy a kind of sullen streak that was more surprising. . . .

January 8: . . . At the studio Billy and I tried to evolve a new picture, discussed an idea of his for a comedy—a man from the Breen office[1] in love with the Mae West of the moment. It's funny but a little piddling. Jose Ferrer and Mae West were considered for the parts. . . .

January 15: Billy, I am pleased to say, begins to show signs of acute discomfort at our inactivity but we remain inactive. . . . I telephoned David

1. The Production Code Administration, headed by Joseph Breen.

O.S[elznick]. making a date to have luncheon on Monday and discuss Billy's Palestine idea. . . .

January 16: Billy and I arrived at the office, each with an enthusiasm for a picture project—his was for a story of a Congresswoman and an avia-tor;[2] mine for a completely modernized Faust. Naturally we went to Henry's [Ginsberg] and sold him and Frank Butler and D. A. Doran Billy's idea, which still seems to me only pretty good. They were over-enthusiastic about it. . . .

January 18: In discussing his new story this morning, Billy said "You know we will have more violent political disagreements on this picture than we have ever had." Suddenly I thought, "Oh no we won't because I can't go through the disagreeableness of association with you any longer. After all, an Oscar one night a year is agreeable, but is it worth looking at that face and listening to that ego all the other days in the calendar?"—and the answer was No. . . .

. . . amused to learn that Mrs. [Joseph] Cotten [Lenore Kipp] keeps a jour-nal. She tells me she writes in it as unrestrainedly as if she was talking to her psychoanalyst. I, who makes notes for future hypothetical reference, was impressed. . . .

January 19: . . . At 4 o'clock by Sam Goldwyn's request, I went to his house to tea with him and [wife] Frances. He wanted to ask if I thought *Ball of Fire* could be made into a musical comedy for Danny Kaye, and also to tell me how brilliant the criticisms of *Best Years* [*of Our Lives*] had been and that he'd never get an Oscar for Best Picture or a producer. I was far too expansive and pontifical in my criticisms of current pictures and came away depressed because I'd talked too much. . . .

. . . dinner party at George Cukor's: Ethel Barrymore, Constance Collier, the Minnellis, Bea Lillie, Dorothy Dickson, Fannie Brice, Ivor Novello,[3] Gladys Cooper, Orry-Kelly, Greta Garbo.

2. The first reference to *A Foreign Affair*.
3. Ivor Novello (1893–1951), gay British composer and actor; also in American films. Known affectionately to his fans through to the present as "Dear Ivor."

After dinner Judy [Garland] sang Ivor's latest song, "When You Come Home Again" and his first song "Keep the Home Fires Burning," to Ivor's accompaniment—sang them with the beautiful simplicity she has achieved, then went into other songs. Beatrice L. did a number or two, and somehow that party didn't jell—too many extra females perhaps. . . .

January 20: . . . After Billy left I got together the Mary Poppins[4] stories (follow-up to my conversation with Bea Lillie). . . .

. . . Came home and called Richard Haydn about the Mary Poppins project, which he said excited him profoundly. . . .

January 23: . . . Billy and I went into session. Billy admitted he felt dried up and written-out. Wouldn't it be best to get another writer on the script? I agreed. . . . A little questionably he mentioned some young writer he heard did magnificent things for radio. Curiously enough, said young writer happens just to have been signed for Paramount. I suspect one of Billy's elaborate brush-offs, but as I also was longing to brush him off, can hardly resent it. All amicably done, and I am gloriously sure I'll never write with him again. Whee! . . .

January 24: Billy and I read one of the radio scripts of Mr. [Richard] Breen and found it Chandlerish but very funny, and Mr. Breen has been ordered to appear and work on *Foreign Affairs* [*sic*], as we now call the piece. . . .

January 29: Drove to the studio filled with the sadness of passing things. Dick Breen arrived about 11:00 and Billy began briefing him as a screen writer, not officially but really—the collaboration was over. Excessively bored with it for a long time, I saw it end with some regret. . . .

4. Title character in a series of children's books by P. L. Travers, first published in 1934; eventually filmed by Disney in 1964.

January 31: [Preview of *The Emperor Waltz* at unidentified location, to which Brackett drives with Richard Haydn and Doane Harrison] The new title was beautiful and gay, the foreword legible, and the audience enchantingly receptive. The picture played as never before and Haydn simmered with appreciation of it as we rode back to Lucey's. All the Paramounteers were impressed and enthusiastic. The cards were mostly good.

February 3: . . . Billy is not pleased with Dick Breen, says he has no sense of construction (he wasn't supposed to have) but he worked with him this morning. . . . He is in a mood of bitterness and resentment for something or other and it seems to be directed at me. . . .

February 4: . . . At the studio Billy decided he didn't want to continue with Breen, so I switched Breen on to *Oh Brother*[5] and Billy took on [Robert] Harari, a half-Egyptian horror he thinks is a good constructionist. . . .

Billy gave me a lift into Beverly [Hills]. His curious procedure of pushing me out of his life continues nevertheless—almost formal conversation, etc., etc. . . .

February 5: . . . At the studio Dick Breen and I began tackling *Oh Brother* and spent most of the morning talking to Jimmy Dundee[6] who gets stunt men for Paramount, he being a stunt man himself. I was astounded to learn that he's two years older than I and has been in the business 28 years. . . .

At 5:00 Billy and I met Jean Arthur at MCA and sold her the idea of playing in *Foreign Affairs*. . . .

February 7: A fine day with Dick Breen, naming our characters, finding what some of them were like, finding a working title. It was to be *The Treet*

5. A working title for *Miss Tatlock's Millions*.
6. Jimmy Dundee (1900–1953), former boxer.

Millions[7] and the family to be named Treet—but we learned that there's an Armour meat product company which is called Treet. . . .

February 16: . . . E. and I went to Cukor's at 4:30, a party for Evelyn Waugh. Ethel Barrymore was pouring, the Reggie Allens and Andrea, Olivia [De Havilland] and [husband] Marcus, Constance Collier, Lucille Watson, Garbo—but no Evelyn Waugh till just as E. had decided she wasn't feeling well and wanted to go home, Mr. and Mrs. Waugh came up the steps, very unprepossessing—a bank clerk and his snuffly wife, an ill-favored tailor's dummy with halitosis and a blue-eyed Elsa Lanchester part. I brought E. home and returned to Cukor's. It seems that in my absence Waugh had sent his wife home, dismissed her in a rude way which impressed everyone unpleasantly. Of my conversation with him I remember only one thing, an earnest question, "Do you think *Brideshead* will make a film?"[8]

Talked at, or rather sat next to Garbo for some time, stirred by her beauty but bored by her little-girl silliness. . . .

February 26: Stayed home this morning and wrote on *The Tatlock Millions*[9] in my bed, enjoying myself thoroughly. Went to the studio about 11:00 to find that Billy had talked to Marlene [Dietrich] in Germany about playing his Nazi woman and she had refused him as it was too unsympathetic a part.

. . . In the afternoon we looked at some film on a dreary French girl the studio is importing, Corinne Calvet.[10] . . .

February 28: A day almost entirely devoted to the Academy, to Olivia's nerves for the most part—a long telephone call to her in the morning making an appointment for 2:30. At 12:30 I had luncheon with the Academy Awards committee, where there was kind of a general acceptance of the fact that Paramount, by failing to follow up with its *TEHO* campaign, had passed up the

7. Later to be retitled *Miss Tatlock's Millions.*
8. *Brideshead Revisited* was eventually produced as a television series in 1981.
9. Which has suddenly become the new title for *The Treet Millions.*
10. Corinne Calvet (1925–2001) made her U.S. screen debut in *Rope of Sand* (1949).

chance of an award for Olivia. . . . The committee was given schedules of a projected Academy program lasting from 8:45 until 11:45 with no intermission. I made one speech: "For God's sake let's cut down the length. Over the last few pages I can hear the sound of bursting bladders." I think it had some effect.

Then to Olivia's. She was pale, pacing, affronted, worried. All other Academy nominees had been given consistent publicity. Not she. I tried to be comforting. I fumed with her against the Publicity Dept. . . .

I came home to get a call from Olivia, of real fury. She didn't want any advertisement now; she had decided to cut off all dealing with Paramount. . . .

March 6: Found Billy depressed about his story He spoke of a book called *Children of Vienna*,[11] the story of children living in squalor in the cellar of a bombed house who are cared for by a Negro-American chaplain. It sounds wonderful to me and I undertook to read the book today and did, to my great disappointment. The chaplain turns out to be not a real, believing Chaplain, he doesn't set the children on their feet in Vienna, and it's just plain mad in spots.

I lunched at the table, Dotty Lamour appealing to me for a joke when she gives a gag Oscar to Bob Hope (to the amusement of Billy, who regards Dottie and me as a droll combination). . . .

March 10: . . . Saw most of *Golden Earrings*, which Mitch showed Billy and me, for the Marlene stuff. Billy appalling on the subject, of course, and it is certainly all old operetta but not unentertaining. . . .

When I got home, very sleepy, Monty [Woolley] was here in a de-insulting mood. Monty was at his best, withdrawing by his very manner all the affronts that have annoyed us in his last visits. Had a very good time with him. . . .

March 12: . . . Dined at home with E., went to a picture and at 11 o'clock to the upstairs rooms at Chasen's where the Board of Governors of the Academy

11. Written by Robert Neumann (E. P. Dutton, 1947).

met and supped and decided on special awards. There was a bloody battle before we got them to give one to *Henry V*, the most vocal opponents being Frank Capra, abetted by Frank Lloyd and Herbert Stothart and Bill Dozier. Jean Hersholt lost his temper. Walter Wanger, Mary McCall, Gene Markey and I fought steadily and well and got our point. My suggestion of an award to Lubitsch was greeted with really heart-warming applause. Alas, Mervyn LeRoy seized on the opportunity, offered by Jean, to give the award, which means that it will completely lack dignity.

March 13: Went to Jean Hersholt's house on the way to the studio and added the Olivier award speech and did a bit of polishing. I was amused at the house itself, at the indecisive quality it shares with so many Hollywood houses, which aren't sure whether they're cottages of simple workmen or palaces—simple, primitive objects all about, and in the dining room some objects of Ducal splendor. . . . Told Jean how badly I felt about Mervyn doing the Lubitsch speech. His only interest seemed to be that he would have liked to do it, to bring up the fascinating fact that 25 years ago he met Ernst at the station. So it wouldn't be much better if he did it. . . .

. . . Mildred Ginsberg, Mitch and Billy arrived. We started cocktails and cana-pés. Twenty minutes later Xan and J. arrived; and twenty minutes later still Olivia and Marcus. We dined in a state of nervous tension. Olivia was wearing as pretty a dress as I ever saw—pale blue, very full-skirted, with a garland of pailletted flowers crossing it. During dinner I spilled some gravy across it— and strangely the frenzied activity it occasioned (the damage was completely repaired and the dampness ironed out) eliminated some of the tension.

We got to the Shrine [Auditorium] just as Jean was giving the special *Henry V* award. He was followed by [Douglas] Fairbanks, who left out the reference to his father which was a mild joke and tried to transfer it to himself, which didn't work. Watching a few of the speeches convinced me that all actors' definition of being tasty is the elimination of jokes . . . and God knows pro-ceedings could have done with some jokes.

I did not win the Original Story Award—the Boxes did for *Vacation from Marriage*.[12] . . . Mervyn LeRoy completely destroyed all scale and significance

12. Actually Muriel and Sydney Box won for *The Seventh Veil*.

in the Lubitsch Award and I could have shot him. . . . The reel of Academy Award cavalcade film was put on backward and caused at least a five-minute wait. Eric Johnston saw fit to make a political speech. Jack Benny, whom I'd mistrusted, was superb.

Anne Baxter won the supporting actress award; Harold Russell (the handless boy) the supporting actor; *Best Years of Our Lives* best picture; Freddie March, best actor; and then Olivia, best actress—which was the only thing I'd asked of the program. We all went back to Olivia's—the Niven Busches, the Kurt Fringses joining us, the Henry Rogerses, George Cukor. There was a pleasant party of celebration.

March 14: Woke about 6:00 and finished *It Must Be Love*,[13] the script Billy got from Ted Leshin. It didn't live up to the glory of its opening but I learned, after breakfast, from Herman Citron that we've already acquired it. Harari wasn't in and Billy and I spent the morning talking that project, *The Tatlock Millions* and the Academy show.

I lunched at George Cukor's with Salka Viertel, who wanted to discuss a project of Garbo's playing George Sand in a picture about George Sand and de Musset. It sounded to me like a rather pastel exploration of the past, but the luncheon on the porch flooded with the smell of jasmine was delicious and George, as delightful as ever. . . .

March 17: . . . At the studio there was a talk by Eric Johnston [president of the Motion Picture Association of America] scheduled for 10:30. A great group assembled and he addressed us in a rambling way about the duty of American films to spread the American idea, to show typical American life—too much drinking in last year's films. Eighty-seven percent of all films showed drinking and only sixty percent of Americans drink, etc., etc. This led into a discussion of censorship and I asked Johnston if he had seen *The Well Digger's Daughter*.[14] He hadn't. Some man with him had and had been so bored he had left before it was over. I said that to me it was delightful and

13. Unproduced.
14. *The Well-Digger's Daughter/La fille du puisatier* is a 1940 French romantic comedy directed by Marcel Pagnol.

that it could not conceivably harm the morals of the most influencable child but I doubted that it could be made under the Code. I said I deplored a code which made us tell certain lies to American youth. Joe Breen, who sat near me, said "I'll fix you when you've got another picture coming along!" Jokingly, I trust . . . [ellipses in original] Frank Freeman spoke of the wild horses that couldn't conform to Law. There was a great deal of calling me a wild horse after the meeting was over and in the afternoon Lynch of the Breen office and Sherwood called to say that I could make *The Well Digger's Daughter* if I wanted to. . . .

March 18: A conference at MCA at 9:30, Lew Wasserman, Herman Citron, George Cohen and I—subject, Articles of Incorporation for Brackett and Wilder, 45% of such to each of us, 10% to MCA. One sad conclusion that it would be unethical for us to hold the script we've bought without offering it to Paramount first (a consideration which, frankly, had never crossed my larcenous mind), so there's practically no chance of making money on that script, which we are naming *Yvonne, the Terrible*.

. . . At the studio killed time until Billy and I went to luncheon with Sam Goldwyn. We thought it was for a fantastic proposal Billy had heard he was going to make. It was merely to get some rush advice from us re *Ball of Fire*. We lunched in Sam's own dining room with Howard Hawks. Howard talked of Hemingway's new book *The Good and the Bad*. He did the same low-key bragging. He saw the pitfalls of making *B. of F.* with Danny Kaye. . . .

At 5:00 I came for E. and took her to Lucey's. Xan and James, also Roland Culver, joined us. We dined on Paramount (so nearly betrayed) and drove to the Academy Theatre in Inglewood to preview that pretty, empty picture. Excellent reaction, excellent cards. Roland depressed on the lack of success of his performance but held back his annoyance (or disappointment) stoutly. . . .

March 20: Started to work with Billy on *The Hon. Phoebe Frost* [*A Foreign Affair*] and learned to my vast disappointment that the stories of "having licked the third act" are simply not true. It's still an inchoate mass of scenes, with no theme, no build. We spent the morning discussing it. . . .

March 24: . . . In the afternoon Billy and I saw *Mr. Deeds* [*Goes to Town*] at Columbia to check on certain similar situations in *The Hon. Phoebe.* It proved helpful and an excellent picture despite curious non-sequiturs and at least one horrible scene, [Gary] Cooper absolutely charming. I could see some loathsome Capra characters beginning to unfold, but still in the lovely promising bud stage. . . . The story Billy and I bought turns out to have been condemned by the Breen office, root and branch, which makes it a rather bad expenditure of more money than I care to mention, so we're in rather a depressed state on the subject and hopeful that we don't have to go through with the purchase. . . .

March 27: Worked with Billy on the outline all morning. Had a conversation with Olivia about *Portrait of a Lady,*[15] in which she restated her enthusiasm. She would consult her agent and we'd have lunch and discuss it further. A few minutes later she called back to say there was no reason to consult her agent, if and when the outline Dodie [Smith] is to prepare pleases her, she will make a firm commitment to do it. She hopes Cukor will direct. . . .

March 28: Arrived at the office at 10:00, to have Helen say "Didn't you stop at MCA for the meeting?"—turned and dashed back. I was therefore three-quarters of an hour late for the first meeting of Brackett and Wilder Pictures, Inc. As I am president, there were some rumors of impeachment.

Back at Paramount Billy and I would have had a fruitful day but Harari is off his assignment and Billy kept him in the room with us and we accomplished nothing. . . .

April 3: . . . Stopped at Goldwyns to see, with Billy and Harari, a few reels of Howard Hawks' picture *Red River* in which there was a young man Howard had told Billy was superb.[16] I found him not very impressive. Undoubtedly he'll be successful but no smash, I should think. . . .

15. The 1881 novel by Henry James, a screen adaptation of which interests Brackett and which Paramount had optioned, but which was not to be filmed until 1996, with Nicole Kidman in the title role.
16. Presumably Montgomery Clift.

April 9: Billy and I dined at Sam Goldwyn's. It had been the idea that he was to run *Ball of Fire* and we were to make suggestions. He didn't run the picture. He felt embarrassed to so do, as though he were imposing on us. What he really wanted was to talk business—to propose our going to his studio on the expiration of our contracts, to write and direct and produce (under his presentation) a picture a year, maybe two. We pointed out his reputation for being difficult. He denied it stoutly but unconvincingly and was smart enough to offer us blood, sweat and tears, but good pictures—an offer that tempts us both, though it's like wading into molten lava.

April 15: A day of misery spent with Billy and Harari, who have not advanced the story an inch the past two weeks. It has too many of the faults of *Emperor Waltz* to soothe my mind. It's funny, funny, funny, and then suddenly it's over. . . .

April 17: . . . Walter Reisch had breakfasted with Billy and we wrote a strong note suggesting that Henry hire him for Paramount, and got a nasty phone call from Henry disclaiming any interest. . . . Billy, Harari and I worked on the story all day, striking what promises to be a right line at last. . . .

April 22: On the way to the studio an instinct prompted me to stop at Billy's. As a matter of fact I intended to talk to him with complete frankness on the effect I thought Doris [Dowling] had on his work (lamentable). However, I found him in full control, with Walter Reisch on the story. Joined the conference and, by George, some kind of a solution had been reached before we went to the studio. . . .

April 29: The hideous impasse on *Operation Candybar* [*A Foreign Affair*] seems to be broken at last and Billy has admitted that the children story won't mix with the love story, and we are to concentrate on the Love Story. Surely this is the mountain giving way for the mouse. Harari and I have been yelling our convictions to that effect for weeks.

I attribute some of the more recent difficulties to the fact that Doris is back, and her strange effect on him. I'm damned if I can account for it, or express

what it is, but he's a different, more irascible and infinitely less competent person whenever she's around. His face is troubled, he is unsure of himself. I think she'll destroy him yet, and Doane [Harrison] rather agrees. . . .

May 2: We worked on *Operation Candybar* with moderate success all morning. Marlene's husband was to be lured to a church for the marriage to Lund . . . [ellipses in original]

. . . Harari happened to say how much more effective it would be if Marlene's jealous lover were a famous Jew-hater and the pretend marriage was in a ruined synagogue. The words set Billy on fire, and a far, better, stronger, simpler plot than *Operation Candybar* began to unroll from him, with Harari and I suggesting scenes which sounded superb. The only difficulty was that it presented no part at all for Jean Arthur and John Lund would be extremely incredible as a Jew, and our glorious title would have to go. We sat around in a curious state, realizing that the new plot couldn't be, but unable to work with any conviction on the old. Finally Billy and Harari fell to playing chess and I came home. . . .

May 6: . . . I went to the first meeting of the new Academy board. I've been elected for a 2-year haul. It was a long, rather fuzzy meeting—election of officers. I was made First Vice President. . . .

May 7: . . . E., Richard [Haydn] and I went, on the invitation of Chas. Jackson, to the Chaplin Studio and saw *Monsieur Verdoux*, his new film, which was preceded by *City Lights*. Lulled by my chronic hatred of pantomimists, I slept through *City Lights*. *M. Verdoux* is one of the worst pictures ever made, of a wild, irrational inconsistency, hideously written, wretchedly directed, with the supporting parts particularly poorly played. I thought Chaplin's performance quite fascinating, preferring it to his pantomimicry, but then I prefer anything to pantomimicry.

May 8: A lot of the morning was wasted by Billy and me in rehashing *M. Verdoux* about which we agreed completely. The rest of the day we concentrated on the problems of the three scenes and the final tag, with interludes

wherein I discussed the love scenes of *The Tatlock Millions* with Dick Breen, who is not going to be much good at them. . . .

May 14: . . . We lunched Charlie Jackson at LaRue's. Charlie seems a little smaller than he was three years ago but not a day older. He had come here to do a treatment of *Fall of Valor* for Warner's but couldn't get himself to finish it, "didn't believe in it." In fact, alibi-ing his lack of discipline with an overlay of nobility, going back with nothing accomplished, not a penny earned. He was wonderful about his reaction to his bad reviews: his inability to face even strangers on the street, when he had read them and the book appeared. He now accepts them quite docilely as what a bad book deserved. "I can't rewrite," with a little pride in his voice. He was full of Chaplin, whom he is apparently seeing a good deal though he doesn't like him much—full of gossip of New York—the fact that he's considered Jewish in Oxford. "His real name isn't Jackson—it's Jacobson," say the local gossips.

May 24: Billy and I worked all morning but Billy indulged in a digression—his feelings about women: his boredom with them, his scorn for them, his intense dislike. He is a real misogynist (like most intense amorists) and I may say I share his boredom with most of the women he picks out, as dreary and affected a lot of empty-headed females as one could imagine. In his attitude there is also a strong increment of European lower-class attitude I found myself feeling as I did years ago when suffrage was a burning question, which I believed in. . . .

May 31: . . . Billy and I went over the treatment. Billy weakened on the title *Operation Candybar* and we called it *Foreign Affairs* [*sic*], which lessens my interest in the project by half. . . .

June 3: . . . Billy not in the mood for work. We wasted the day trying to find a prop which will reveal that Capt. Pringle has a girl, when first he goes to meet Phoebe—a hairpin the best we can do so far. Had conferences with Butler, Doran, Meiklejohn and, strangely, Billy has a hunch that despite their enthusiasm the picture will never be done. . . .

June 4: Worked on *O.C.* all morning, not progressing far but getting some good stuff. Lunched and Word-gamed at the commissary. As I was going back to the office I saw Billy going across the campus to Henry Ginsberg's office. He gestured me to come on along and I did. Henry had summoned Billy alone but the conference turned out to be a violent and abusive denunciation of me. It was largely incomprehensible but based on the fact that I thought I was going to Europe with Billy, did I? Well, I wasn't. I had started too many projects and had finished none. Who decided what pictures were to be made, and how they were to be made? Not I . . . [ellipses in original] His face was purple with fury. Having had the blessed experience the other night of losing my temper,[17] I remained comparatively calm. Billy was stalwart in defending me, backing me up. The conference ended on an indeterminate note. Whether Henry wanted me to resign or not I don't know. Certainly that appeared to be his wish. . . .

June 12: Dick Breen came in with his first batch of stuff for *O.C.* I thought it funny and gay but Billy wasn't really pleased with it. We worked all morning, Billy and I trying to get the scene in the plane really going but with no success. . . .

[Below is the first reference to the House Committee on Un-American Activities (HUAC), chaired by J. Parnell Thomas. Brackett makes references to the Committee hearings and to Wilder's response. He does not discuss the Hollywood Ten (originally the Hollywood Nineteen) or the Hollywood blacklist. Wilder comes across perhaps as somewhat hypocritical, but then he is responsible for the famous but unsourced quote about the unfriendly witnesses comprising the Hollywood Ten: "only two were talented; the others were just unfriendly."]

June 13: A Friday falling on the 13th I always regard as particularly lucky but I can't see any particular seeds of luck in today. Dick presented us with a funny scene but Billy, who wanted him, resents his scene, resents the intrusion of his kind of wit and even doesn't quite understand the wit. The

17. At a June 2 meeting concerning the Academy of Motion Picture Arts and Sciences and Eric Johnston's plan to merge it with the Motion Picture Producers Association.

arrangement isn't going to work . . . [ellipses in original] Billy and I did the meeting between Phoebe and John and really got into it, so that they were two people meeting, not just characters in a story. It's a lovely phenomenon when it happens.

We were lunched by Mr. Ginsberg in the commissary and treated to his account of what happened when he appeared before the committee investigating Communism in Hollywood. Or, as both Billy and I concluded separately, we were treated to an account of what he wished he had said and done. It was a dreary luncheon and in the afternoon we tackled a speech of the Colonel's to the troops in Berlin, which didn't go very well at all. . . .

June 16: A telephone call from Jean Arthur saying she wanted to talk to us within the next couple of days (and making an engagement for 4 o'clock tomorrow) rather stopped our creative ardor, but we finished the Black Market scene during the day. We lunched at the commissary and saw the balanced print of *The Emperor Waltz*, Billy sitting through it very unhappy because he really hates it by now. And he has cause for some self-accusation though it's still a good picture. The performances are sloppy, however.

I stopped at the Academy and Margaret Herrick babbled away, defending her beloved Shorts Department while I fumed at the ridiculous proportion of Awards they carry away. . . .

June 17: . . . In the afternoon Jean Arthur called us, worried about the fact that there's another woman in the picture. "I have sex appeal," she said calmly, but inaccurately, "only I don't wear it on my sleeve. I've always been very careful to avoid that kind of rivalry." . . .

I came home for dinner, then had to preside at a long, dull Academy meeting whereat we turned down Jock Lawrence's[18] idea of giving an Award (not an Oscar, mind you) to Arthur Rank, in appreciation of the work done by the British film industry at the premiere showing of Rank's picture, *Black Narcissus*, a project dear to Hersholt's heart.

18. Jock Lawrence was U.S. publicist for the J. Arthur Rank Organization.

June 18: A box in *Daily Variety* announced that "Uncle Sam had clamped down on the B & W picture *Foreign Affairs*, which dealt with an American Congresswoman and a German woman." We immediately called Luraschi. There was no evidence whatever of Govt. action. A telephone call came from Jean Arthur saying that she liked the story. There were some little things—no, she wouldn't go into them over the phone. It was easier for her to write them down.

We worked on the Marlene-John scene and the M.P. scene, lunched at the table. Luraschi, Billy and I went to see Henry with our problems re the picture and I think I convinced him that if he and Barney Balaban stood out for the story, undiluted, they would prove themselves great and courageous producers. Henry dropped into the role a little before we left.

E. and I dined together and went, with some reluctance, to *Miracle on 34th Street*. It's George Seaton's picture, about which he told me in great detail about a year and a half ago with the idea that Billy and I might want to do it. While he was otherwise engaged. Frankly I had been bored with it as he told it and thought it was the kind of picture I'd hate to do. Therefore I found it difficult to get myself to the theatre. It turned out to be a picture of straight luminous enchantment. We both loved it.

June 20: . . . In the afternoon we discussed our series of dissolves, discussed the Russian problem—about which we disagree violently—and had an interview with Jean Arthur, who came, blonde, faintly goofy, vague, clutching little slips of paper and making sense about only one thing: she thought Marlene would be just right for Erika, would be glad to cut the pie in three equal halves if that was what we wanted—one for Marlene, one for Lund, one for her (it isn't what we want)—but she did think it would be a mistake to have some young unknown actress play Erika. And there she was right, as the role would make a newcomer and won't be violently noticeable with Marlene. . . .

June 22: . . . It was Billy's birthday and I took him some small presents and we worked all morning, mapping out the G.I. scene. . . .

. . . I left for the Academy Theatre where I had to welcome the audience and introduce Billy Wilder, who commented on *Murderers Are Among Us*[19] and pinch-hitted for subtitles. There was a fantastically brilliant audience. I read some uninspired words. Billy spoke pretty successfully but when he got into the commentary his voice was so low and his accent so thick that I and a lot of others couldn't hear him. And he made a few jokes perhaps better not made. The picture bored the hell out of everybody. There was an attempt at a discussion period afterwards, with no one giving answers and some one fainting in a side aisle, and it was all more or less of a bust. . . .

June 23: Billy a little depressed all day from a feeling that last night didn't go too well. It seems Lewis Milestone berated him for saying *The Murderers* was not a great picture and for cheapening it with his jokes (the only things which made the evening endurable) . . . [ellipses in original] We worked all morning, interrupted by one long telephone call from Hedda Hopper: why in hell did the Academy want to have that damn foreign picture anyway? Every stinking German in town was there.

June 24: Billy and I worked at Billy's all day, getting quite a bit done. Billy spoke about his desire to be a producer, not a producer-director or a producer-writer—a straight producer, something I should think as remote from his personalized talent as it was from Ernst Lubitsch's. . . .

June 28: Wrote a great deal during the night on *Portrait* [*of a Lady*], not improving it in the least but shortening it a little. Got up wearily at 9:00 to learn that Sam Goldwyn had called at 8:00. Called him but he'd gone out. He was at Billy's when I got there, begging us to write a few scenes for *The Bishop's Wife*. He hadn't slept all night worrying about it. He made a fantastic under-the-table proposition which I for one won't go for, but I can't let him cry for scenes in vain. . . .

The picture *The Bishop's Wife* was run for Billy, Sam and me and is a fair, weak little picture with charming performances by David Niven and Gladys

19. *Die mörder sind unter uns/Murderers Are Among Us*, written and directed by Wolfgang Staudte, was one of the first postwar German feature films, released in 1946.

Cooper, a far less charming one by Cary Grant who is wildly miscast. After the picture we all went to Sam's house for dinner with Max Somebody, an employee of Sam's,[20] as a fourth, and Henry Koster who directed the picture coming in later. We talked the picture till 11:00.

June 29: . . . Billy and I worked on a scene from *The Bishop's Wife* all morning. . . .

June 30: . . . We worked on *O.C.* all morning, went to Goldwyn's for luncheon in his dining-room with him, Koster and Max. I read the scene we did Sunday. Koster had reservations, Sam was enthusiastic, Max had a certain contribution he'd made to the former scene, which he loved. Sam lost his temper at him. Billy and I had the time of our lives. It was very like being schoolboys again instead of adults.

We went to Paramount for a moment, then back to Billy's. . . . Henry telephoned from New York, all clear on *Candybar* . . . [ellipses in original] We worked on the scene outside Erika's apartment. I dined at Billy's and we did another scene for Sam, which we think extremely funny—the Bishop in a chair that sticks to him.

July 1: Woke at 6 and a little work on the Bishop scene, then on *Tatlock* and couldn't get back to sleep. Got to Billy's before he was down. Sam came in early and was enthusiastic about the scene which Koster later called too broad, getting objurgations and commands from Sam. Billy and I worked on *Operation Candybar*. . . .

July 2: Worked at Billy's all day, finishing the needed repairs on *The Bishop's Wife*, save for one prayer which I don't think we'll do. Had more light-hearted fun doing the job than we've had since struck amidship by the torpedo Responsibility . . . [ellipses in original] We lunched at Billy's and at 5 Max came in and we read him the stuff because Goldwyn had gone to Arrowhead. Seeing that he was panic-stricken by the responsibility, I insisted that we call

20. Max Wilkinson, head of the Goldwyn Story Department.

Goldwyn to whom I read the stuff over the phone. Although panic-stricken by a reference to eggnog, Sam approved. . . .

July 3: . . . Billy and I went to the studio this morning, cleaned up the Goldwyn stint by writing a fairly good but less than angelic prayer. . . . Stopped at Goldwyn's, gave the material to [Max] Wilkinson, yowled and howled at some changes that had been made ("egg-nog" out). Max finally talked to Sam long distance, who revoked the changes (which he had suggested). . . .

July 6: . . . to Billy's, a little conference as we walked to Henry's. Henry in a perfectly agreeable mood, no pressure for a starting-date on *O.C.* so that it made any suggestion of my going with Billy entirely out of the order of business. . . . Walked back to Billy's, exchanging notes on the paltriness of Henry as a human being. . . .

July 7: Billy and I went to the studio. It seems it's too late for me to go to Germany with Billy even should Henry change his plans. Permissions couldn't be obtained from the Army. Quite a crisis because Goldwyn has asked us to luncheon to settle the problem of payment. I told Billy how I felt on the subject; he thought I was being Quixotic, that under-the-counter payments were the rule out here, that it meant throwing away practically a year's savings (calculated at $10,000 to each of us). I felt like teacher's pet and holier-than-thou, but had to stand firm. We got to Sam's. He said, "Now about payment." Billy said, as agreed, "We don't want anything; we can't take anything. It was a pleasure to do. Let it go." Thereupon Sam finished the speech he had begun: "I find I cannot possibly pay you without reporting it, but maybe if I asked Henry Ginsberg that will be all right." He thereupon mentioned the sum he'd intended to give us, $5,000 apiece, which came as a blow to our pride. Since he was telling us that he couldn't do it, Billy said it might at least have been a big sum he couldn't transfer.

The awful suspicion has arisen in my mind that Sam, before he asked the favor of us, knew he couldn't make any such transfer, as well as I did, and went ahead, pretending to offer it until he got performance. Billy was pretty damned pleased that we'd made our refusal first. It's the first time anyone's gotten the best of Goldwyn in a bargain . . . [ellipses in original] He showed

us the rushes of our stuff, which were so-so plus. David's sermon a good deal better than that. . . .

July 9: . . . Lew Wasserman and Herman Citron came to lunch with their plans for us when Paramount contracts are up—plans for making the B&W Co a going concern. The plans as always involved a tie-up with Jimmy Stewart, which bores me, and this one included a tie-up with Bette Davis. The plan itself is a sound one and apparently the only possible gamble for big stakes which we can make. . . .

July 15: Billy and I spent the day at the studio. In the morning I called on Henry to tell him clearly that my not going abroad with Billy meant a delay of at least two or three weeks in *O.C.* He said he didn't mind. His anxiety is to get the pictures out. Could I go ahead with *Tatlock*? I said, possibly. . . . When I reported the advancing of *Tatlock* to Billy, he was delighted and it gives him a longer time for preparation. . . .

July 17: In the afternoon Billy saw Lund in Betty Hutton's *Perils of Pauline* and a reel of him in *The Night has a Thousand Eyes*, and came away shaken. It seems Buddy Coleman, that great brain, doesn't think much of Lund as a leading man, and Billy has been doubtful himself, as has been Jean Arthur. Tonight I saw *Perils of Pauline* myself with Dick Breen, who dined with me, Dodie and Alec. Lund plays an obnoxious, untrue character, with complete integrity. The result is a thoroughly unattractive personality. This to me presents a challenge—not to Billy.

In the afternoon I had a long talk with Doran about *Portrait*. It seems $1,700,000 is about all the traffic a De Havilland picture warrants and he fears *Portrait* would run to $3,000,000. Most of the time we spent fuming against the studio.

July 18: All day at the studio. Billy definitely has the wind up about John. I registered very clearly the fact that the person who told Lund he was to have the part and built up his hopes was Billy. In a town of many loathsome happenings, such a performance on the part of a major director would seem outstandingly loathsome. . . .

July 21: . . . Lunched at the table and napped inadequately, as I had wakened at 6:00 and worked on *Tatlock* for a couple of hours. When we went to Billy's, his gift from Sam Goldwyn was there—a very handsome gold cigarette case, which pleased him enormously. Yvonne de Carlo dropped in and interrupted our conference, so I came home and found my Goldwyn present: a really superb gold watch. . . .

July 25: Grabbed orange juice and coffee and rushed to Billy's to help, or rather watch him pack and talk matters over with him as he went to the station and boarded The Chief, on which were Arthur and Bubbles Hornblow, and steamed away (electrically). . . . [Wilder, along with Buddy Coleman, is en route to Berlin to shoot exteriors for *Foreign Correspondent*.]

July 29: Had my meeting with Doran, Butler, Meiklejohn and [assistant director] Youngerman. Told *Tatlock* pretty well and proposed [Richard] Haydn as a possible director, which staggered the group, but finally they listened with some respect to my arguments. Doane Harrison appeared and put in a good word and there seems to be a possibility. . . .

August 4: . . . Had a conference in the office with Dick Johnson, who had made out a tentative budget allowing for a 31-day shooting schedule [for *Miss Tatlock's Millions*], which I told him to revise with a more practical one allowing for 40-some days of shooting. Called Howard Lindsay[21] and asked if there were a chance that he'd play Gifford Tatlock. He said "No," but the conversation ended "When would you start shooting?" . . .

August 5: Was summoned to Jack Karp's office and told that the studio had decided to go ahead with R. Haydn directing *Tatlock*, if a satisfactory contract could be arrived at. Put in a call for Richard immediately, felt qualms and clutching of the stomach such as any vital decision involves . . . [ellipses in

21. Howard Lindsay (1889–1968), producer, playwright, director, and actor; Lindsay does not appear in the film, but his wife, Dorothy Stickney, plays Emily Tatlock.

original] James [Larmore] and I inspected the standing set we've been offered as a basis for the Tatlock house. . . .

August 9: I went to the office and found a wire from Billy saying that Dietrich would play the part but that she wanted more money for it than she had received for *Golden Earrings* (this was to be her first demand) and that she was essential to the role and he strongly recommended giving it. . . .

August 11: . . . Doran whispered to me that chances for *Tatlock* looked very slim—New York alarmed about the cast, anti-Lund feeling. The meeting was somewhat footless, everyone reiterating to everyone else the need of economy but the absolute necessity for making good pictures. . . .

August 13: Interview with Henry. He suggested [Ray] Milland for Burke. I said he was too heavy, no contrast to the family, too important, too realistic. Mentioned [Alan] Ladd as a possibility. Henry seized on the idea. I pointed out that he wouldn't be as good as Lund, that the picture would be a lot more expensive. Henry still avid. In any case, the picture is postponed for the present. Warned [art director] Hans Dreier that it was. He had already laid out the house for the set as used. . . .

August 22: . . . I got an hysterical wire from Billy about Dietrich. . . . Henry agreed to the extra $10,000 for Dietrich on which Billy is insisting.

August 31: . . . at about 10:30 telephoned Henry [Ginsberg] with the suggestion that I fly to Paris [22] and come back with Billy, a suggestion which met no opposition whatsoever. . . .

22. Initially, it is puzzling that Paramount should suddenly decide to send Brackett to Paris, but on reflection, it would seem that the reason is for him to meet with Marlene Dietrich, use tact and diplomacy and persuade her to star in *A Foreign Affair*.

[On September 1, Brackett takes the plane to New York, arriving the next day. On September 5, he flies, via Newfoundland and Shannon, Ireland, to Paris. In Paris, Brackett stays at the George V and enjoys a whirl of social engagements with, among others, Geraldine Fitzgerald, Mercedes de Acosta, Rex Harrison, Lili Palmer, Arthur Hornblow, Jr. and his wife, Gilbert Miller and his wife, Elsa Schiaparelli, and Lady Mendl, who invites him to her home in Versailles, to which he will be driven by King Peter of Yugoslavia. Billy Wilder arrives on September 8, and that day "Marlene came to our rooms and finally gave her word to do the picture on our terms . . . but please punish Paramount a little for not picking up that option." On September 10, Brackett, Wilder and Buddy Coleman travel by boat and train to London, where there was a Paramount press luncheon. With Billy Wilder, he returned to New York by sea the next day, playing gin rummy with Ray Milland, discussing the script with Wilder until on September 15 he reports that "Billy was so absorbed in *The Last Days of Adolph Hitler* that he couldn't work." The couple had seen the film the previous day, with Brackett's calling it "interesting . . . but one I found confusing as I can never really keep the titles of the Nazi party leaders straight." The ship docked in New York on September 16. On September 20, Brackett took the train for Los Angeles, via Chicago, arriving two days later.]

September 23: . . . I came home to find E shockingly ill—though she looks much better—unable to walk without a cane and without someone supporting her—she ate a little breakfast, then was nauseated. . . . I got to the studio about eleven, went to call on Henry [Ginsberg] who turned my blood to vinegar by saying someone had suggested putting Bob Hope into [unidentified]. Word gamed at the lunch table, and when Frank Butler called down the lunch table, "Charlie, did you go to bed with anyone in Paris," merely looked at him and said, "Frank, be our age."

. . . Went to [executive William] Meicklejohn's office and arranged a Dietrich contract I think she'll go for. Got mad at Billy for thinking the Bob Hope suggestion a flattering one for us—when he found out it would be a big money-making picture said, "I don't give a damn about money-making pictures, I want to make good ones." . . .

September 25: Went to Billy's house about 9:30 and worked there all day with a break at luncheon during which I met [producer, director, screen-

writer] Eddie Knopf at Romanoff's, and we discussed getting writers for [Harold] Stassen[23]—not sure who will write speeches for him—and I don't think he has any here good enough, certainly I know I'm neither good enough as a writer nor informed enough.

[On September 28, Brackett records what appears to be the first time he takes his grandson, "Tig," to the studio, where the boy plays with Y. Frank Freeman's dogs.]

October 1: . . . at seven Eddie [Knopf] called for me. We stopped at the Beverly Hills Hotel and I picked up Harold Stassen and a Mr. Davis who is here with him. We drove to Metro to a dinner in the Executive Dining Room— in place of one at L. B. Mayer's house—called off because of the death of Mayer's brother. We had advised a lot of questions and answers, so after the dinner Stassen made only a brief speech and devoted the rest of the time to questions. He had taken three already and I thought it was a little off at the beginning of the meeting, but he . . . gave a magnificent demonstration of qualities Hollywood admires . . . if it does not possess them: wisdom, balance, judgment. . . .

October 4: Worked at Billy's all morning, patching together a sequence which will give us about 45 pages of completed script. . . . I had lunch with Chuck West at the cutters table and he told me the tale of Frank Freeman's son who appeared at the studio one day this week dead drunk—tried to push his way into the projection room where Henry [Ginsberg] was running some stuff, but was kept out by some of Chuck's boys, he began yelling epithets about the Goddamned dirty kikes that were running the studio up and down the hall, saw [radio comedian] Jack Pearl and called him a stinking Yid—followed him across the street and was detained by studio policemen. . . .

23. Harold Stassen (1907–2011) is for the second time seeking the Republican Party nomination for president. Throughout October, Brackett and others have meetings with Stassen including a discussion of his wardrobe (which Brackett likens to that of John Lund) and a 500-strong cocktail party on October 27.

October 9: . . . [Billy] has formed a habit when there are others about of saying with a sigh that it was I who kept him from enlisting at the outbreak of the war. I was shocked, but not surprised that Billy showed an inclination to enlist for a cause which was certainly his cause. Before Pearl Harbor I was conditioned not to expect any enlistment as a soldier—and to tell the truth enlistment as a soldier would have been unsure considering Billy's neuroses. . . . When however a chance at a commission came and he did consider going to make moving pictures in a uniform, I advised him that I thought it would be just as well for him to make them in the studio—he was just getting his first chance as a director, he hadn't enough authority to impress himself on the Army—and I thought it was the time for him to press ahead, making pictures which because of their pleasure giving powers would do more good, because they expressed him more fully than any Army made picture could.

I had some experience in the last war as a false officer—who was really a scribe and had no respect for the uniform so employed. However, also for the record I want to point out that within a week or so of the outbreak of war in 1917, I enlisted as a soldier—infantry. I was sent to Madison Barracks for officer training. Because of an appalling lack of military dexterity, was dropped from camp to my infinite agony [but managed] to get to France before any man in my company—this I did by getting a job as Vice Consul in Nance through Franklin Delano Roosevelt—a friend of my father's—who was Secretary of the Navy. Once in France I began to try and transfer to the Army—and managed it eventually—a dreary story with a farcical ending.

October 10: Billy and I worked at the studio all day doing the final polish to the first 40 pages . . . lunched at Perino's with the building committee of the Academy—a meeting which led to recognizing the fact that the Academy is running about $1600 a month behind on its expenses. Charlie Skouros arrived in a very brutal mood—said the studios must give both the Academy and the building committee enough to contain their losses—and I suggested that he go with [Academy President] Jean Hersholt to the studio heads collecting funds. . . . I pointed out that as an owner of theaters he could point out the real values of the Academy better than anyone. He agreed to undertake the job. . . .

October 13: At the studio all day—going over stuff, talking with Friedl [Frederick] Hollander who is to do our music and has a highly censorable song which would be great for Dietrich called "Black Market." ... After dinner I went to Sam Goldwyn's where Sam, Frances [Goldwyn], Billy, Sam's butler and I saw the Danny Kaye musical [*A Song Is Born*] Sam and Howard Hawks made out of *Ball of Fire*—a disastrous dull redoing of a picture that wasn't too bad in the first place. This version highlighted all the silliness of the plot, gives Danny Kaye no numbers, and gets from his personality none of the charm of the Gary Cooper character.

Virginia Mayo plays the Barbara Stanwyck part & while it's pleasant to see someone really young and pretty in the role, her performance didn't have the authority of Barbara's. ... Sam distressed about the picture. ...

[From October 16 through October 23, Brackett and Wilder are primarily concerned with the file room scene in *A Foreign Affair*, which is not shot until January 23, 1948.]

October 23: A day of pleasant work with Billy with a grumble of political quarrel under it, a thing which doesn't bother me in the least. Finally, he said, "You did the one mean thing to me—you kept me out of the Army." Whereupon I spoke my piece, and the subject will never be mentioned again. ... I pointed out ... it had seemed better we work with supreme effectiveness making pictures out of uniform than ... hobbled and confused and driven crazy trying to make them in uniform. He is now busily at work counseling for the 19 in Washington—who have caused so much disruption in the industry and whom I strongly suspect as being Politburo boys. ... After dinner I went to an Academy meeting (instead of obeying an hysterical telegram from Billy, Willie Wyler and John Huston). The Academy meeting lasted forever and revolved around the problem of when & where to have the Award Presentations this year. On the way home I heard a very shabby little morsel of the Washington hearings—Lela Rogers & Walt Disney, etc.

October 24: Billy telephoned while I was at breakfast to say that he got in at 7 o'clock, could we not work today. All night he's been saving the world for the Politburo. ...

October 25: . . . I went to Billy's to learn that he spent Friday night not making the world safe for the Politburo—but standing by Anatole Litvak in a terrific gin game with Sam Goldwyn at Sam's. Tola lost $6000 to David Selznick about a month ago, a terrific loss for him and one he couldn't afford—then he got in a game with Goldwyn and won $52,000 which cheered him considerably. Friday night Sam demanded his revenge and Tola went to his house taking Billy to stand by as a kind of mascot . . . Just as well because Sam after things had been fairly even all night kept insisting that Tola play . . . let him win $16,000 and at seven, accompanied by Billy, was able to break away. . . . I got with the Partoses and we went to the Brown Derby for supper and a long argument about the Washington hearing. Frank believes passionately that they are violating the Bill of Rights. . . . It doesn't seem to me that to have to state things is a denial of freedom. That there are certain instances where you can't say "None of your damned business." I developed a thesis that the right of free speech also carries a complementary duty of expression . . . , and asked Frank if after the Revolution, the founding fathers had become aware that a small group were gathering, making plans . . . to get the United States to repent their errors and go back to England as colonies—in such a case would John Hancock and Thomas Jefferson and John Adams have said, "Well that's what we fought the revolution for—they've got a right to their opinion—let them go ahead."

October 26: John Howard Lawson Day—he was called before the Thomas committee and according to his lights he put on a very good show. He used all the communist tricks of attack rather than defense (well maybe some of them were from Howard Hughes's book) in any case he raised one hell of a scene, screaming that the committee was trying to control thoughts on the screen, that his relation to the SWG was not in the purview of the committee, that he had been "vilified" and demanded the right to question the writers who had spoken against him—His voice was more intellectual, more cultured that that of the slick, ungrammatical congressmen who were having at him, losing the sequence of their thoughts in rage. . . .

October 27: Worked at Billy's ineffectually . . . until the noon broadcast—which displayed Dalton Trumbo's refusing to testify. I voiced my opinion that the congressional committee had a right to ask him whether he was a com-

munist, whereupon Billy had a complete tantrum, saying that if that was so, this wasn't the country he'd been lead to believe it was, and he'd prefer to go back home. We lunched together somewhat silently. . . .

October 31: . . . I lunched with a committee of moderates who feel that the general reaction of the country to the hearings was against the Reds—I don't know. . . .

November 2: During our discussion [Brackett and Wilder] of the Bill of Rights broadcast, Billy informed me that he wasn't a communist but he gave considerably to the left, which makes him a Fellow Traveler I should think. . . .

November 4: In the middle of a rather pleasant writing session this morning Billy said "This is the last picture we will do together. I want to do things more politically daring than you would permit. I want to stop working, to start when I want to. I am no longer afraid." I heard this with a mixture of consternation and relief, for the stress of laboring on this picture has been hellish. We resumed writing.

Billy was lunching with Leland Hayward at Romanoff's. He asked me to go along; in talking with Leland mentioned four projects, one of which was mine originally (to do *The Robe*);[24] another of which was following a dream I've always had of making a picture about colored people; two others were musical comedies on which, it appeared to my incredulous ear, we were to work. . . . Whether I've lost a partner to the French I don't know, or much care. . . .

November 5: . . . At Billy's working all afternoon until Frank Ross came to talk the possibility of our doing *The Robe* with him, a project I find exciting but to which our Paramount contracts are definite borders. Lew Wasserman is going to try and meet the problem. To do *The Robe* would be exciting as it

24. Lloyd C. Douglas's *The Robe* was eventually filmed by producer Frank Ross at 20th Century-Fox in 1953 as the first CinemaScope production. The screenplay is credited to Gina Kaus, Albert Maltz, and Philip Dunne.

can be made into a far better picture than the book was a novel. To work with Billy again is a prospect that makes my innards curl. All fun has gone out of the relationship. . . .

November 7: Worked at Billy's today, taking a spin around a few blocks in his tiny MG, a little English car he bought from Ray Milland when we were on the boat. [Producer] Joe Sistrom came to lunch and urged me to join and get David Selznick to join the Bill of Rights Group, which are being condemned all over the country as Communists for having flown on to Washington. I think it was a Party member who called the signals, but am sorry for the liberal non-card-carriers who are suffering for their foolish liberalism. . . .

November 9: Worked at Billy's all morning. . . . I was to have a talk with David Selznick about doing something about the condemnation of Humphrey Bogart et al for flying East to protest the Hearing. I said something to Billy: "What should I suggest to David?" And very piteously he replied, "That's up to your conscience"—but what I really think he means should be on my conscience is the discomfort to which the Communists were put. I'm pretty muddled about him and want to do, with David or someone, a short: *How to Recognize a Communist.* One that will state the arguments they make to the uninformed, and meet said arguments. . . .

November 17: Billy greeted me with great coldness because I'd been at Hedda's yesterday.[25] "Now you know why I don't want to work with you." However, the morning's work went rather well. Lew Wasserman and Herman Citron came to lunch to discuss a conference Lew is to have with Barney Balaban tomorrow regarding getting Paramount to let us do *The Robe.* . . .

November 23: . . . Billy, Dick and I worked at Billy's, Billy in a very belligerent (pro-Communist) mood. . . . At 8:30 I went back to Billy who had learned that none of the ten Unfriendly Witnesses are ever to be employed in pictures again; so runs the edict of the producers, under pressure from the public. I

25. A cocktail party for the owners of *Look* magazine.

may say Billy sang a little lower. We didn't write much, but I think the bit we did was effective.

November 24: Marlene arrived at 8. Billy met her at the airport but was at the office when Dick and I arrived. The morning was full of Jean Arthur and what should her gold dress be and Marlene and Friedl [Frederick Hollander] and the songs.

We lunched Marlene and John in the commissary and by then the overpowering boresomeness of that super egotism had begun to pall. We handed her over to hairdressers gladly and concentrated on getting out a white script, a job which took us until almost 7:00. . . .

November 25: . . . Billy seemed to have convinced himself during the night that I was Congressman Rankin[26] and it was a day of bitter storms, in which he said, among other things, "I spit upon the Congress of the United States."

Dick Breen watched the whole proceedings with Irish delight in a row and very little progress was made on the script. . . .

November 28: With production near, activity in the office was so frenzied that Dick and I were unable to do a single page of script. Billy was rehearsing John and Jean. There were makeup tests to be seen, costume tests to be weighed, there was a scene I had to read for Jean.

There was a luncheon at the commissary, a hectic afternoon ending at 5:00 with a meeting at the SWG office—the Board plus Willie Wyler and Ronnie Reagan. Wyler, whom I now recognize as unadulterated Fellow Traveler, was urging on our harassed members conduct exactly like that of the Committee for the First Amendment. Reagan was being cautious of us, playing his cards close to his chest. The Board was under the slight disadvantage of having been ordered by its members to take steps against any blacklists. There is no effective step to take this side of a strike vote, which is unthinkable.

26. Anti-Semitic Congressman John E. Rankin, a central figure on the House Un-American Activities Committee.

November 29: . . . Just before I left I went to Stage 10 to see the miraculous Dietrich, looking perhaps 32, try out various pajama combinations. Her beauty is fabulous at this particular time. . . .

November 30: Billy, Dick and I worked at Billy's, then at the studio, laying out the next scenes. On the way back to Billy's he discussed *The Robe* possibilities. He didn't like Gregory Peck, would never do anything with him. Peck was set for *The Robe* so he, Billy and I were out. It was all part of that process of breaking with me which he is going about so deviously and saddeningly, trying to lay it on to social conscience, now to a caprice on his part against the most popular actor of the moment. I have long ceased to protest such things, but feel them bitterly. . . .

. . . the telephone rang and I answered. It was Billy, with the news that Ernst was dead—Ernst, who brought us together, Billy's special hero, and the man in the industry we both most respected.

I went to Walter Reisch's where the German contingent assembled: Otto Preminger, who is to finish *The Lady in Ermine*, the picture on which Ernst was working; Marlene, who was to have seen him this afternoon; the [Miklos] Rozsas, Gottfried Reinhardt and his wife, Salka Viertel, Eva Gabor, Henry Blanke, and Billy, looking like a heartbroken cherub—Billy at his dual-natured sweetness. We were all happy at the suddenness and lack of suffering with which the end had come—it was so on the cards that he would suffer long and painfully. We talked of his great, great gifts to the art of picture-making, the greatest any of us knew. I kept remembering how, whenever Ernst didn't know what picture to do next, he always said, "I think I may do *The Lady in Ermine*." When he actually started it, I had what one might call a premonition that it was a terminal symptom. . . .

December 1: A hell of day. I waked early and did a draft of a little memorial to Ernst from 6 to 8, got to the studio at 9:30 and gave a mezuzah to Jean Arthur, then waited around the set for the first take, which was forever starting.

Lunched with Leland [Hayward] at Romanoff's, told him my suspicions about Billy's plans and he assured me hollowly that they weren't true; had no suggestions in case they were. Back at the studio I was warned that Jackson and the

others from the Breen office would descend. Got Dick Breen to face them with me, went through a hellish session. They are worried about the congressional angle, the Army angle, but most of all the sex angle, forbidding the first scene with Marlene almost in toto, though we salvaged the mattress. . . .

December 3: . . . At 4:00 the rushes and Billy, damn him, has directed Dick Breen's very comical speech for Salvatore ("If you send a loaf of bread, that's democracy—if you leave the wrapper on, it's imperialism") so that it becomes a grave, ill-tempered bit of propaganda instead of a very funny statement. Distraught about it and the way the topper to a speech of Salvatore's yesterday was drowned in direction. Suddenly I find my own picture doing the very kind of things the Unfriendly Witnesses were hauled up before Congress for. . . .

December 4: . . . Billy and I drove out to Forest Lawn. He went to the room with the bearers; I to a rear room where sat Jeanette MacDonald and Rabbi Magnin. We visited until a signal was given and Rabbi Magnin led us out to the dais, where Ernst's coffin stood. Magnin said prayers in Hebrew (I never knew what a beautiful language it was) and in English, before us seemed to be most of the industry; about us the fabulous, hideous flowers of a Hollywood funeral. Magnin introduced me; I read my eulogy without any stage fright, although to lack the little encouragement of laughs or applause, even though they're only polite, gives one a strange feeling. Jeanette MacDonald sang Ernst's waltz [from *The Merry Widow*], very badly. Magnin made some remarks, said some more prayers. Jeanette sang "Beyond the Blue Horizon" from *Monte Carlo* which she and Ernst did and the services were over, save the bearers carrying the heavy copper coffin to the hearse and its going away.

. . . In the afternoon Luraschi appeared with a letter about our script so appallingly unreasonable that he's going to advise that it's useless to try and placate the Johnston office and that the studio go ahead with the picture, relying on us, which puts us on a spot.

December 6: . . . went to the office to learn the black news of the day—that the song "Black Market" has been rejected in toto, which kicks the hell out of another sequence. . . .

December 7: . . . [Richard] Haydn here to dinner. He has a lot of reservations and I question whether he has enough enthusiasm for the project though he is most anxious for the opportunity. The most amazing change has happened in the feeling of both Elizabeth and me towards Haydn. He's gone out of focus for us—neither of us likes or is amused by him any more. I still think him a talented potential director, however.

December 10: . . . Spent most of the day with [Luigi] Luraschi and [Frederick] Hollander, cleaning up the "Black Market" lyric into a state of most uninteresting purity. . . .

December 11: . . . a delightful letter from R. Haydn who is wild with delight at the prospect of directing *Tatlock*. Rather suspect that all his reserve with us has been an endeavor to hide his anxiety. . . .

1948

January 5: . . . In the afternoon I learned that we couldn't possibly get Barry Fitzgerald for *Tatlock*[1] and suggested that the studio buy another six-months option on *Portrait*, though somehow I have the feeling it will never be done. . . .

January 6: . . . went to Billy's at 8:15 [p.m.] with Hedy Lamarr[2] being expelled for our evening session. Tonight we at last got the finaletto down on paper. Billy's at that state of complete knowledge of the people he has to deal with which comes to him mid-shooting, and hot with the ardor of directorial creation. My job was straight midwifery.

January 8: . . . Billy and I lunched with Sam Goldwyn who tried to wheedle us into putting our names on the Danny Kaye picture. Billy said that as we hadn't and couldn't have written it for Danny Kaye, and as we hadn't received any money for the remake—No. I think the underlined phrase made some impression on the old boy. . . .

January 9: . . . Saw the rushes and liked them better than Billy, who felt the pay-off line of the first night club sequence not strong enough and is going to reshoot them. . . .

1. Barry Fitzgerald was cast as Denno Noonan.
2. Perhaps at this time having an affair with Wilder.

January 11: Spent most of the day with Billy and the final sequence is actually shaping up, to my intense relief, and shaping up more simply and naturally than anything we planned earlier. . . . Back to Billy's at 4:00 and at 6:45 Billy and I went to the Goldwyns', where we dined (great difficulty about getting bread to Billy as early in the meal as he likes it) and drove through a thick fog to Glendale for a preview of *A Song Is Born* (the *Ball of Fire* remake) which has been miraculously whittled down and played extremely well. Sam again urged us to have our names on it but the preview has been so successful it was easier to say no than it might have been. . . .

January 15: Found a large box of d'Albert's candy in my office, a present from Jean Arthur. . . . Saw the rushes with a gag scene of [Ray] Milland playing John's role, which Billy did for the front office and which depressed me because in it Ray proved himself so much [a] better farceur than John. . . .

. . . I went to Billy's to find an exhausted Billy who took a nap after he'd finished his dinner, then discussed the airport scene with me, suggesting excellent lines but no line. He was expecting a lady so I had to leave about 10:30. . . .

January 16: . . . When I got to the studio learned that Jean was home ill. Marlene claims she's afraid of singing her song. Spent a good deal of time on the old horror that's to be the *Tatlock* set. . . . Billy promised to work during the afternoon but slept it away instead. . . .

January 18: . . . At Billy's until about 10:30. We got the airport scene done, Hans Otto Birghel's entrance into the night club; in fact The End seems to be in sight. Billy in one of his moods of revolt against Paramount and Henry G.—in the morning all for going to New York but in the afternoon suggesting a contract with me to do four pictures in the next seven years. In the evening he had started to plan a new modern house he wants a man named Eames to design for him.[3] . . .

3. Designed by Charles and Ray Eames, the house was never built.

Billy today described our romantic triangle in the picture in somewhat realistic terms. "A mad woman, Elsie Mendl, and a boy with piles." . . .

January 26: . . . I was a little troubled that Phoebe's flight down that file room didn't get a laugh from the 4 o'clock rushes audience and Billy suspected I was troubled and wormed it out of me but when we re-ran the rushes they looked as wonderful to the rest as they had to me. Why that lack of laughs? . . .

January 27: A troubled day at the studio. Bill Meiklejohn (determined that it should be so) assured me we couldn't get Barry Fitzgerald for *Tatlock*— did we want Frank Faylen? If so we must get him before day after tomorrow as RKO is going to get him otherwise. . . . Had a talk with [D. A.] Doran, confused as usual. Had some words with Henry, no help. Luraschi confided to me that the scene in the file room got no laughs from the executives—first rushes which have disappointed him. We wonder if Billy will prove right and that an audience in a theatre will knock itself out at the scene. . . . Doran asked me to read *The Gauntlet*,[4] with the idea of a Protestant *Going My Way* with Gary Cooper. . . .

January 29: . . . Showed three reels of the picture to some English exhibitors, to Breen and Haydn and old Mr. Zukor, getting vast enthusiasm from all. I was particularly anxious to get Haydn and Breen's reactions to the file room chase. Haydn, like me, found it a beat too long but I found it played infinitely better in context than in separate rushes. . . .

February 1: . . . The finale is written save for about six lines which Billy couldn't get, so that they didn't sound to him like a "good boy." Such is his horror, just as virtue is the horror of Maugham and depraved of virtue the inspiration of most of his works. . . .

4. *The Gauntlet* by James Street (Doubleday, Doran, 1945).

February 2: . . . met Noel Coward at Perino's and had a grand time at luncheon with him, discussing his career and the great cemetery full of our dead friends. . . . David Selznick had asked him to rewrite *Private Lives*—"It's impossibly dated and old-fashioned now"—adjectives which don't seem to have warmed his heart. . . .

February 3: . . . At 2:30 Elsie Mendl and Sirie Maugham came to see Marlene singing the Berlin song and when the artificial smoke and the repetitions got too much for Elsie, I let them see the Black Market reel. . . . Then to Billy's with Dick Breen and another tackling of the final scenes and perhaps we're a little nearer than on Sunday.

February 4: . . . Amazing dissertation by Marlene this morning on Astrology. . . . I said "What are people like who are born in May?" "Oh, Taurus people!" she said. "Stubborn, set, can only see the inch before their eyes, always thinking of themselves—Gary Cooper, Jimmy Stewart, Jean Gabin. A Taurus person never goes into a bathroom that he doesn't stay forty minutes looking in the mirror, trying different expressions. They are the men you think you can lean on in a crisis—and if you lean, they just drop apart." This delivered by a Delphic bitch in an off-shoulder Persian-patterned evening gown with polychrome paillettes on it and great pale roses around the shoulders.

February 5: . . . went to Billy's where he, Dick Breen and I finally finished the script. Billy and I fell on our knees in Japanese gestures of praise to God. . . .

February 6: . . . Got a book on Astrology from Marlene, with an inscription: "After you've read this, you'll be able to despise Astrology more intelligently." . . .

February 7: . . . I took a very long nap and went to a party Tola [Anatole] Litvak gave for Billy—black tie indicated, and I expected twenty guests or so but there was only Marlene and Patricia Neal, a young actress. We went to

the Champagne Room, Marlene rather overpowering in black with a sugges-
tion of white lace in the full skirt, a diamond necklace, long diamond ear-
rings and a diamond-and-ruby bracelet of fabulous workmanship. I sat on
one side of Marlene at dinner, Billy on the other, and she talked unceasingly,
mostly about the time cameramen waste, the magnificence of an Italian pic-
ture called *Paisan*.[5] We moved to Mocambo after a delicious dinner. I had one
dance with Pat and left at about 12:30.

February 9: . . . Got back to the studio just in time to get a message from Bill
Meiklejohn—if it was the only way to get Barry Fitzgerald, could we start the
picture March 6th? Consultations everywhere and we decided while it would
be a good deal of a mess, Barry was worth the mess.

February 11: . . . After dinner we went to the theatre and ran *A Foreign Af-
fair*, the entire rough cut. It's not quite as impressive as I thought—the crazy
kid ending will play well but is a little too light. Marlene's spitting in the first
scene is deplorable; there are some rough spots; but over-all it's an excellent
picture. Dick Breen, Doane's assistant and I went to Lucey's and dished about
it afterwards. The only people to voice very articulate suggestions about the
picture were Marlene and Harari. Their suggestions were bad.

February 12: The morning first on the set, discussing with Billy the rear-
rangement of the opening scene in the plane which he was retaking; then in
a projection room with Dick Breen, Henry Alter and Frank, doing some wild
lines for Millard Mitchell to speak tomorrow. Luncheon at the table, eight
word-game players, including Billy and Richard H., all bored by the scent of
Marlene, who stayed at the table despite being practically ignored, pouring
out her complaints about the picture to Haydn. I realized she was waiting
for me, so walked to her dressing room with her and it all came pouring
out again—resentment of Doane Harrison, of Charlie Lang, stressing one
thing: the number of closeups of Jean in the picture. "Undistinguished, old-
fashioned cutting—monotonous, etc., etc." Jean, on the other hand, I had
found calmer and more cooperative than ever. I told Marlene my doubts of

5. On February 23, 1949, Brackett notes that both he and Billy Wilder disliked the film.

the spitting scene and I left it to her to wangle a retake if she could, but I imagine she thinks it startling and distinguished. . . .

[On February 27, Brackett and others leave by train for San Francisco, arriving the next morning, for a preview of *A Foreign Affair* at the Great Lakes Theatre.]

February 28: . . . The picture went wonderfully, the laughs beginning with the unpacking of Phoebe's bag, and building. No laugh line missed. The melodramatic climax was exciting; the ending a great roar of laughter. . . . There were 65 good cards; 10 bad to negative.

February 29: . . . drove out to Burlingame where we had another preview, which went even better than last night's, at least the cards were better and the laughter began sooner, and while it hit different spots, was as constant. A hundred and twelve good cards, 12 bad ones. . . .

March 3: . . . At the studio found things moving well. Richard [Haydn] and I inspected the set, which begins to look rather well. I read Richard the scenes I did in S.F. and he was nice about them. He read me his and I thought it "cute" and unsexy and he was furious and sulked through luncheon. When I asked "What the hell is the matter?" he said he thought I didn't have sufficient faith in him—and, as a writer, I don't. . . .

[On March 8, Brackett and others begin scouting for a garden to use as an exterior shot in *Miss Tatlock's Millions*; they start in Santa Barbara, then move on to the West Adams neighborhood of Los Angeles.]

March 9: At the request of Wasserman and Citron, stopped at MCA for what turned out to be a business chat. They feel that now that poor times are upon the industry, it's the moment for Billy and me to make our move. They suggest that they can make an arrangement whereby we continue our present

salaries and commit ourselves to make three pictures for, let us say, Metro. We are to get 50% of the profits of the pictures and no overhead is to be charged against our productions. A bright dream indeed. . . .

March 11: . . . to Pasadena to a preview of *A Foreign Affair*, which was again highly successful, Lund getting most of the cards this time. . . .

March 15: . . . A telephone call from Billy that something hellish had happened to him yesterday in regard to the picture. It seems Jean Arthur and Frank Ross had appeared at his house, Jean hysterical, saying that Billy, because he was in love with Marlene, had cut out her best scene, her best speech (the beautiful boat one), had simply sabotaged the best take. Billy assured her he hadn't, that he had used the only retake. Jean asked Frank to leave the room, then told Billy she would never make another picture again, that she was a dead woman, that she and Frank hadn't lived together for five years[6] but please (last request department) wouldn't he let Frank see that take. Billy continued to tell her she was wrong.

He, Doane and I discussed the problem at luncheon, decided to have all takes assembled to show the Rosses. I went back to the office and was in the lavatory when Doane hurried over to tell me that Rosses had already gone to Frank [Freeman]—well, he didn't get as far as that, because Jean and Frank popped into the office just as he did and explained they'd found the first take and it was the one Jean meant and it had moved Frank profoundly. Billy agreed by phone to have it put back in the film, but as I write these lines anger tempts me to countermand that decision. I gave the crazy girl a brief lecture on the wicked folly of a girl of her talent saying she wouldn't act in pictures in the future, and we parted friends. . . .

March 19: . . . At quarter past 10 I had to slip away [from dinner] for the Academy meeting to determine Special Awards and the Thalberg Award. I thought it would be over in an hour but it wasn't until half past 2 that I got home. A great battle on the subject of the Thalberg Award, which [Walter]

6. Jean Arthur and producer Frank Ross, Jr. were married from 1932 to 1949.

Wanger had decided must go to Zanuck for *Gentleman's Agreement*. Mary McCall made an emotional and over-passionate speech for that candidate. Del[mer] Daves spoke for Jerry Wald, Peter Rathvon for Dore Schary. Willie Wyler and I suggested no Thalberg Award this year, believing that *Gentleman's Agreement* wasn't really a first-rate motion picture and that *Forever Amber* more than outweighed its virtues. Finally No Thalberg Award won, and a long dispute on whether to give *Shoeshine* a Special Award, as we wished, with the Award granted.

March 20: . . . we went to the Academy Awards, which seemed to me more tidily done that I'd ever seen them—sentimentally, folksily, but at least with a care and preparation and consideration for the feelings of everyone. . . . Elia Kazan got the Best Director Award,[7] which he in no way merited, and he hadn't the grace to wear a dinner coat. Social protest, I presume.

March 31: . . . Billy made a brief appearance at the office to say that he is so upset by E.R.P. [European Recovery Program] giving money to Spain that he may leave America—nonsensical John Huston talk for which I reproved him. . . . On thinking about Billy's attitude and that of all the Mittel Europeans I know towards their American citizenship, it seems to me this: they've come into a department store, been crazy about its stock, and put themselves down for a charge account. No more involvement than that.

April 1: . . . I had to go to a meeting of Brackett & Wilder at MCA where we renewed our rights to sell stock for another year. Wilder very funny indeed about what demands he would make to take a contract with MGM, then included "One night a week with Ida Koverman."[8]

April 10: Billy came to the office with an invitation to come to the house tomorrow night to a party in honor of Sam Spiegel and Lynn Baguette, who

7. For *Gentleman's Agreement*.
8. Louis B. Mayer's elderly, unattractive secretary; a Republican and well-connected politically.

are being married tomorrow, with a request that I work with him for a few minutes on a foreword to *Sorry, Wrong Number* which has had ghastly laughter at the preview because the ringing of the telephone became too frequent an interruption. This was pleasant to do but the foreword will never save the picture. . . .

April 15: Haydn was back in the studio today and as I went over on the set to do some lines, rather winsomely suggested that his name go on the screenplay as co-author. In fifteen years of Hollywood brassiness that is the goddamndest request I have yet heard made, including Harari's. . . .

April 23: Our preview [*A Foreign Affair*] was at the Westwood Village Theatre. Every Mittle European in town was there. The preview went just like the other previews. I felt that music covered some of the laughs but not importantly. Afterwards those who'd been here to dinner and Billy's party consisting of the Hornblows, Slim Hawks and Leland Hayward, Audrey Young (Billy's current gal), Anatole Litvak and Willie Wyler supped with me at the Papillion, a sup which set me back almost $500. I was annoyed by the gobbling rudeness of Wyler and Litvak, who are not housebroken but who apparently liked the picture very much.

April 24: . . . It was Billy's last day in the studio and we had a wonderful visit. I asked him if it was the music under Jean's poetic speech which made it play less well and he pointed out what I'd forgotten that the speech is the "self-pitying one" which we'd never used before until Jean insisted. Therefore, my worries rolled away and I ordered the other one replaced. At about 12:00 he was off for seven weeks [vacation], leaving the studio a flaccid place. . . .

April 26: . . . I saw *Abigail, Dear Heart,*[9] for which they want a foreword. It is a very dreary and rather silly (rather?—hell, extremely!) but very good looking and I think beautifully directed by Mitch [Leisen]. The foreword it

9. Released as *Song of Surrender.*

needs is one to account for the utterly phoney attitude in 1906 of a small New England town. . . .

[On May 13, Brackett leaves for the East Coast, and in great detail tells of engine problem which forces the plane to make an emergency landing at Chillicothe, Iowa. He eventually arrives at La Guardia at 2:00 the next day, and heads for the Westchester Country Club, where he is participating in a weekend round table, organized by *Life* magazine on the subject of "The Pursuit of Happiness." On May 18, he takes a plane to Washington, D.C., for a brief visit with his younger daughter and her family, and then leaves for Los Angeles on May 19, arriving the following afternoon.]

May 21: [To Pomona for a preview of *Miss Tatlock's Millions*] Rarely has there been as good a preview, an audience that responded as flawlessly to a picture, as that one. They laughed at every right place; they were interested in the plot and understood it perfectly; they even sniveled at the right place. It was a real smash first showing and the cards were raves. . . .

May 25: . . . went to a long Academy meeting at which I had to preside. . . . As usual there was a $35,000 bid from Bulova to be allowed to call a watch the Academy Award watch and as usual we were high-minded and turned it down.

May 26: The day of the premiere of *Emperor Waltz*. Spent the morning in the projection room, looking at *TTM* [*Miss Tatlock's Millions*] which has been improved by some judicious pruning. . . .

At 8:00 we went to the Paramount Theatre where the premiere was being televised. I said a few lines about Billy into the microphone, shook hands with Hedda and Esther Williams under the lenses of television, if they are so called . . . then *The Emperor Waltz*. I guess it played pretty well but the absence of belly laughs disturbed me and the fact that it is in no way outstanding (save for cast and expense). I think the audience liked it pretty well, not passionately.

Afterwards Paramount gave a party for about 400 at the Beverly Hills Hotel, very well done with lots of violins, with Crosby, with the Eastern executives. To me it was nothing but a chore, a laudable attempt to launch the picture properly. . . .

May 31: . . . Now that *Tatlock* and *A.F.A.* [*A Foreign Affair*] are out of the way I find myself searching for another picture desperately and I find that I define a workable picture design in this way: a project plus a situation. Where, oh where can I find a fresh project which enters an exciting situation? Subconscious powers, come to my aid!

[On June 7, Elizabeth Brackett dies.]

June 7: . . . I held my dear girl's hand and, very quietly, more quietly than drifting to sleep, the breathing stopped and I was left with a sharp sense of aloneness, of realization of how I'd depended on that wise, ill woman, how she'd meant home and refuge from the foolishness of this foolish town. . . .

[There are services in Los Angeles, and then, on June 9, Brackett, his family, and Elizabeth take the train to Saratoga Springs for the burial. They arrive on June 12 and are met by Monty Woolley. Brackett goes to New York by train on June 21, meeting Billy Wilder the following day.]

June 23: . . . at 4:30 went with Billy to see Barney Balaban, who did nothing but talk of the parlous state of the motion picture industry, give us statistics on the dropping boxoffice and generally depress us. He succeeded in depressing Billy pretty severely and Leland Hayward, when he left, took us to dinner, did further keening for the dead picture industry. . . .

June 27: . . . We went to the Paramount and saw the premiere of *A Foreign Affair* which was pretty brilliant, with a fine audience reaction, and brilliant

comments from Irving Berlin, Leonard Lyons, Radie Harris, . . . etc., etc. Marlene there had become the grandmother of an 8-lb today. . . .

[Brackett leaves New York on June 29, visiting first with Dodie Smith and her husband in New Jersey, and then leaving for Kentucky to visit with Elizabeth's friends and relatives. On July 4, he leaves by train for Chicago, connecting with the Super Chief for Los Angeles the next day. He arrives back in Los Angeles on July 7.]

July 7: . . . Arrived at 9:45. James [Larmore] at the station to meet me. We drove out to a house I dreaded to enter because E's voice wouldn't say "Darling, Darling" as I crossed the threshold. . . .

. . . got to the studio and a conference with Billy. . . . The studio is in a state of blissful adoration because of the reviews of *A Foreign Affair*. I lunched with Dick Breen, pleasantest of witty men, napped, had a conference with Haydn, Doran and West about retakes on *Tatlock*. Then Haydn and I went to the *Tatlock* house and doped out an additional scene we're going to take. . . .

July 8: Ran *Tatlock* with Richard H., Billy, Charlie Lang this morning. Billy still worried that points aren't clear, which four hundred [preview] cards have proved are perfectly clear, but otherwise wonderfully helpful. . . .

July 9: Went over the retake scene for *Tatlock* with Dick Breen and made some small changes. Billy came in and we discussed what he confidently thinks is the Palestine Story and which has still the fault of being no story whatever. He has the excellent idea that James Mason play a Jew who sells guns to the Arabs, sees the light (what light?) and is shot by his own guns. Vague as that. . . .

July 10: . . . finished *He Died of Murder*[10] so that my mind would be entirely free for *The Loved One*[11] which Billy wanted me to read because it would

10. First reference to this presumably unproduced work.
11. Evelyn Waugh's 1948 novel was eventually filmed in 1965.

make such a sensational announcement of purchase if we bought it. That it would! I read it, and while it is of course written with Waugh's astringent brilliance, it seems to me that it hammers home the same old jokes pretty hard, has no story, and might make some episodes for a Red Skelton picture. It couldn't be a whole picture.

July 12: ... spent the morning at the studio in conference regarding *Tatlock* retakes. Haydn is really completely satisfied with the last shot so probably an $11,000 chance to go out and shoot the scene well would be wasted on him, but it remains a disgrace to the picture....

Billy and Walter Reisch and I discussed *The Loved One* for which Walter has an obsessive passion. Its warmth rather cooled Billy and my interest in the strange, cruel book....

At 8:45 we had an enormous showing of *A Foreign Affair*—all of Billy's acquaintances and most of mine, in a boiling Projection Room 5. Despite the disadvantage, they seemed to like the picture enormously....

July 15: Retakes on *Tatlock*, Lund looking like death warmed over, Barry [Fitzgerald] not remembering a line.... David Low, the British cartoonist,[12] did cartoons of Billy and me from 12 to 1, saying that Billy had a Hollywood face but I didn't ... [ellipses in original] Billy and I lunched with Henry Ginsberg in the commissary, discussing studio problems in general. I told him Mindret Lord's[13] idea of doing Betty Hutton as Elsie Dinsmore.[14] He seemed amused and D. A. Doran, who joined us, did also....

July 19: ... Billy was at the studio early and we got into the Palestine story deeper than we have before. Suddenly it was a good story of Fritz Mandl, world adventurer, with a forgotten wife who turns up, a little tortured wisp of a prematurely aged woman in a D.P. camp....

12. David Low (1891–1963), famous for his creation of the character, Colonel Blimp.
13. Mindret Lord (1903–1955), a male screenwriter with few credits.
14. A character in a series of children's books by Martha Finlay, written between 1867 and 1905.

I had napped and Billy and I were resuming our discussions when summoned to Henry G's office to be told that James Mason (the actor we had in mind for Mandl) was refusing to [come] to Paramount because of his lawsuit with David Rose. Our spirits dropped low. We tried to figure out some way for us to meet and talk with Mason. . . .

July 21: . . . Billy and I spent most of the day in the desultory conference which drives me crazy. . . . I had here to dinner Dorothy and Howard Lindsay and Frances and Albert Hackett—as pleasant a set of four friends as the world boasts. The Hacketts were full of grim news about Judy Garland's appalling health—sleeping pills, Benzedrine, and a doctor to [pump] her stomach once a week. After dinner we went to the studio, joined there by Billy, Carol Matthews and Fred Brozio (now running Lucey's) to see *Sorry, Wrong Number* which [Anatole] Litvak (damn him) has made into a pretty good but over-elaborately plotted picture. Stanwyck does a good job; Burt Lancaster a fair one, Ann Richards is appalling, but it's a highly successful shocker. . . .

Fred Brozio is an avocado-textured Italian who used to be a headwaiter, a singularly dull human being who was the first love of that small horror Gail Russell. Billy has a loyalty about waiters and a rude and taciturn one, because his father used to be one. I think this is the explanation of a preposterous friendship with Brozio, although the ranks of Billy's yes men are very crowded and naturally Brozio is one of those.

July 23: . . . The day was not very profitable as to new work . . . and seeing *Double Indemnity* [screened by Wilder the previous night] had the salutary effect of making Billy long to deal with material he knows. Suddenly he realizes how we'll be faking if we write about Palestine. . . .

. . . I had a conference with Margaret Herrick and one with [attorney] Lloyd Wright about Memorial Services for David Wark Griffith who died this morning and whose death must be recognized and his career memorialized by the Academy. It's a difficult problem as he was one of the first and most loathsome victims of Hollywooditis.

. . . We dined at Lucey's and drove to Pasadena to an excellent preview [of *Miss Tatlock's Millions*], though our new scene in the hall played rather badly.

The retake of this we'd been dubious about, on the other hand, was a great success. . . .

July 25: Most of the day devoted to the Griffith eulogy. In the morning I took it over to Billy's and got his opinion on it (and to plug *The Robe* as a project). He claims it's an absolute impossibility. . . .

July 27: Spent most of the morning getting ready for the Griffith eulogy. . . . got to the Masonic Temple early and spent my time waiting backstage with Donald Crisp who told me stories of Griffith at his peak. One of a party Lillian Gish gave as a youngster, Lillian wearing a dress borrowed from the property department. Griffith arrived and thought the guests were being noisy and started to bawl them out. Lillian said "Now, now, now, Master—remember this is a party." And because she had been so impertinent Griffith (in his Inverness cape) left at once and didn't let her work for six weeks.

The funeral services went off without incident and without any nervousness on my part. I had some words with Hedda and with Harriet Parsons (pleasant ones), got back to the studio and Billy was having a visit from [daughter] Victoria and a little friend of hers, the friend's mother and sister. He was also having a picture made by an arty man who calls himself Weegee run in a projection room. Having nothing else to do we took all the guests and some of the travelogue proved to be borderline pornographic. . . .

July 28: . . . tried to talk the Palestine story with Billy who is a little discouraged by undramatic developments in Palestine and preferred taking photographs with his stereoscopic camera. . . .

July 29: Billy and I scrapped the Palestine project this morning and embarked on the Hollywood one.[15] . . .

Nan and Roland Culver, Audrey Young and Billy came to dinner. Billy is the worst guest in the world and I wouldn't impose him on E. during her lifetime.

15. This oblique reference is the first mention of *Sunset Blvd.*

He criticized the cocktails, the bread which had been put on his plate (at his demand) because it was white and not pumpernickel. After dinner we went to see *So Evil, My Love* at the studio and having slept through it, Billy informed the projectionist (a Wallis employee) that it was no good and when I protested, announced boldly (he has so much to lose) that he was going to tell Hal Wallis so, that was the only way for pictures to get better, he wasn't afraid to do so. In fact, the wisdom of not seeing Billy after office hours was given a big-scale workout.

August 3: . . . Billy and I spent the morning in discussion of the Hollywood story. It's all centered around a swimming pool owned by an old silent days' star and nothing about it is set as yet. . . .

I neglected to mention that the *Times* on the upper left-hand corner of its editorial page printed a letter about my D. W. Griffith speech, indicating that I personally should have hired D. W. Griffith when he was alive instead of eulogizing him when dead, and hinting that I might suffer his same fate, which seems not unlikely, though it would all be much less gaudy. . . .

August 5: Billy and I agreed on one character in our Hollywood picture and chose a tentative title, *A Can of Beans*. The character is the harassed head of the studio, half heavy, half hero, who dies of heart exhaustion driving back from a preview in Pomona. We've also pretty well set on the raddled old picture star who is keeping a young man, probably a writer. . . .

August 7: . . . About ten of us drove out to Glendale and dined at the Saddle and Sirloin and held what I think will be the last preview of *T.T.M.*[16]— a very successful one, though the audience as not as intelligent as the one in Pasadena. We had a couple of bad cards but over a hundred excellent ones. The new cut of the Hilo Hattie scene is abrupt but it works pretty well. . . .

August 11: . . . Billy arrived at the office with a new slant on our Hollywood picture. Mae West as the faded glamor item; Millard Mitchell as her

16. There was actually a further one in Riverside on August 13.

manager; Wally Beery as a Texas oil man who finances her. Funny but infinitely less true than the former set-up....

August 12: ... At the office we all agreed that the Mae West story, while offering riotous possibilities, could not possibly result in a picture of distinction and began thinking more about the Gloria Swanson set-up.[17] ...

August 17: ... Dined at Joan Crawford's with Xan, James and Ruthie Waterbury. A grim evening—all four adopted children as hors d'oeuvres and *Arch of Triumph* after dinner in the projection room. James and Ruthie played Gin. Xan, Joan and I watched the picture, marveled at its dullness.

August 18: I was in the office enjoying a more profitable discussion on the Hollywood or Swimming Pool picture than we'd had before, when a telephone call came from Henry. New York wanted to change the title of *TTM* to *Miss Tatlock's Millions*. It was important because the sales offices were so enthusiastic, etc., etc. I said I didn't like the change, minor as it was, but I'd think it over. On thinking it over I concluded it would be better to go back to the frankly vulgar *Oh, Brother* than make the change.... Henry then said he's called New York. They wanted it called *Miss Tatlock's Millions*, no interest in *Oh, Brother*....

August 27: ... Billy, Mac and I sat in session all day, Billy coming across with an excellent reason for the meeting of Clift[18] and Swanson: his car, on which payments are overdue, which he wants to hide in her garage, where it won't be picked up by the refinancing company....

September 1: A day thunderous with Billy's emotions about *Tatlock* [after a projection room screening the previous night]. "It's just a bad picture. It's the worst picture you've ever had your name on. Ever. That showing was a flop.

17. The first reference to Gloria Swanson.
18. First reference to Montgomery Clift.

I heard what those people really thought about it. They'd go to you and say how good it was then tell me how they hated it."

Remembering how Billy had yelled when I ventured to suggest that Olivia's performance was Academy Award material. "You're crazy! I'll bet you anything you like she'll never be even nominated." Remembering my own black exultation when I saw the rough cut of *Double Indemnity* and thought the sub-plot awful, I was not too disturbed. But it made for a disagreeable weather in the office. . . .

[On September 3, Brackett leaves by plane for New York, arriving the early afternoon of the next day. The American Airlines flight had been scheduled to arrive at 9:00 a.m.]

September 4: . . . I had wired Gloria Swanson that I couldn't make breakfast with her, how about luncheon? I telephoned from La Guardia. She was good temper itself and finally we had luncheon at La Cremailliere. She is fabulously unchanged—the same piquant, dramatic face. She says she's been offered a part in Mike Curtiz's *Serenade*[19] and it's a part so like the one in our picture it would be impossible that she play both (my opinion). However, she was most interested in the chance at a good dramatic role. Her television commitments wouldn't interfere if she could make some 16mm TV shorts at Paramount. She ended by telling me that she has one more year of being in her forties, that she is almost certain she is as young, if not a little younger, than Irene Dunne. I'm inclined to believe that. . . . The great impression she creates is of enormous vitality.

[On that same day, Brackett takes a plane to Washington, D.C., to visit his youngest daughter and her family. He leaves for Los Angeles on September 6, arriving the following day.]

September 9: . . . Billy came across with the wildest, most arresting frame for our picture. Our hero is brought dead into the morgue and tells the other dead occupants of the morgue the events leading up to his death. . . .

19. Unidentified production, perhaps based on the 1937 James M. Cain novel.

... I ate dinner alone and went to an Academy Board meeting where we, the Board, sold the Academy down the river to Bulova Watches for the good round sum of $140,000.[20]

September 10: Billy in one of his preposterous moods, a mood of resentment and suffering, brooding angrily most of the time, with arms held agonized over his head some of the time, and all of the time a list of the faults of America. Today the flag was too elaborate; the national anthem unsingable (I agree); the only pleasure the country offers—to walk into Romanoff's and have everyone say "Look at that crazy man, he's beginning his picture with corpses talking at the morgue." ...

September 15: ... Billy, Mac and I worked all morning—another character creeping into the script, a former husband of Swanson's. ...

September 20: ... at about 3, Herman Citron came in with news from the sessions in New York, where Balaban et al seem to have agreed to most of Lew Wasserman's demands and particularly the one giving Billy freedom to make certain pictures away from Paramount—very important to him. Billy has insisted, as to be all tied up gave him claustrophobia. It developed, however, that the proceeds of getting away were to go to the firm, not to Billy himself, and thereupon he began to kick like a steer—which was slightly inconsistent in a man who, as he constantly reiterates, cares nothing about money. Herman argued with him but to no effect. ...

September 22: Montgomery Clift came to the office with Herman Citron at half-past nine and Billy did a very good job of telling him a faked version of story I and story II and he seemed enthusiastic. When he'd gone we tried to iron out the story line, but didn't succeed at all. ...

September 24: The log jam of our story gave some signs of breaking. Billy, though saying he detests a Camille scene as corny, is definitely set on a

20. For the right to name a watch after the Academy Awards.

Camille scene for our hero and the pattern now will be: fly caught in spider web, escapes because he falls in love with another fly. To promote the second fly's happiness goes back into the spider web briefly and is killed by the spider ... [ellipses in original] How grisly it sounds, stated like that, but I think the pattern is sound. ...

October 7: Yesterday, as far as our work on our project was concerned, was a good day. ... Billy said he despised the bourgeois custom of marriage without complete sex knowledge in advance. "How can you know you're in love with any woman until you've slept with her—until you've waked up in the morning and found her beside you?"

I said that sex was not the predominating factor in any marriage, certainly not after the marriage has lasted five years and that to base marriage on it was asinine. His talk seemed to me jejeune, and as I come to think of it, Billy hasn't the faintest idea what it is to love anybody, to project his imagination really beyond that body where he lives a vigorous and absorbing life, far enough to live the life of the beloved person. ... Anyway it was a fruitless morning. ...

October 11: Went to the studio full of my belief that we are talking our enthusiasm away on our current project. Billy would hear none of it and had a new thesis—that escape from Gloria's house should be impossible to Clift, not by physical obstruction but by its moral equivalent. The more I consider this the more nonsensical I think it is. ...

October 14: ... [At the Ambassador Hotel, after the premiere of *Johnny Belinda*] Jane Wyman, going out, spoke of the three men who had meant most to her career—me, Clarence Brown and Jerry Wald. We were all at her table and pictures were taken of the three of us. Jane, in this, was a singular exception to other girls, who remember their present producer and no other. She looked extraordinarily pretty, in a dress by her beloved Milo Anderson, and I was very happy for her. ...

October 15: ... Back at the studio we talked script. Montgomery Clift came in, troubled by a suspicion that his might be a passive role. Billy seemed to

pacify him but Mac and I don't think he really did. God help people who have to deal with young Mr. C. in a couple of years, maybe a shorter time than that. . . .

October 19: Did a little work on the story this morning but a call from Herman Citron making an appointment with him and Lew Wasserman to see us at 2:15 rather distracted both Billy's mind and mine . . . [ellipses in original] I lunched Joe Sistrom at Lucey's . . . then went back to the great, the all-important conference which was to tell us what had been developed in the conferences between Lew and the top brass in New York. Like all these conferences, it was a complete flop and the final blow to the Brackett-Wilder producing set-up. Paramount had agreed to everything, but a little too readily—then had gone over the money-making results of our pictures, which are not too hot. With pictures costing as much as they do, Lew questions the advisability of any such set-up.

Billy chimed in agreement. It was my instant suspicion that Billy had told something to Leland on Sunday which made Leland telephone Lew "Unsell Charlie on the idea, sell him the following—to wit: a fine contract for active service at $2,000 a week, plus five years inactive at $1,000"—or was it ten years inactive? Anyway, the whole conversation turned on the desirability of such an arrangement the ability to retire, to travel, to invite the soul . . . [ellipses in original] I had a feeling of being euchred by these oriental intelligences, not inimical ones, but ones determined to get me out of the way and prepare for really interesting dealings with Billy . . . [ellipses in original] On the other hand I very much liked the sound of such an arrangement and thought it superbly suited to my particular temperament. Since the meeting I have found myself warmly embracing the possibility, and yet sure some deviousness is involved. When Herman and Lew had left I questioned Billy directly about his conversation with Leland. He swore to me that was wrong. . . .

October 22: Stopped at MCA and discussed terms on what Lew thinks a possible contract with Paramount. His ideas in the past have been sadly inflated. Nevertheless it amused me to be discussing a deal which would call for a million dollars for my services. . . .

October 25: . . . Herman Citron telephoned in regard to the contract negotiations and it's as well that I never thought they'd be quite as rosy as he and

Lew painted them, for his word was that Barney Balaban was in a very gloomy mood. There would evidently be no agreement. I should think I'd be more depressed by the fact than I am. . . .

October 27: A dull, lonely day at the studio, its only happiness the negative one of not having to see and be in the room with and feel myself absorbed in the life of Wilder. . . .

October 29: Roland Culver called on me this morning and told me how Carole Landis, the night of her suicide, came to his and Nan's house. He and Nan had known her with Rex Harrison. Rex had been with them while Carole read *Ann of the Thousand Days*, then Rex had gone to Carole's, leaving her about 2:00. Evidently about three she'd lugged down *The Road to Rome* and Nan's two suitcases filled with all the presents Rex had given her, all the pictures, all the books. She left them blocking the Culver front gate, with a note to Roland telling of her suicide intention. Under ordinary circumstances they'd have been found early the next morning and her attempt stopped. Such, he thinks was Carole's intention. The next day, however, was a holiday. Roland left the house about 10 the next day, backing his car from the garage and never seeing the suitcases. Carole was found dead at about 1:00 and Roland joined Rex at her place, knowing nothing about the note for him and therefore testifying in all innocence regarding his lack of knowledge. It wasn't until about 10 that evening that the wife of the golf pro calling on the Culvers said, "There are two suitcases at your front gate," and Roland at last found the note and destroyed it, with no feeling of bad conscience as the [indecipherable word] was all ended by then.

November 4: . . . Came home to find a case of champagne from MCA which makes me suspicious of our contract . . . [ellipses in original] I dined with Tony Duquette at his studio halfway downtown. It was a party for Mary Pickford and her poor Buddy Rogers, Lillian Gish. . . . Save for Cobina [Wright],[21]

21. Cobina Wright (1887–1990), opera singer and actress who later gained fame as a socialite and gossip columnist.

who gives me the creeps, it was an agreeable party, though Mary was very tight and fixing me with a basilisk eye kept informing me could kill someone, would kill someone. My heart goes out to that poor boy who's married to her. . . .

November 5: . . . In the afternoon Herman Citron came in with the press release about our new contracts and I learned for the first time that Billy was signing for two pictures, as producer-writer-director and that the two pictures will not be made with me. Just as well, but it would have been agreeable had I been informed in advance. I gather that his near future will be dedicated to showing how much better his pictures will be than mine, and they may well be—but Paramount will be the loser, not I, and I'll be pretty busy making the best pictures I can. . . .

November 7: . . . As evening fell I'd found myself getting depressed at being alone in the cinema world for the first time in twelve years. . . . When I got home I put on my overcoat (I think I was chilly more from panic than the weather) and walked almost to the far gate, arguing with myself, giving myself the assurance that I know a damned sight more about what constitutes an attractive and entertaining or touching picture than anybody in town, that if I don't make good ones it's because I allow myself to be panicked by Henry's fears. I invoked the spirit of Edgar Truman Brackett, as fighting a one as I ever knew, and came home comforted.

November 9: . . . It develops that Billy is planning to keep on our offices. . . . Oddly, my worry is about the Sunset Boulevard Picture, which I think lacks at the moment everything a picture concerning Hollywood shouldn't be: ugly, perverted, banal, in the producer-with-an-ulcer way.

November 12: . . . Billy, Mac, Buddy Coleman, Syd Street and I went out looking for houses for *Sunset Boulevard*. The one we'd almost decided upon by photographs looked a little meager. "It's the house of a Post Office official" Billy said, and next week I go to Santa Barbara to find one of the old houses which I rejected when starting *T.T.M.* . . .

November 15: I was wakened at 8:00 and hurried to breakfast because Syd Street was stopping for me at 9:00 to take me to Santa Barbara to look at some of the ruinous, sad, great houses.... [On return] I stopped at Billy's and told him about the houses, finding him very chilly and remote....

November 17: ... Henry Ginsberg and I lunched together, discussing the Wilder-Brackett situation. Henry I think was more responsible for the split-up arrangement than I'd imagined. I think I sold him the *I Capture the Castle* project and even titivated him about *The Duchess of Suds*.[22] It was, as are most meals with Henry, a depressing luncheon. Also tried to sell [James] Larmore as an actor with some success....

November 21: ... Billy and I worked at his house on the meeting between Swanson and Clift and it went very well—oddly, eerily—but well. We went to the studio around 12:00.... Napped at the office and went back to Billy's to an afternoon of pretty solid work. At 5:30 to Rex Cole's. It seems he and Citron have discussed my contract with Paramount. Para says quite simply they are paying me a million dollars for six and a half year's work—they don't care how the payments are made.... We discussed it about an hour. At the end of the session Cole raised his own salary to a hundred dollars a week....

December 2: Worked at Billy's all morning. We went to the studio around noon for our sessions with Rex Cole ... went back to Billy's and worked until almost 7:00 when Audrey, Walter and Liesl Reisch and Tola [Anatole] Litvak arrived. The success of *Snake Pit* has turned the detestable Litvak into something completely intolerable and he pronounced edicts from Mount Sinai, saying he had liked such and such a picture, had disliked such and such a picture, that such a picture had truth, etc. He informed me he'd seen one of mine (confusion as to whether mine and Billy's, but he undoubtedly meant *Tatlock*) and hadn't liked it. But when I said "Which one?" he hadn't the nerve to name it and said *The Major and the Minor*—

22. This is not a planned remake of the 1920 Mary Pickford Paramount feature, *Suds*, which had the working title of *The Duchess of Suds*, but rather the latest title for a remake of *Madame Sans-Gene*.

and I said, "Well, I saw *The Long Night* and hated it." The atmosphere was disagreeable but the dinner excellent. We went to 20th and saw *A Letter to Three Wives*, an entertaining and unpretentious picture which Joe Mankiewicz directed and when it was over Tola began fulminating against it and according to Walter, pale with fury I charged to its defense. All very foolish but good fun.

December 7: . . . Billy and I went to Pickfair at 3:30 to tell our story to Mary and get a reaction as to whether she'd play it. She came in in a dark blue dress with great diamond clips and diamond bracelets, which she pulled off after a time. She sat on a couch facing us, in the full light of the sun, looking remarkably young and quite wicked. We told the story and she said it was very interesting and she'd think it over and let us know tomorrow. We both knew with relief that the answer was No. . . .

December 9: A dreary session in Geo. Cohen's office, pointing to the fact that the contract discussions were all predicated on non-existent tax situations. Rex Cole, Citron, George Cohen all deplored that Billy had broken free rather than sign for the unit. When I went to Billy's house I began to discuss it with him and heard nothing but his claustrophobia—he wouldn't be able to take trips abroad when he wanted, we'd be tied up in business we didn't understand, etc. We worked until noon when he went to have a luncheon with Goldwyn and I went to Paramount to luncheon. . . .

Back to Billy's. We worked all afternoon. Finally, in talking about new deals, I said "Billy, one thing has shocked me and hurt me immeasurably—that after fifteen years of close and dear partnership, you never once said 'What will be the best for us?' Only 'What will be best for me?'" I believe it struck him as a bolt from the blue and it goes to prove how unfair to him I've been by not striking out my feelings. When Cole came in later he had really applied his mind to our problems, and to mine. "The trouble with Charlie's staying at Paramount," he said, "Is that he grew up there. He's old hat. He'll always be taken for granted. I'll tell you what I'll do. If he goes to Metro, he can offer himself with a contract with me to do two pictures there for him." I don't know how practical such an idea would be, but a great emotional rock rolled off my heart and I felt happier than I have in weeks. . . .

December 13: Worked at Billy's all morning, finishing two connective scenes. We went to the studio for our customary luncheon rite. . . . I went to see Jules Stein on the possibility of working out a deal as a man who had a contract for two Wilder-directed pictures in my pocket. Jules bore out in every way the theory that MCA works for Paramount, not its clients. He implied that such an equipment would not add to my studio-desirability and added that if I wanted to get out of the Paramount deal there would certainly be no trouble about that. Indeed he succeeded in convincing me I was pretty lucky in having shelter during a period of coming storm. . . .

December 21: Worked at Billy's all morning. . . . We then went to the studio and started the mimeographing of our script. . . . Relations between Mac and Billy are rather strained, because Mac gave us some notes on the script which Billy thought supercilious and silly, and arty as well. . . .

[Usually, Brackett ends the diary each year noting that he and Elizabeth jump into the New Year holding gold and champagne. This year, he wakens his grandson, Tig, and together the two jump into the New Year holding the customary gold but not the champagne.]

1949

January 3: Worked at the studio with Billy all day, advancing our script not one inch. We are stuck with the problem of Gillis changing his position from one of secretary tomcat to one of actual lover. . . .

January 9: Slept late but got to Billy's about 11:15 and found that he'd decided that the motif of writing a screenplay for Desmond should be set in the first scene between her and Gillis. Disapproved, and argued against it, but Mr. W. was insistent.

January 11: . . . I spent the evening reading *The African Queen*,[1] not very impressed with it as story possibility.

January 12: Not a pleasant day. I had to stop at MCA to see Herman Citron about my contract, which it seems will have all the unpleasant aspects we tried to fight against and in addition pay me $25,000 less than the million originally stipulated. . . .

Stopped at Billy's to get his proxy for the SWG meeting and he gave me one of his lethal cocktails. Mac and I dined here and went to the most extraordinarily dull Guild meeting I ever attended. Toward 12:00 the Leftists began their usual delaying tactics—a kind of dreary filibuster and I knew something

1. The 1935 novel by C. S. Forester, which became a very successful 1951 film, directed by John Huston and starring Humphrey Bogart and Katharine Hepburn.

was up. It turned out they wanted John Howard Lawson on the bargaining committee which is to meet with the producers. Motion defeated. We killed off *The Screenwriter* [organization newsletter] to save $2,500 a year. . . .

January 14: Billy and I, instead of fiddling with the last scene, discussed the next scene all morning. . . . [Herman] Citron arrived with Montgomery Clift, with whom we discussed the story, selling him the idea at last, or so we think. As he left Billy said, "He might be any pimply messenger boy on the lot" and so he might in appearance.

January 15: Went to Billy's to work but Billy felt he was coming down with the flu and must have a penicillin inhalation, and work, save for the briefest exchange of ideas, was unthinkable. It is a fantastic proof of the strength of Billy's personality that after fifteen years of such nonsense he can awaken a kind of amused solicitude in me. . . .

January 21: Discussed *The Heiress*[2] with Billy and Mac [Marshman], then worked with Billy the remainder of the morning. The English distributor insists of having the Hilo Hattie scene cut from Tatlock [*Miss Tatlock's Millions*]. . . . Billy and I worked until a call came from Willy Wyler to come and discuss his picture. "Now tell me," he said, "all the things you've been saying about the picture all day." He took our comments with wonderful good temper and grace but still seems to feel that he is right about not revealing the purpose of the young man early in the picture. . . .

Came home and changed and went to the Dwight Taylors[3] to a family dinner—Jessie Royce Landis[4] and I the only guests. It's a house where there seems to be happiness and fun. Dwight told wonderful theatrical stories like the

2. Some additional scenes were shot in January 1949 for this William Wyler–directed film, starring Montgomery Clift.
3. Dwight Taylor (1902–1986), American playwright and screenwriter, married to Natalie Visart, and son of theatrical star Laurette Taylor (1884–1946), best remembered for *Peg o' My Heart* on Broadway from 1912 to 1914 and on screen in 1922.
4. Jessie Royce Landis (1904–1972), character actress often playing mother roles.

one about Ethel Barrymore who had at some provincial theatre the dressing room next [to] her brother Jack. A tiresome late Victorian lady came to call on her, full of admiration for her uncle, John Drew,[5] what a wonderful actor he was, what a great gentleman, etc. She's seen him last in the last play where he portrayed a man of the world. What was the name of it? Ethel couldn't think, so she called through the partition, "Jack, what was the name of that last thing Uncle John was in?" "Mary Boland,"[6] Jack's voice boomed out.

He told a story he'd told me before, of his mother [Laurette Taylor] at a British dinner party, seeing a woman whose back and arms were covered with freckles. She said to the man next to her, "Do you think a woman with all those freckles should wear such a low-cut dress?" "Madame," her neighbor replied, "That is my wife." Laurette didn't let herself be thrown off her stride. "Then you can tell me," she said, "if she's like that all over."

January 30: . . . As I worked with Billy this morning he said something which shows his fantastic lack of ability to appraise himself. "I could make a million dollars in a few years," he stated. "I would only have to hire five or six radio writers, get hold of some properties cheap, turn them into practical screenplays and sell them for tremendous capital gains." That the sterile perfectionist should have such a dream amused Mac Marshman as much as it did me when I recounted it to him. . . .

February 3: The day's work was broken up by the news that Miss Swanson had arrived in town. We made some changes in the portion mimeographed so far. I suggested that she drop in at 12 o'clock. She allowed as how she'd arrived at 6, hadn't got a proper room at the hotel. I suggested tomorrow at 12. . . .

February 4: Actually did a paragraph or so with Billy before la Swanson arrived. We had a satisfactory talk with her. I took her to Romanoff's to luncheon and drove her back to the studio to see *A Foreign Affair*. Billy was

5. John Drew (1827–1862), Irish-born stage actor, whose daughter was the mother of the Barrymores.
6. Mary Boland (1882–1965), buxom leading lady and character actress.

out looking at pictures. When he got back we conferred with Miss Swanson, Buddy Coleman, Edith Head, etc., about costumes for Miss S's test. . . . She has been ill from an appendix operation which had to be done twice and was scared almost out of her wits by having her bed in the train start to close with her in it (a frightful experience for a claustrophobe). I thought she'd had enough for today and sent her home. I am greatly impressed by the extraordinary, rather violent, slightly wicked beauty of her face, of her hair.

February 6: . . . A frenzied call came from Swanson—she didn't get the line of the part, would I discuss it with her? Reluctantly I went down and listened for a couple of hours while she picked flaws in Norma Desmond's living in such curious squalor if she had a million dollars. I foresee that Billy simply won't be able to take this kind of star-interference with the script. . . .

February 7: . . . Billy and I worked on the home-movies scene until Gloria appeared from Edith Head's, whereupon Billy was really superb, quieting her fears, telling her to stop worrying about script and let us take the responsibility—kidding but bolstering her at the same time. I think she'll be all right. . . .

February 8: Forgot to set down a story la Swanson told us yesterday. It was about the days when she and Herbert Marshall were a thing that was setting Hollywood on its ear. Finally people began cutting them and one night for a joke Gloria called Marshall and said "Wear your black tie tonight. It's a dinner party." When he arrived he said, "Are there really people coming? Who?" "Surprise," she said—and led him to a dining table with ten guests. Only the guests were dummies brought from the studio and seated around the table, each with a place card with some bitter parody of an erstwhile friend's name on it. They went through dinner, strangely put out by the dummy presence, then took the elevator down to the projection room and saw a picture. When they left the projection room the elevator brought them to the dining room. The butler had set all the dummy guests against the wall. Gloria had not dreamed any such thing could happen. It was all right save for the fact that the male dummies had no legs but sat with little stumps sticking out before them . . . [ellipses in original] To submit the one-legged Marshall to the spectacle of

that row of figures was so horrible to her that she burst into tears and ran into the library, Marshall hobbling after her to take her in his arms.

February 9: . . . When I got to the studio at 5, Gloria had gone and Billy felt very pleased with her. She has no inhibitions, it's just a question of holding her back properly. . . . To RKO at 8:00 to see the running of nominated short subjects, which were highly mediocre. Margaret Herrick talked part of one ear off afterwards. In her way she's as great a master of doubletalk as Henry Ginsberg.

February 11: The Awards nominations were in the morning paper. . . . At the studio Billy paid the first acknowledgment to the fact that we as a team had worked together that I can remember. He had read the Academy Awards and while *Foreign Affair* is on the list for Best Written Picture, it is our only mention. . . . He sighed and said, "For some time I have been worried about our product." So have I. . . . At 3:00 saw the tests. I thought the first one appallingly directed, the second pretty good. The front office was very impressed. It was agreed that Swanson would do. . . .

February 15: . . . a conference with Bill Meiklejohn who said flatly that New York refused to pay a cent more than $35,000 for von Stroheim; with D. A. Doran, who said Henry was apoplectic with horror at some of the lines in the test, which he regarded as befouling the nest of Paramount. Billy and I had a talk with Doran explaining in von Stroheim we had plus values, of audience knowledge that we couldn't possibly get with any other man. . . .

February 21: Fortunately, Billy called me in the midst of leisurely dressing to remind me that we were going to Pasadena at 9:30 to inspect the house Buddy [Coleman] had found there [to stand in as the Norma Desmond mansion]. I had to race through my breakfast with Tig, to get to the studio in time, and we set out. . . . The house wasn't nearly as good as it had looked in the photographs. . . . We were just finishing our luncheon when Buddy Coleman pointed up to the ceiling, "We've found it, we've found the house!

It's the one Frenchy has been passing everyday for ten years." "Where is it?" "On Wilshire." As soon as we could, we piled into studio cars and went to the corner of Wilshire and Irving, where stands the ghost of a very great, preposterous pachyderm of a mansion in a ruined garden, with a garage in just the right relation to the house, with every detail of old box hedges, smothered in high grass, completely perfect. We came back elated and did a little work on the young New Year's Eve. . . .

February 23: A rather alarming day of trying to block out the remainder of the script and finding nothing but banal scenes and emptiness ahead. . . .

February 28: . . . Billy came in with a good suggestion for using Artie Breen, a boy already introduced into the script, for the boy with whom the girl's happiness lies. We discussed until noon, when there was a great general meeting of everybody in the studio with the big brass from the East—addresses by Balaban and Zukor. . . .

March 4: . . . We had sandwiches and bridge with Dick Breen at luncheon and Bill Meiklejohn brought Nancy Olson,[7] who's to play our lead, into the office—she's not very pretty but has a right quality.

March 6: . . . 5:30 when *Foreign Affair* was on the air with Roz Russell playing Phoebe, Marlene playing Von Schutow and John playing Captain Pringle. Billy did an introduction and played the waiter in the Lorelei. The radio script was horrible, with every situation and every joke commonized and Roz's performance, had it come early, would have got the Academy Award—for Jean Arthur. She played it like a comic valentine old maid, as Ruth Hussey did. . . .

March 7: . . . I'd had the idea it might be wise to build a fake swimming pool outside our house on Wilshire, so after luncheon we took [Hans] Dreier and

7. Nancy Olson (born 1928), subsequently nominated for an Academy Award for her performance in *Sunset Blvd.*, the most important film in her career.

Bud [Coleman] and Sid over there and planned it. I then started a nap while Billy worked on his speech for the Cinematographers' Society [American Society of Cinematographers].

I was rudely awakened from it by Billy, Herman Citron, and the news that Montgomery Clift has turned down *Sunset Blvd.*—a staggering blow which ended work for the day, save for feeble attempts to recast it, I thinking Alan Ladd would be endurable, Billy thinking John Garfield would be endurable, Mac [Marshman] thinking Burt Lancaster would be endurable—which means Garfield, if I read my stars aright.[8]

March 8: . . . Our project has been torpedoed by the news. Billy tends steadfastly towards John Garfield. I have moved my support to Burt Lancaster. Bill Meiklejohn wants me to talk to Clift. . . . Inspected some plans for the pool in our picture, finally got hold of Monty Clift on the phone, who was adamant in his feeling that he shouldn't play in *Sunset Boulevard*—but adamant in a rather gentle way, if I may say so, which gave me some hope. I flattered him outrageously. He said he liked me and longed to work with us, but not in this. . . .

March 9: . . . Talked from the studio with [agent] Leland Hayward, who said he'd made a pitch with Clift. Billy announced that if the studio made him put Lund or Ladd in the part he'd walk out of the picture. I replied that if Garfield was put in the part I'd walk out of the picture. We then started work on the Schwab's[9] scene.

March 10: The morning was spent trying to find someone to replace Clift, who has repeated to Herman Citron that he won't do the picture—a weary round of Garfield, Lancaster or Marlon Brando (if by odd chance we could get him). . . . I dined at home and went to 20th to see [producer] Sy Bartlett's

8. Alan Ladd (1913–1964), Burt Lancaster (1913–1994), John Garfield (1913–1952), all prominent Hollywood leading men of the decade, and all of the same age.
9. Famous West Hollywood drugstore, located at 8024 Sunset Boulevard, where many Hollywood stars might be found and where Lana Turner was incorrectly identified as being discovered.

picture, *Down to the Sea in Ships*. My reason for going was that we had some wild idea that Richard Widmark (who plays his first sympathetic screen role in the picture) might do for our boy. He wouldn't, as he looks a very balding thirty-five and has a kind of old abalone toughness which I find very displeasing. The picture is one that Sy consulted me about a year or so ago. I suggested some elimination and a couple of scenes (one based on a scene about the old grandfather in my play *Legacy*) and I was pleased to see that they were in the picture. Naturally no reference to the fact from Sy. I wonder if a Jew has ever been known to acknowledge that he got an idea from anyone.

March 11: Billy came into the studio, resigned to the substitution of Bill [William] Holden for Montgomery Clift. . . .

March 14: Billy collided with the von Stroheim character today, realized he wasn't an integral part of the story but must be, must at least have some important scenes. Therefore a stalled and agonized day. . . .

March 15: Worked with Billy all day, trying to find scenes for Stroheim and putting back patches Billy had unraveled. Why such indecisiveness should have descended on him I can't understand. Rosy Rosenstein brought in Dick Breen's radio actor, Jack Webb, whom I'd suggested to play Artie Breen in our picture. Billy was enchanted with him. . . .

March 16: Quite a row developed in the office this morning when Mac (who was making revisions in the first part) asked about changing the name of Artie Breen. I'd suggested calling Jack Webb something Italian. Billy insisted he be called Artie Hirsch. Suddenly he was accusing us of disapproval of Jewish-Gentile marriages. We informed him that we thought to make the one pleasant and likeable and good person in our current undertaking too obviously Jewish would have the same irritating effect on a public which has been overdosed with *Gentleman's Agreement, Crossfire, Young Lions*, etc. We're all for a touch of Jewish propaganda—that's why I didn't hesitate to take delightful Jack Webb for the role—but don't overdo it by having it bad and irritating propaganda. He will probably be called Artie Hirsch. . . . At

3:00 Montgomery Clift came into the office—pleasant, polite, even affection-
ate, but with a kind of bending-backward-but-not-breaking firmness. We
avoided any hint of high pressure. I tried to tell him more of the story and
interest him. He left unyielding. I could swear someone he loves has said to
him, "You mustn't play that dreadful part. Promise me you won't. I'll never
speak to you again if you play that part."[10] Anyway, we seemed to be wasting
our arguments on some offstage person and profound depression settled on
me as we saw Henry and made the definite decision to put Bill Holden into
the role. We solaced ourselves with bridge until 7:00.

I dined home alone and went to see Bill Holden in *The Dark Past*, a quite
interesting picture in which he wears a crew cut, still looks thirty, but gives a
wonderful performance.

March 19: Had a serious conference all morning, Billy, Mac and I, as to the
degree of Norma Desmond's insanity, it being my point that we're making
her too insane—that our boy is kept not by a rich egocentric woman but by
a madwoman. That he becomes not only kept but the keeper. Billy defended
her sanity stoutly. . . .

March 23: . . . I had to go to the last-minute-before-the-awards meeting
of the Academy. First Jean [Hersholt], Margaret Herrick and I had to count
the Foreign Picture Award ballots—which chose *Monsieur Vincent* by a very
small margin. Then came the big meeting of the Board. The spectacle of mak-
ing special awards was made a little uglier this year by Walter Wanger, who
was in slugging for an award for *Joan of Arc* (which had been turned down
by the Academy membership as not one of the best pictures). He had [publi-
cist] Perry Lieber beside him with notes and also argued passionately for the
picture himself. Finally it was decided to give Walter himself an award "for
increasing the moral stature of the industry in the world community by his
production of *Joan of Arc*."

10. While Montgomery Clift is primarily identified as gay, he did have a sexual inter-
 est in older women. At this time, he was in a relationship with the notorious torch
 singer and actress Libby Holman (1904–1971), and she may very well have warned
 him against taking a screen role that paralleled his personal life.

Then came special awards, one to the boy in *The Search*, one (and here I retched and argued, as did Willie Wyler) for Sid Grauman as a showman, one for Adolph Zukor. Then came the battle about the Thalberg Award, Walter Wanger fighting to get it for himself; Dore Schary pretty [indecipherable] that it wasn't being given to him (his publicity has convinced him that all such trifles should automatically be laid at his feet). Some men from 20th loud and stubborn for [Darryl F.] Zanuck. Willie Wyler and I thought no award should be given but finally voted for Jerry Wald. Then, after the meeting was over, came the problem of phrasing the presentation speeches. It's now 3:15.

March 24: . . . I'd asked Frank and Mariska [Partos], Allen Vincent and Gloria Swanson, Dick and Dorothy Breen to dinner before the celebration. Frank arrived as nervous as a witch, convinced he was going to win the Award, that *Snake Pit* would make a clean sweep. . . . We all had to break from the table and run to the parking lot to be transferred to other cars and whisked to the Academy Awards Theatre. We got there before the Star Spangled Banner had begun.

The show ran infinitely more smoothly and better than any previous show. Dick and I had known our chances of the writing award were small but had thought it would surely go to Alan or Frank. It went to John Huston. So did the award for Direction. *Snake Pit* was never mentioned and my pictures were never mentioned in the finals. . . . As a crowning surprise came the award for Best Picture. Ethel read the names of the nominated pictures, opened the envelope, seemed to gag, then uttered the syllables *Hamlet* and almost ran from the stage. She of course hates *Hamlet* (Olivier's version) as does no other human being, regards it as a sheer impertinence done against her brother Jack's memory. . . .

March 26: . . . at 4:00 this morning Billy shot the scene at the entrance to the morgue. What was my surprise to find him at the office when I arrived, though asleep or trying to sleep. We visited when he gave up the attempt, walked on the set, discussed various aspects of the picture, but did no work. I lunched John Van Druten at Romanoff's. . . . He hadn't known that *Sunset*

Boulevard was to be my last with Billy and he was quite unflatteringly affected by the news. . . .

March 27: . . . I had two hours very pleasant work with Billy. He tells me he's going to direct *The Last Frontier*[11] for Sydney Buchman—strangely enough a book I once wanted to buy for pictures. I told him Van Druten's line about thinking our severance like the breaking up of Gilbert and Sullivan. "Breaking up?" he said. "What does he mean 'breaking up?'" "Merely that we'll never work together again." "Want to bet?" Billy asked, with the sublime assumption that it would be he who decided whether we'd work together. I didn't take the bet, couldn't in honor. . . .

March 28: Billy and I dined at his house with Audrey [the future Mrs. Billy Wilder], who is "his girl" and he and I worked until 10:30. Audrey is pretty, young, a little deaf, and limited in education and intelligence. . . . Am I merely deceiving myself when I view his life, upon which the bores and parasites are moving so fast, with a lot of pity for him, and regret for that mind of his which can be so first-rate at best, and so ox-stupid at worst. . . . It was not an evening of inspired work but very useful.

April 2: Billy came to breakfast, liked the bacon, liked the muffins, and there is something about the odd, capriciously critical creature that makes it pleasant to have him like them. . . .

April 4: . . . Billy and I set to work on the rewrite but there was an interruption of some length when we had to go to Edith Head's and inspect some costumes for Gloria. . . . We started to work briskly—when Erich von Stroheim and his Denise [Vernac] arrived and we had to devote over an hour to hearing his criticism of and suggestions for the script. They boiled down to the fact that his part wasn't important enough and his suggestions of flashes showing him doing various menial duties, with worship of Swanson in his

11. Presumably the 1941 novel by Howard Fast.

eyes, were endless—polishing shoes being the chief one (c.f. the foot fetish-ism in his *Merry Widow*). Anyway the afternoon was gone. . . . I dined at Billy's with Audrey. . . . After dinner, until 11:15, Billy and I wrote hard . . . [ellipses in original] It seems to me we're being heavy-handed, but perhaps it won't show in this picture, as it did in *The Emperor Waltz*.

April 5: . . . Saw the set, which is miraculously good in its recapturing of old Hollywood. Worked until about 6 on the script (including calling on DeMille to confirm the fact that he'll do our scene). . . .

April 6: . . . Billy took Audrey and me to The Blue Danube, the restaurant he's helped to finance for Joe May[12] (the director who brought him to Holly-wood in the first place). It is badly located—on Robertson [Boulevard]—and was not very full tonight. The food is superb, but Viennese and a little esoteric for the average American palate. I'm afraid it isn't going to be a go . . .[ellipses in original] After dinner Billy and I worked at his house until 11, making real progress.

April 7: . . . I got to the studio and we did some more work and played bridge, then Billy came here to dinner and we worked until 10, when he was off, on some amorous adventure, after the most tender and devoted call to Au-drey. It is the pattern of his life to reduce girls, by amorous methods to a kind of subhuman form of life—to revel in their subjection—and yet to have to get away from it . . . [ellipses in original] The methods, I gather, are great sex vital-ity, with a great deal of jollity about it, terrific ham histrionics of melancholy and need, and unremitting protestations of devotion (utterly without sub-stance). The result is a kind of drooling dog worship, embarrassing to witness.

April 12: Billy, Mac [Marshman] and I discussed our story problem all morning and got word that [Cecil B.] DeMille, whom we'd hoped to have

12. Joe May (1880–1954) began making films in Germany in 1912; emigrated to U.S.A. in 1933; The Blue Danube was open far longer than the two weeks that some writers claim as Brackett records visiting there in late June.

free, would cost $10,000. He's well worth it. . . . Hedy Lamarr had agreed to appear for a flash for $1,500. She upped it to $20,000 and is out. . . .

April 14: A long conference this morning, geared by Doran's criticism. We decided that the emotional Norma-DeMille scene may throw the emphasis of the picture out and that it should be replaced by a scene of arrogance on her part—another ice-cold scene in a chilly picture. . . .

April 18: Woke at 7:45, breakfasted with Tig and got to the studio well before the first shot. Gave Billy the mezuzah with which we begin our ventures, saw the first scene shot, grieving that nice Bill Holden looks so hopelessly connubial. Had a long session with Gloria and Edie [Edith Head], looking at the costume tests—an agonizing session, as they had been lighted from above and Gloria looked not a smart woman of fifty but a horrifying lady of sixty-odd. Went to the luncheon table but Billy was just finishing so I had to go back to the costume rushes with him. Fortunately they showed costume tests of Nancy Olson first, whose youth showed up the withered photography of Gloria, to her infinite relief . . . [ellipses in original] [D.A.] Doran worried about some of the clothes, which means that Henry [Ginsberg] was worried about them—an involvement we've met before.

April 19: Gave Gloria her mezuzah but felt it would make her nervous to watch her first scene so did some writing in the office. Lunched and word-gamed at the table, napped. At 4:00 Mac [Marshman] and I saw yesterday's rushes, which were excellent, though Bill Holden looks too old in the first scene. In the scene with Stroheim he's just the right age and Stroheim's personality gives just the right note to the house. Then went to the set and heard Gloria do her scene about the movies—just as heavily and badly as she did it in the test. Billy assures me it will be so arresting in the sinister atmosphere of the house that it won't matter. He may be right but I feel she could be coached to something more human.

April 21: It was the company's first day on location on Wilshire but I had no time to go there. . . . Dinner at home and an Academy Board meeting,

the last for the current board. It was remarkable only for a long diatribe by Walter Wanger, the only Academy member who has done something this year to embarrass the Academy. First by unblushing efforts to get an Award for *Joan of Arc* and when they were unsuccessful and he only wangled an award for himself—he's advertising the picture as one which had been given an Academy Award. Tonight he had the unmitigated gall to try and becloud our memories by talking interminably on the great part the Academy could play in the industry by cleaning up the impressions made by "those damned columnists." . . . At the close of the meeting I couldn't believe that Jean [Hersholt] wouldn't be sitting at the head of the table at the next meeting. Indeed I felt as I did when the old *New York World* folded. . . .

April 25: . . . In the afternoon Margaret Herrick brought me the Academy cheques to sign and apprised me of the fact that Jean Hersholt wants to be nominated by acclaim for the Presidency of the Academy next year, though it will require a setting-aside of the Academy rules. My feeling is that this is a dandy solution—but the fact that it is being maneuvered by Walter Wanger makes me pretty mad. . . .

April 28: Another figure on the set is Sugie, the stand-in for Bill Holden, who uses him when Brian Donlevy[13] doesn't. Sugie is a veteran of World War One and would appear to be the most flaring fairy imaginable, If anyone uses an obscene word before him he says, "oh, you wildflower." He is addicted to hot chocolate and sometimes comes in with a real chocolate hangover. He will say, "Oh, I feel just like a butterfly that's come to beautiful rest on a marshmallow!" It seems that in the war he was in some burst of shellfire which castrated him, cost him an eye, so that one of his eyes is glass, and crushed in his skull so that it's been trepanned with a silver plate. The attitude of Paramount to him, the protectiveness gentleness and affection everyone shows him, is one of the endearing things about the studio.

April 29: . . . Saw the rushes which were badly lighted. Johnny Seitz not being a top-notch cameraman. As a result we have to say that every day's work

13. Brian Donlevy (1901–1972), screen actor, at ease in both leading and supporting role.

should be printed "up" or "down" ... [ellipses in original] It seems Erich von Stroheim, in a brief scene yesterday, had merely to arrange the screen for the showing of a silent picture. He sweats a good bit as he is apt to do and Billy told the makeup man to take care of his face. When the makeup man approached him Erich said, "What do you think you are going to do?" "Makeup, Mr. von Stroheim." "Are you going to make up my ass?" Erich responded, "because that's all that's being photographed." ...

May 2: There were tensions between Billy and von Stroheim on the set and I had to do my best to ease them, get the scene we did yesterday typed, telephone Theda Bara[14] to try and get her to sit at the bridge table, a job she refused with hauteur. Had to get Jetta Goudal[15] on the phone for the same purpose. She refused with hauteur, but as bad luck would have it, knew Bill [Holden] and Betty Allen and yukked about them for a good half hour. Finally Billy and I decided on good, kind Anna Q. Nilsson,[16] who arrived about 5. I had to see to what she shall wear. The rushes were brief and showed the monotony of attitude in Swanson and Holden which is beginning to worry Mac Marshman and me considerably. Mac said quite simply, "It just occurred to me this can be a picture that nobody will like." I'd thought of that before.

May 3: Had to get to the studio in time to give Anna Q.'s get-up my approval. She looked well, by the way, the ghost of a beauty. H. B. Warner and Buster Keaton were somber relics of the past. And Gloria, looking absolutely sparkling, full of the sense that she'd beaten the years far better than they, made a great fourth. . . . Spent most of the morning on the set, a deep depression upon me. . . . Went to the Academy to sign some cheques and talk with Margaret, who had nothing to say but a lot of words to say it in. Back in time for the rushes, which were good. There was a picture taken of the whole cast and crew on the staircase, DeMille amongst us. (I said to him as he entered

14. Theda Bara (1885–1965), legendary "vamp" of the silent screen, whose career ended in the early 1920s.
15. Jetta Goudal (1891–1985), Dutch-born exotic star of the 1920s; later a Los Angeles socialite.
16. Anna Q. Nilsson (1888–1974), silent screen star who worked in later years as an extra.

the set where H. B. Warner sat, "Prepare to meet your God") . . . [ellipses in original] Erich von Stroheim had been told that the picture would be taken at 5:30. He arrived at 5:15 and it was already taken and he came into the rushes (as run for the company): "Not that I give a damn, I'm not in the picture anyway." . . .

May 4: Mac [Marshman] came to dinner with me and from 9 till 10 I worked with Billy at Billy's. He tells me a colloquy with von Stroheim who has always thought Swanson too young and desirable for the role of Norma. "Look at her," he said. "I would like to fuck her now!" "I," said Billy, "would rather fuck you." "You have," von Stroheim retorted.

[On May 5, Brackett records the birth of his grandson, C. J. Moore III, and the next day Hedda Hopper runs an item in her column.]

May 7: Got to the studio at 9 and heard the run-through of the Producer scene, which is Nancy's first entrance. Wasn't particularly impressed with her, but the scene played well. . . .

May 9: . . . Saw the rushes at 4. . . . Fred Clark, who played the producer (a Paramount producer at that) had translated the lines of what was not meant to be heavy-handed . . . into a scene of such nasty cruelty that I hate it violently. Billy upset by my criticisms but even his stooges agreed that the producer was a stinker. It isn't bad for our story but it makes our attitude towards Hollywood snide and unworthy of the treatment Hollywood has given us. . . .

May 10: . . . The company was shooting the start of the chase sequence at the Bel Air Gate. I watched them until about 10:30 then went to the studio. Herman Citron and Lew Wasserman came in. We went through the proposed contract, as revised. I signed it. Lew tried to get me to sign a new 7-year contract with MCA. I refused and shall continue to do so. . . . Billy and the company came back. We conferred on various matters. The front office has passed the Sheldrake scene without a question. Strangely I think it has convinced

Billy that I am right about the scene being too disagreeable and the front of-
fice is wrong. We had in Luraschi and questioned him about the Breen office
attitude towards Bill Holden's kissing Gloria as she lies on the bed. "All right,"
Luigi said crisply, "so long as he has both feet on the floor." . . .

May 13: In the afternoon I spent a little time on the set. Gloria was about
to do her Chaplin imitation and everybody on the set wore a black derby.

May 16: . . . had a talk with D. A. Doran, who wants me to take on a great
project about Mack Sennett and Mabel Normand, which doesn't stimulate
me in the least. . . .

May 19: . . . [An Academy board meeting] Walter Wanger primed for mis-
chief; the Board not too full of friendly faces except John Green's and George
Murphy's (which was covered with a growth of gray beard for the picture he's
doing); George Stevens. The rest impersonal, friendly enough. I opened the
meeting. I recognized Wanger and he made a long, unspeakably dull speech re
Academy aims, all vague, and yet somehow hypnotic to this particular board.
He began urging Hersholt's election, which necessitated a change of by-laws
which could only be done by the vote of 2/3 present. It was voted . . . [ellipses
in original] (Herschel Green was presiding by now) to take a vote on having
another meeting to change the by-laws. We adjourned the meeting and re-
assembled. The vote as to whether the by-laws should be changed was secret.
Looking at Wanger's exuberant face, I voted no. Two no votes were necessary
to defeat the change of rules. There were four. Johnny Green nominated me.
I was then elected by acclaim, except for Dore Schary's proxy who consci-
entiously registered Dore's third-choice vote, Hersholt—Brackett—Murphy.
Murph refused nomination flatly. It was all a little shabby and tricky but I was
in and Wanger's angry face made it eminently worthwhile. . . .

May 20: Slept rather late, found a good many telegrams of congratulation
at the studio but none from Jean Hersholt. There was a lot of pleasant jok-
ing about my new title around the lot. Billy was shooting the kid New Year's
party. . . . In the afternoon Gloria and I looked at *Queen Kelly*. . . . Much of it

has the fantastic physical beauty silent pictures achieved and which talking pictures have never quite reached. . . . The only comment Gloria made on the extravagance of the picture was to say quietly, "I paid for that food." . . .

May 22: . . . at the studio I greeted DeMille to the production. It was his first day on the set. . . .

May 23: . . . Billy, Doane, Mac, Artie, Frank, Buddy Coleman, Hugh Brown and Oswald and I dined at Lucey's and then looked at the rough cut. It's an uneven picture, interminably slow in parts, excellent when Swanson is involved, dull otherwise and lacking in emotion. If we can speed up the beginning it may be viable. . . .

May 24: All day they shot a scene of von Stroheim driving Gloria's car up to the gate, the reason it consumed so much time being that von Stroheim can't drive a car.

June 4: . . . At the studio I had a call from D. A. Doran. It seems Russell Holman in New York had drawn up a plan for making *Streetcar Named Desire* into a picture. He gave it to me to read. I told him I thought Paramount was making enough morbid pictures but would read it. Did so and was intensely amused to find that what Holman had emphasized was the so-called Communist angle. Holman the most conservative of reactionaries. Also it was clear that his idea of making an arresting picture is to make a shocking story mildly, an interesting document. . . .

June 6: . . . Henry lunched me at Perino's . . . asked me to do more work as an executive, not produce any more pictures this year. I said I'd try the script-overseeing he suggested for a time, but doubted if it would work out. Went back to the office and napped and wrote on the Norma-Gillis final scene. Saw the rushes, which will have to be retaken due to faulty lighting. Gloria, who saw them with me, was delighted at the chance to work some more.

June 8: Billy and I lunched with the Head of the Homicide Squad in Los Angeles and pumped him about what would happen in the case of a murder like the one in the story. At least Billy got him to say that everything he, Billy, wanted was perfectly probable. Buddy Coleman and I would have settled for a quieter murder.

June 9: ... the Bulova [watch] deal, at a lowered rate, has gone through, so some hopes of Academy solvency. ...

June 12: ... At 1:00 I had to go to Louella's and read her a scene between her and Hedda and urge her to consent to do it. It seemed possible she would. ...

June 14: A day of racing activity that got nowhere. Two memorable telephone calls: one from Garbo asking if I would work away from Paramount. The second (and how different) from Louella. There was a notice in the Rambling Reporter [gossip column in *The Hollywood Reporter*] that Billy and I were angling to get both Louella and Hedda into the picture, with snide implication of trickery. I had a call from Louella when I was out, called back. She was busy. Finally I got her, tried to reopen her interest in the project and was greeted by scurrility and real washerwoman abuse. "It was an insult to ask me to do such a thing. I've stuck my neck out for you and Billy Wilder, but never again. You're not a friend of mine and never have been. A woman of my position doesn't have to put up with that kind of thing. ..." One has to be 57 I guess to be able to get that kind of a storm of abuse and while it is in progress be amused, realize that one doesn't give a damn and maintain a few points on one's own side for future vindication.

I also had a long talk with Henry, sold him the idea that he, Billy and I should map out an exciting over-all studio policy, and that the immediate need of the studio was story constructionists—Walter Reisch suggested. ...

June 15: A day spent largely on the final speech of Norma's. On the set Billy changed to my suggestion that the words "cameras" wake Norma from

her doze instead of having Max use the cameras as a stratagem to make her talk. . . .

Dined at home and went at 9 to Billy's. Billy had the excellent idea that the last speech be a kind of happy madness, touching the sort of emotion we once had in the DeMille scene. We wrote it. . . . I took the stuff to the studio, just for the pleasure of that familiar ride, made easy by the night emptiness of the roads.

June 16: This is the day we were to do the von Stroheim–Gillis scene in the interstices of Billy's day on the set. It proved to be a day practically without interstices, the day of Gloria's descent of the staircase and final speech. . . .

. . . back to Lucey's for dinner with the crew, Billy, Doane, etc. Back to the set to see the final scene. I felt Billy should have gotten more takes. Afterwards he was too tired to work, so came home. His fatigue fails to impress me as much as the fantastic stamina of Swanson, a woman of fifty who spent the day going down a staircase without looking at the steps, having her hand in a strange Salome-esque dance fashion, who at 8:00 o'clock had to do her most highly emotional scene, and who seemed to get through with no bad effects whatever.

June 17: Went to Billy's at about 9 and we did the Max-Gillis scene, getting through it by 11:30. It was probably the last scene we'll write together, but neither of us referred to that fact. . . .

June 20: . . . I went to the Blue Danube where Billy and I gave a party for the cast, crew and staff—a highly successful one. . . .

June 22: . . . Billy tells me he's going away for a week with Audrey. Whether he will marry her or not he doesn't know. If he does it only means he won't have to drive her home late at night. He is in his child-of-destiny, tossed by-the-winds-of-change mood. He knows with complete, carefully-thought-out clarity.

Gloria gave gifts today. It's the only thing about which she's been uncomfortably old-fashioned—the giving of lavish gifts. She presented me with a small Chinese philosopher (very fine and very rare) on a crystal stand. This caused me discomfort and embarrassment and was the kind of extravagance Gloria couldn't afford. . . .

June 28: I was completely factual in my criticisms of the picture and Billy agreed with almost every one and also agreed to a close-up retake on "I am big—it's the pictures that have grown small."

[On June 28, Brackett leaves by plane for Chicago, and then by car to South Bend, where he represents the Academy at the presentation of the Laerte Medal to Irene Dunne. From there he flies to Washington, D.C. to visit his youngest daughter and family, and returns to Los Angeles on July 4.]

. . . James [Larmore] drove me to the airport. I'd been thinking what a good thing it would be for my family if the plane cracked up and my family could collect all my double indemnity insurance. James however was a little tight as he is all too frequently, and I thought maybe it might be better for Tig to have me around for a little. . . .

July 7: The one retake I've requested on *Sunset* was made today. A close-up of Gloria saying "I am big—it's the pictures that have gotten smaller." And a necessary corresponding close-up of Bill Holden. I was on the set. . . .

I lunched at the table, went to the dubbing stage and worked with Doane and Frank, getting some lines from Gloria in the scene as taken on the first day of shooting. Consulted with Chuck about starting [composer Franz] Waxman on the picture. . . .

July 8: . . . dined at Frances [Goodrich] and Albert's [Hackett]—a party for New York stage people. . . . I dined at the table with Phil [Dunne] and later played bridge with him. . . . I find Phil the most unendurable young man I know, a supercilious stinker, with a very devious record as a fellow traveler which he tries to make one forget.

July 9: A call from Marcus Aurelius Goodrich, to protest that a man named Leanout, who is doing shorts for the industry under the aegis of the Academy, had written Olivia [De Havilland] a letter which may have killed her and their unborn child—at least may have produced a miscarriage. "What kind of a business is this that will do such a thing to a woman? Everyone knows she is sick—and that every letter that reaches her is screened—but this Leanout wrote her a letter with a blackmailing threat in it, and marked it personal. It reached her and she is in such a state as I have never seen her in!"

I calmed him as best I could, finally got hold of Leanout. He is making a short on the Sound Department. *The Snake Pit* got the Academy Award for sound and he asked permission that a portion of the film in which Olivia appeared be in his short. Olivia had made a rule that no film should be shown which she had not personally inspected. She couldn't inspect, so Marcus and her agent refused permission, not telling her. Feeling that this wronged the sound men who had worked with her—and that the refusal had probably been made without her permission, Leanout wrote, putting the case up to her. The blackmail part consisted of a sentence saying if she wouldn't give her consent they'd have to use some film of Ingrid Bergman from *The Bells of St. Mary's*.[17]

July 12: Rushed to the studio to get in an hour's work with Billy before I had to rush back to the Academy to a meeting with the Bulova people to discuss their contract. It was a long, unpleasant meeting. Evidently the Bulova people have heard that we are hard-pressed and so have heightened their demands. Their plan seems to be to make a shoddy, cheap watch with the name. . . .

July 13: Got to the studio about 10 and worked with Billy on the commentary [the Holden character's voice-over] all morning. . . . In the afternoon Billy finished the commentary and our fifteen years of collaboration, with mutual relief.

17. A viewing of the short *The Soundman* in the "Let's Go to the Movies" series indicates very clearly that a clip from *Snake Pit* was to have been included but has been removed.

July 15: Up at 8:30 and to the sound stage where I spent the day with Billy, Doane, Artie and Frank, supervising the commentary for *Sunset*. Bill has a flat and uninteresting voice but I think the commentary is pretty good. . . .

July 19: . . . Had a talk with Y. Frank Freeman about pictures I made last year, which was not exhilarating. *Tatlock* is the only one that will make its costs. *Emperor Waltz* lost hideously, and even *Foreign Affair* lost a million. I was interested to hear that *TEHO* was one of the company's really big grossers.

July 26: Had to be at the studio at 9:30 to appear with Billy in an Academy short showing a producer and director at work. My hair was parted at the side and I waited for Billy, the most observant of people, to notice it. He didn't as he entered the office, and after a minute or two I noticed that he was doing a revelatory thing—not looking at me. It always means something when he avoids one's eyes, and I wondered what.

. . . After luncheon Dick Breen got me aside and told me about the Sid Skolsky[18] column which revealed the reason for Billy's evasiveness. It seems Skolsky announced that we wouldn't work together anymore, but that Billy was taking as his producer Mr. William Shore.[19] This I sensed, very clearly. I told Doane, to whom Billy had offered an associate producership, and he too failed to be very surprised, though Billy had given no hint of this incredibly silly plan. I say silly because Shore seems to me not conceivably on the scale of person Billy should be taking in.

August 10: . . . I dined with Henry [Ginsberg] at Ciro's, a party for Billy and Audrey, Bill Holden and his wife, Jack Warner and Anne, Steve Wiman and Gloria. I'm afraid our host was a little fried, but we all loved Dean Martin and Jerry Lewis, the two bawdy, satirical entertainers, all except Billy, who thought them egregiously unfunny. . . .

18. Sidney Skolsky (1905–1983), gossip columnist from 1929 onwards who claimed to write his Hollywood column at Schwab's drugstore; he makes a cameo appearance in *Sunset Blvd.*
19. William Shore has no screen credits.

August 18: . . . Walter [Reisch] and I began work together. He came with a fully laid-out draft of the beginning of the story, which seemed to me like an old Fox picture. He grew very discouraged. . . . After luncheon we began to see eye to eye on certain points approached the problem from the mother's angle and seemed to agree on a beginning. Walter is a much harder worker than Billy but not nearly so difficult to satisfy. . . .

August 24: . . . I haven't mentioned the curious harassed appearance of Billy as he comes in and finds us at work. I would say that the spectacle may have something to do with the troubled look in his eyes, but I'm probably flattering myself. It's some difficult adjustment about Audrey. At least so Henry Ginsberg thinks. . . .

August 30: Worked all day with that wonderful hard-driving Walter Reisch. There's none of the wild gaiety of accomplishment with him that one gets with Billy, but a steady drive that I think I can control wisely.

September 1: Only talked with Walter [Reisch] for an hour this morning. Preston Sturges came in at 11:00 to say he'd like to do a picture with me and tell me the sketchy, brilliant ideas for several pictures. I told him I'd be very much interested in doing a non-comedy with him. Something in the vein of *The Power and the Glory*, or his *Remember the Night*. Whether he could shuck off the over-funny comedy style which has been his undoing, I don't know. Whether the studio would be interested in my doing a picture with him, I don't know. He has always been completely non-controllable. . . .

September 2: Went to the set and heard the score for "A Strange Garden" as Waxman calls Gillis' glimpse of the swimming pool and the burial. Then Walter and I worked pretty intensively for an hour or so, then back to catch some more of the music. . . .

Came home and changed and went to a party at the Maibaums, given for Alan Ladd and Sue. . . . Alan got me in a corner and said "Why don't you like me? I don't mean professionally." And instead of saying "Because you

demand complete dominance of the picture, which destroys any excitement or suspense," said I liked him very much and that I wanted to do *American Tragedy* with him, which was true, but not helpful to the boy or our future professional relationship. . . .

September 6: . . . Back at the studio I went to the Dubbing Room and heard reel three and was very disappointed with Franz's music, which instead of emphasizing points like the dead chimp stops entirely when it gets to a place of the sort. Billy assures me that is the latest wrinkle for scoring, but I—who have always eyed background music askance—eye it more askance. . . .

September 9: . . . After luncheon . . . drove to the Bel Air Hotel and had some iced tea with Jed Harris and a long talk about various things. I think he'd like to do a picture with me and he'd probably be extremely good, but too difficult. . . .

September 13: . . . Amused at young Elizabeth Montgomery and her brother. I spoke of my passion for *I Capture the Castle*, and it seems it's the book she loves best. She longs to play Cassandra (as what right-thinking girl with red blood wouldn't) and thinks Bob would be fine as the father. . . .

[On September 20, Brackett flies to Chicago, where he meets his colleagues for previews of *Sunset Blvd.*]

September 21: . . . drove out to the Variety Theatre in Evanston for our first preview . . . a good audience with a sprinkling of college kids. We got some bad laughter, nevertheless the picture played extremely well. One could sense the impact of its shock on the audience. Odd laughs—the taking of the socks from the dead boy's feet and the tying of a tag to his toe and the wheeling of his body into the morgue. No laughs whatever on the dialogue in the morgue. A bad laugh on the dissolve from Gloria's embrace of Bill to Bill lolling in the pool. A bad laugh on Bill's line "How old are you?" (to Nancy). "Twenty-two.

That's it. You smell of being twenty-two." One bad giggle as Gloria starts into her final scene. Cards excellent for the most and plentiful. . . .

September 22: . . . Our preview [in Joliet] was preceded, not by a card, but by an announcement by the manager of the house. The show started with the same bad laugh on the tag attached to Holden's toe, but then tightened to an infinitely better audience reaction that that of last night. . . .

. . . After the excellent audience reaction, what was our surprise to find the cards infinitely tougher than last night, with more "poors" and "stinks" than I ever got on a picture. . . .

[On September 23, Brackett flies to New York, and then on to Washington, D.C., the following day to visit with his youngest daughter and her family. On September 25, he takes the train to New York for a preview in Peekskill, "singularly like the other previews, with cards like the other cards." On September 27, he flies from La Guardia to Los Angeles, arriving early the following morning.]

October 11: Worked with Billy a few hours this morning, getting something singularly undistinguished in the way of opening commentary. . . .

A call from DeMille asked me if he might come over to see me about *Sunset*. I went instantly to his office and heard his opinion of it (bad) and his very kind and helpful ideas for saving it. I was greatly touched by his sincerity and thought for us and impressed by his feeling that we should preserve the morgue scene. Also I felt that his urgent feeling that Norma should be humanized and made normal at the beginning was right.

When I told Billy what he had said Billy said, "Well, I'll tell him what I thought of *The Unconquered*,"[20] whereupon I had a fit.

October 12: Had an almost sleepless night, possibly because of worry due to the DeMille talk. In any case I found myself jotting down a lot of notes. Spent

20. Released February 1948 and directed by DeMille.

the morning with Billy, trying to get some warmth of reference into the script (which he constantly shies away from).

October 17: . . . Billy and I looked at some footage of *Sunset* which we're going to retake, then he left. I was so unwise as to say I'd see poor Preston Sturges, who came in desperate, trying to sell any one of his picture ideas— eager to get work to get money before the Government takes all his real estate holdings from him. I wish the hell some idea of his would excite me, but they all sounded like rather tired celluloid and after an hour of anguish he saw it was no use and withdrew with great style. . . .

October 18: A morning of some activity with Billy but we disagree on the necessity for a strong DeMille speech about Norma. Billy thinks a weak one sufficient for what is to come; I don't. . . .

October 19: . . . A long wrangle with Billy to try and get some warmth into the DeMille scene. Finally a compromise which Mr. DeMille okayed with an additional compromise, the whole thing not much good. . . .

October 20: Billy shot the police cars racing down Sunset at dawn, so wasn't around this morning. I got in some little work on the commentary, lunched at the table, napped, and was back at work when Billy appeared, rather weary, though he'd gone back to sleep. We discussed commentary, saw the rushes of the stuff he'd shot—all too dark (Johnny Seitz's weakness). . . .

October 24: . . . Billy made his first shot with Gloria—the relaxed retake of the scene at the time she hires Bill. I spent most of the day on the set and was impressed more and more by what a bad actress Gloria is—how lacking in control of her instruments of expression.

. . . We had written a speech for Gloria to DeMille which should have been brave and touching. It got more and more lugubrious. I could stand hearing it murdered no more and went to the office. . . .

October 25: At the office, working on the commentary, until Billy came in about 11:30, whereupon we fell into conversation about aesthetics. . . .

Lunched and word-gamed. When I came back to the office Helen was perturbed for fear Billy was planning to take over the office and eject us. But it turned out he had no such idea in mind, says he can work with Horace McCoy on the second floor. We saw, with DeMille, the rushes of yesterday's work and I believe they will make a difference in the picture. . . .

October 27: Arrived at the office at 10:15 to find Billy there and we had a day of wrangling over various cuts I want to make and over every line of commentary, though he is in general following my line. His latter passion for rephrasing so that the words will be his was repugnant. . . .

October 29: . . . Billy was there [at the studio], surprisingly making arrangements for the housing of his unit and acting very martyred. I felt like the heartless mortgage-holder in a Victorian melodrama. Helen was worried and affronted by his attitude towards her. . . .

October 31: Worked with Billy on the commentary all day, and very amicably. Horace McCoy, his next collaborator, appeared, looking unspeakably wretched. He'd had some kind of a heart attack Saturday. Billy rushed him off to get a cardiogram. . . .

November 1: Worked on the commentary with Billy all morning; with the last speech he disappeared, not wasting a moment of his time on going over and perfecting what is the most important factor in a picture highly important to his career. . . .

November 7: . . . Van Druten was in the office with 20 or 30 pages of rewrite he'd done over Sunday, but today we ran the revised *Sunset Boulevard* for the Music Dept. and he sat in on it. His enthusiasm was wonderful. I myself was disappointed that the picture wasn't more improved. Van Druten really raved.

. . . I had a long call from Goldwyn about making it possible for independents to show their pictures to Academy members via the Academy Theatre, and stopped at the Academy for a long talk with Margaret Herrick, largely about the Short Subject branch which threatens to resign en masse in protest at the cutting-down of their awards. . . .

November 11: Got to the studio about 10. Walter, John and I had begun discussions when Billy asked me to look at a new arrangement of the ending. I did so and disapproved. Had to argue the point with Billy, He had tacked the explanatory speech about Norma's madness at the very last. It was put in to avoid a bad laugh as she started down the stairs and not only couldn't perform that function at the very end, but destroyed the drama of the last shot by calling on the audience to use its brains. . . .

. . . we couldn't get started because Doran was on his way over . . . [ellipses in original] Doran came with discouraging talk about the casting of pictures that would be necessary now the exhibitors were to control product (under Divorcement).[21] It ended with his asking Reisch to see *The Lie*[22] at 4:45. John [Van Druten] had to leave and announced huffily that we had until Wednesday to talk over emendations with him. This was a slight extension of the terms of his contract. I would sympathize with the limitation perfectly, had he not put in my hands as his first draft a thin little script infinitely more amateurish than I'd dreamed he'd hand in.

I sat through *The Lie* with Walter. It's a respectable melodrama three-quarters of the way through, then burns into utterly incredible nonsense. . . .

November 14: Lunched and word-gamed at the table, then John [Van Druten] and I heard Bill Holden record his final line of commentary.

November 19: Went to Clifton Webb's birthday party. It was large: Hedda, Myrna Loy, George Cukor, the Lamar Trottis, Otto Preminger, Tyrone Power and the monstrous evil-looking girl he's married [Linda Christian], Gladys

21. The Consent Decreee, which ended the studios owning of their own theaters.
22. Released in May 1950 as *No Man of Her Own*.

Cooper (who appeared in a mask of her own face when younger and did a little dance), the Jack Warners, Humphrey [Bogart] and Betty [Lauren Bacall], etc., etc. There were a great many drinks, wonderfully good food by Romanoff. I sat with Hedda and Myrna, and Hedda told us about an article she was going to write about what paraplegics in the hospital here remembered—fiend[ish] meanness in making GIs pay for all water used, English insults. Myrna, as a staunch UNESCO girl, begged her not to foment quarrelsomeness.

November 21: . . . Billy has fired Horace McCoy and acquired a young radio writer to work on his story.

November 26: . . . we men [Brackett, D. A. Doran, Chuck West, and Mac Marshman] drove to the airport in a Paramount car and took plane for San Francisco. . . . We came to the Clift Hotel where we found Bill Holden, Brenda, Billy, Audrey and the eternal [dancer/comedian] Willie Shore. I napped, joined the others at a cocktail party in Bill Holden's suite—not drinking, as is my rule before previews . . . went to the Academy Theatre in Oakland, where we showed an enormously improved picture to an audience which responded beautifully, giving lots of spontaneous applause at the end. I sat next to Bill Holden, who wore glasses and kept his head down, and still was recognized.

Afterwards we went to Trader Vic's, read excellent preview cards, and telephoned Henry Ginsberg and Gloria of the greatly improved picture. Chuck said it was a nice birthday present for me and I thought with amusement what a surprise it would have been to Mr. and Mrs. Brackett of 605 N. Broadway, Saratoga Springs, New York, could they have been told that 57 years after the arrival of their matutinal son he would be celebrating on the other side of the continent a pleasant event in a medium of which they'd never heard.

November 27: . . . drove some 30 miles to Redwood City where we previewed to a nerve-wracking juvenile audience which returned preview cards not as literate as the first ones we got last night, but in the same proportion of Excellents and Goods. . . .

December 5: At 2:00 we ran *Sunset*, Gloria seeing it for the first time. We stopped between reels for discussion. I urged the removal of more of Gloria's more florid speeches. Billy claimed we would have nothing left. My cut of the "stars are ageless" scene was in. Whether it works or not, I don't know. It seemed abrupt to me. I felt the removal of "The Paramount-Don't-Want-Me Blues" song[23] was very bad. Billy liked it. Gloria regretted some of the sobs which had been whittled from the bedroom scene.

December 6: . . . Billy and I, augmented by Franz Waxman, worked for a couple of hours on *Sunset* commentary; Dick, Walter and I worked half an hour on *Sunset*; then Billy and Willie Shore appeared for bridge with Dick Breen and me. . . .

December 7: A morning with Walter and Dick, pushing forward slowly. . . . An afternoon in the dubbing room with Bill Holden (Billy deserting us early), getting a final commentary, or bunch of commentaries. . . .

December 20: . . . the house was prepared for the thirty people who were supping with me. All the tables were set up in the living room. . . .

My guests started to arrive, everyone intimately connected with *Sunset*, from Cecil B. and Mrs. DeMille to Artie Schmidt, the cutter, and Helen Hernandez and a beau (actors excluded). We had cocktails, ate hurriedly and went to the Bay Theatre, way down Sunset. There were Dodie and Alec and Christopher Isherwood.

It was a laugh-crazy audience and the picture played magnificently, some laughs still over commentary ("Something I think I should tell you about" still dangerous, but we killed the "That's it—there's nothing like being twenty-one" laugh by replacing, "That's it—a smart girl.") The cards were phenomenal (thank God we didn't preview the picture here first—we'd have had much too easy a time. . . .

23. Music and Lyrics by Jay Livingston and Ray Evans.

December 21: A day devoted entirely to *Sunset*—discussion of the picture with Walter, with Dick, with Dodie. Luncheon with Billy, Doane, Chuck, Frank, Artie, and discussion, Billy fighting any change; Doane even suggesting the replacement of stuff which died in the East because the photographic quality of stuff shot since doesn't match. The result of all the discussion is a rooted conviction on my part that the questioning of Norma by the police must be reshot, with some semblance of realism, with the definite implication that she's to be carted off to the county psychiatric ward as soon as her big scene is over.

This Henry and Doran agree to. . . .

December 22: Christopher Isherwood[24] wrote me a superb letter about *Sunset*, with which I plan to combat Billy's childlike resistance to retaking the questioning scene. Christopher points out, in highly literate English, why it's wrong—that the detectives seem to have read the end of the script.

December 27: . . . I lunched at the table, Billy very reasonable and friendly was still adamant about doing the extra scene we need.

. . . dropped in on D. A. Doran to talk over the Billy problem. He took me to Henry, who instead of considering it gave me a godawful speech he is making to all the exhibitors on the continent by radio, to rewrite. I wasted most of the afternoon on it. . . . Stopped at Gloria's on my way home, was greeted by Master Tig Larmore who was having a great time with some pet rodents of Gloria's (not real rats but tailless ones, rather like guinea pigs). Minna Wallis was there, Gloria's adopted son and his wife, some man who owns stores on Larchmont, the Larmores, and finally Michele. Gloria gave me a Guest Book and we discussed the [Clark] Gable-Sylvia marriage at length. . . .

December 28: . . . Billy put off our discussion of *Sunset*, so after my nap I conferred with Walter again. Suddenly a call from D.A. summoned me to

24. Christopher Isherwood (1904–1986), British-born novelist and occasional screen-writer, wrote to Brackett on December 21, "It is the best thing ever done about Hollywood, and one of the most terrifying sermons on human vanity ever put on the screen."

conference with him, Billy, Chuck. After viewing the film and arguing for hours, Billy consented to do some retakes though he announces that he thinks they'll be a waste of money. . . .

December 29: . . . Went to a party at the Artur Rubinsteins' which was a lot of fun—delicious food, good music (plus a little of the great playing of Artur). . . . I sat between Mrs. Louis B. Mayer and Joan Fontaine at dinner.

After dinner there was a dance orchestra. . . . We all danced, and then when the musicians were tired, Artur sat at the piano and played and suddenly Nella[25] began to dance around the dance floor. I hadn't known she was once in the ballet, and the exquisite grace with which she moved around the paneled room, sometimes getting one of the other women to dance a brief figure with her, was enchanting. I remember particularly Joan Fontaine, in her deep green, wide-skirted dress. Nella's dress was black, and out of Renove. She outdanced Joan, but Joan was in one of her moments of extraordinary beauty. Heather Angel,[26] looking like something exquisite from Godey's Ladies Book,[27] sat watching. . . .

December 31: A quiet morning of conference with Walter Reisch at the studio. . . .

Alan Campbell, Xan and James dined with me. . . . We played bridge until 11:30, tried setting the grandfather clock to the point of absolute accuracy. Got Tig down and all of us jumped into 1950—champagne and some strange doughnut things afterwards.

25. Rubinstein's wife and a former Polish ballerina.
26. Heather Angel (1909–1986), British-born actress in Hollywood from 1931.
27. The most popular ladies magazine of its day, published from 1830 through 1898.

LEADING NAMES AND SUBJECTS IN THE DIARIES

The individuals and subjects referenced here appear frequently in the unedited diaries, but may not always have a strong presence in the diaries as edited.

Academy of Motion Picture Arts and Sciences (AMPAS). Brackett's involvement with the Academy began in October 1942 when he was elected to the board of governors as a member of the Writers Branch; he continued to be reelected through May 1955, serving as 1st Vice President from May 1947 through May 1949 and President from May 1949 through May 1955. He was nominated for Best Writing Oscars for his work on *Ninotchka* (1939), *Hold Back the Dawn* (1941), *To Each His Own* (1946), and *A Foreign Affair* (1948). He won the Academy Award in that category for *The Lost Weekend* (1945), *Sunset Blvd.* (1950), and *Titanic* (1953). He was also nominated as producer of Best Motion Picture for *The King and I* (1956) and the following year received an Honorary Academy Award for "outstanding service to the Academy." In 1960, he transferred from the Academy's Writers Branch to its Producers Branch. The diaries contain many references to his interaction with the Academy's Margaret Herrick (1902–1976), whom he later refers to as "Maggie," and with whom he fights over his desire to reduce the number of Oscars given for short subjects. Born Margaret Buck, Margaret Herrick took her name from her second husband, Philip, whom she married in 1946. Her first husband, Donald Gledhill, became executive secretary of AMPAS in 1931, and five years later his wife began working in the Academy's library; when Gledhill joined the Army in 1943, Margaret was appointed in his place. She retired in 1971.

Barney Balaban. *See* Paramount Executives.

Jack Baragwanath. *See* Neysa McMein.

Alexandra Corliss Brackett (1920–1965). Affectionately known as "Xan" or "Xanu," Brackett's eldest daughter eloped to Las Vegas in March 1942 to marry James

Larmore, Jr. The couple had one son, James III. She died as a result of a cerebral hemorrhage after a fall in her home.

Elizabeth Barrows Fletcher Brackett (1890–1948). A descendent of Stephen Hopkins who came to America on the *Mayflower*, Elizabeth Barrows Fletcher married Brackett in Indianapolis on June 2, 1919. The diaries are very circumspect and make scant reference to the ongoing battles of "E," as she is called, with alcoholism and mental illness. Often when she is described as being in the "East," she is actually at the Austen Riggs Center in Stockbridge, Massachusetts, a psychiatric facility. It is obvious that she was never happy in Los Angeles or comfortable with many of her husband's friends (including Billy Wilder).

Elizabeth Fletcher Brackett III (1922–1997). Brackett's youngest daughter, affectionately known as "Bean" or Betty, married Army Air Corps pilot Clifford J. Moore, Jr. in February 1944. The couple had two children, Victoria (born 1944), also known as Vicky or "Victo," and Clifford James III (born 1949). She, her husband, and daughter moved away from Southern California after World War II and feature little in the later diaries. During the war, Moore named his P-38 and P-51 fighters "Uninvited" and "Uninvited II," respectively, after Brackett's movie.

Lillian Fletcher Brackett (1894–1984). The younger sister of Brackett's first wife, she and he were married in 1953 and remained together until his death. Lillian later moved back to the Fletcher family home in Peewee Valley, Kentucky, where she died. Lillian played a prominent role in Brackett's life during the later years he was married to Elizabeth.

Richard L. Breen (1918–1967). After reading one of his radio scripts, Brackett and Wilder hired Breen in January 1947 to work on *A Foreign Affair*, for which he received screen credit with the two. Breen also shared screen credit with Brackett on *Miss Tatlock's Millions* the following year, before embarking on a distinguished writing career in his own right. He was president of the Screen Writers Guild from 1952 to 1953, and in 1953 shared the Academy Award for Best Writing—Story and Screenplay, along with Brackett and Walter Reisch, for *Titanic*.

Sam Briskin. *See* Paramount Executives.

Alan Campbell. *See* Dorothy Parker.

Charles "Buddy" Coleman (1901–1972). The much-liked assistant director on the Brackett-Wilder films which the latter directed at Paramount, Coleman was an assistant director at the studio for twenty-one years and earlier had served in a similar capacity at Columbia for eighteen years. He died as a result of a fall from the roof of his Sherman Oaks, California, home, lying unconscious for twelve hours before being found by a neighbor.

George Cukor (1899–1983). After a stage career, Cukor came to Hollywood in 1928, working as a dialogue director on *All Quiet on the Western Front* (1930) and co-directing three 1930 features at Paramount; it was the start of an illustrious career, which included, among many other classics, *The Women* (1939), *The Philadelphia Story* (1940), *Born Yesterday* (1950), and *My Fair Lady* (1964). George Cukor was the first director whom Brackett met when he first came to Hollywood in 1932, and he worked with him peripherally on *Rockabye* (1932) and more prominently on *Little Women* (1933); the two men became close friends and the diaries contain reports on many of Cukor's star-studded parties.

George "Buddy" De Sylva (1895–1950). A legendary songwriter, who usually worked in concert with Lew Brown and Ray Henderson, and was played by Gordon MacRae in the 1956 film biography of the trio, *The Best Things in Life Are Free*. He produced *Five Grave to Cairo* (1943) and *The Uninvited* (1944), and appears to have been well liked by Brackett.

D. A. Doran. *See* Paramount Executives.

Doris Dowling (1923–2004). A former chorus girl, who followed sister Constance to Hollywood and made her screen debut in 1945 in *The Lost Weekend*, shortly after becoming Billy Wilder's mistress. Dowling enjoyed a later career both in Italy and the United States. Brackett did not care for Dowling and was not happy with her being cast by his collaborator in either *The Lost Weekend* or *The Emperor Waltz* (1948).

Henry Ginsberg. *See* Paramount Executives.

Frances Goodrich (1890–1984) and **Albert Hackett** (1900–1995). The most prominent husband-and-wife writing team in Hollywood were married in 1931; in 1933, they signed a contract with MGM, where they remained until 1939 and created "The Thin Man" movies. Other films include *It's a Wonderful Life* (1946), *Easter Parade*

(1948), *Seven Brides for Seven Brothers* (1954), and *The Diary of Anne Frank* (1959, and based on their play). They and Brackett were close friends; he would hire them in the 1940s to work on abortive projects and, uncredited, on *To Each His Own* (1946), albeit briefly, and *Miss Tatlock's Millions* (1948). In 1956, Brackett wrote to the couple, "there was always something one hadn't thanked the wonderful Hacketts for—and always will be: some holdover of generosity, or shared remembrance, or bawdy humor, or understanding. . . . I see no termination of my gratitude to you."

Albert Hackett. *See* Frances Goodrich and Albert Hackett.

Robert Harari (1906–1978). Despite describing Egyptian-born Harari in his diary as "a half-Egyptian horror," Brackett did write of him elsewhere as "a man with a stimulating, creative mind . . . resourceful and productive. . . . My association with him was always most pleasant." Harari was hired by Brackett and Wilder in February 1947 as a constructionist, which he did well on *A Foreign Affair* and on productions for others, for which he often did not receive screen credit. Harari's earliest screen credit is *Music for Madame* (1937) and his last *A Millionaire for Christy* (1951).

Richard Haydn (1905–1985). An actor known for his eccentric comedic roles, who made his screen debut in *Charley's Aunt* (1941), after radio in his native Britain and appearances on Broadway. He was also an occasional director, but is best remembered for films such as *Cluny Brown* (1946), *Alice in Wonderland* (1951), and *The Sound of Music* (1965). Despite being somewhat obviously gay, Haydn was engaged briefly in 1943 to Marlene Dietrich's daughter, Maria Riva. For Brackett, he appeared in *Ball of Fire* (1941), *The Emperor Waltz* (1948), and *Miss Tatlock's Millions* (1948, and, at Brackett's recommendation, also director).

Doane Harrison (1894–1968). A veteran film editor from the mid-1920s onwards, who joined Paramount in 1935, where he worked frequently with director Mitchell Leisen and became the studio's supervising editor. His earliest involvement with Brackett and Wilder is on *Midnight* in 1939; from *The Major and the Minor* in 1942, Harrison worked on all the films directed by Wilder for the next twenty-five years, later becoming his associate producer and producer.

Helen Hernandez (1904–1980). When Brackett and Wilder began work on the script for *What a Life* in 1939, they chose Helen Hernandez from the studio secretarial pool to work with them. Hearing that Brackett and Wilder were moving into new offices, she wrote the former on June 9, 1942, "what a happy thing it would be to work as your

secretary in your new set-up." On June 29, 1940, Brackett records that she has been installed as their secretary. Hernandez worked with both men, but it is very apparent that her primary loyalty was to Brackett. She once called Wilder "a stinker," and she went with Brackett to 20th Century-Fox. In all, Hernandez spent nineteen years at Paramount and a further nineteen years at 20th Century-Fox.

Margaret Herrick. *See* Academy of Motion Picture Arts and Sciences.

Dr. Sam Hirschfeld. The personal physician, and later a close friend, of Brackett's, who also took care of Brackett's wife, Elizabeth, and Billy Wilder. Indeed, Hirschfeld appears to have been the personal physician to many Hollywood celebrities. It is Dr. Sam who gives Brackett his weekly B-12 shots, which are so frequently mentioned in the unedited diaries.

Hedda Hopper (1885–1966). An actress turned gossip columnist in 1938, Hedda Hopper was, like Brackett, a staunch Republican, but unlike Brackett she was also extremely right-wing. Not only for her politics, but also because she was fun, Brackett much preferred Hedda to her competitor, Louella Parsons.

Arthur Hornblow, Jr. *See* Paramount Executives.

James [Matthew] Larmore, Jr. (1910–1965). Little is known of Xan's husband, with whom she eloped in 1942. He is credited with small roles in four Broadway productions: *Russet Mantle* (1936), *Daughters of Atreus* (1936), *Good Hunting* (1938), and *Winged Victory* (1943). In a diary entry dated May 2, 1955, Christopher Isherwood writes that Larmore "used to be a chorus boy and it showed," relative to his dancing. In April 1946, Brackett obtained work for him as a production assistant at Paramount and was able to promote him to the small role of Lieutenant Hornby in *A Foreign Affair* (1948). Billy Wilder biographer Maurice Zolotow describes him as "a person of charm and talent when he was sober |who| became a monster when drunk." Larmore died of an alcoholic convulsion in Detroit while en route to visit relatives in Cleveland.·

James Larmore, III (born 1943). Known affectionately as Jim, "Jimbo," "Tigger," or "The Tig," the son of Xan and James Larmore, Jr. was closely chaperoned by his grandfather, who was concerned about his grandson's daily welfare in light of his parents' drinking. The boy spent more time at Brackett's 10601 Bellagio Road home in the 1940s than he did at his own. The relationship between Brackett and his grandson was not approved of by Billy Wilder, in particular Brackett's insistence on bringing the

boy to the studio and allowing him on the set (where he appears to have been adored by Marlene Dietrich and Gloria Swanson). One Wilder biographer has written that the former detested James Larmore, Jr. and his presence at the studio destroyed any social relationship between him and Brackett. As the diaries prove, this is not true, and it may well be that the problem between Wilder and Brackett was not James Larmore, Jr. but rather James Larmore III.

William LeBaron. *See* Paramount Executives.

Mitchell Leisen (1898–1972). An art director and costume designer, Leisen became a director in 1933, closely associated with romantic melodramas and screwball comedies. He appears frequently in the diaries, being involved as a director with the following Brackett projects: *Behold My Wife!* (1934), *Midnight* (1939), *Arise, My Love* (1940), *Hold Back the Dawn* (1941), and *To Each His Own* (1946). "What calm, beautiful days we used to have in that golden era at Paramount!" wrote Leisen to Brackett in 1959. The diaries would seem to suggest otherwise.

David Lewis (1903–1987) and **James Whale** (1896–1957). Lewis was prominent as a producer in the 1940s–1950s, involved in such memorable films as *Camille* (1937), *Dark Victory* (1939), *King's Row* (1942), and *Raintree County* (1957). Brackett and Lewis first met in the 1920s, when Brackett was drama critic at *The New Yorker*, and later he loaned Lewis $600 to come to Hollywood. It was Lewis with whom Brackett first socialized when he followed him to Hollywood, although Brackett appears to have found the young man somewhat tedious. Lewis introduced Brackett to his "lover" James Whale, and the diary records not only the amusing stories that Whale has regarding Mrs. Patrick Campbell in *One More River* but also the slow deterioration of the Lewis-Whale relationship. When Wilder and to a lesser extent Brackett began drafting a script, *Of Ice and Woman*, for Sonja Henie, they gave it to Lewis, and he produced it as *It's a Pleasure!* (1945).

Ernst Lubitsch (1892–1947). Some of America's greatest and most sophisticated films boast of "the Lubitsch touch," from this German-born filmmaker, including *The Love Parade* (1929, his first sound film), *The Smiling Lieutenant* (1931), *Trouble in Paradise* (1932), *Shop Around the Corner* (1940), and *Heaven Can Wait* (1943). Brackett regarded Lubitsch as his mentor, although the men were associated on only two films: *Bluebeard's Eighth Wife* (1938) and *Ninotchka* (1939). He socialized with Lubitsch and his wife Vivian, perhaps more so than Billy Wilder. Brackett promoted a special Academy Award for the director in 1947, and he wrote and read the eulogy at his funeral.

Lucey's Restaurant. Located at 5444 Melrose Avenue, at the corner of Windsor Avenue, Lucey's quickly became a popular eating place for Paramount personnel, including its stars, directors, and writers. It was opened in the 1920s by Antonio "Lucey" Luciano, who sold it in 1945 to Nathan Sherry, owner of approximately a dozen other restaurants and nightclubs. After Sherry's 1954 death, the name was changed to Lucey's New Orleans House in 1959 and Casa Lucey's in 1963. It was later demolished. Lucy's El Adobe Café, also on Melrose Avenue, which opened in 1964, has no connection to the earlier restaurant.

John Lund (1911–1992). A former Broadway actor, Lund was given a Paramount contract and heavily promoted by Brackett for male lead in *To Each His Own* (1946, Lund's first Paramount film), *A Foreign Affair* (1948), and *Miss Tatlock's Millions* (1948). Brackett seems very attracted to and defensive of this far-from-stereotypical leading man and devotes time to criticizing the cheap quality of his wardrobe; he socialized with Lund and his wife and one might well hypothesize that Brackett had a "crush" on the actor. This is further suggested by a curious diary entry dated October 21, 1948: "I find myself staring hypnotized by my poor John Lund as he eats luncheon in his *Mask of Lucretia* [*Bride of Vengeance*] wig. It makes him look like a girl, but a not-pretty girl, an almost-pretty and not attractive girl. I wish he weren't doing the picture."

Luigi Luraschi (1905–2002). London-born Luraschi joined Paramount in 1929 and remained with the company through 1960, with his primary responsibility being U.S. and foreign censorship issues (from 1936 onwards) and oversight of foreign production. His relationship with studio personnel became increasing difficult when it was revealed that he had also been working with the CIA in the 1950s and that he had lobbied to prevent *High Noon*'s being given an Academy Award. He left Paramount in 1960 to work with Dino DeLaurentiis in Italy, but returned to Paramount in 1965, working out of Paris and London.

Mary C. McCall, Jr. (1904–1986). One of Brackett's closest friends and supporters in his battles at the Screen Writers Guild, Mary C. McCall, Jr. had come to Hollywood when her 1932 novel *Scarlet Dawn* was filmed by Warner Bros. Among the prominent productions upon which she worked are *A Midsummer Night's Dream* (1935), *Craig's Wife* (1937), and eight of the "Maisie" films starring Ann Sothern. She was president of the Screen Writers Guild from 1942 to 1943, 1943–1944, and 1951–1952. Called before the House Committee on Un-American Activities on July 27, 1954, because of her membership in four so-called Communist front organizations, she uttered the cliché: "I would rather be dead than be a Communist." At that time, Brackett issued an undated

statement noting that a number of anti-Communist members of the Screen Writ-
ers Guild had put all their energies into fighting off a Communist takeover: "Of all
the fighters on our side, of all the ardent and aware anti-communists, Mrs. Bramson
[McCall] was the most ardent and most effective. She was my right hand in the fight,
and in later years, when she became President of that Guild, she carried on and spear-
headed that fight." One of her daughters is the former film critic of the *Los Angeles
Times*, Sheila Benson.

Neysa McMein (1888–1949). Born Marjorie Moran and adopting her professional
name on the advice of a numerologist, Neysa McMein was one of the most prominent
magazine cover illustrators of her day, creating all the covers for *McCall's* from 1923
to 1937, producing posters for the U.S. government during World War I and coming
up with the image of the stereotypical American housewife, "Betty Crocker." She was
also a member of the Algonquin Round Table, and in 2001 she was honored on a U.S.
postage stamp. In 1923, she entered into an open marriage with the wealthy mining
engineer and author John C. "Jack" Baragwanath (1888–1965), whose comedy "about
society and things," *All That Glitters*, co-written with Kenneth Simpson, opened on
Broadway in January 1938. It is the family's belief that Brackett desperately wanted
to be McMein's lover, but she, while always kind, rebuffed him. In Brackett's novel,
Entirely Surrounded, her character of Leith O'Fallon is the only one not savaged by his
satire; he wrote of "That voice of hers with the squeak of a bed in every inflection."
After reading the novel, McMein wrote to Brackett, in an undated letter, "you have
blackened my reputation for good, I forgive you and wish you'd come home." Brackett
would always come home to McMein.

D. M. "Mac" Marshman, Jr. (born 1922). A former film critic at *Life* (1945–1948) and
Time (1948), Marshman was invited to join Brackett and Wilder on the script for *Sun-
set Blvd.*, sharing screen credit and an Academy Award for his work. He was involved
with two other minor films and two television series in the 1950s before embarking
on a career in advertising with Young & Rubicam. "I know no one with a finer, wiser
instinct for celluloid than his," wrote Brackett to Marshman's mother in 1949.

William "Bill" Meiklejohn (1903–1981). A legendary talent agent, whose discoveries
include Judy Garland and Ronald Reagan, he began his career in 1921 as a booking
agent in vaudeville. In the 1930s, he joined MCA, and in 1940, Meiklejohn became
head of talent at Paramount, a position he held for the next twenty years. He founded
his own agency in 1961. Brackett discusses Meiklejohn's discovery of Gail Russell, who
was subsequently cast in *The Uninvited* (1944).

Mezuzah. The mezuzah may be a sacred parchment, inscribed by hand with two portions of the Torah, stored in a protective case and hung on the doorposts of Jewish homes, but to Charles Brackett it appears to have been treated as some sort of good luck charm that he gave to each of his leading ladies and to Billy Wilder in the 1940s. It is also possible that he and Wilder, as screenwriters and as the Gods of production and direction, were enjoying a joke in that the prayer within the Mezuzah refers to keeping "God's words constantly in our minds and in our hearts." Brackett would often describe the pleas of help from others as "Macedonian cries" (Acts 16:9). Not to respond to a Macedonian cry was to turn one's back on something best not ignored. Perhaps Brackett's handing out of Mezuzahs was his way of warding off Macedonian cries from the set.

Alice Duer Miller (1874–1942). Brackett was devoted to the novelist and poet, who never denied that her most popular books were written to make money, and whose works include a number that were filmed, although she herself was not a prolific screenwriter and should not be confused with Alice Miller (who was). She is perhaps best remembered for the poem, "The White Cliffs," which was the basis for the Irene Dunne vehicle, *The White Cliffs of Dover* (1944). "It is a bleak fact," wrote Alexander Woollcott, "that there is now no such person in our world as Alice Duer Miller."

John [Chapin] Mosher (1892–1942). Mosher came to *The New Yorker* in 1926, and became its film critic two years later. One of his first pieces for the magazine in 1926 was a profile of F. Scott Fitzgerald, "That Sad Young Man," which apparently soured the relationship between the two men. Shortly before his death, Mosher published a collection of his sketches on "Mr. Opal," which had appeared in *The New Yorker*, under the title of *Celibate of Twilight*. He was a graduate of Williams College, where he and Brackett were fraternity brothers. The two became extremely close, with Brackett devastated at Mosher's death, leading Janet Flanner to question if their relationship went beyond friendship. Certainly, Mosher would appear to have been gay—"I lead a strange life," he wrote to Brackett in March 1942—with his keeping an apartment in New York, shared with another (unidentified) man and a home on Fire Island. "He was a very great human being," wrote Brackett to Mosher's mother, two days after his death, "immeasurably greater than most people know."

Paramount Executives. The most frequently mentioned of Paramount executives are president of Paramount from 1936 to 1964, Barney Balaban (1887–1971); production executive Sam Briskin (1896–1968), who was responsible for Brackett's leaving Paramount, and of whom Brackett wrote to Balaban in 1951, "by profession, he is a bookkeeper, he is by nature and experience an ill-bred, uncouth and illiterate person . . . not

to be trusted with film production"; production executive D. A. Doran (1898–1978), whom Brackett perhaps despises the most (his first name was Daniel and he claimed never to have been told what his middle name was; to his family, friends, and his wife he was always "D.A."); vice-president and general manager in charge of studio productions Henry Ginsberg (1897–1979); producer Arthur Hornblow, Jr. (1893–1976), whose wife from 1936 to 1942 was Myrna Loy; producer William LeBaron (1883–1958); producer Joseph "Joe" Sistrom (1912–1966); president and later, from 1936, chairman of the board Adolph Zukor (1873–1976).

Dorothy Parker (1893–1967). Dorothy Rothschild became Dorothy Parker when she married stockbroker Edwin Pond Parker in 1917; her other husband was Alan Campbell, whom she first married in 1934, divorced in 1947, and remarried in 1950. Charles Brackett was the best man at the second wedding. One of the founders of the Algonquin Round Table, on whose fringes Brackett lurked, Dorothy Parker was a phenomenal wit, whose short stories and poems were widely popular. With husband Alan Campbell (1904–1963), she came to Hollywood as a screenwriting partnership. Despite being an outspoken liberal, Parker and Charles Brackett were close friends and perhaps also bed partners, with his often staying at her New York apartment; probably in part he was drawn to Parker because of her alcoholism. Campbell was often as witty as his wife; for example, referencing a Paramount "B" actress, he wrote to Brackett in the 1940s, "I always feel that a letter to the studio is likely to result in an autographed picture of Wanda Hawley."

Frank Partos (1901–1956). Partos was a Hungarian-born screenwriter who came to Hollywood as a story scout in 1928; he and Brackett were first paired together by Paramount in May 1934, working on *Her Master's Voice*, for which they did not receive credit. Brackett and Partos remained friends and worked together, respectively as producer and co-screenwriter, on *The Uninvited* (1944).

Walter Reisch (1903–1983). A writer and director in Germany and Britain, Reisch came to the United States in the late 1930s, where his credits are substantial. He worked with Brackett and Wilder in 1939 on *Ninotchka*, for which the three received an Academy Award nomination. When it looked as if Wilder and Brackett were splitting up, Reisch was assigned as the latter's writing partner in August 1949, and the pair, along with Richard Breen, worked together again and received an Academy Award for their work on *Titanic* (1953).

Screen Writers Guild (SWG). The Guild has its origins on the East Coast with the Authors' League of America, Inc. (founded 1912), the Dramatists' Guild (founded 1919),

and the short-lived Photoplay Authors' League (1914–1916). It was initially founded in October 1920 as a branch of the Authors' League, but reorganized in April 1933 with John Howard Lawson as its President. In 1936, Conservative writers (excluding Brackett) began the Screen Writers of Hollywood, led by Herman Mankiewicz. The SWG was dissolved in July 1936, but reorganized in June 1937, with Brackett on its board; the following year he was elected President, replaced in 1939 by Sheridan Gibney. Prior to his election as President, Brackett noted that for the two preceding years, as Vice President, he had been acting President due to the absence of President Dudley Nichols. The activities of the SWG are complex, and Brackett's diaries record endless meetings and disputes between the left- and right-wing factions, much of it incomprehensible to outsiders, and fights with the studio-sponsored Screen Playwrights. It was not until May 1942 that SWG signed a contract with the producers, something for which Brackett fought strongly. In 1954, SWG became the Writers Guild of America.

Joe Sistrom. *See* Paramount Executives.

Dodie Smith (1896–1990). The English writer, best known for the plays *Autumn Crocus* (1931) and *Dear Octopus* (1948) and the novels *I Capture the Castle* (1948) and *The Hundred and One Dalmatians* (1956), became a close friend of Brackett's in the 1940s; he found her work on *The Uninvited* (1944) and other unrealized projects. Brackett's diaries reveal her as a difficult person, although as he admits she suffered much anguish in her protection of husband Alec Macbeth Beesley, who was a conscientious objector.

Jacques [Edmond] Théry (1881–1970). Brackett regarded Théry as an outspoken, hard-line Communist and thus someone to despise, and yet at the same time he had to admit his capabilities as an often-uncredited script collaborator in the 1940s. Aside from his film work, Théry also co-wrote a 1928 French farce, *The Madcap*. Théry was active in his native France from 1931 and it is his wife who introduced Billy Wilder to his future wife, Judith; Théry co-wrote the story of *Rhythm on the River* (1940) with Billy Wilder, and received co-screenplay credit on *Arise, My Love* (1940) and *To Each His Own* (1946).

Ruth Waterbury (1896–1982). A fan magazine writer and editor (*Photoplay* and *Silver Screen*), and later an assistant to Louella Parsons, Waterbury was highly regarded by Brackett as the best in her field. On a weekly basis, Brackett would take Waterbury to lunch at Perino's in the 1930s and 1940s. There is no evidence of any special relationship between the two, although Waterbury was certainly a highly sexual lady.

James Whale. *See* David Lewis and James Whale.

Billy Wilder (1906–2002). Austrian-born Billy Wilder began his career as a screen-writer in Berlin in the late 1920s. He made his directorial debut in Paris with *Mauvaise Graine/Bad Seed*, which he also co-wrote. Wilder came to Hollywood in 1933, prior to its 1934 release, and after three films at Fox he was teamed by Paramount with Charles Brackett in the summer of 1936. After splitting with Brackett, Wilder's first film was *Ace in the Hole* (1951), which he directed, produced, and co-wrote. Later films include *Stalag* 17 (1953), *The Seven Year Itch* (1955), *Some Like It Hot* (1959), *The Apartment* (1960), and his last, *Buddy, Buddy* (1981). His first wife was Judith Coppicus, whom he married in 1936 and divorced ten years later, and of whom Brackett was obviously fond. After a stormy relationship with actress Doris Dowling, Wilder married Paramount contract player Audrey Young (1922–2012).

Menahem Mandel "Manny" Wolfe (1904–1952). Born in Russia, "Manny" Wolfe came to the United States at the age of two, and had an early career as a newspaper writer and theatrical company manager in the 1920s before joining Warner Bros. as a reader in 1928. He came to Paramount in 1931, eventually, by 1939, supervising sixty-one writers as Head of the Editorial Department. From Paramount, he moved to RKO (1944), Universal-International (1947), and Edward Small Productions (1952). He died of a heart attack the day before his wedding. Wolfe is generally credited (by Wilder) as the executive who brought Brackett and Wilder together, although the former does not acknowledge this, and there are similar claims by others.

Alexander Woollcott (1887–1943). A larger-than-life humorist, critic, and commentator, as well as a leading member of the Algonquin Round Table, Woollcott wrote a column in *The New Yorker* from 1929 to 1934. In 1924, with others, he purchased Neshobe Island, Vermont, and lived there permanently from 1938 until his death. Woollcott and life on Neshobe Island is parodied by Brackett in his 1934 novel, *Entirely Surrounded*. At Woollcott's death, Brackett is pleased with the published quotes from the novel but realizes how little he is affected by it, compared to his deep sorrow at the loss of Alice Duer Miller and John Mosher. Perhaps little wonder in that he described Woollcott as "a competent old horror with a style that combined clear treacle and pure black vile."

Monty Woolley (1888–193). A large and flamboyant actor with a magnificent beard and an arrogant demeanor, Monty Woolley and Brackett were friends since the late 1910s. A gay man who was close to Cole Porter, as the diaries reveal, Woolley is best re-membered for his caricature of Alexander Woollcott in the George S. Kaufman–Moss

Hart comedy, *The Man Who Came to Dinner*, first staged in 1939 and filmed in 1942. For Brackett, Woolley appeared in *Miss Tatlock's Millions*.

The Word Game. Throughout his time at Paramount, Brackett participated in the "word game," played each noon at the writers' table in the studio commissary. Each writer was provided with a card, ruled into twenty-five squares, five across and five down, and placed letters in his squares as they were called out. Whichever writer constructed the most five-, four- and three-letter words won. The stakes were twenty-five cents a game. The only non-writer known to participate was Claudette Colbert in the 1940s, much obviously to Brackett's distress.

Adolph Zukor. *See* Paramount Executives.

NOTES TO INTRODUCTION

1. The first biography was *Billy Wilder in Hollywood* by Maurice Zolotow (G. P. Putnam's, 1997); other volumes include *Conversations with Billy Wilder* by Cameron Crowe (Alfred A. Knopf, 1999), *Billy Wilder: Interviews*, edited by Robert Horton (University Press of Mississippi, 2001), *Nobody's Perfect: Billy Wilder, a Personal Biography* by Charlotte Chandler (Simon & Schuster, 2002), and the most prominent, *On Sunset Boulevard: The Life and Times of Billy Wilder* by Ed Sikov (Hyperion, 1998).

2. A tourist community, famous for its race course, Saratoga Springs can also boast Monty Woolley as one of its best-known residents, although he was not born there.

3. Quoted in Sam Frank, "Charles Brackett," in Robert E. Morsberger, Stephen O. Lesser, and Randall Clark, eds., *American Screenwriters* (Gale Research, 1984), p. 34.

4. There is no complete record of Brackett's stories for *The Saturday Evening Post*. The following is in all probability incomplete: "Pearls before Cecily" (February 17, 1923), "Domestic Relations" (November 10, 1923), "Interlocutory" (March 15, 1924), "Sun Cure" (November 14, 1925), "By Request" (February 20, 1926), "Sheik's Clothing" (August 14 and 21, 1926), "As Suggested" (January 22, 1927), "On Second Thought" (September 3, 1927), "Epilogue to Cinderella" (September 24, 1927), "Valse Oubliée" (October 15, 1927), "The Travel Test" (November 19, 1927), "Professional Reasons" (June 30, 1928), "Ever Bright and Fair" (October 13, 1928), "Stormy Passage" (October 27, 1928), "Mrs. Eldridge" (February 23, 1929), "Rx" (May 4, 1929), "Big Rich" (January 11, 18, and 25, 1930), "What Have You" (July 19, 1930), and "Between Shirt Sleeves" (July 9, 1932).

5. Zolotow, *Billy Wilder in Hollywood*, p. 11.

6. Quoted in Chandler, *Nobody's Perfect*, p. 77.

7. Arthur Conan Doyle, "A Scandal in Bohemia," *The Strand Magazine*, July 1891, p. 2.

8. "Idea-a-Minute Men," *Liberty*, May 4, 1945, p. 59.

9. Ibid., p. 19.

10. Nancy Lynn Schwartz, *The Hollywood Writers' Wars* (Alfred A. Knopf, 1982), p. 128. The book devotes little space to Brackett's work with the fledgling Screen Writers Guild.

11. Quoted in Crowe, *Conversations with Wilder*, p. 40.

12. Lincoln Barnett, "The Happiest Couple in Hollywood," *Life*, December 11, 1944, pp. 100–112.

13. Phil Koury, "The Happy Union of Brackett and Wilder," *New York Times*, April 18, 1948, p. X5.

14. Burt Prelutzky, "An Interview with Billy Wilder," in Horton, ed., *Billy Wilder: Interviews*, p. 184.

15. Quoted in Chandler, *Nobody's Perfect*, p. 162.

16. Garson Kanin, *Hollywood: Stars and Starlets, Tycoons and Flesh Peddlers, Moviemakers and Moneymakers, Frauds and Geniuses, Hopefuls and Has-Beens, Great Lovers and Sex Symbols* (Viking Press, 1974), pp. 178–79. Kanin's comments on Brackett are, in all probability, partly fictional. He writes of Brackett's having six Oscars sitting on a table behind him, when the actual number is only four. He also describes them as "tarnished and faded," and wonders why nobody has bothered to "shine them up." In fact, as Jim Moore points out, they were routinely polished.

17. Louella Parsons, "Brackett out of Paramount," *Los Angeles Examiner*, October 30, 1950, p. 3.

18. Diary entry dated February 21, 1945.

19. 20th Century-Fox inter-office memo, dated October 31, 1950, copy in the author's collection.

20. Charles K. Feldman to Darryl F. Zanuck, October 17, 1950, copy in the author's collection.

21. It is claimed that he feigned deafness "in order to exclude unpleasant sounds like directorial objections or symphonic music." Barnett, "The Happiest Couple in Hollywood," p. 110.

22. Letter to Brackett's widow, dated March 16, 1969.

23. Letter to Brackett's widow, dated July 29, 1969.

24. Diary entry dated September 12, 1938.

25. "Idea-a-Minute Men," *Liberty*, May 4, 1946, p. 59. This same description pretty much matches the one found in Barnett's profile, "The Happiest Couple in Hollywood."

26. Diary entry dated January 4, 1937.

27. Harold Hildebrand, "Charles Brackett: Foe of Gimmick," *Los Angeles Examiner*, December 6, 1959, sec. 5, p. 16.

28. The selling of the Saratoga Springs home was devastating to Brackett. It was not only the house in which he was born but also the home where he was raised,

where his brother died, and where his writing endeavors began (for the community newsletter *The Comet* in 1910).

29. William F. Nolan, *Hammett: A Life at the Edge* (Congdon & Weed, 1983).

30. Diary entry dated September 28, 1932.

31. William J. Mann, *Behind the Screen: How Gays and Lesbians Shaped Hollywood, 1910–1969* (Viking, 2001), p. 205.

32. Ibid., p. 206.

33. Ibid., p. 206.

34. Ibid., p. 206.

35. *American Colony* (1929), p. 86.

36. *Entirely Surrounded* (1934), p. 115.

37. One exception is Ed Sikov in *On Sunset Boulevard: The Life and Times of Billy Wilder*, p. 215.

38. Katherine Bucknell, ed., *Christopher Isherwood: Diaries*, vol. 1, 1939–1960 (Michael di Capua Books/HarperCollins, 1996), entry dated May 2, 1955.

39. Ibid., entry dated December 27, 1959.

40. Ibid., entry dated July 11, 1960.

41. Katherine Bucknell, ed., *Christopher Isherwood The Sixties: Diaries, 1960–1969* (HarperCollins, 2010), entry dated October 31, 1961.

42. Ibid., entry dated November 17, 1966.

43. E-mail from Kate Bucknell to Anthony Slide, March 28, 2013. Ms. Bucknell holds a PhD from Columbia University.

44. Telephone conversation with Don Bachardy, April 15, 2013.

45. Ibid.

46. The young man is probably sketch artist Alan Shepherd.

47. See Tyler Alpern's website. Fletcher was promoted in her column by Hedda Hopper, who was always sympathetic to gay men in private if not in public.

48. "Idea-a-Minute Men," *Liberty*, May 4, 1945, p. 59, confirms that Brackett's "old-fashioned" longhand "can be deciphered only by Miss Hernandez."

49. Letter dated November 16, 1951, on the letterhead of Random House, Inc.

50. Doubleday first rejected the diaries in August 1965, and again in 1973 and 1976.

51. I was surprised by this superstition as I had assumed I was the only person to greet each new month not with "rabbits" but with "white rabbits."

52. In all probability, he and his daughters visited the Will Wright's at Beverly Drive and Charleville in Beverly Hills, although they may well have visited the branch at Glendon and Lindbrook in Westwood.

53. Barnett, "The Happiest Couple in Hollywood," p. 112.

54. In the 1950s, there were certainly parties; as grandson Jim recalls, "It was at such parties that I learned to play cribbage from Raymond Massey and met John Steinbeck. People came over to swim, to play skittles in the garden room, to play bridge ... it was a busy house until Charlie could no longer appreciate them due to his illnesses. Muff was a great hostess."

INDEX

In that Charles Brackett appears throughout the book and Billy Wilder through most of it, only specific matters related to them are indexed under their names. References to films on which the two worked, as well as other films in which Brackett had an interest, are indexed under the titles of those films. Subjects referenced in the diaries are similarly indexed under the subject.

FILM AND CULTURE
A series of Columbia University Press
Edited by John Belton